W9-CHQ-698

ARTHUR HENRY
KNIGHTON-HAMMOND

ARTHUR HENRY KNIGHTON-HAMMOND

Peter Norris

The Lutterworth Press
Cambridge

The Lutterworth Press
P.O. Box 60
Cambridge
CB1 2NT

First published by The Lutterworth Press, 1994

British Library Cataloguing-in-Publication Data
A record is available for this book from the British Library

ISBN 0-7188-2824-0

Printed in Hong Kong by
Paramount Printing Group Limited

CONTENTS

LIST OF ILLUSTRATIONS

All works are by Knighton-Hammond unless otherwise stated.

PLATES

FIGURES

FOREWORD

It is a fascinating, but sometimes frustrating, occupation trying to identify the location of pictures. But when this is done another piece of a historic jigsaw fits into place.

For approximately eighty years my father painted all over the UK and in parts of France, Italy and Tunis. He also had a commission soon after the First World War to do some drawings and paintings for the Dow Chemical Co. in Midland, Michigan. It is particularly gratifying that seventy years later they are still supporting A. H. Knighton-Hammond and have been willing to sponsor Peter Norris' comprehensive book on this very talented artist.

As a young girl, I remember my father always had a sketchbook in his pocket which would come out if he saw an interesting subject in a restaurant or train which he could not resist drawing. In his younger days, I doubt if he ever went out without his easel and paintbox.

It is impossible to say how many water-colours, oils, pastels, etchings, not to mention sketchbook drawings, he made in his lifetime. (I remember him painting four water-colours in an hour.) These are now scattered all over the world and are becoming much sought after.

Peter Norris himself has a comprehensive and very pleasing collection of the artist's work. He told me when I first met him that Knighton-Hammond was his favourite artist and it is therefore appropriate that he should have written this book which I know my father would have appreciated.

Mary B. Jopp

To the artist's daughter
Mrs Mary Jopp

THE SPONSORS

THE HERBERT H. AND GRACE A. DOW FOUNDATION

The Herbert H. and Grace A. Dow Foundation, located in Midland, Michigan, USA, was established by Mrs Grace A. Dow in 1936 in memory of her husband Dr Herbert H. Dow, founder of the Dow Chemical Company. The Dow company has its headquarters in that city. By its charter the foundation's mission is to improve the educational, religious, economic, and cultural lives of the people of the state of Michigan. It is governed by a board of trustees composed predominantly of descendants of Herbert and Grace Dow. Its president is Herbert H. Dow, grandson of the founder.

THE MIDLAND CENTER FOR THE ARTS

The Midland Center for the Arts was inaugurated in 1971 as a focal point for the fine arts in Midland, Michigan. Its founder was Alden B. Dow, the distinguished architect son of Herbert H. Dow. Its facilities include a large auditorium, theatre, lecture hall, art galleries and studios, and other areas for art, science and history exhibits. Home to six community arts organisations, the Center is noted for the Hall of Ideas, a science museum, and Matrix: Midland Festival, an annual celebration of the arts, science and humanities.

ACKNOWLEDGEMENTS

The publication of a book in this form would not have been possible without the kind assistance of many people. In addition to those mentioned in the introduction the following persons must be acknowledged and thanked:

Miss Ann Benson (the artist's step-daughter), Mr Michael Hammond (the artist's great nephew), Mrs Dinah Wright, The Right Hon. The Viscount Tenby, Dr W. Warnock and Mr W.J. MacKie, Works Managers, ICI Huddersfield, Mr Gordon Hodge, Dr L. Wear, Mr Harold Brayne, Mr Charles Lee, The Hon. Henry Lopes, Mrs Jeffery, Mrs Ruth Creed, Mrs June Creed, Mr Balthazar Korab for photographing the paintings at Dow, and Keepers of Art and Curators at the many Art Galleries and Museums who have supplied me with exhibition information and details of pictures. Also Mollie Dickenson for her editorial assistance and Jane Davey for typing up much of my research material.

Grateful thanks go to HRH The Duke of Kent for his kind permission in allowing me to quote from letters to the artist from his grandfather, Prince Nicholas of Greece.

Finally my wife, Flora, who has had to put up with me spending more time working on 'the book' than with her over the past few years.

INTRODUCTION

My first introduction to the work of Arthur Henry Knighton-Hammond was in 1982 whilst viewing my first picture sale at a local auction house. A water-colour catalogued as *A Continental Street Scene with Figures* (*A Street in Nevers, France*, Plate 50) attracted my attention above all other lots. The picture had an exquisite style and a use of light, colour and movement of outstanding quality. With the purchase of the painting my personal collection had begun along with an interest in the artist and his work which has resulted in this book. I was accompanied at that auction by my old friend and mentor, Tom St. Amand, who had a number of water-colours by Knighton-Hammond in his collection, and he told me of the comment made by Augustus John: 'That man [Knighton-Hammond] is the greatest painter in water-colours of our time'. My friend further stressed that Augustus John was not a man to bestow praise unless it was truly deserved – a comment which has come to my notice from other sources later.

Whilst his works turn up at auction quite frequently and he lived the latter part of his life not far from my home in Dorset, it was remarkably difficult to find any significant information about such an undoubtedly talented artist, and one who only died in 1970 and had exhibited at the Royal Academy as early as 1907. Art reference books gave only a very brief account of his life and exhibitions. Fortunately my search led me to Mrs Mary Jopp, the artist's daughter by his second wife, whose help in supplying me with material and personal recollections has been invaluable. The book is dedicated to Mrs Jopp without whom this publication would not have been possible. It was fortunate that many of Knighton-Hammond's personal possessions were passed to his daughter after his death as they have been looked after with care and pride.

It became clear from my initial research that the artist was well travelled. He first studied at the Nottingham School of Art before moving to London in 1900 where he struggled to make a living. The young artist could barely pay the rent and eventually returned to the north of England. During the Great War his work was seen by Lord Moulton, the British Government's representative on the board of British Dyestuffs Corporation, who gave Knighton-Hammond a job illustrating the buildings and plants which were constructed as part of the war effort in the north of England. The artist's greatest opportunity to date came in 1920 when he was commissioned by Herbert H. Dow, president and founder of the Dow Chemical Company in Michigan, USA, to carry out a series of paintings of his chemical plant. Whilst the commission only lasted 6 months the recognition which accompanied its exhibitions in the USA was to lead to the artist being elected a member of the

American Water Color Society. It was a measure of his success that only he and Sir William Russell Flint from Britain at this time enjoyed membership of this prestigious society.

In 1922 the artist moved abroad for a ten-year period to live on the Continent but continued to make frequent return trips to England for painting expeditions and exhibitions. During this time he lived a very cosmopolitan life style. The artist became a personal friend of Prince Nicholas of Greece who collected his paintings as did other members of the Greek Royal Family. His work was also collected by art connoisseurs of the day, including Sir Joseph Duveen (later Lord Duveen of Millbank). Queen Mary visited an exhibition of Knighton-Hammond's water-colours in 1924. Clearly he had an impressive following which also included many fellow artists. During the 1930s he was elected a member of The Royal Institute of Painters in Water-Colours, The Pastel Society, The Royal Institute of Oil Painters and The Royal Scottish Society of Painters in Water-Colours.

The acclaim gained by the artist over the previous decade possibly resulted in him receiving a commission in 1933 to paint the portrait of the former prime minister, David Lloyd George. His move to Ditchling in Sussex brought about friendships with fellow artist Sir Frank Brangwyn and Edward Johnston the calligraphist; portraits of both by Knighton-Hammond are in the National Portrait Gallery.

It was in 1933 that the artist adopted a hyphen between his surnames, having previously called himself 'Knighton Hammond'.

My search for information on the artist has lead me in many directions and to many people who have been most helpful in assisting me with my research. From various sources my research lead me to the Dow Chemical Company in Michigan, USA. My initial letter received a reply from Mr E.N. Brandt, Company Historian at Dow, who immediately supplied me with invaluable information about Knighton-Hammond's commission for Mr Dow in 1920 and about the paintings still in their possession. Also a number of books documenting the history of the Dow Chemical Company were dispatched to me. Mr Brandt and his colleagues already had an interest in the artist's work which may have been further fuelled by my communication. As Mr Brandt discovered more correspondence between Mr Dow and Knighton-Hammond in his archives he very kindly sent me copies. Furthermore, I have imposed a great deal on him over the past few years with regard to the pictures at Midland and he has always been very obliging. The information provided has been invaluable for Chapter 3 of the book.

Many of Knighton-Hammond's pictures still adorn the walls of Mr Dow's home which has been preserved much as it was since his death. The interest at the Dow Chemical Company was such that they have been instrumental, by way of sponsorship, in making this publication possible. My personal thanks go to Mr Brandt and also The Herbert H. and Grace A. Dow Foundation and the Midland Center for the Arts for their generosity.

My search for the artist's work during and immediately after the First World War led me to ICI's Library and Information Services and to Mr Ken Magee, Historical Archivist at Blackley, Manchester. During a day spent with Mr Magee it was pleasing to see that Knighton-Hammond had not been forgotten by the Company: in addition to the pictures still in their possession, many of which are hanging in the Works Manager's office at Huddersfield, they have used one of his oil paintings (Plate 16) as an illustration in their brochure on *ICI Huddersfield Works*. Also many of his pictures have been reproduced on to boxed sets of table mats which are given as gifts to retiring long-service members of their staff and to prestigious visitors and customers. Ken Magee has been of considerable assistance in my research for Chapter 2 of this publication and my thanks go to him.

Again my personal thanks to Mrs Mary Jopp, for both allowing me access to her father's possessions and for checking through my drafts. It has been enthralling to have had the opportunity

to look through Mr Knighton-Hammond's personal possessions, in particular his diaries, scrap-books, letters and unpublished memoirs.

My interest in collecting paintings and in art history came about as a result of my friendship over many years with Tom St. Amand. He is remarkably knowledgeable about art and literature and it has been with his advice and encouragement that this project was undertaken. He has always been on hand to assist in my research and to give advice on the many occasions when help was needed. He has been most helpful in checking my drafts and giving guidance for which I will be eternally grateful. His friendship is of great value to me and gleaning a little of his knowledge and wisdom has been to my considerable benefit.

Most pleasing is that without exception all the people interviewed who knew Knighton-Hammond personally talked about him with great affection. He was quite obviously a most likeable person and from evidence gathered he was most generous. He enjoyed making gifts of his paintings. Many people quite clearly greatly valued his friendship.

The assistance of those mentioned above has made this project possible. The ultimate aim of the writer is that the work of Knighton-Hammond should become more widely known and appreciated, and for those who possess paintings by the artist to have a greater insight into his life and work. My personal view is that soon the work of the artist will be placed alongside that of the other great painters of his generation such as Philip Wilson Steer, Professor Henry Tonks, John Singer Sargent and Wilfrid de Glehn. The writer sincerely hopes this book will go some way towards giving the recognition in modern British art history to Arthur Henry Knighton-Hammond which he undoubtedly deserves.

Reprinted from the
"Menton & Monte Carlo News"
March 6th 1926

We happened to mention to a well known Royal Academician (Augustus John) who is stopping in Monte Carlo at present that Mr. Knighton Hammond was holding an exhibition of his works in the Palais des Arts, 9 Avenue Félix Faure, in Menton. "That man", said he, "is the greatest English painter in water colours of our time". That is the most recent dictum, of course, but is confirmed by the fact that Mr. Knighton Hammond has just been elected a member of the American Water Colour Society, whose headquarters are in New York, and this is a very rare honour indeed for a British artist. But then, he has pictures of his in the Tate gallery. Apart from the exhibition he is 'at home' in his studio in the Impasse Bellecour, behind the Banca Italiana on Wednesdays from 10 to 12 and 3 to 5.30 Sundays 3 to 5.30.

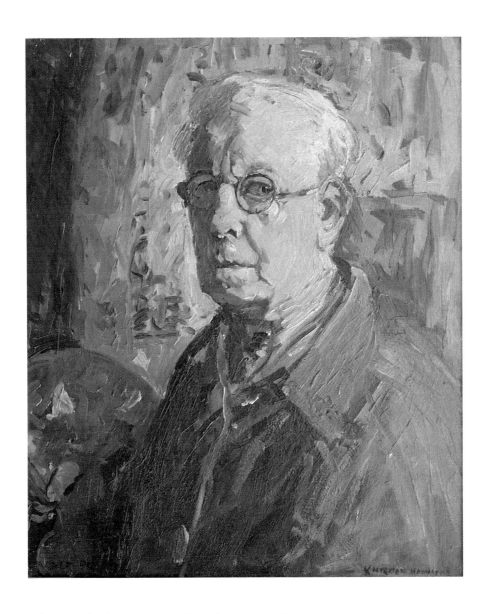

'That man is the greatest painter in water-colours of our time' – Augustus John

Knighton-Hammond Self Portrait Oil on panel. 60.5 x 50cm (23.75 x 19.75in).
Private Collection.

CHAPTER 1
EARLY LIFE AND
THE HAMMOND FAMILY
1875-1913

Arthur Henry Hammond was born on 18 September 1875, at Church Street, Arnold, Nottingham. He was the son of William Hammond (1829-1901) and Mary, née Knighton (1833-1906). He later adopted his mother's maiden name, possibly to make his name more distinctive. He used it first as a Christian name around 1912 and it featured intermittently in his signature from that time. He then added it to his surname by deed poll in the latter part of 1933.

William and Mary Hammond had six children: the elder two, Mary Ann and John were born at Top End, Arnold in 1855 and 1858 respectively. A year or so later, the family moved to Dass Terrace where Elizabeth was born in 1860 and Mark Bazil in 1863. With a growing family, larger accommodation was needed, so a move to Church Street was made where Harriet was born in 1869, followed six years later by Arthur. Shortly after Arthur's arrival, the family moved once more, this time to Walters Cottage, Front Street, Arnold.

The earliest extant photograph of the young Arthur with some members of his family (Fig.1) dates from 1880/1. It portrays (from left to right) Mary Hammond (mother), Harriet (sister), Ada (cousin), William Hammond (father), and Arthur (aged about 5 years). Many years later Arthur wrote on the back of the photograph: 'I remember asking why I had to have a whip when it was not my own. It

belonged to the photographer.' Clearly the young Arthur did not understand the point of this photographer's prop. The picture portrays a family in middle-class Victorian dress, accurately reflecting the family's values as Arthur later recalled them. Sadly, little Ada, Arthur's cousin, died shortly after the picture was taken.

Arthur's father lived all his life in Arnold and had a furniture and general hardware shop where various members of the family worked. Many years later, in his unpublished memoirs, Knighton-Hammond recalled with much affection old Sally Mellors who was in attendance at his birth and did the family washing as well as acting as a child nurse to the younger children, while Mrs Hammond helped out in the shop. He recalled that Sally was born in 1814, the year before the Battle of Waterloo, and that she was small and wiry with weather-beaten cheeks and always wore an old fashioned milkmaid-type soft bonnet. Sally Mellors would often spend the evenings with the Hammond family gathered round the fire singing hymns, unaccompanied, *Abide with Me* and *Lead Kindly Light* being the favourites. William and Mary Hammond and Sally Mellors were great admirers of George Gordon, Lord Byron, and they would read his poetry as part of an evening's entertainment. As a young girl of ten, Sally had accompanied her father at Byron's funeral, which took place near his

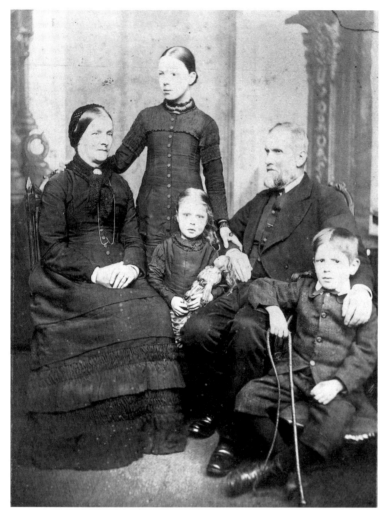

Fig. 1. The Hammond Family.

former home of Newstead Abbey, Nottingham.

For a short time, Arthur attended the National School in Arnold, which was then under the aegis of the Church of England, before attending from the age of six the British Board School, only a short distance from his home. He used to recall that his favourite teacher was Sam Spencer, later headmaster, whom he was to meet again some years later at evening classes at Nottingham School of Art. Also at this time, Arthur was taken to Sunday School at Cross Lane Chapel accompanied by his sister Harriet, with whom he was to maintain a close relationship throughout his life.

In 1886, Gladstone, then on his Home Rule campaign, came to Nottingham. Arthur very much wanted to get a glimpse of the great man. Unfortunately, William Hammond was too ill to take his son but arranged for a friend, Sam Allen, to accompany him. Standing in the crowd, Arthur watched Gladstone come out of the Mechanics Institute with Sir John Turney, the Mayor of Nottingham and get into an open landau. Carried away with excitement Arthur ran after the carriage, attracting the attention of Gladstone, who acknowledged his efforts with a smile and a nod of his head, a gesture the boy was to remember for the rest of his life.

Arthur's admiration for great men was such that he often reflected when he was walking the same road between Arnold and Nottingham, that the likes of Richard Parkes Bonington and Lord Byron would have walked the same road years before. Indeed, he was very proud to share the same birthplace as Bonington, and to know that Lord Byron had lived close by at Newstead Abbey.

From a very early age, Arthur had a passion

for drawing. After Sunday School he would go out alone, with his sketchbook to draw from nature. It was noted at school that he spent much of his time with a pencil in hand at the expense of his lessons. This information found its way back to his parents, and although his father was very impressed by his son's artistic ability, Arthur was given a ticking off and told not to let it interfere with his other work.

The family's only association with fine art was that William Hammond would buy and sell paintings by a number of Nottingham artists, including Jack Birkin, William Stanley, Thomas Cooper Moore and his son Claude Thomas Stanfield Moore. These artists were often invited to the Hammonds' home for Sunday lunch. Another frequent visitor on Sundays was Sylvanus Redgate, a Nottingham portrait painter. He was a very old man when Arthur knew him at this time and he would tell the family stories of Bonington and his father which he had heard in his early life from those who knew them.

Arthur worked in a grocery shop owned by his brother, Mark, after leaving school at eleven. As well as resenting the manner in which his brother treated him, Arthur hated shop work. Whenever possible he would disappear into the fields with his sketchbook. William Hammond recognised his youngest son's unhappiness and one Sunday, over lunch, it was arranged with Sam Allen that Arthur would be apprenticed to him. Sam Allen, an Ulsterman from Dungannon, was a watchmaker with a shop in Nottingham. Arthur was only twelve years old when indenture papers were prepared for him. In his memoirs, he recalls thinking to himself as he signed the document: 'You are doing wrong, you hate any sort of machinery'.[1]

An agreement was reached whereby William Hammond would pay Allen 3s a week for his son's midday meal and tea. Arthur's wages were 1s 6d per week for the first year, rising to 8s 6d in the fifth and final year. Whilst Arthur much preferred to be out drawing, he felt obliged to enter into the apprenticeship because his father was now in ill-health and was to remain so for the last decade of his life.

Earning a Living

The new job involved setting off from Arnold on foot every morning at 7.30 am for the four-mile journey to reach the shop at 8.30 am. Sam Allen and his employees would work in the shop window in full view of passers-by displaying their skills to whoever wanted to watch. The new apprentice was not allowed to leave the shop until 7.30 pm. Occasionally he would get a ride home on the horse-drawn bus which ran between Arnold and Nottingham, and which was owned by his Uncle Joe, his father's younger brother.

In spite of the long hours and his general misgivings, working in Nottingham did have some advantages. Arthur soon enrolled for two-hour evening classes at the Nottingham School of Art. These started at 7.30 pm so he had to find ways of leaving work a few minutes early, which he seems to have managed. Initially, he attended the School of Art for the geometry class on Friday evenings. Such was his enthusiasm to learn, however, he began attending other evenings for lessons in free-hand drawing and drawing from sculpture casts. Arthur recalled a great many years later that the clock face and hands at 7.30 always remained significant to him as the time in the evening when he was free to leave the watchmaker and do what he really wanted - draw and paint. The journey home on foot at 9.30 at night must have been quite daunting during the winter months. Arthur recalled later,

> There were only a dozen oil or gas lamps along the whole stretch. Even then during the moonlight nights the lamps were not lit, and of course the moon did not shine all the time, so I nearly always walked in the middle of the road, thinking that in doing so I had the width of half the road and could run away should any robber, bent on my destruction, spring out of a hedge. However, I was never molested.[2]

Among the other students at the Nottingham School of Art during this time were Laura Johnson, later Dame Laura Knight, and her future husband, Harold Knight. Arthur envied the couple and the other full-time students for being able to spend whole days at the School

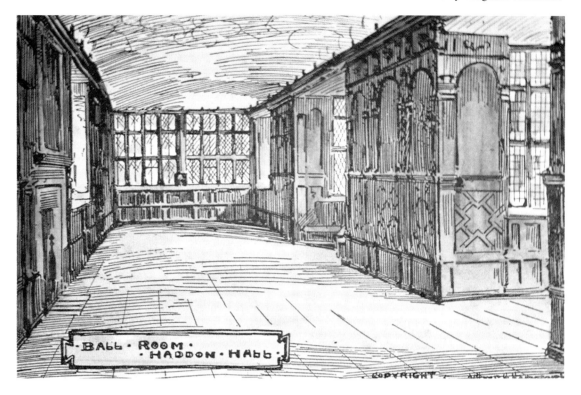

Plate 1. *Ball Room, Haddon Hall*. Pen, ink and wash. 9 x 14cm (3.5 x 5.25in). Private Collection.

of Art while he was at work. To compensate, by the time he was fourteen years old, he was attending the school every evening of the week except Saturdays and Sundays.

During 1890, Arthur's summer holiday from the watch shop took the form of a painting expedition to Derbyshire's famous beauty spots, Haddon Hall, the Derwent Valley and Lathkil Dale. He set off on the train from Nottingham to Rowsley where he settled into his lodgings near the railway station.

At Haddon Hall, artists and art students were privileged to have full access to a large sunny room set aside for them called The Artists' Room. This studio was equipped with sketching easels and stools. He met a number of artists at Haddon Hall, including Ernest Arthur Rowe, an accomplished water-colourist. They took him under their wing for the week giving him guidance and tuition on his water-colours.

It is quite likely that Arthur produced a series of small pen, ink and wash drawings at this time. *Ball Room, Haddon Hall* (Plate 1) is one of these pictures, depicting the interior of this fine building. Also in the series was

Youlgreave Church (Plate 2), which Arthur considered to be the most outstanding feature of the village with its tower dominating the surrounding countryside. Both these works are typical of his style at this time in their boldness of line and softness of tone.

Whilst painting an external view of Haddon Hall, Arthur recalled being distracted by an elderly gentleman dressed in Harris tweed and a Glengarry bonnet. He sat down on a garden seat under a yew hedge and fell asleep. Arthur learned that this was Lord John Manners (1818-1906), Duke of Rutland.[3] He was a politician, who had entered Parliament in 1841 as Conservative member for Newark, at the age of 23. A close friend of Gladstone, he was to be one of the pall-bearers at his funeral at Westminster Abbey in 1898. The artist, subsequently, always regretted having continued to work on his water-colour and not having painted the aristocratic gentleman sleeping peacefully on the seat.

The days soon passed and, as Arthur had spent very little of his money, he wrote to Sam Allen and to his family telling them he was staying for another week. During this second

week the young student went further afield including a small village called Edensor, attached to Chatsworth House where he spent an enjoyable day working in water-colour. At the end of the fortnight, Arthur reluctantly returned to work even more dissatisfied with the profession which was keeping him away from painting.

Arthur's lunch hours were often spent at the Reference Library in Nottingham University. Here he would read books on art, in particular Ruskin's *Modern Painters*. Absorbed in his study, he would often lose track of time, and would return to the shop sometimes after 3 pm. Sam Allen was unhappy but as Arthur's wages were so small he was not able to make any significant deductions.

Arthur's dislike for his job was so great that whenever the opportunity arose, he would take days off supposedly ill, and go out painting. This dereliction was abetted by the local doctor, Dr William Lamb, who had a keen interest in his water-colours and encouraged him to take long periods of convalescence. He records '. . . so off I used to go in the fields sketching or surreptitiously take a few days off and go to Haddon Hall'.[4]

Studying at Nottingham School of Art
In his early days as a student, Arthur won second prize for his geometry homework. The following year he repeated his success with second prize for perspective drawing, for which

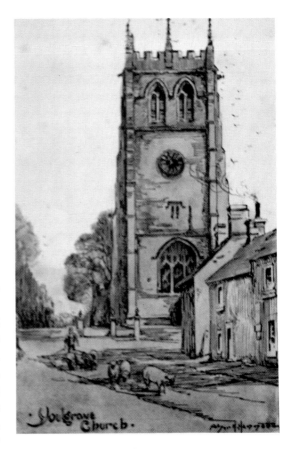

Plate 2. *Youlgreave Church*. Pen, ink and wash. 13.5 x 9cm (5.25 x 3.5in). Private Collection.

he was presented with a French *pochade* painting box and a folding sketching easel. Arthur was pleased that as a part-time student he had done so well, since the winner of the first prize in both years was a full-time student. The perspective drawing, *Perspective Study*

Fig. 2. *Perspective study*
Pencil. 25.5 x 35.5cm
(10 x 14in). Private Collection.

(Fig.2), was undertaken, as was most of his homework, from 5.00 am on Sunday mornings. This was the only time when he could get sufficient peace and quiet to concentrate on his work. His sister Harriet would then get up at about 8.00 am to cook Arthur his breakfast. The drawing shows that the young student had a good grasp of perspective, a basis upon which he built his considerable expertise in draughtsmanship, which was to dominate much of his later work. The School of Art appears to have awarded prizes annually for students' homework exercises and as the prizes were general painting implements, this gave the students an added incentive to produce their best work.

The examinations at Nottingham School of Art were set by the Department of Science and Art of the Committee of Her Majesty's Most Honourable Privy Council on Education. Arthur's first examinations as a part-time student were on 28 April 1892, aged 16, and were the Second Grade Examinations in Model and Free-hand Drawing for which he attained a First Class Grade in both disciplines.

Sam Allen and his workmen could see that Arthur's heart was not in the repair of watches. Finally, in 1893 Arthur's love of art and eagerness to study resulted in the mutual termination of an unhappy five-year apprenticeship, six months short of the indentured period. This allowed the budding young artist to attend the School of Art on an almost full-time basis. As a source of income, Arthur erected a sign board outside his father's shop, now run by his sister. The sign advertised watch and jewellery repairs which Arthur worked on two days of the week, earning enough to make a living and help the family income. His sister would take in watches in the shop mostly from local villagers and Arthur would reluctantly settle down at his bench and carry out the necessary repairs or cleaning, earning about £2 per week. On the days Arthur was not working on the watches or at the School of Art, he would be off on painting trips often by the River Trent at Wilford, Clifton or around the Nottingham villages, frequently accompanied by his friend and fellow student,

Jack Bowman, or the artist, Arthur Redgate.

Arthur's second examination was taken on 3 May 1893 and was in Model Drawing (Advanced Stage) for which he again attained a First Class Grade. The following year, he sat for no less than three examinations in Perspective, Free-hand Drawing of Ornament (Advanced Stage) and Drawing in Light and Shade (Advanced Stage) and he once again achieved a First Class Grade in all three examinations.

In July 1894, with examinations now over for the year, Arthur undertook a further short expedition to Haddon Hall and the surrounding area. This time he was accompanied by Jack Bowman and Sydney Gardner, who was by then making a living as an artist. From Rowsley station the three of them walked the two miles to Haddon Hall passing the Lathkil and Alport Dales. So charmed were they by the area that they returned almost immediately after their day trip for a stay of six weeks. They lodged at a farmhouse on Stanton Hill. Arthur recalled that from the windows they had a view of Haddon Hall silhouetted against the sky line, with the rushing Lathkil river immediately below, lined with beautifully shaped trees and straddled here and there by old bridges.

Arthur spent his nineteenth birthday on this expedition. He recalls working on a water-colour, alone in a tapestry-hung room called Dorothy's Room after the daughter of Sir George Vernon who had lived at Haddon Hall in the sixteenth century.[5] The young artist was interrupted by a lady dressed in black full-length voluminous robes who sat down and began sketching an impressive oriel window in the room. The two spoke for quite sometime, Arthur noticing that the charming lady seemed sad and troubled. The reason became clear when he later discovered that she was Violet, Marchioness of Granby, wife of Henry Manners[6] and daughter of Colonel the Hon. Charles Hugh Lindsay[7] whose eldest son, Lord Haddon, had died a few days earlier on 28 September 1894, aged only nine. The Marchioness was an accomplished artist and Arthur was to become better acquainted with her and her family in later life.

Stimulating as the environment at Haddon Hall was, Arthur had to leave Bowman and Gardner before the end of the six weeks to return and clear the backlog of watch repairs which had built up in his absence. Yet he did not neglect his art and, as part of his continuing development, Arthur exhibited annually at Nottingham Castle Museum from 1895 to 1899. He was particularly fond of painting the moods and delicate light of dawn. The majority of the pictures he exhibited were painted at this time of day, including *A Winter's Morning* exhibited in 1895, and a water-colour of the birthplace of Richard Parkes Bonington. This was a Georgian house in Back Street, Arnold, and the picture was exhibited in 1896 along with an oil painting of Gedling Church. There was great prestige in students having their work selected for exhibition at Nottingham Castle Museum, and as the oil painting of Gedling Church was of sufficient quality to be accepted for exhibition, Arthur was, by now, also clearly confident in this medium.

The Nottingham School of Art was run under the South Kensington rules by Joseph Harrison, its headmaster at this time. Arthur considered him to be bossy and small-minded and not a particularly good teacher. The unimaginative teaching syllabus of the South Kensington Schools, which repressed rather than stimulated natural talent, was rigidly adhered to by Harrison. When, as a young student, Arthur attended classes in drawing from classical antiquity (the Antique), it brought him under the tuition of Wilson Foster who taught drawing both from classical antiquity and from life. Arthur desperately wanted to study in the life class but met opposition from Joseph Harrison who insisted that all necessary examinations in drawing from the Antique and perspective had to be gained first. Laura Johnson was fortunate in being allowed to work in the life class at the age of 14, a privilege against all the rules laid down by Harrison. However, Arthur found out that it was through her mother's insistence that Laura was allowed to study and make drawings in the life room at so early an age.

On 6 May 1896, Arthur, together with all the advanced students and teachers (with the exception of Joseph Harrison) at the School of Art, sat for a four-hour examination in drawing from the Antique. The examination was under the South Kensington rules and regulations, and was held from 6 pm to 10 pm. Arthur's pencil drawing for the examination was from the standing *Discobolus*.

After the school had closed for the summer holidays, any student could visit during the day to use the facilities. Within a few months the results of the examinations were received from South Kensington and posted on the notice board in the main hall of the school. Arthur went to the school in the early evening. As he looked down the examination list, he saw that he was the only one in the Nottingham School of Art to have won the top grade of First Class Excellent. As Arthur was looking at the results, Wilson Foster looked over his shoulder at the list and saw that he himself had only won a standard First Class. The young artist long recalled the look of vexation on his teacher's face at seeing a student's work graded above his own.

Following Arthur's success in his examinations, Joseph Harrison entered him for further examinations the following year, but in a subject he had no intention of studying – designing in the lace industry. The only reason, it seemed to Arthur, was that the better the examination results, the greater the school's grant would be from South Kensington. As Arthur refused to study lace design, Harrison responded by not allowing him to study in the life room, which, having passed the Antique exam, he was fully entitled to do.

Arthur may well have been aware of Ruskin's view on lace design from reading his books and articles, one of which appeared in the *Art Journal* in 1873. This referred to the lace manufacturers of Nottingham where Ruskin comments, 'Do you think that, by learning to draw, and looking at flowers, you will ever get the ability to design a piece of lace beautifully? By no means. If that were so, everybody would soon learn to draw, everybody would design lace prettily, and then nobody would be paid for designing it. . .'[8] He goes on

to say that there must be a burning desire to make designs in lace as in any other of the arts. Arthur quite clearly did not have that desire and, after much heated argument, Harrison relented and withdrew his name from the examination list and allowed him free access to the life room.

Although Arthur attended the life class regularly thereafter, he became increasingly dissatisfied with the South Kensington method of teaching and the continual use of the same young male model. Since his relationship with Joseph Harrison was by now severely strained, he decided to leave the School of Art.

The Atelier Club

In the late 1890s, Arthur had met a Swedish sporting artist called John Beer, a man in his fifties who had come to Nottingham to work for a firm of lithographic printers named Earps. John lived with his wife and five sons, two of whom were keen artists like their father. Arthur recalls that John was a very fine draughtsman and a man of knowledge and culture. He had been the guest of the Prince of Wales at Sandringham on at least two occasions. He had made a fine drawing of Gladstone for the Prince during one of his visits to the Royal Palace.

In 1898, after much discussion, Arthur and John formed a life class called the Atelier Club for the study of the nude figure. The club was to be open every day except Saturdays. The two artists persuaded Kiddier, a large brush manufacturer, to sponsor the launch of the club. This was in the form of a dinner at the most important hotel in Nottingham, to which local dignitaries were invited along with many art students.

The club was held in a large rented room with a big sky light in Parliament Street, Nottingham. Initially, about twenty students enrolled as members. Mrs Beer was given the job of finding models. According to Arthur, she provided a good selection of girls and young men who were willing to pose nude for the classes, very few of whom wanted payment, doing it for the love of art and to help young art students. In addition, a friend of Arthur's even provided a horse and donkey for study and they had a great deal of fun getting them into the studio. Arthur and John enjoyed the camaraderie within their club which had not existed at the Nottingham School of Art, and the variation in the models also added to its popularity. However, Arthur soon became aware that the attraction for most of the students had more to do with the female models than any serious interest in drawing. Furthermore, the returns from the Atelier Club were barely sufficient to sustain both Arthur and John, so when the latter eventually ran into financial difficulties, the club was closed.

The Move to London

After the closure of the club in 1900, Arthur became despondent with life in Arnold and made up his mind to set off on an adventure to London, determined to live off his art. He said an emotional farewell to his father and his distraught mother, who tearfully packed her youngest son a trunk full of clothes and provisions. His sister Harriet gave him £10 from her hard-earned savings. With this and three guineas he had recently been paid for a drawing, he set off with Herbert Hitchin, a young man three or four years older than Arthur. Herbert had spent a year in Paris studying painting and was equally keen to work in London. They left by train on a dark Saturday afternoon in November. They arrived in London in the evening and spent the night at the YMCA hostel in the Fulham Road.

The young artists soon found two empty rooms on the second floor of 68 Walton Street for 10s per week. Arthur immediately made contact with the Beer family, who were living in fashionable Hampstead. Mrs Beer insisted that he visit every Sunday for lunch, which was to be Arthur's main meal of the week.

John Beer was then making a good living by painting small water-colours, 'potboilers' as they both referred to them. These pictures were of horses racing past the winning post, painted on every race course in England. John would make a weekly visit, with the pictures he had painted during the week, to Fores, the sporting art publishers and dealers in Piccadilly.

Arthur was a great admirer of John's natural ability to draw and thought it sad that, with this talent, he was reduced to production-line painting in order to provide for his family. Potboilers or not, Arthur considered they were still fine paintings. Some years later in the illustrated article 'Sportsmen's Pictures' by Guy Paget for *The Studio*, John Beer's considerable skills were acknowledged: 'To compare ancient with modern, one must call up a squadron against the Alken horde. The first I can think of is John Beer, whose pictures of the latest big race always drew a crowd to the window at Fores' Sporting Gallery in Piccadilly.'[9]

Both Arthur and Herbert returned home for a week at Christmas. Neither of them had sold many pictures and their money was running low. A good Christmas with their families, however, revitalised them and they returned to London with greater determination to make a success of their art. Arthur responded to an advertisement in *The Studio* magazine giving an address in the Fulham Road of someone who would buy water-colours for cash. He began work on a water-colour of a hunting meet at Woodborough Hall, Nottinghamshire. He took the picture to the address in the Fulham Road. The man he met there, after a critical examination of the work, requested a set of four paintings illustrating four phases in a day's hunt ending up with the kill. A figure of £12 was agreed and Arthur returned to Walton Street and immediately set to work on the other three pictures.

After six months together, Herbert left the lodgings at his family's request and moved in with a family friend in Thornton Heath. He and Arthur parted as good friends and the landlady reduced the rent to 6s per week even though Arthur retained both rooms. Herbert and Arthur still saw much of each other and one evening they went together to a dance in Chelsea. There, Arthur met a girl called

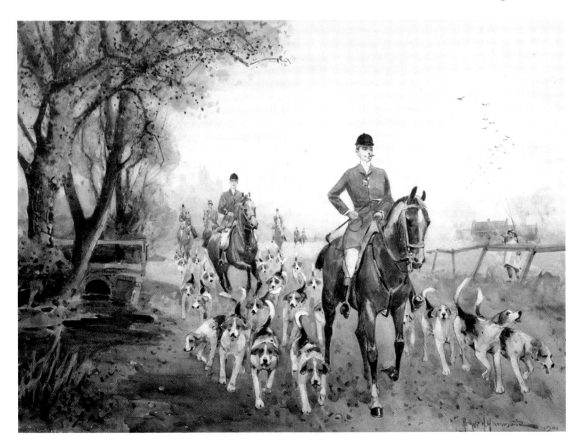

Plate 3. *The Hunting Party. 1901* Water-colour. 38 x 52cm (15 x 20.5in). Private Collection.

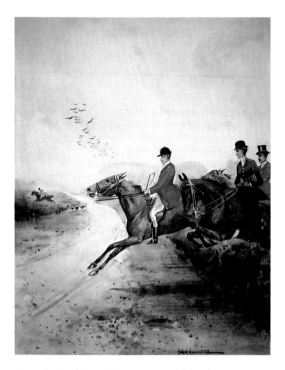

Plate 4. *The Hunt*. Water-colour. 35.5 x 27.5cm (14 x 10.75in). Private Collection.

Winifred Annie Reeves (b. 17 January 1884), who showed great interest in his work. He took her back to his lodgings to show her examples of his pictures. The next day the landlady told him that he was not allowed to take girls up to his rooms. Arthur responded by giving her a week's notice, and found a room in a house popular with artists at 18 Wellington Square, off the King's Road, Chelsea, for 17s per fortnight. Living in the same house was a Scottish landscape painter, Robert Scott Temple and his wife Maggie. In the back garden was the studio of Ernest Thesiger, who was then studying at the Slade School. Arthur and Robert Scott Temple had much in common and became great friends.

During the winter evenings, Arthur attended life classes at the old Westminster School of Art in Tufton Street. He recalled in his memoirs that the studio was dirty and the conditions were poor but the students were keen and jolly. He also joined the life classes at the Chelsea School of Art. *The Hunting Party, 1901* (Plate 3), a water-colour he painted at this time, was influenced by the work of John Beer. Both artists were aware that there was a market for this type of picture and the subject

allowed Arthur to show off his drawing skills to the full. In *The Hunting Party*, the crowded scene of horses, hounds and riders gathering for the hunt creates great atmosphere of anticipation. Much of the skill in the foreshortening of the animals may well have been gleaned initially from John Beer during their days at their Atelier Club, but the landscape elements in the picture are also well handled as a result of Arthur's earlier work in Nottinghamshire and Derbyshire. *The Hunt* (Plate 4) is a similar picture but shows the riders and horses at full gallop as they jump the hedgerow in pursuit of their quarry.

In spite of this excellent work, the young artist was struggling to make a living. He was desperate for money and was considering giving up painting and taking a job with a regular income. One evening in June 1901, during the Epsom Derby week, he was reading the report of the Oaks which had been run the previous day. He recalled John Beer's water-colours of race finishes and decided to paint a

Fig. 3. Arthur H. Hammond sketching.

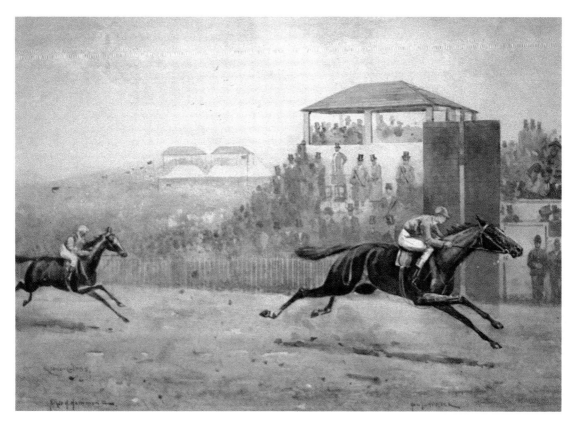

Plate 5. *The Finishing Post - 'Ard Patrick' beating 'Rising Glass' in the Derby, 1902*
Water-colour. 35.5 x 51cm (14 x 20in). Private Collection.

similar subject with the intention of selling it to Fores in Piccadilly. As a last ditch effort, Arthur got up early next morning to sort through the sketches he had made the previous year on Derby day. Before breakfast, Arthur had started a water-colour showing the finish of the Oaks. On completion, he gathered a few other pictures together and set off for Piccadilly, as he recalls, wearing a morning coat and silk topper (see Fig.3). Fores purchased the water-colour of the Oaks for two guineas. The same day, Arthur sold the remainder of the pictures to another dealer for £6.10s. Such success in one day strengthened anew his determination to live from his art, and he quickly gave up the idea of getting a regular job.

The Finishing Post - 'Ard Patrick' beating 'Rising Glass' in the Derby 1902 (Plate 5), is a water-colour of Derby day a year later. This is a fine example of Knighton Hammond's expertise with racing subjects, although in fact the picture had been made up from earlier drawings. The horses, in particular, are expertly drawn, their magnificent athletic frames racing towards the finishing post give a great sense of movement and a tense, excited atmosphere is captured with a skilful and subtle use of light and colour.

The young artist was still struggling to make a living. He had begun designing picture postcards in about April 1901 and, fortunately, a craze for these cards soon enabled him to obtain an increasing amount of work from various publishers, including Raphael Tuck and Co., Hills and Co., Faulkner and Co., Davis and Co., E. W. Savoury Ltd., and others. His designs were principally of sporting subjects such as hunting, shooting, polo, cricket, fishing, motoring and coaching scenes, sometimes with a touch of humour. Within a two-year period, Arthur had produced over two hundred designs for publication.

Whilst this work - supplemented by the tuition he gave to art students - kept the artist away from landscape painting, which he preferred, the income was essential. This was

especially so as Arthur's relationship with Winifred Reeves had flourished. They were married in Chelsea Registry Office on 29 May 1902, with John Beer and Scott Temple acting as witnesses. The newly married couple moved to a studio in Marlow-on-Thames soon after the wedding.

Living on Marlow Common at this time were the sculptor, Conrad Dressler, and his wife. They lived in an unusual house designed by Dressler himself. He and Arthur became friends and they would go for long walks every Sunday morning over the Chiltern Hills. The two artists would talk at length about their art, and Dressler, having been close friends with John Ruskin, William Morris, James Abbott McNeill Whistler and George Frederic Watts, would regale Arthur with interesting stories about each of them.

Through his friendship with Dressler, Arthur was able not only to learn about famous

figures in the art world of the previous century, but also to expand his acquaintance with contemporary artists. Attending Dressler's studio at this time (about 1902-3) for instruction in sculpture was Violet, Marchioness of Granby, whom Arthur had met at Haddon Hall some years earlier. She was working on a monument in memory of her dead son, which was later to be placed on his tomb at Haddon Hall. The Marchioness's interest in sculpture may well have resulted in George J. Frampton exhibiting a marble bust of her at the Royal Academy in 1902.[10] At the same exhibition, James Jebusa Shannon exhibited a fine portrait of the Marchioness's daughter, Lady Marjorie Manners.[11] Around this time, Arthur also made the acquaintance of Mrs Mary Sargent Florence, a mural painter who also lived on Marlow Common.

Near Marlow-on-Thames (Fig.4) was a quick sketch made around this time as an

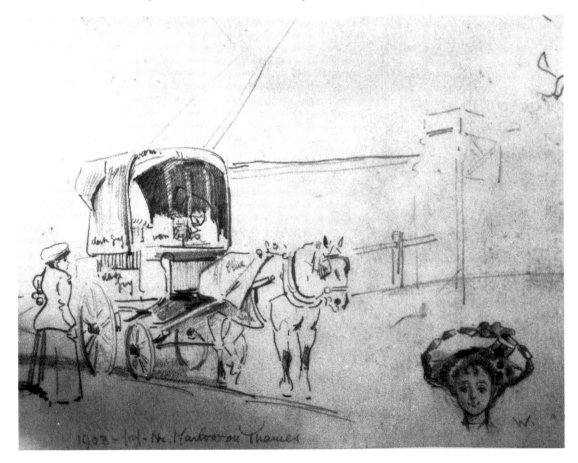

Fig. 4. *Near Marlow-on-Thames*. Pencil. 16.5 x 21.5cm (6.5 x 8.5in). Private Collection.

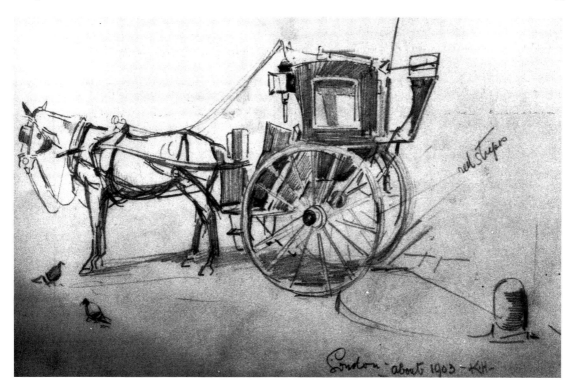

Fig. 5. *Horse and Carriage, London, 1903*. Pencil. 13.5 x 21cm (5.25 x 8.25in). Private Collection.

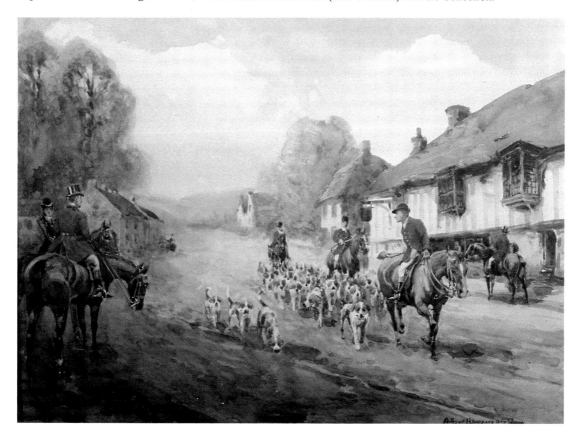

Plate 6. *A Hunting Scene*. Water-colour. 26.5 x 37cm (10.5 x 14.5in). Private Collection.

Fig. 6. Arthur H. Hammond painting.

and politician. He had four sons, and Frederick, his second son, won first prize in the point-to-point race that morning. Arthur spent a busy morning sketching the various activities taking place around him and attracted the attention of Frederick, who asked to see his drawings. He was so impressed that he asked Arthur to join him at his table at the hunt breakfast in the hall at Parmoor. Much champagne accompanied what Arthur recalled as a splendid meal, during which he was also introduced to the fourth son, Stafford Cripps, then a young man of about 14 years old, destined for a career as a statesman and lawyer.[13] The conversation at the table was of the artist's drawings, and Frederick suggested asking everyone to mount their horses and pose for further sketching on the lawn outside. The guests duly obliged and Arthur, by now slightly the worse for the champagne, sketched with all haste. At

exercise in foreshortening. The wagon and horses are sketched with minimal detail. It is thought that the small study of a head in the foreground is that of the artist's wife. *Horse and Carriage* (Fig.5) is similar in execution, but here the carriage receives greater attention to detail. Both of these drawings are the spontaneous expression of the artist as he stands before the subject. The fluid simplicity of line seems close to the artist's original thought; indeed, it may be seen as the artist thinking on paper, prior to the execution of a painting in oil or water-colour.

At Marlow on 26 March 1903, Winifred gave birth to a daughter, Marjorie, the first addition to the Hammond family. The doctor who attended Winifred during the birth later invited Arthur along to a point-to-point race with the draghunt at Parmoor, Henley-on-Thames. Parmoor was the home of Sir Alfred Cripps, later Lord Parmoor,[12] an eminent lawyer

Fig. 7. *Mrs Winifred Hammond*. Pencil. 21.5 x 17cm (8.5 x 6.75in). Private Collection.

Fig. 8. *The Jolly Wheelers*. Pencil. 25.5 x 35.5cm (10 x 14in). Private Collection.

Frederick's request, Arthur later produced a number of water-colours from the drawings which were presented to him.

A Hunting Scene (Plate 6) was painted about this time in the style of the pictures produced for Cripps. This water-colour, not unlike *The Hunting Party* (Plate 3), is a fine depiction of horses and riders in their hunting pink surrounded by hounds. It has a depth and maturity of composition and technique, and one can see why Fores would have been interested in purchasing this type of picture. In a rare photograph of himself, Arthur can be seen at work on his Derby and hunting pictures (Fig.6). On the back of the original he inscribed, 'About 1898 or 1900 when I had to paint hunting pictures to live.'

However, hunting scenes were not the only subject of Arthur's painting, and Winifred soon became the subject of her husband's pictures. *Mrs Winifred Hammond* (Fig.7) is a simple pencil drawing, produced in 1903 and portrays Winifred on her bicycle, smartly dressed and wearing a fashionable wide-brimmed hat. Drawing expresses the first impulse of the artist's creative process, and this medium allowed Arthur to produce a charming study of his young wife.

Around this time, Arthur moved his family to Richmond where they stayed for only a short while, but were able to entertain the Dresslers, Mrs Florence and a number of other artists. Whilst living in this area, Arthur took great pleasure in painting subjects near the River Thames. He would go out with Dressler on painting expeditions to Oxford as well as places closer to home.

On 3 March 1904, Arthur Hammond attended an exhibition of the work of Hector Caffieri held at the Dore Gallery, 35 New Bond Street, London. While at the exhibition, Arthur possibly made arrangements to sell some of his works through the gallery because later that month he records that he took three water-colours to them, which they presumably sold. It is likely that he sent further pictures to the

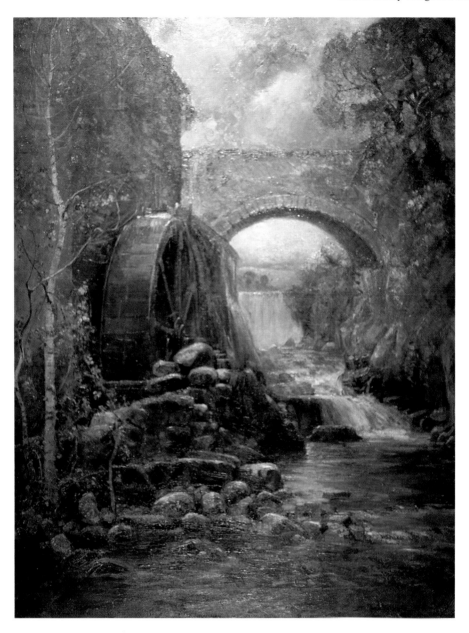

Plate 7. *The Mill*
Oil on canvas. 128 x 96.5cm (50.5 x 38in). Private Collection.

gallery, but no records are available.

In September 1904 the Hammond family made another short move to a flat in Hounslow before making a more permanent move on 15 October 1904 to 'Newstead', Horn Lane, Woodford, near Epping Forest in Essex at a rent of 8s 6d per week. Their second daughter, Dorothy Rita was born here on 14 September 1905. Epping provided choice locations for landscape subjects and Woodford itself featured in many of the artist's works.

By now, Arthur had painted a sufficient number of pictures to hold an exhibition at his home. This exhibition was reviewed in a local newspaper. From the wide range of Arthur's sporting subjects displayed on the walls, and the high volume reproduced as picture postcards, the reviewer observed that 'he is not only an artist but a humorist as well'. It was, however, Arthur's landscapes which the

reviewer was to praise above all, 'he has a genuine talent as is evident from the charming colour effects and general broad treatment of the scenes he depicts'.

During November 1904, the artist produced a drawing of *The Jolly Wheelers* at Chigwell (Fig.8). His attention to architectural detail and skilful foreshortening of the dray horses in this pencil sketch show great confidence in his command of perspective and composition. The signature and inscription on the left-hand side of the drawing were added later.

Return to the North

In spite of his growing confidence and success, there were still occasions when Arthur was unable to pay the rent during this period. Many years later he would recount how he and his family had to pile up their belongings on a push cart and leave their lodgings in the dead of night. He would, however, always leave a water-colour behind in lieu of rent.

In the latter part of 1905 the Hammond family moved north, back to the artist's beloved Derbyshire. They settled in the village of Youlgreave, well known to the artist from his painting expeditions of the 1890s. He frequently revisited Haddon Hall, which was close by, and it featured in a great many of the paintings he executed at this time. The Derbyshire Dales were also a great inspiration to the artist.

It is likely that the oil painting of *The Mill* (Plate 7) was painted in the Dales. In this large oil painting, Arthur expertly unifies the disparate elements of the waterfall, water-wheel, bridge and mill building in a style typical of the popular Romantic landscape paintings of the previous century.

Soon after his return to Derbyshire, the artist held an exhibition of his works at Bakewell Town Hall, clearly quite a novelty for the area. The *Derbyshire Times* reported, 'Mr Arthur H. Hammond, an artist whose work has attracted a good deal of appreciative attention locally, since he made his home at Youlgreave, is holding an exhibition at Bakewell Town Hall next week. This is quite a new departure for the district, and Mr

Hammond's enterprise should attract the interest of art lovers in the neighbourhood.'

In 1906, a further exhibition at Bakewell was held, as well as a joint exhibition with Hector Caffieri, at a gallery at Tankerville House, Buxton. Here, Arthur exhibited mostly local scenes of the Derbyshire moors and Dales, Youlgreave, Alport and Buxton. Caffieri's work consisted of studies of Boulogne fishing-folk and English rustic childhood scenes.

The Marchioness of Granby, now Duchess of Rutland, attended at least one of the exhibitions at Bakewell Town Hall, accompanied by her daughter, Lady Marjorie Manners, and bought a number of water-colours. Arthur's friendship with them through their mutual love of art led to his being invited to many of their garden parties at their home, Stanton Woodhouse, near Rowsley. Here, again, the artist would have his sketchbook in hand and would give advice to Lady Marjorie, who, following in her mother's footsteps, had taken up painting.

The following year of 1907 brought perhaps the artist's greatest achievement to date when he had a picture accepted by the Royal Academy. The work was entitled *Golden Autumn, Derbyshire*. In the same year, Arthur Hammond exhibited twice at Manchester City Art Gallery as well as holding his annual exhibition at Bakewell.

A further picture was accepted by the Royal Academy in 1908. This canvas, painted in August 1907 on the side of the road at Alport. was entitled *An Autumn Afternoon, Lathkil Dale, Derbyshire* and attained the distinction of being placed on the line (the line of pictures hung at eye level was considered by the hanging committee to be the most important). On varnishing day at the Academy, Arthur first met Alfred Munnings and the two artists had an enjoyable discussion about art in the refreshment room over strawberries and cream. The same painting was later exhibited at Manchester City Art Gallery and at a one-man show at Carruther's Gallery, 3 Bull's Head Yard, Market Place, Manchester, along with about fifty other works. The latter exhibition received good reviews in the press. *Manchester*

Plate 8. *A Passing Storm*
Water-colour. 38 x 54.5cm (15 x 21.5in). Reproduced by kind permission of Gordon Hodge Esq.

City News reported, 'Mr Hammond has caught the spirit of the country; his painting is capable and sincere, with an absence of tricks and mannerisms, and his pictures are Derbyshire. Among his water-colours are several pleasant studies of Haddon Hall, both the delightful light effects of some of its interior and corners of its old-time gardens.'

The artist had a busy year in 1908 with a further exhibition at the Horner Gallery, Watson's Walk, Sheffield. Again, the press gave favourable reviews with the *Sheffield Independent* reporting, '. . .What strikes one most forcibly when one makes a survey of the pictures is the painter's remarkable versatility, and the bold and sometimes daring manner in which he treats his various subjects.' With the exception of a couple of views of Epping Forest, the entire collection was landscapes of the Derbyshire area.

Arthur Hammond was by now an established landscape painter of some note. He was able to work in both oil and water-colour with equal skill. The water-colour, *A Passing Storm* (Plate 8) portrays the fundamental elements of aerial perspective, giving breadth and depth to the landscape, created with local and atmospheric colour. The local colour is that viewed at close range, such as the green of the grass and foliage. The atmospheric colour is affected by the veil of atmosphere, or in this case a passing storm, through which we view the distance. The grass-covered hills in the greater distance do not appear green, but blue, the atmospheric colour.

In the latter part of 1908 the Hammond family were on the move again. They spent a short time at Conwy, North Wales, where, as well as painting a great deal, Arthur met the architect, Sydney Colwyn Foulkes. Foulkes was highly regarded in his profession and lived at Colwyn Bay. His love of his home had led him to adopt Colwyn as part of his name. The friendship struck up here between the architect

and the artist was to last all their lives, and Sydney Foulkes sold a great many of Arthur Hammond's works over the years, often to his clients, sometimes to decorate their new homes which he had designed. The architect also maintained a collection of Arthur's works for himself.

On 9 March 1909, Arthur joined the Stockport Reform Club, and records reveal his address at this time was 98 Didsbury Road, Heaton Norris near Stockport. The artist rented a studio at No. 4 St Peter's Square where he held an exhibition of his work. Once again the show received good reviews in the local press. The *Stockport Echo* (March 1909) reported, 'There is another phase of Mr Hammond's art which should appeal strongly to our townsmen. We allude to his pictures of hunting and coaching scenes, which are treated most artistically. In this branch of his art Mr Hammond receives great encouragement from publishers in London, Paris, and New York. A very fine reproduction of his well-known picture of the *Morning of the Derby* is also amongst the collection.' Also included in the exhibition were pictures of his beloved Haddon Hall and the Derbyshire Dales.

By the latter part of the year the family moved yet again to a studio at Grosvenor Chambers, Deansgate, Manchester. In September 1909, Arthur Hammond exhibited fifty-four oils and water-colours at his studio. The large number of exhibitions the artist undertook within two years (see Appendix A) indicates a prolific output at this time.

From Manchester, Arthur Hammond set off on a painting expedition to Worcester. Based at Charlton, he painted extensively in the areas of Evesham, Pershore, Cropthorne and Fladbury. *Hereford Cathedral* (Plate 9) was painted on this trip. The water-colour is dominated by the bridge over the River Wye with the tower of the cathedral standing out proudly in the background. The effect is

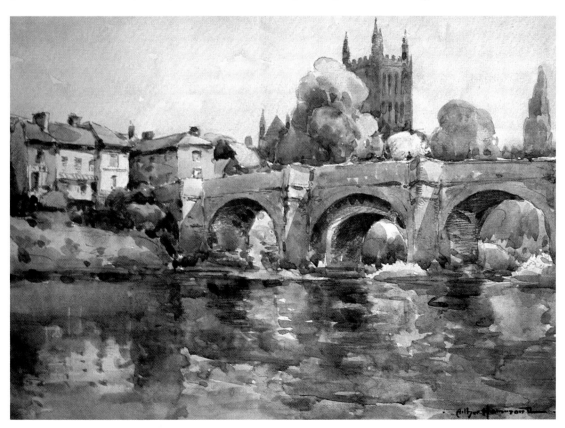

Plate 9. *Hereford Cathedral*. Watercolour. 21.5 x 30cm (8.5 x 11.75in). Private Collection.

Plate 10. *A Mill by a Stream and Bridge*
Water-colour. 25.5 x 34cm (10 x 13.5in). Reproduced by kind permission of Gordon Hodge Esq.

enhanced by subtle treatment of the reflection in the water. Arthur's work in and around Herefordshire culminated in an exhibition at Messrs Fowler, Son and Chapman, High Street, Evesham, in August 1910. The artist also brought a number of pictures back home, which he was to exhibit later in the year, again at his studio in Deansgate, Manchester.

A Mill by a Stream and Bridge (Plate 10) and *Timber-framed Cottage in Landscape with a Hay Cart* (Plate 11) are typical water-colours from this time. The locations of these pictures are not known but they are characteristic of Arthur's interest in rural architecture and landscape. The execution of the buildings in both pictures shows them to be as much architectural studies with regard to detail and perspective as studies of landscape and composition. Arthur was by now selling his pictures to a distinguished clientele. Sir Charles

Seely[14] bought a number of pictures directly from the artist, as did the Duke of Rutland, the Marchioness of Anglesey and other dignitaries, both local and from further afield.

With a fast-growing reputation in the art world, Arthur Hammond was invited on a number of occasions to talk to various photographic societies. His notes have not survived, but a report in the 13 May 1909 edition of the *Stockport Express* gives a full account of a talk Arthur had recently delivered to the Stockport Photographic Society, and it is clear that his lecture concentrated on pictorial composition from an artist's point of view. He illustrated his lecture with deftly executed sketches in chalks on a blackboard and with lantern slides of some of the finest works of Rembrandt, Titian, Michelangelo and Raphael. After his lecture the artist answered questions from the Society's members and gave

Fig. 9. Page from 'Pictures Painted and Sold'

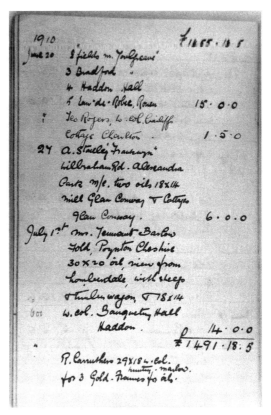

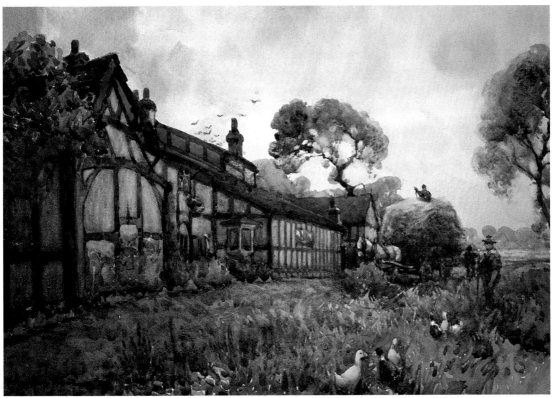

Plate 11. *Timber-framed Cottage in Landscape with Hay Cart*
Water-colour. 26 x 37.5cm (10.25 x 14.75in). Reproduced by kind permission of Gordon Hodge Esq.

constructive criticism of their photographs with regard to composition. Arthur's formal education would have included very little, if any, study of art history. He was, however, confident and competent to lecture on the great masters from his personal research during his extended lunch hours in the Reference Library in Nottingham University while he was an apprentice watchmaker, and during his studies at the Nottingham School of Art.

Arthur Hammond kept a book listing pictures painted and sold between August 1894 and October 1918. Unfortunately, not all the pictures he painted are included in the book but the document gives an interesting insight into the works he carried out and the income he generated from his art. Fig.9 shows one page from the book and indicates that the artist's attention to detail extended to his stylish handwriting. The entry for 1 July 1910 would appear to relate to *A View of Lomberdale, with Sheep and Timber Wagon* (Plate 12). The

quality of brushwork, colour and light in this oil painting is quite outstanding and is that of an accomplished landscape painter working from nature. Indeed, there is a natural quality in all aspects of the picture, and the Lomberdale river running through the scene adds life and movement.

Another oil painting from this time, or perhaps earlier, is *Entrance to a Church* (Plate 13). This too is distinguished by the fine quality of perspective and brushwork. Bold strokes of a heavily laden brush give texture and life to the foliage, while the thick dabs of paint create an effect of dappled light.

Arthur Hammond appears to have particularly enjoyed painting in and around village churchyards. The church architecture is always painted with great sensitivity, a skill which he continued to develop later in his career in his work on the Continent.

Arthur Hammond probably made his first trip abroad during 1913, apart from possible

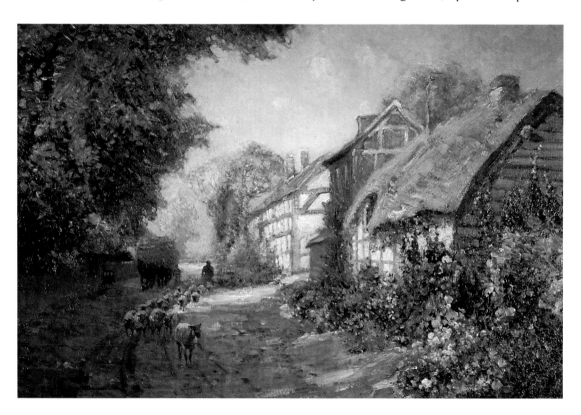

Plate 12. *A View of Lomberdale with Sheep and Timber Wagon*
Oil on canvas. 49.5 x 75cm (19.5 x 29.5in). Reproduced by kind permission of Gordon Hodge Esq.

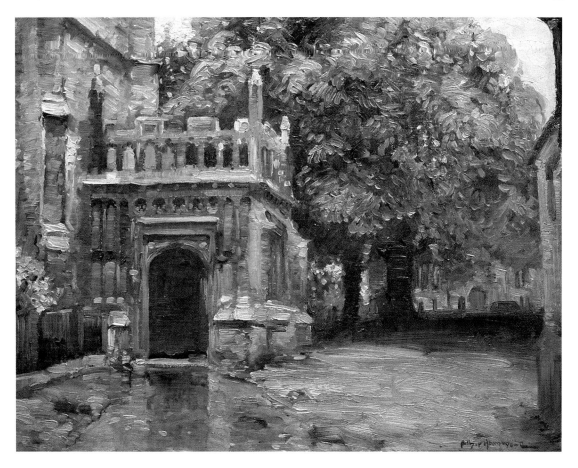

Plate 13. *Entrance to a Church*
Oil on canvas. 34.5 x 44.5cm (13.5 x 17.5in). Author's Collection.

day trips to Boulogne and Calais. A photograph of an etching of *Old Paris* is amongst the artist's possessions and is inscribed and dated 1913 on the rear. It is possible that he went to Paris to study although only a few pictures of France - Rouen and Paris - appear in the artist's list of pictures painted and sold. This would indicate that he travelled beyond the Normandy coast, but one would have expected many more works to be listed had he actually studied in Paris.

Arthur's successful exhibitions at his studio at Grosvenor Chambers, Deansgate and at 3 Bull's Head Yard, Market Place, Manchester took place at least annually, and, when possible, more frequently until the outbreak of the First World War. The artist continued to sell many of his works directly to his many clients from around Lancashire, Cheshire and Yorkshire and he also undertook many commissions. In addition, Arthur took on restoration work, generally of oil paintings, although he cleaned at least one water-colour attributed (Arthur felt incorrectly) to Joseph Mallord William Turner. It is likely that he undertook this restoration work as much out of interest as for the money. None the less, the earnings from this work were to see him and his family through the troubled times that lay ahead.

Fig. 10. *Haddon Hall*
Etching. 25.5 x 27.5cm (10 x 10.75in). Author's Collection.

CHAPTER 2
FIRST WORLD WAR
1914-1920

Manchester

From about 1912 onwards, Arthur had added 'Knighton' to his Christian name, and although his family always called him Arthur, to others he became known simply as Knighton. By 1914, the family had moved house again and were now living in Cheshire at 33 Beech Road, Cale Green, Stockport. The artist was still busy working in the Manchester area, where he had become interested in the art of etching. As his enthusiasm for etching grew he would take his completed plates to Manchester Municipal School of Art to use their printing press. The great care he took with his etchings is evident and they reveal his fine draughtsmanship. His beloved Haddon Hall was the subject of a number of these etchings, including *Haddon Hall* (Fig.10) in which the great house dominates the background and the central focus is provided by the huge trees flanking the river.

It is probable that since he obtained permission to use their printing press, Arthur was studying at the Manchester School of Art. Working as Principal Art Master at this time was Adolphe Valette who is mainly remembered for his paintings of Manchester and his excellent work at the Municipal School of Art between 1906 and 1920. His unusually liberal teaching methods and his knowledge of the latest Parisian trends made him popular with his students who nicknamed him 'Mr

Monsieur'. Valette rejected the traditional academic approach and followed instead the example of the impressionists, taking his tiny canvases and boards out onto the streets of Manchester in search of interesting light effects.

His approach was unusual not only in style, favouring a free impasto technique, but also in his choice of subject-matter. In Manchester, Valette saw beauty even in the grey smog-filled streets, in the dark canals and gloomy factories, and his 'Manchesterscapes' are perhaps a forerunner to the work of his celebrated pupil L.S. Lowry.

In an illustrated article in *The Studio*, Jessica Walker Stephens writes, 'There is certainly beauty in the eye with which Mr Valette sees the atmospheres and effect which come from the commercial effects of the city of his adoption: the very fact that Manchester should have gained and kept the services of this French artist is a tribute to her unpremeditated charm.'[1]

The novelty of Valette's style was both exciting and stimulating to all those who attended the Manchester School of Art during his time there. His work reflected some of the charm and intrigue of the French impressionists whilst encouraging a modern approach to painting, all of which would have proved irresistible to Arthur. Valette was the most influential art teacher with whom Arthur had come into contact and his work soon began to show this influence.

War Work

Outside this artistic haven, the war in Europe was exacting a heavy toll in loss of life and the demand for more soldiers was steadily increasing. In 1917, Arthur found himself before the Medical Board only to be graded C3, the lowest category of fitness. Unfit for active service, his contribution to the war effort would have to be on the home front and he was placed in the munitions drawing office of Simon Carves of Manchester. He began his work there on a wage of 30s per week, travelling about ten miles to work each day by train. He was responsible for helping to prepare drawings of buildings and components for the engineering industry, and his drawing skills soon induced the chief draughtsman to raise his wage to 35s per week. Simon Carves, his employers, were deeply involved in the war effort, and members of the government would often call at the plant. Arthur had been working there for about three months when Lord Moulton,[2] Director General of the Explosives Supply Department in the Ministry of Munitions, and later joint Managing Director of British Dyes, visited the plant.

In September 1914, after a long and brilliant career in several fields, Lord Moulton had been asked by the Government to address the problems of the British dyestuffs industry. The supply of coal-tar was of particular strategic importance as its derivatives were major components in the manufacture of high explosives such as TNT (trinitrotoluene) and lyddite (picric acid). As the war intensified, efforts were made to unify the British dyestuffs industry under a single management within the Ministry of Munitions. In June 1915, Lord Moulton became Director General of the Explosives Supply Department and a Director of the Board of British Dyes. In this capacity he had overall control of the gas works, coke ovens, and fat and oil supplies of the whole country.

One of Lord Moulton's colleagues knew of Knighton Hammond and his work, and pointed out his drawings. Lord Moulton was so impressed that he offered Arthur a job drawing the new coke ovens, granaries, munitions and acid-making buildings which were being constructed for the war effort, and which were of a type not seen in England before. He considered it important that a pictorial record be kept of the tremendous advances in these key areas of British industry during and immediately after the war. Arthur accepted this offer and his wages were raised once again to £500 per annum plus expenses.

Initially, Arthur worked under the direction of Lord Moulton and, during the summer of 1917, he was sent on an assignment to make drawings of a coke plant four miles from Durham. During his time in Durham, Arthur made several drawings of the castle which were later transferred to etching plates and a series of prints was produced. The cathedral also proved a great attraction for him and in the evenings he would paint water-colours in the cathedral precincts. One evening he was invited to the home of the Revd William Greenwell, a retired canon and former librarian to the Deanery, to view a water-colour by Joseph Mallord William Turner. Although he did not consider the picture to be one of Turner's best, Arthur was fascinated to learn that the elderly vicar had met the artist just before his death in 1851. Arthur was greatly intrigued by the old man's recollections of this most enigmatic and revolutionary artist whose paintings may be regarded as the earliest exponents of the impressionist style so much in vogue during Arthur's time at the Manchester School of Art.

In March and April of 1918, Arthur made a private painting expedition to Warwick. En route he stopped and sketched at Kenilworth, Stratford-on-Avon and Chipping Campden. He also revisited Evesham where he had worked during 1909, and visited Ludlow, where he produced a drawing which he later reproduced as an etching. The result was *Ludlow* (Fig.11), which was printed at the Manchester School of Art.

Industrial War Artists

During the 1914-18 war, there were many artists involved in recording the events on the battlefield, but a few, like Knighton Hammond, were engaged in mapping industrial deve-

Fig. 11. *Ludlow*. Etching. 29 x 26cm (11.5 x 10.25in). Private Collection.

lopments at home. As Knighton Hammond discovered, the efforts of these artists were often used to illustrate books and articles on industrial development. The American artist, Joseph Pennell[3], made a significant contribution to this work which culminated in his book *Pictures of War Work in England*[4] published in 1917, where he offers an apologia for this form of art. In the Preface, he explains 'But as we are in the midst of war, though some of us are not of it - and as war has developed the most incredible industrial energy all over the world - there is no reason why some artistic record should not be made, and my record is in this book.' The book is illustrated with a vast range of industrial subjects from industrial landscapes to the interiors of engineering works. The introduction by H.G. Wells comments, 'It has been wise of Mr Pennell therefore to make his pictures of modern warfare not upon the battlefield but among the huge industrial apparatus that is thrusting behind and thrusting up through the war of the gentlemen in spurs. He gives us the splendours and immensities of forge and gun-pit, furnace and mine-shaft.'

There are many similarities between the work of Pennell and that of Knighton Hammond at this time. Both artists brought their fine skills as draughtsmen to similar subject-matter, achieving comparable qualities of atmosphere and movement in their compositions.

Another artist working on subjects even closer to Knighton Hammond's was Frank Brangwyn (see Chapter 5). He was commissioned by Levinstein Limited to do a series of pictures of their Ellesmere Port plant. The work was used to illustrate a book published by Levinstein's entitled *Four Years Work*[5] which was 'An account of the progress of the Coal-tar Chemical Industry in England during the First World War'. Four drawings were used to highlight the significance of the discovery of the process for making synthetic indigo. The four pictures were bold pen and ink drawings using heavy line work and very little in the way of hatching or modelling. Brangwyn uses a strong, vigorous style to produce a powerful image. The Fine Art Society, London, held a comprehensive exhibition of Brangwyn's work in 1916 entitled, 'A Collection of Drawings of Belgium and of War Lithographs.' Brangwyn's work was also used to illustrate an extensive article on Levinstein Limited in the 30 June 1917 edition of *The Manchester Guardian*.

British Dyes Limited

Arthur returned from his trip to Warwick to keep an appointment with Joseph Turner, Joint Managing Director of British Dyes Limited

Fig. 12. Sir Joseph Turner.

(Fig. 12). Originally the owner of the dyestuffs manufacturer Read Holliday, Turner had joined British Dyes when his company was bought by them in July 1915. In 1918, Turner took over the direction of Knighton Hammond's work from Lord Moulton. At their introductory meeting on 15 April 1918 at the new Dalton plant near Huddersfield, Knighton Hammond was shown over the vast works by the chief engineer. At a further meeting on 25 April, the artist's salary was discussed and a figure of £500 per annum plus bonus payments was agreed.

The artist would catch a train early on

Fig. 13. *View of Dalton Works from near the Reservoir*. Pen and ink. 24.5 x 89.5cm (9.75 x 35.25in). Reproduced by kind permission of ICI Dalton Works, Huddersfield.

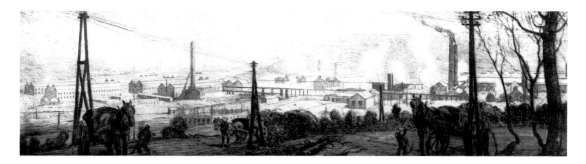

Fig. 14. *View of Dalton Works from near the Reservoir*
Etching. 12 x 44cm (4.75 x 17.25in). Reproduced by kind permission of ICI Blackley, Manchester.

Monday mornings, stay in lodgings during the week and return home on Friday evenings. His first assignment on 30 April, was to produce a panoramic view of the Dalton plant from a nearby hill. He started the drawing in the very early morning and *View of Dalton Works from near the Reservoir* (Fig.13) was the result. This pen and ink drawing was one of two he executed over the following few days. The skill of his draughtsmanship is fully revealed in this picture, combining scale, aerial perspective and composition to good effect, but most importantly for his employers, clearly illustrating the work going on at the impressive new factory. The drawing was eventually scaled down and reproduced on an etching plate from which *View of Dalton Works from near the Reservoir* (Fig.14) is a signed artist's proof. Arthur worked on a variety of views of the site from different vantage points. Also produced at this time was the etching *View of the Power Station and Gas Plant from the River, Dalton Works* (Fig.15), which lends an air of tranquillity to the dynamic atmosphere of the industrial activity so crucial to the war effort.

From the artist's diaries it appears that he would spend the morning working on one subject and change location after lunch; presumably the variation in scenery kept his mind fresh. At regular intervals he would take his portfolio of work to Mr Turner for approval, discussion and agreement of further subjects. A diary entry on 10 May indicates that the artist also discussed the possibility of producing

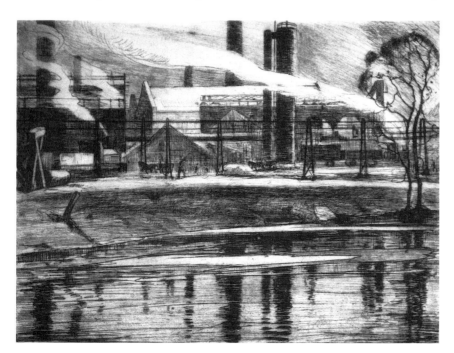

Fig. 15. *View of the Power Station and the Gas Plant from the River, Dalton Works*. Etching. 18.5 x 25cm (7.25 x 9.75in). Reproduced by kind permission of ICI Blackley, Manchester.

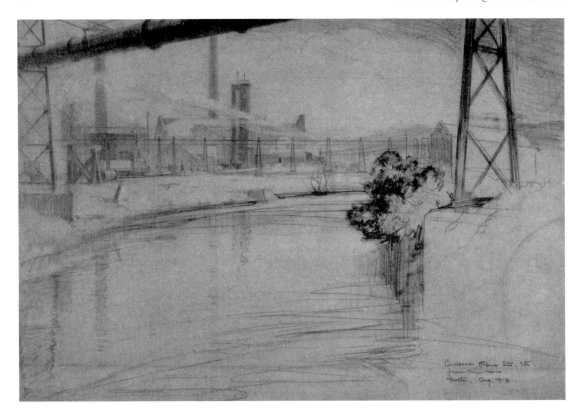

Fig. 16. *Condenser Power Station, etc, from the River, Dalton*
Pencil. 36 x 53cm (14.25 x 21in). Reproduced by kind permission of ICI Dalton Works, Huddersfield.

work for advertising material with Turner.

On his return home at weekends, Knighton Hammond would often take his family to Manchester or in and around the Bramhall and Woodford areas to sketch. In Manchester, he continued going to the School of Art to use the etching press and also to attend lectures.

Most of Knighton Hammond's work at the plant was pencil drawings, some of which he transferred to etching plates. Whether this was at the direction of Joseph Turner is not known, but it would seem to have been the favoured medium. *Condenser Power Station, etc, from the River, Dalton* (Fig.16) was produced in this way. Knighton Hammond combines his flair for landscape painting with his skills as a draughtsman in the documenting of the industrial elements. The interior of the works buildings were of equal interest and importance and on 14 May 1918 the artist started working on a drawing of the gas producer plant which he completed on 27 May. Again, a drawing

was made in the first instance, and then a redrawing was made onto an etching plate from which prints were taken. *The Gas Producer Plant* (Fig.17) is one of the artist's proofs (7th state) showing the working conditions and atmosphere within the plant. The etching, like the original drawing, was finely drawn, showing Knighton Hammond's understanding of the unique demands of the technique where the constraints of mono-chrome reproduction require a careful treatment of light and shade by means of subtle cross-hatching.

Later in the same month, Knighton Hammond started a pencil drawing of the *Nitric Acid Shed, Dalton* (Fig.18). This is a most impressive, detailed study of the interior of one of the production sheds, and like so many of the other drawings of the plant is an important historical record of social and industrial conditions during the war.

In *The Main Avenue, Dalton, 1918* (Fig.19),

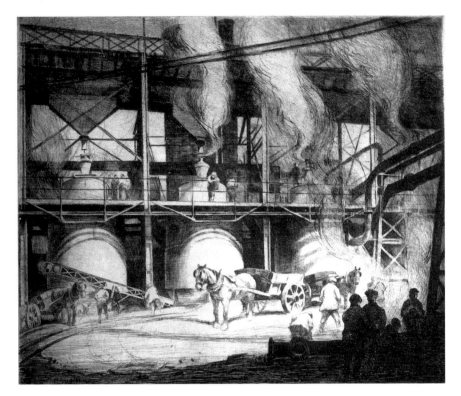

Fig. 17. *The Gas
Producer Plant*
Etching (7th state)
28 x 33cm
(11 x 13in).
Reproduced by kind
permission of ICI
Dalton Works,
Huddersfield.

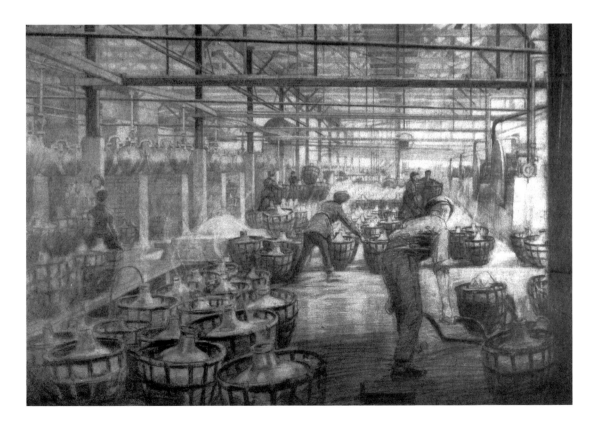

Fig. 18. *Nitric Acid Shed, Dalton*
Pencil. 38 x 53cm (15 x 21in). Reproduced by kind permission of ICI Dalton Works, Huddersfield.

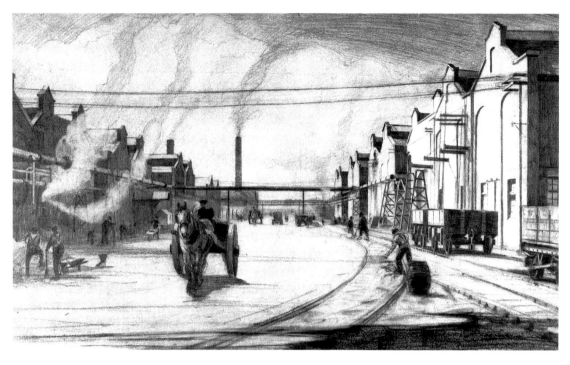

Fig. 19. *The Main Avenue, Dalton, 1918*
Pencil. 32 x 53cm (12.5 x 21in). Reproduced by kind permission of ICI Dalton Works, Huddersfield.

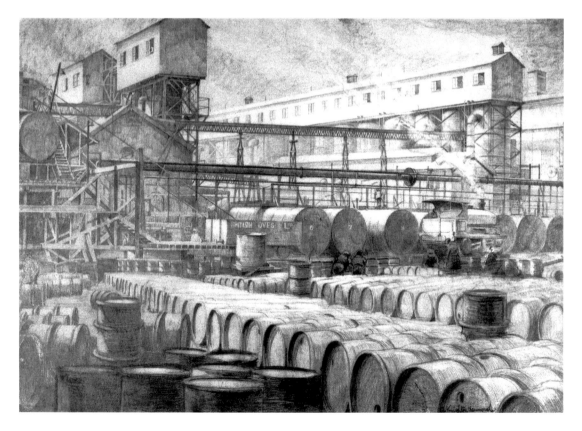

Fig. 20. *Oleum Plant, Dalton*
Pencil. 38.5 x 59cm (15.25 x 22in). Reproduced by kind permission of ICI Dalton Works, Huddersfield.

a roadway which ran the length of the plant and which was flanked on both sides by gable-ended industrial buildings, Knighton Hammond records the various modes of transportation used around the works.

Working constantly, his next assignment was the *Oleum Plant, Dalton* (Fig.20). In this accomplished exercise in perspective study, Knighton Hammond painstakingly details every stored barrel as a record of the plant's productivity, while in a further pencil study, undertaken in August and September 1918 of the interior of the *Benzidine Shed, Dalton Works* (Fig.21), it is the human figures which give scale to the mass of machinery and a vivid impression of the energy and motion of the industrial process.

During discussions with Joseph Turner in August, it was decided that the artist should have a room at the plant in which to work and set up a studio. This was also to house the etching press that Turner had bought for

Knighton Hammond. It cost £30 and was put to good use.

While working in and around the plant the artist made the acquaintance of a number of chemists and managers, which resulted both in encouragement and, in some cases, in private commissions. Knighton Hammond would generally take his lunch and evening meal at Dalton Grange Club which was owned by British Dyes and was available to senior members of their staff. In the evenings he would regularly play billiards and bridge with company personnel. At weekends, he was kept very busy and undertook a number of portraits. A Mr Douglas Beith commissioned him to paint portraits of his father, mother and grandfather. The artist received a fee of 100 guineas for the portrait of Mr Beith's father. He also undertook a commission for a portrait in oils of a Mr Tonge, from which he did a series of etchings.

During the latter part of September 1918,

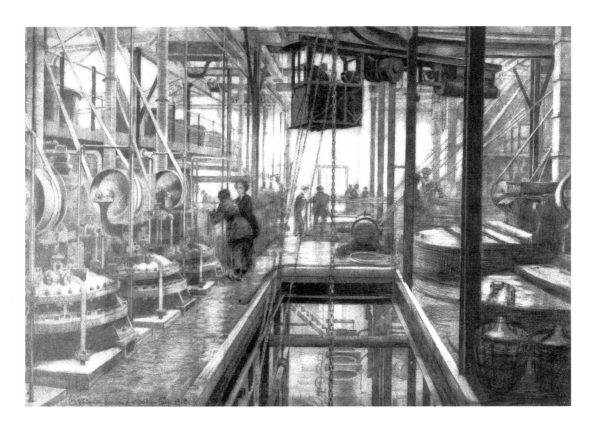

Fig. 21. *Benzidine Shed, Dalton Works, Sept. 1918*
Pencil. 36 x 53.5cm (14.25 x 21in). Reproduced by kind permission of ICI Dalton Works, Huddersfield.

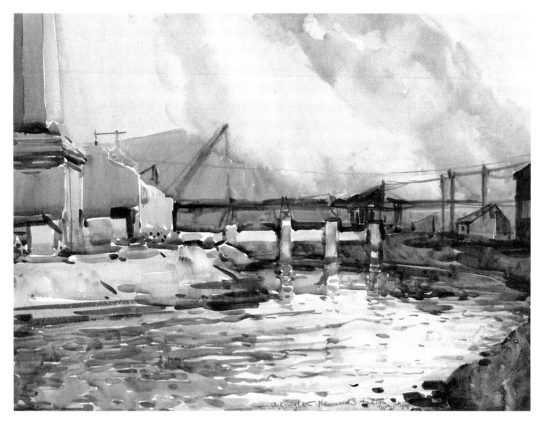

Plate 14. *View of Dalton Works, 21 Nov., 1918.* Water-colour. 26 x 36cm (10.25 x 14.25in).
Reproduced by kind permission of ICI Blackley, Manchester.

Knighton Hammond was asked to paint at the nearby Turnbridge plant where he painted a water-colour of the works from Kilner bank. Here, too, his work brought him friends and attracted the attention and admiration of the staff. The artist would often be invited to supper with senior chemists such as Dr David Segaller and his family, who had shown a general interest in his work.

In November, Arthur was back at the Dalton works and a water-colour, *View of Dalton Works, 21 Nov., 1918* (Plate 14) shows a change in style from his earlier work. It has a new freedom in the flowing, broad washes of colour but it retains the underlying precision of line. This change in style may have been a result of the influence of Adolphe Valette.

Valette's influence may also have affected Arthur's choice of subject-matter during weekends at home in December 1918. The artist would go out and about in Manchester drawing street scenes, developing a particular

interest in architectural subjects which show the benefits of his experience in recording industrial plant.

During 1919, Knighton Hammond began to work increasingly in water-colours and oils. In this year, he painted *Azo Colour Shed, Dalton Works, in Course of Construction* (Plate 15). The shed was a rigid steel-framed construction which gave the artist the opportunity to combine a composition, well-structured in terms of perspective and scale, with human interest as the construction workers went about their work. He also etched a plate *Azo Colour Shed, Dalton Works, in Course of Construction* (Fig.22), demonstrating that an etching can be as attractive as a water-colour with skilful use of the etching needle.

Knighton Hammond moved between Dalton and Turnbridge, producing numerous works at each site. In *Nitration Plant, Turnbridge* (Plate 16) he captures atmosphere and movement in a typical composition. In

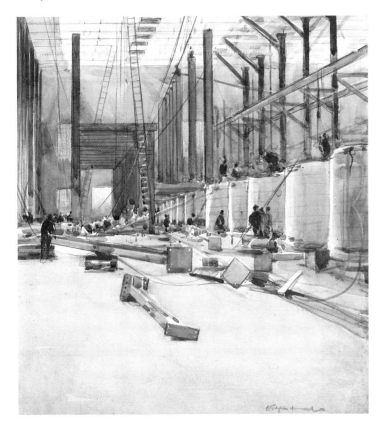

Plate 15. *Azo Colour Shed, Dalton Works, in Course of Construction* Water-colour. 38 x 33cm (15 x 13in). Reproduced by kind permission of ICI Blackley, Manchester.

Fig. 22. *Azo Colour Shed, Dalton Works, in Course of Construction* Etching. 30.5 x 26.5cm (12 x 10.5in). Reproduced by kind permission of ICI Blackley, Manchester.

Plate 16. *Nitration Plant, Turnbridge*
Oil on panel. 59 x 44.5cm (23.25 x 17.5in).
Reproduced by kind permission of ICI Dalton Works,
Huddersfield.

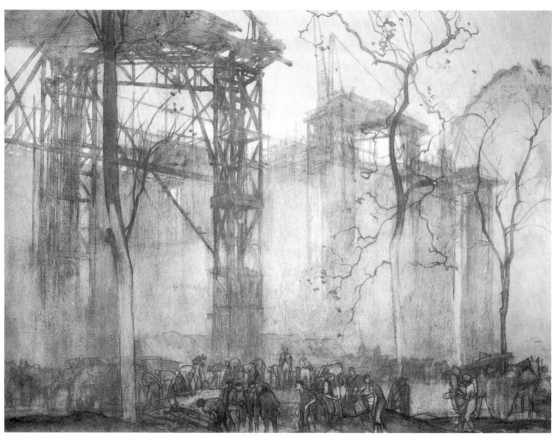

Plate 17. *Industrial Scene.* Pen, ink and water-colour. 33 x 44cm (13 x 17.25in).
Reproduced by kind permission of Gordon Hodge Esq.

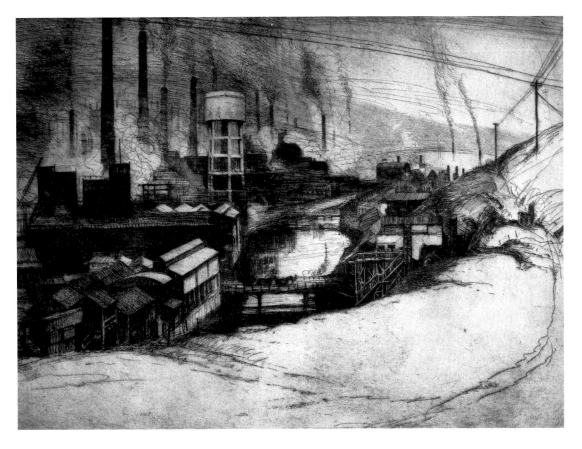

Fig. 23. *View of Turnbridge Works from Kilner Bank, 1919*
Etching. 25.5 x 35.5cm (10 x 14in). Reproduced by kind permission of ICI Dalton Works, Huddersfield.

contrast to his ever-developing water-colour style, his brushwork and technique in oils remained very similar to that of his earlier work. He continued to produce many etchings for his employers and in *View of Turnbridge Works from Kilner Bank, 1919* (Fig.23), he achieved another fine example of the technique, scattering subtle areas of highlight across the etching to add drama to the panoramic view.

British Dyes Limited took a stand that year at an exhibition at Manchester Technical College. Arthur's pictures were displayed on the stand and he visited the exhibition with one of the company's chief colourists, Croyden Meredith Whittaker. The pictures attracted a good deal of attention to the stand and Mr Whittaker was certainly impressed, subsequently using many of Arthur's drawings and water-colours to illustrate his book, *Some*

Modern Tendencies in Dyeing, coupled with A Few Notes on Colour Manufacture. The first edition of the book was published in 1919 (second edition, 1920). Twenty-five works by the artist were selected for reproduction and integrated into Whittaker's text to illustrate the various plants and processes in operation.

On the amalgamation of British Dyes Limited with Levinstein Limited in the summer of 1919, Arthur was introduced to Dr Herbert Levinstein, who was greatly interested in his pictures, having himself been responsible for appointing Brangwyn to record his Ellesmere Port works. Although Brangwyn no longer worked for Levinstein, Knighton Hammond would certainly have seen his work for them. Knighton Hammond's *Industrial Scene* (Plate 17) and *War Work* (Fig.24) are further examples of his work from around this time. Their exact location is not known.

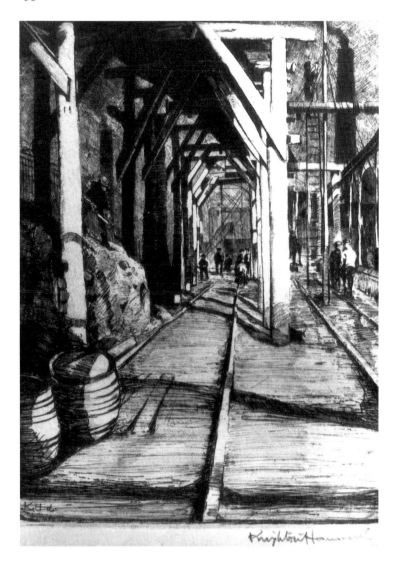

Fig. 24. *War Work.* Etching.
27 x 19.5cm (10.75 x 7.75in).
Private Collection.

Time for Change

After two years as an industrial artist, Knighton Hammond felt that subjects at British Dyestuffs Corporation, as it had now become, were more or less exhausted and he had to make some decisions as to his future. He had enjoyed the work and was obviously receiving some acclaim, his work appearing in books and publicity material, but he began looking for further opportunities elsewhere. On 18 May 1919, he sent a letter to the Dow Chemical Company in Midland, Michigan, USA, giving an account of himself and his working history, and offering his services. This providential step was to lead to new opportunities and an exciting adventure.

A reply dated 28 May 1919 was received from the President and founder of the Dow Chemical Company, Herbert H. Dow, indicating an interest in his offer. Knighton Hammond was then delighted to receive a further letter dated 6 November 1919 in which Mr Dow suggested that the artist should come to America to discuss a possible commission. Mr Dow's interest seems to have been awakened by seeing paintings of chemical plants being displayed by other companies at the annual National Exposition of Chemical Industries. He could clearly see the publicity potential in his own company being represented in this way.

Knighton Hammond replied to the letter,

outlining his work on industrial plants, granaries, collieries, coke oven plants, engineering and chemical works for the British Dyestuffs Corporation. He also gave details of his salary arrangements with the corporation and suggested a similar agreement, should a commission be forthcoming. This would involve the purchase of the artist's services for a given time so that work would be uninterrupted.

Mr Dow's letter of 24 December 1919 indicated that he was willing to accept the proposition to employ Knighton Hammond for six months at $5,000 payable in monthly instalments with additional travelling expenses. A great deal of further correspondence passed between the two parties finalising details of the proposed trip. Mr Dow also gave the artist some idea of the locations at his plant which he thought would make good subjects.

Meanwhile, Arthur's industrial paintings were continuing to reach an expanding audience. In January 1920, he helped to set up another trade exhibition stand featuring his paintings, this time at Turnbridge. There he records that the British Dyestuffs Corporation's chief scientists, Professor Arthur Green and Professor Sir Robert Robinson, who were advising on the stand, took an interest in his work. When the stand was finished and approved by Croyden Whittaker, it was dismantled and transported to Glasgow for an exhibition. The artist followed shortly afterwards to ensure that the reconstruction was satisfactory and to be in attendance during the exhibition.

On 8 March, Knighton Hammond attended a meeting with Dr Levinstein to discuss his forthcoming trip to America. There it was decided that duplicate copies of his drawings should be made before his departure and Levinstein told him that there would always be a job for him at British Dyestuffs Corporation on his return from America if he so wished. He was very touched by this confidence in him.

As a token of appreciation for his work, Knighton Hammond was invited to a farewell dinner at Dalton Grange on 10 March 1920 as a guest of Sir Joseph Turner. Many of the other guests were chemists and managers with whom

he had become good friends. After the meal, Sir Joseph gave a speech thanking the artist for the work he had done for the corporation and for his friendship over the past 18 months, and presented him with a fashionable walking stick and umbrella.

Knighton Hammond spent several more weeks completing the work in hand and copying his drawings. He then took the finished works to Dr Levinstein, received his fee of £100 and finally left British Dyestuffs Corporation on 7 April 1920.

After his departure, four of Knighton Hammond's drawings were reproduced for an advertisement, which appeared on the front page of the Empire Number of *The Times* of 25 May 1920. The full-page British Dyestuffs Corporation Limited advert was illustrated with *View of Dalton Works from near the Reservoir* (Fig.13), *Nitric Acid Shed* (Fig.18), *Oleum Plant* (Fig.20) and *Benzidine Shed* (Fig.21). The newspaper reproductions, however, were not able to do justice to the quality of the original drawings. A similar selection of drawings was used to illustrate an edition of *The Graphic British Industries* magazine.

Some idea of the number of works Knighton Hammond produced for the British Dyestuffs Corporation Limited can be gleaned from a letter, dated 22 November 1919, to Mr Dow. He gives an account of his work as, '. . . over 60 paintings in oil and water-colour and five etched plates, with an edition of 50 impressions (signed) off each plate.'

In addition to the duplicate drawings, British Dyestuffs Corporation had a series of glossy monochrome prints made of Knighton Hammond's work. These would have been produced for publicity purposes and as art prints in their own right; many are still in circulation.

Before he left for America, Knighton Hammond was delighted to discover that his work had been acquired for the first time by a public gallery. Manchester City Art Gallery had purchased two of his drawings of the Manchester Royal Exchange for their permanent collection. One drawing was of the building before alteration, and the other showed the scaffolding erected for the building work

which was taking place. A drawing of Hobson Square was later added to the collection in 1923. With a satisfied employer and this last major achievement to encourage him, Arthur was able to leave for America confident of success.

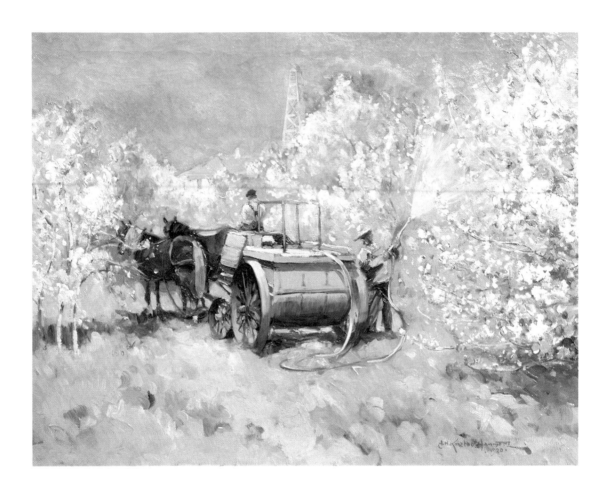

Plate 18. *Spraying in H.H. Dow's Apple Orchard with Brine Well in Background.* Oil on canvas. 45 x 59.5cm (17.75 x 23.5in). Reproduced by kind permission of the Dow Foundation, Midland, Michigan, USA.

CHAPTER 3
AMERICA
1920-1921

The Dow Commission

Knighton Hammond secured a berth for himself on the *Mauritania*, while Mr Dow made arrangements for one of his executives in New York, Ralph E. Dorland, to take care of the artist on his arrival. Leaving his family to travel so far from home must have been quite an upheaval for Knighton Hammond, especially since travelling abroad was no simple matter at that time and the departure of the *Mauritania* was postponed at least twice before it finally set sail.

The artist left Huddersfield on 12 April 1920 by train bound for Southampton via London. The liner set sail on 14 April and, from notes in the artist's diary, it is clear that he was not a natural sailor and was relieved to dock at New York on 22 April. After passing through customs, Knighton Hammond made his way to the Belmont Hotel, as arranged, where he was met by Mr Dorland.

A few days were spent in New York enabling the artist to visit the Metropolitan Museum of Art where he admired, in particular, the collection of Rembrandts. A trip to the top of the sixty-seven storey Woolworth Building was his first experience of skyscrapers, and his initiation into American culture was completed when he was taken to a baseball match by Mr Dorland and his son.

On 26 April the artist boarded the night train for Michigan. From Bay City he was driven to Midland, where Mr Dow was waiting to take him on a tour of the works complex.

Herbert H. Dow and his Company

Herbert Henry Dow (1866-1930) was born the son of an accomplished and innovative mechanical engineer, who encouraged his son's interest in science. The young Dow graduated from the Case School of Applied Science in Cleveland, Ohio, before moving to Midland in 1890. His research at the Case School had revealed vast natural resources of brine trapped under the town. He had made a brief stop in Midland in 1889 during a trip to gather brine samples at various places in Michigan and Ohio which he then tested in the laboratory. The bromine content of the Midland brine was found to be very high, and it was this that he was looking for. The foundation on which his company was eventually built was the extraction and blending of chemical elements from the brine deposits and their conversion into useful products.

Since his arrival in Midland, Dow had been involved in setting up several chemical companies to produce bromine from brine and to research new methods of production. Indeed, in January 1891 the pioneering young chemist made an important breakthrough, which went unrecorded except for a brief note in one of Dow's notebooks, when bromine was produced electrolytically for the first time in the world

Fig. 25. Herbert Henry Dow (1923)

(as far as is known). An equally important event for Dow in November of the following year was his marriage to Grace Ball, a local school teacher, who was to be the staunchest of allies and gave up teaching to work alongside her husband.

It was in 1897 that the Dow Chemical Company was formed and the articles of incorporation were filed in Michigan on 18 May of that year. Dow set about gathering around him a team of young men, most of them graduates of the Case School of Applied Science. The chemical industry was still very much in its infancy in America at this time, so the scientists had to develop their own plant and equipment by trial and error. Investment from Cleveland businessmen enabled the company to prosper. Dow was allotted funds for building a new plant at the east end of Main Street, Midland, and work started in the summer of 1897 with a feverish burst of activity. He brought in his brother-in-law, Tom Griswold Jr., to help design the plant. Griswold, also a graduate of the Case School of Applied

Science, was the first of the remarkable group of talented men whom Dow would attract to Midland through the years. Dow also brought in his father from Cleveland to help supervise the construction.

The plant became operational on 25 November 1897, initially producing bleach, and was powered by an advanced electricity generator. Also at this time, Dow was involved in the construction of a new large and comfortable home for his family. There were quite serious 'teething' problems to be overcome concerning both the financing of the plant and its production levels. Dow felt that the financial problems would only be solved by improved production results, so he worked closely with Griswold and his chemist, Jim Graves, to overcome the production problems. Dow's optimism and determination successfully pulled the Dow Chemical Company through this difficult period. Production improved dramatically and the plant at last began to make money, much to the relief of the Cleveland backers. Furthermore, Dow's pioneering enterprise is of major historical importance as the first stirrings of what was to become a powerful American chemical industry.

In 1900, Dow brought in two more men for his team who were to play a major part in the growth of the company. The first to arrive was Earl Willard Bennett who, on a visit to Midland, applied for a job as bookkeeper and was duly appointed. The second was E.O. 'Ed' Barstow, an outstanding student at the Case School who was steered to Midland by Professor A.W. Smith, Dow's former classmate and close friend. The nucleus of his team now took on a coherent form with Tom Griswold as construction engineer, Bennett in charge of finance, and Barstow helping manage the plant, conducting laboratory experiments and bringing these experiments into production.

By this time, Dow had developed a full line of bromides used by the pharmaceutical and photographic industries along with bleach and mining salts. But the years ahead were stormy, and competition from Europe was fierce. The British bleach industry presented a particularly

strong challenge, although even this paled beside the competition from the German bromide producers who entered the American market in response to Dow's expansion into the European arena. Dow, in turn, concentrated on the German home market where he was able to undercut the home suppliers by buying German-made bromides on the New York market where they had been subject to an import duty, and selling them back to Germany where there was no import duty. In effect, he had the Germans working against themselves, but in spite of his success, Dow's trade war was a strain on the Company's resources.

In 1907, Dow decided to take his wife and family to Europe for a holiday. He now had five children: Helen, 12, Ruth, 11, Willard, 10, Alden, 2 and Margaret, 1. They sailed for England in January and stayed in London. Dow made a business trip to Germany to see his competitors' manufacturing plants which they believed to be the most efficient in the world. He soon realised that his own plant was more efficient and that the demand for bromides was even greater than he had suspected.

Perhaps the most important thing to come from his European trip was the realisation that the Dow Chemical Company was relying too heavily for survival on bromides and bleach. He knew he was taking from the brine only a small portion of its chemical wealth. The greater part of it was still being discarded as waste. He felt the waste had to be turned into useful products and his aim was to move in that direction.

In 1908, Dow strengthened his research and development team by bringing in a young chemist named Charles Strosacker, another graduate of the Case School, to work alongside Ed Barstow. By the end of the year the Germans had withdrawn from the American bromide market and Dow gradually halted shipments of bromide to Germany. Whilst this was a costly victory for Dow, it had enhanced the reputation of the small Michigan chemical company which had stood up to a powerful European rival and won.

In 1913, Herbert Dow dropped what must have been a bombshell on his team. Barstow, Strosacker, Griswold and Bennett were called into his office and he announced that they were pulling out of the bleach business. As bleach was still their big money-earner, Dow had to explain his reasons. He told them the future of the company lay in the use of its chlorine for products other than bleach and that it was too valuable to sell in the form of bleach.

The outbreak of the First World War in Europe in 1914 brought about rapid expansion for the chemical industry as the German chemical giants, who had dominated the world markets, became subject to British blockade. By this time, Dow employed approximately one hundred qualified chemists, many in senior positions. Expansion at the Midland plant now forced him to seek out other qualified chemist/ managers to share the workload with Barstow and Strosacker and it was the Case School yet again that provided for his needs in the form of Mark E. Putnam, a professor of chemistry. In 1915, Dow foresaw an imminent shortage of dyes in the American textile industry which had relied heavily on German supply. He brought in Dr Lee H. Cone of the University of Michigan, an organic chemist, to develop a manufacturing process for making synthetic indigo, and within 18 months the first synthetic indigo ever made in the United States was dispatched from the plant.

In December 1915, while absorbed in the supervision of the plant expansion, Dow received a sudden shock. He was summoned to Cleveland and informed that a majority of the board of directors was in favour of selling the Dow Chemical Company to a syndicate from the East coast. The sale hinged on Dow and his team remaining with the company. Returning to Midland, Dow must have thought carefully about the offer knowing that, if he accepted, it would make him a wealthy man and allow him and his family to live in comfort for the remainder of his life. When a meeting was called for a decision on the sale of the company, Dow summoned his team and took them to Cleveland without disclosing any of the proposal. The team waited in an adjoining office while Dow entered the board meeting.

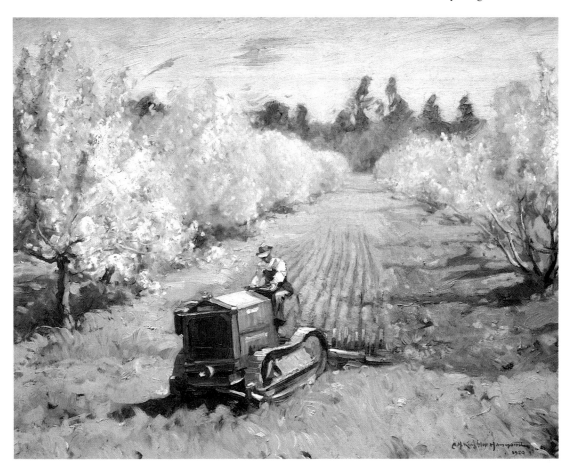

Plate 19. *H.H. Dow's Apple Orchard, Midland, Michigan, 1920.* Oil on canvas. 44 x 60.5cm (17.25 x 23.75in). Reproduced by kind permission of the Dow Foundation, Midland, Michigan, USA.

After a short time, Dow emerged and explained details of the proposed take-over, indicating that he would not oppose the sale if that was what the board wanted to do. He gave them the option of continuing in their jobs or resigning and going with him because, if the company was sold, he was prepared to start a new one. All of the team expressed their loyalty and agreed to stand by him. When Dow announced the decision, the Eastern syndicate was no longer interested in the Dow Chemical Company without its successful management and the matter was closed. This was a measure of Dow's dedication to his profession and to his company, both of which were of greater importance to him than money.

For the duration of the Great War the plant ran to capacity, developing many new products as part of the war effort. When America entered the war, President Wilson set up a War Industries Board and Dow was appointed a member of its chemical section. In June 1918, the Dow Chemical board of directors promoted Herbert Dow to the presidency of the company. However, economic depression followed the end of the war as the abnormally high demand for goods and labour ended abruptly. Dow was forced to cut back his operations, but none the less expanded his research staff with the employment of his son-in-law, William J. Hale, a professor of chemistry at the University of Michigan who had married Dow's eldest daughter, Helen, during the war. Helen had died in the terrible influenza epidemic that occurred in the autumn of 1918 leaving behind a baby daughter. Hale was appointed to organise an organic chemistry research laboratory, and his first important contribution was to put

together a company chemical library stocked with technical books, papers and reference material which eventually grew into one of the largest chemical libraries in the United States.

The Company continued to find the economic climate more and more difficult. In this time of depression advertising to maintain market share and product awareness was all the more important and Herbert Dow, always a shrewd marketing man, was keenly aware of its power. He had seen and been impressed by a review of some industrial landscapes done for the National Aniline & Chemical Company in 1919. It was then fortuitous that, at this juncture, Knighton Hammond's proposal arrived. By November 1919, Dow had already decided that an artistic record of his plant would greatly enhance its public image and this seems to be borne out by an early letter to Knighton Hammond, in which he comments, 'At the National Exposition of Chemical Industries, which is an annual exhibit of the leading chemical companies of America . . . the writer noted a number of fine paintings shown by the National Aniline & Chemical Company that were very much of a credit to their exhibit.'

Painting at the Plant
On 28 April, the day after his arrival, Knighton Hammond was up early sketching around the plant. Mr Putnam arranged lodgings for the artist and helped him settle in. The painting materials he had sent from England had arrived in advance of him so, with those he had brought with him, the artist was able to start work immediately. Initially, he commenced work on a number a canvases of the indigo shed, insecticide plant and the machine shop. At any one time, Knighton Hammond would have a number of pictures on the go. He would be outside working in fine weather and interior scenes were undertaken when the weather was poor. Some of the paintings were completed at his lodgings and new, larger canvases were ordered from Detroit. In the meantime, the artist started a number of half-imperial size water-colours including the potash towers and the lead arsenate shed.

Knighton Hammond was well entertained, especially by Mr and Mrs Dow. He was invited many times by them for dinner and, as the artist describes in his diary, 'for cosy chats'. As contemporaries, the conversation between the two men may well have involved reflections on earlier and more difficult times when Dow had been struggling to find the finance his business required and Knighton Hammond in London had been struggling to pay the rent. Both men, by 1920, must have been reasonably happy with their respective progress since those earlier days.

From the entries in the artist's diary, it appears that Mr Dow gave up a great deal of his valuable time to be with Knighton Hammond. He took delight in introducing him to visitors at the plant and involved him in his social activities. Mr Dow's close friends, such as Dr Smith from Cleveland, became friends of the artist. Indeed, Dr Smith usually called on the artist on his frequent visits to the plant.

Other members of Mr Dow's team also entertained the artist. On a number of occasions, Mr Bennett took the artist to lunch at the Rotary Club as well as inviting him to dinner in the evenings. Knighton Hammond gave a talk on art at the Rotary Club at Mr Bennett's invitation. A great deal of time was also spent with Mr and Mrs Griswold and with Mr and Mrs Putnam, with whom he occasionally attended chapel on Sundays. So frequent were his visits to the Griswolds for tea, Mrs Griswold recalled shortly before she died that a beautiful bone china cup and saucer became known as 'Mr Knighton Hammond's'.[1]

Mr Dow's son, Alden, appears to have been quite intrigued by watching Knighton Hammond at work. He recalled sometime later accompanying his father in the apple orchard to watch the artist painting a horse-drawn sprayer, and being fascinated by the way Knighton Hammond was able to convey power and muscles straining in the horses' hind-quarters with just a very few brush strokes. Alden also recalled that when his father expressed an interest in learning to paint in water-colour, Knighton Hammond obliged by presenting him with a water-colour set and

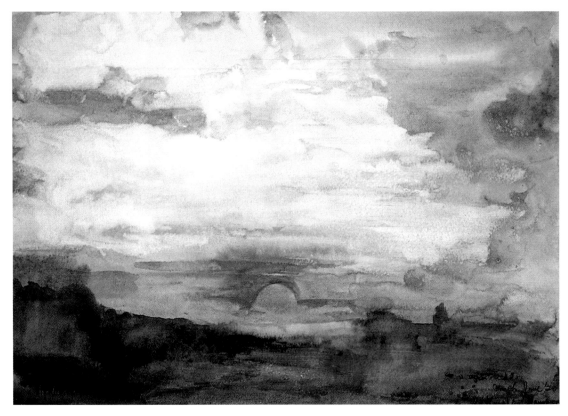

Plate 20. *Sunset Michigan, June 1920*. Water-colour. 24.7 x 35.5cm (9.75 x 14in). Private Collection.

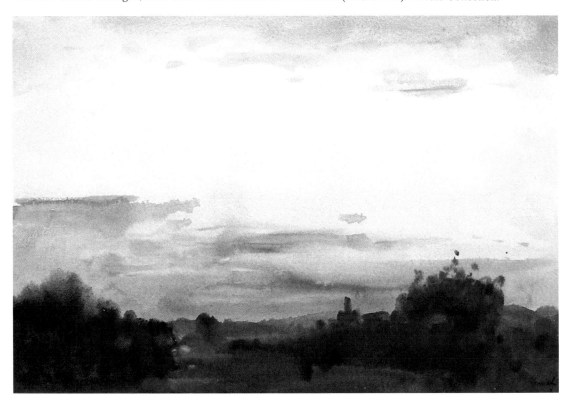

Plate 21. *Sunset Michigan.* Water-colour. 24 x 34cm (9.25 x 13.5in). Private Collection.

offering some instruction. Mr Dow Jr. said his father's efforts 'were pretty good'.[2] Alden Dow did not follow his father into the chemical business but went into architecture, studying under Frank Lloyd Wright.

Willard Dow, the eldest son, was instrumental in teaching Knighton Hammond to drive, enabling him to obtain an American driving licence. The artist bought a Ford Sedan car and would go out in the evenings for a drive, often taking one or more of his hosts with him. Unfortunately, with his limited experience, he had the odd mishap, getting stuck in sand on one occasion and causing minor accidents on others.

The picture the artist had been painting in the orchard while the Dows looked on was *Spraying in H.H. Dow's Apple Orchard* (Plate 18) which was painted between 22 and 26 May 1920. Its companion picture, *H.H. Dow's Apple Orchard* (Plate 19) was painted during 28 and 29 May 1920. Both of these pictures

show a freshness of light and colour inspired by the new and colourful landscape in which Arthur found himself. Observing the beauty around him, he brings out the warmth and brightness of the setting sun over the blossoming apple orchard with broad impasto brush strokes.

In a letter to Knighton Hammond dated 3 February 1920 during negotiations for the commission, Mr Dow explained, 'The sunsets in this locality are frequently very brilliant and beautiful. I believe all artists enjoy these wonderful displays of color. I understand these are not seen in England – presumably because of the great humidity of the climate.' Knighton Hammond was also impressed with the sunsets, and his diary records that he painted at least five in water-colours and one in oils. Mr Griswold was given a sunset in water-colour by the artist when he purchased two other water-colours. The oil mentioned was purchased by Mr Bennett for

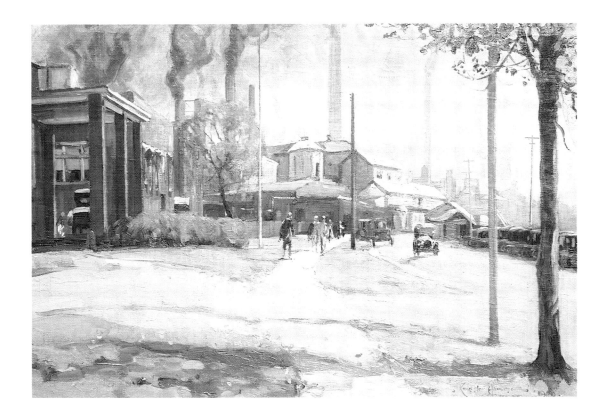

Plate 22. *The Dow Chemical Company Main Office Building, Midland, Michigan.* Oil on canvas. 60.5 x 91cm (23.75 x 35.75in). Reproduced by kind permission of the Dow Foundation, Midland, Michigan, USA.

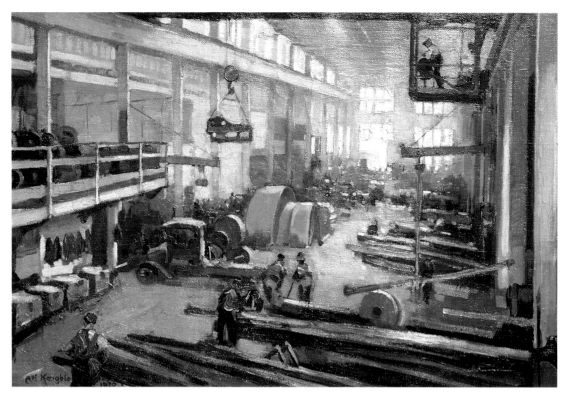

Plate 23. *47 Building Machine Shop.* Oil on canvas. 34.5 x 52cm (13.5 x 20.5in). Reproduced by kind permission of the Dow Foundation, Midland, Michigan, USA.

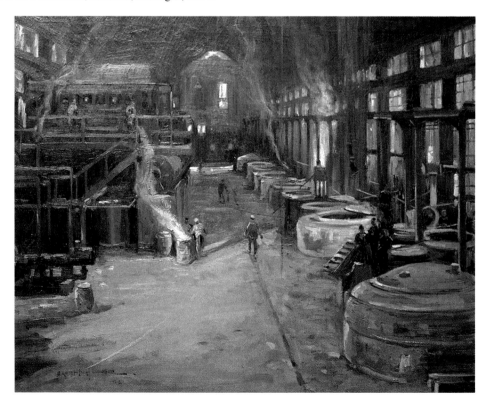

Plate 24. *Caustic Pot House Caustic Soda Production, Midland, Michigan.* Oil on canvas. 70 x 90cm (27.5 x 35.5in). Reproduced by kind permission of the Dow Foundation, Midland, Michigan, USA.

$250. *Sunset, Michigan, June 1920* (Plate 20) and *Sunset, Michigan* (Plate 21) are two of the water-colours which came back to England, presumably returning with the artist. Here, the effects of the setting sun are spectacular. The former painting shows a cloudy sky with a subtle burst of orange sunlight radiating from the setting sun. The latter painting shows a tranquil evening sky with the sunlight still warming the scene as the sun disappears over the horizon.

Knighton Hammond would explore the plant looking for the best vantage points from which to paint. *The Dow Chemical Company Main Office Building* (Plate 22) transforms the office building with the industrial plant in the background into a delightful picture. It would appear to have been painted during the autumn as the trees are losing their leaves, and the

seasonal light and colour give it great depth and atmosphere.

The artist was well versed in selecting industrial subjects from his days with the British Dyestuffs Corporation. He would, however, agree subjects in advance with Mr Dow during their discussions on the pictures he had already produced. As in the past, Knighton Hammond was equally interested in the interiors of the buildings and the processes which took place there. Again, he would seek out a good vantage point to set up his easel. On 1 May 1920, he climbed on to a gantry to paint *47 Building Machine Shop* (Plate 23). This location gave him a bird's-eye view of the shop floor, with its heavy engineering, and also a view of the crane operator at high level. He chose similar high-level vantage points from which to paint two pictures of the *Caustic*

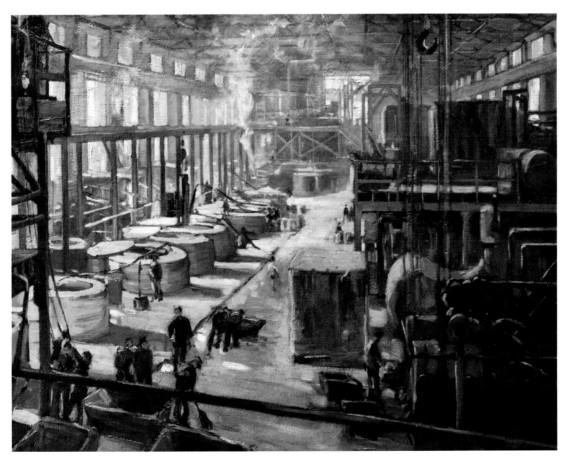

Plate 25. *Caustic Pot House Caustic Soda Production, Midland, Michigan*. Oil on canvas. 74 x 87.5cm (29.25 x 34.5in). Reproduced by kind permission of the Dow Foundation, Midland, Michigan, USA.

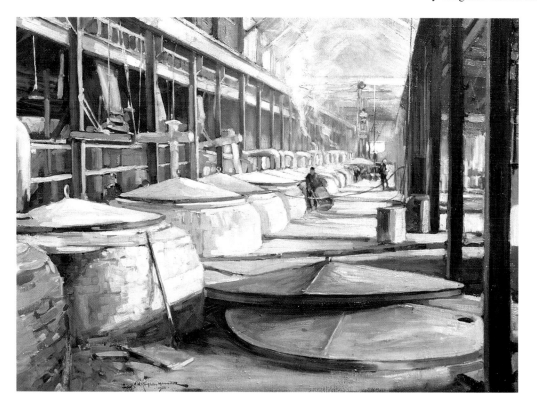

Plate 26. *Partial View of Caustic Plant Interior*. Oil on canvas. 70.5 x 91.5cm (27.75 x 36in).
Reproduced by kind permission of the Dow Foundation, Midland, Michigan, USA.

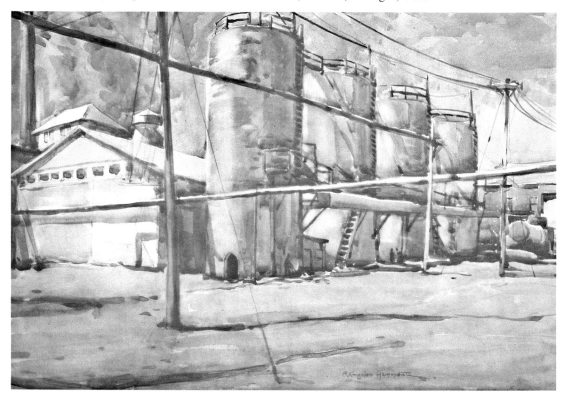

Plate 27. *Part of Cal-Mag Production, Midland, Michigan*. Water-colour. 37 x 54.5cm (14.5 x 21.5in).
Reproduced by kind permission of the Dow Foundation, Midland, Michigan, USA.

Pot House (Plates 24 and 25), using a different colour scheme in each. In Plate 24, Knighton Hammond subtly lights the scene with subdued background colouring and bright highlights in the foreground for dramatic effect. By way of a contrast, in Plate 25, he uses brighter, warmer colours to give an all-over light to the scene. Both paintings show a busy workplace with the figures giving some idea of scale to the compositions. *Partial View of Caustic Plant Interior* (Plate 26) illustrates the same process but from a lower view point. From the factory floor at closer range, this oil painting focuses on one aspect of the production process, and uses a wider colour range than its companion pictures.

Whilst the artist appeared to prefer working predominantly in oils for the industrial scenes, he did produce a number of water-colours, including *Part of Cal-Mag Production* (Plate 27) and *Epsom Salt Plant* (Plate 28). These pictures continue his development of freedom of brush-work. The compositions are well structured with regard to the elements of

drawing, but are given a more sweeping colour wash; an effect that was to be further developed later.

Knighton Hammond had arranged for his family to join him in America and on 25 August he left Midland for New York to meet them off the *Mauritania*, taking the opportunity whilst in New York to renew his acquaintance with Mr Dorland. The *Mauritania* docked on 28 August and after waiting for two hours on the pier, Knighton Hammond was reunited with his wife and daughters. After spending the following day sight-seeing in New York, they left on a train for Buffalo. From here, a day was spent at Niagara, taking a trip on the *Maid of the Mist* around the falls before boarding a boat in the evening bound for Detroit across Lake Erie. On arrival back in Midland, Knighton Hammond moved from his lodgings into a larger rented house which would accommodate himself and his family. No doubt exhausted after the long journey, Mrs Hammond spent the first few weeks of her stay in Midland ill in bed. The artist resumed his

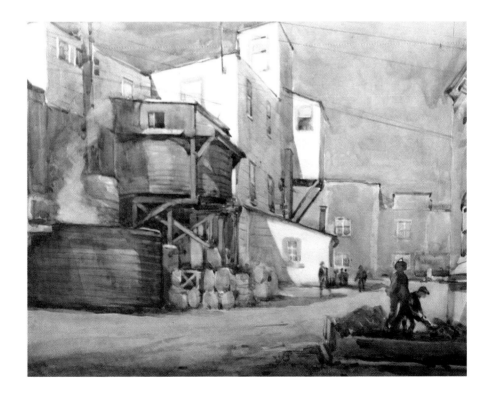

Plate 28. *Epsom Salt Plant, Midland, Michigan.* Water-colour. 35.5 x 46cm (14 x 18in).
Reproduced by kind permission of the Dow Foundation, Midland, Michigan, USA.

work at the plant and took his family out in the evenings, in the car, to explore the area.

In addition to the work undertaken for Mr Dow, Knighton Hammond painted in his own time and built up a sufficient number of pictures to hold two exhibitions at the Community Centre in Midland. These were held in September and October of 1920 and apparently received good attendances. In the first exhibition, he sold a number of pictures of locations in England which he must have brought with him. He records that, as well as those bought at the exhibition, Mr Bennett bought two further water-colours from the artist for $65 and Mr Barstow also bought an oil painting for $425.

Towards the end of September 1920, the canvases that were complete, amounting to about twenty, were taken to New York for

display on Mr Dow's stand at the Chemical Exposition held at Grand Central Palace. Mr Dow recalled, in a letter to Messrs Armour & Company dated 7 October 1920, that the pictures attracted an unusual amount of attention and that they were proving a very effective means of advertising the Company. At the close of the exposition one of the paintings entitled *The Power House* was presented to The Chemists' Club to hang in their headquarters at 52 East 41st Street, New York, and another called *The Indigo Shed* was presented to the American Dyes Institute.

Knighton Hammond's commission was already enhancing the prestige not only of the Dow Chemical Company but also of Dow himself. An article by Dr J. Merritt Matthews appeared in the *Color Trade Journal* published in New York, circa 1921, entitled *Art and the*

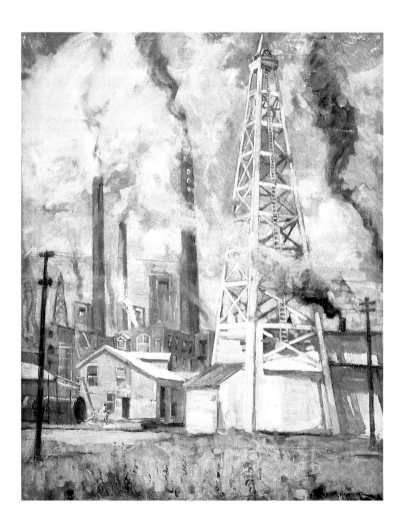

Plate 29. *Brine Well with "A" Power House in background, Midland, Michigan, 1920* Oil on canvas. 87 x 66.5cm (34.5 x 26.25in). Reproduced by kind permission of the Dow Foundation, Midland, Michigan, USA.

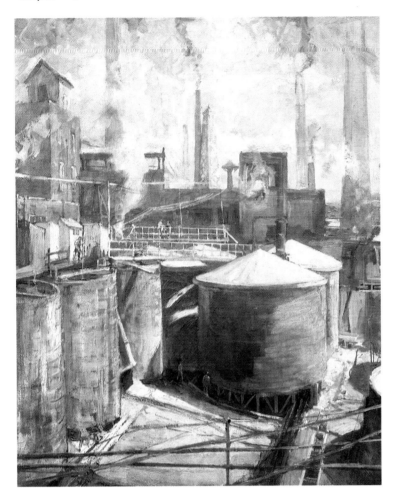

Plate 30. *The Nail Process Plant, Midland, Michigan*
Oil on canvas. 75.5 x 63cm (29.5 x 24.75in). Reproduced by kind permission of the Dow Foundation, Midland, Michigan, USA.

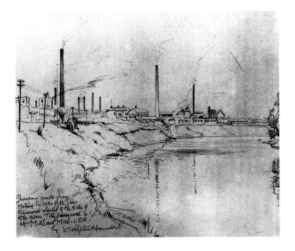

Fig. 26. *The Dow Chemical Works by the side of the River Tittabawassee at Midland, Michigan, USA.* Pencil. 21.5 x 26.5cm (8.5 x 10.5in). Reproduced by kind permission of the Dow Foundation, Midland, Michigan, USA.

Dyestuff Factory and was illustrated with two works by Knighton Hammond. Dr Matthews considered Mr Dow to be the first chemical manufacturer in America to have an artistic vision of his factory. 'He saw beyond the uncouth habiliments of his material plant and believed there was a spirit within vainly striving for expression'.[3]

Many of Knighton Hammond's external views of the plant, portraying rows of chimneys with their tall vertical lines breaking across the horizon at different heights and distances, create without any artificiality an inherently dignified design. Yet this design remains purely unself-conscious, since the plant itself was built with no other purpose than to be functional. *Brine Well with "A" Power House in back-ground* (Plate 29) and *The Nail Process Plant* (Plate 30) are examples of a haphazard grouping of buildings which, when translated

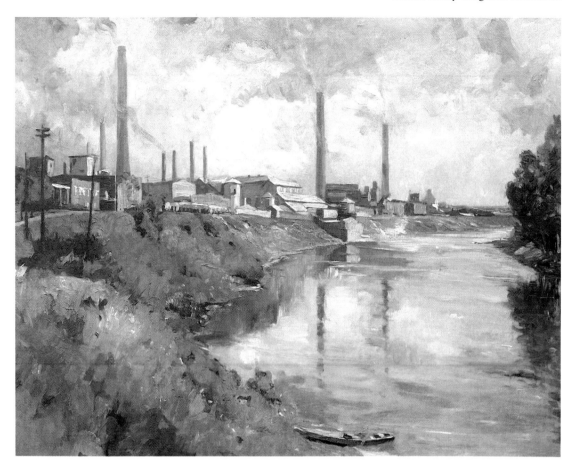

Plate 31. *Looking down the Tittabawassee River at the Dow Chemical Plant, Midland, Michigan.* Oil on canvas. 66.5 x 87.5cm (26.25 x 34.5in). Reproduced by kind permission of the Dow Foundation, Midland, Michigan, USA.

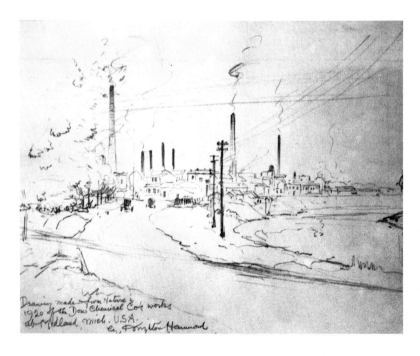

Fig. 27. *The Dow Chemical Company's Works at Midland, Michigan, USA.* Pencil. 21.5 x 26.5cm (8.5 x 10.5in). Reproduced by kind permission of the Dow Foundation, Midland, Michigan, USA.

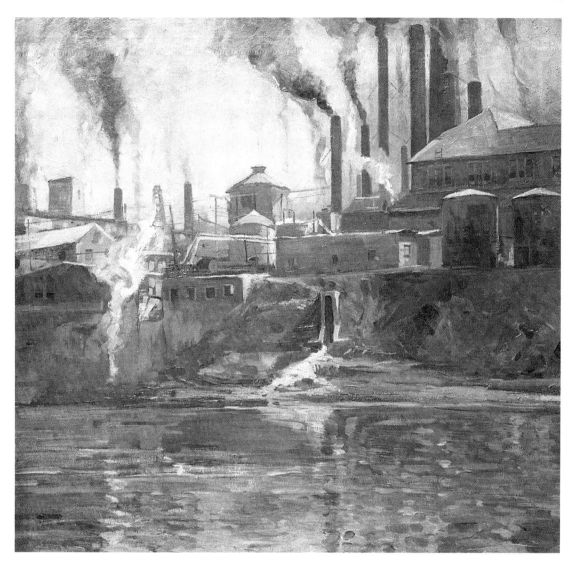

Plate 32. *View from the River showing "A" Power Pump Station and Discharge Flume, 1920.* Oil on canvas. 45 x 59.5cm (17.25 x 23.75in). Reproduced by kind permission of the Dow Foundation, Midland, Michigan, USA.

onto canvas through the filter of the artist's eye, takes on a new role. Shape, line and space combine to bring order to the disorderly industrial scene, transforming function into form and creating a subject worthy of artistic interest.

The essential design and first impressions of colour, tone and atmosphere are immediately apparent in those paintings where a preliminary sketch was produced. *The Dow Chemical Works by the side of the River Tittabawassee* (Fig.26) is a preliminary sketch drawn from nature. The sketch, drawn with vigour and swiftness of line, enabled the artist to plan his composition before returning to the same spot to convert the idea into an impressive oil painting, *Looking down the Tittabawassee River* (Plate 31). Dr J. Merritt Matthews later described this painting, commenting, 'In another picture representing the smokey activity of the underlying power of movement the impressionistic quality of smoke-stacks is ably dealt with. These chimneys rise like silent giants, straight, imperturbable, yet purposeful, suggesting power, strength, as well as the breathing lungs of the living factory.'[4] But, clearly, Knighton Hammond has sought to show industry harmonising with nature by

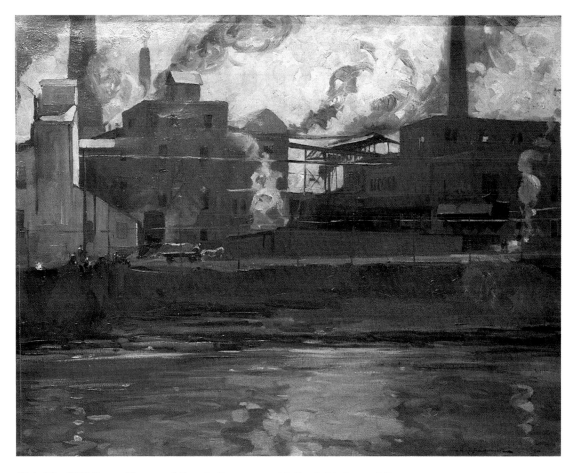

Plate 33. *"G" Power House and Caustic Evaporator, Midland, Michigan.* Oil on canvas. 66.5 x 87cm
(26.25 x 34.25in). Reproduced by kind permission of the Dow Foundation, Midland, Michigan, USA.

complementing the colours found in the natural landscape with those of the buildings and stacks. *The Dow Chemical Works* (Fig.27) is another study which shows the artist's initial impression of the subject. This, again, would have been a very quick sketch but clearly shows the type of picture he was searching for. In an attempt to capture this same effect of man-made grace and beauty, Knighton Hammond set up his easel on a bank of the river to work on *View from the River showing "A" Power Pump Station* (Plate 32), *"G" Power House and Caustic Evaporator* (Plate 33) and *Caustic Pot House Stacks,* (Plate 34). The buildings are shrouded in haze from the industrial processes which provides an atmospheric counterpoint to the bright sparkle on the water and reflections of the tall structures.

Some of the subjects chosen by Knighton Hammond might appear at first glance to be uninspiring, but he was able to transform them into pictures of great interest and beauty. With an expert eye he has achieved extremely pleasing and artistic compositions. The settings are not in any way contrived but accurately represent the plant and its operations. The paintings in and around the plant are tinted with the colours of the chemicals emanating from the processes taking place. This series of pictures by Knighton Hammond shows the beauty to be found in the commonplace and seemingly unlikely locations of the smoke-swathed edifices of industry. The task of the artist is to discover this beauty, to interpret it, and to open the eyes of the world at large to its infinite variety.

The exact number of works Knighton Hammond carried out for Mr Dow is not certain. However, it appears that the pictures were photographed for the artist towards the

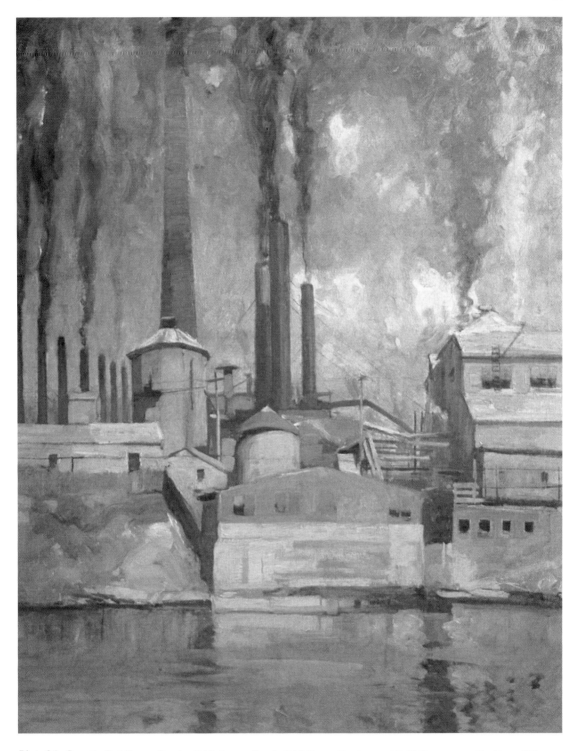

Plate 34. *Caustic Pot House Stacks, "A" Power Stack, "A" Pump Station and "A" Evaporator Building.* Oil on canvas. 91 x 70.5cm (35.75 x 27.75in). Reproduced by kind permission of the Dow Foundation, Midland, Michigan, USA.

end of the commission. From the collection now in the possession of the Herbert H. and Grace A. Dow Foundation, all of which are illustrated here, and the photographs in the artist's scrapbook, the commission would have amounted to about thirty paintings in oils, at least two in water-colours and about seven large pen and wash drawings. A number of study drawings have also survived which have been acquired by the Foundation.

Chicago and Home

With the commission complete the Hammond family said their farewells to the Dow family and their other friends and set off on 24 October 1920 on the long drive to Chicago. The roads took their toll on Arthur's car and they were delayed by numerous breakdowns. However, the family eventually arrived at their destination on 28 October.

Knighton Hammond called on a number of business associates of Mr Dow, among them, Mr Myron E. Adams, whom he had met in Midland, and who arranged temporary honorary membership of the Chicago University Club. In the meantime, Mrs Hammond and the girls found a flat to rent at 4545 Forestville Avenue.

By prior arrangement through Mr Dow, the artist visited a number of companies including Armour and Company – for whom Joseph Pennell had recently completed a commission – and The International Harvester Company. He carried out a number of paintings in and around their sites with the hope of gaining a further commission in America. Knighton Hammond also painted at various locations in the city and sold some of his works through the Carson Pirie Scott Store's art gallery.

The artist frequently visited the Chicago Art Institute and the Board of Trade where he was also able to sell his work. Knighton Hammond regularly lunched at the University Club, where he met a number of interesting people among them William Jennings Bryan, a former Presidential candidate and Secretary of State in President Wilson's administration, who became notorious for his part in the effort by the state of Tennessee to ban the teaching of Darwinian evolution in schools.

Knighton Hammond set about winding up his affairs in America and managed to sell his car towards the end of the month-long stay in Chicago. When arranging the trip home, however, he came across an unforeseen financial problem. When he had received his salary, he either sent most of it home or, latterly, had invested it in bonds leaving himself just enough for the trip back to England. He had not realised that all income tax accounts had to be settled before he could leave the country. Fortunately, Mr Dow came to the rescue, sending him a cheque for $360 to cover his debt.

In a letter to Mr Dow dated 27 November primarily to thank him for the loan of the money to pay his income tax, Knighton Hammond wrote summing up his stay in Midland: 'I shall always look back on my sojourn there as a very interesting phase in my life, and I would like to thank you very much and Mrs Dow also, for all you did for my wife and family and myself while we were there.'

With all financial matters resolved, the family left Chicago on 1 December 1920, heading, by train, for the east coast passing through a snowy Toronto and Montreal before arriving at Portland, Maine, on 3 December. They boarded the White Star liner *Canada* the following day but it became fog-bound outside Halifax Harbour. During the voyage, when weather permitted, the artist would set up his easel on deck and paint. Unfortunately, none of the family travelled well and they were probably all relieved to dock at Liverpool on 14 December, nine months to the day since Arthur had set sail at the start of this adventure.

From Liverpool, the family caught a train to Stockport and were fortunate in finding a house to buy within a few days of their return for the sum of £775. The Hammonds moved into 'Avondale', Garner's Lane, in the Davenport area of Stockport on 22 December, just in time for Christmas.

After a short break for the Christmas holiday the artist resumed his painting. In early February 1921, Knighton Hammond travelled to Sheffield and secured a commission to paint

for a company called Newton Chambers. He commuted to Sheffield regularly to work at the plant. His first project was a 61 x 45.4cm (24 x 18in) canvas of the *Blast Furnace*. This was followed by 76 x 63.5cm (30 x 25in) canvases of the *Fettling Bay* and the *Foundry*. Various drawings were also undertaken of the moulding and fitting shops.

During March and April, Knighton Hammond secured a further commission with Thorncliff's of Sheffield. Here he worked illustrating the *Construction Shed, Smiths' Shop, Boiler Shop* and *Radial Drilling Plant* - all very typical subjects for this, by now, well-established industrial artist.

Industrial landscapes were not, however, popular subjects among artists who were not members of one of the groups which formed the Modern movement at this time, due to their limited appeal to prospective private buyers. The completion of his commissions for Newton Chambers and Thorncliff in May 1921 appears to have been the end of Knighton Hammond's industrial painting. With the opportunities provided by his patrons Lord Moulton, and Herbert Dow, Knighton Hammond, had he continued with the genre, would surely have earned a place in the history of English industrial landscape painting alongside Sir Charles Holmes, the father of English industrial landscape painting who worked from 1907 on subjects in his native Lancashire.

He returned instead to the more traditional English subjects of pastoral landscapes and such like, which he had been painting during the first decade or so of the 1900s. He recorded in his diary painting four small water-colours of sunsets in Aderwood Lane near his home. The subject may well have been prompted by memories of his sunset paintings in Michigan the previous year.

Many of the paintings produced by the artist towards the latter part of 1921 were sold through art agents, in particular Bourlets of London who assisted artists by distributing their works to galleries and exhibitions. Knighton Hammond also returned to giving instruction in painting to supplement his income.

In his pursuit of new subjects to paint, Knighton Hammond would travel the country as much as he could. Indeed, by this time, it is reputed that he had painted in every English county.

One of these trips took him to the city of Bath, where he produced a water-colour of the *Abbey Church Yard and Pump Room* (Plate 35). The picture shows the Grand Pump Room Hotel (demolished 1958) in the background and the impressive Georgian façade of the Pump Room to the left. The bath chairs in the Church Yard are awaiting passengers taking the cure in the spa baths. The artist sat in the doorway of the Abbey to paint this water-colour, which exemplifies his technical skill with architectural subjects. Knighton Hammond's early training and dedication to his draughtsmanship can be seen in the very fine perspectives, giving great depth to the picture. The underlying foundation of form is also evident. There are very few traces of initial pencil drawing, indicative of his confidence and precision in the use of water-colour. A few deft touches with the brush create the figures going about their business beyond the colonnade in the centre of the picture.

This return to a settled life, although it lacked the novelty and excitement of life in America, allowed Knighton Hammond more time to enjoy the company of his daughters who would frequently accompany him on local painting expeditions on their bicycles. Dorothy had taken up painting and would sit alongside her father taking instruction in the art of water-colour painting, which gave him much pleasure. But this stability was not to last long, and already his experience of travel and new landscapes had whetted his appetite for more.

Plate 35. *Abbey Church Yard and Pump Room, Bath.* Water-colour. 38 x 27.5cm (15 x 10.75in). Author's
Collection.

CHAPTER 4
LIFE ON THE CONTINENT
1922-1931

Time for a Change

By 1922 Knighton Hammond found living in Manchester more and more restricting. His eyes and mind had been opened by his trip to America where he would willingly have stayed longer if his wife had been happier. He was now moving into his prime as a water-colour painter and had to travel to find more subjects to paint and he gravitated naturally towards sun and blue skies.

Towards the end of July, he took Dorothy to Nottingham to visit his sister Harriet and brother Mark and other members of his family he had not seen for many years, and he was able to wander around some of his old haunts. The next day, he put Dorothy on the train back to Manchester and set off himself for London, Paris and Venice. This must have given him a wonderful sense of freedom and the next few months were the only period in his life when he kept a full diary every day.

Knighton Hammond was overwhelmed by the beauty of Venice and, one suspects, was revelling in being unburdened, even if only temporarily, from family responsibilities. At this stage, he did not speak any foreign languages, but usually found someone wherever he was who could speak English.

On his travels, whether in the train, on the boat or even waiting at a station, if he saw a figure or a view that attracted him, out would come his sketchbook.

He arrived in Venice late at night and as there was no-one to help him, he engaged a porter who, according to his diary, 'shouldered my cabin trunk and took my bag also, all the way to Casa Petrarca about 1¼ miles through very queer streets.' Next morning he found himself sitting next to an art master called Wilson from Birmingham. This must have been very helpful to him and from his diary it is obvious they went exploring together.

Knighton Hammond found plenty of subjects to paint including the Bridge of Sighs and Santa Maria Della Salute. Such was his enthusiasm that these pictures were finished the following day and he commenced other water-colours in the back streets or canals. On Sunday 30 July and for the next few days Knighton Hammond worked on pictures of St Mark's, The Doge's Palace and The Rialto Bridge. These were followed by a picture of San Giorgio Maggiore, and this magnificent church, which was built between 1566 and 1580, can be seen in the background of *Venetian Sailing Boats* (Plate 36). Absorbing the scene before him, he confidently reproduces it in water-colour with such bold precision that it comes to life on the paper. The Palladian architecture in the background complements the colourful sailing boats in the foreground.

By early August, Knighton Hammond found the heat of Venice too much so he decided to move to Cortina where the air was

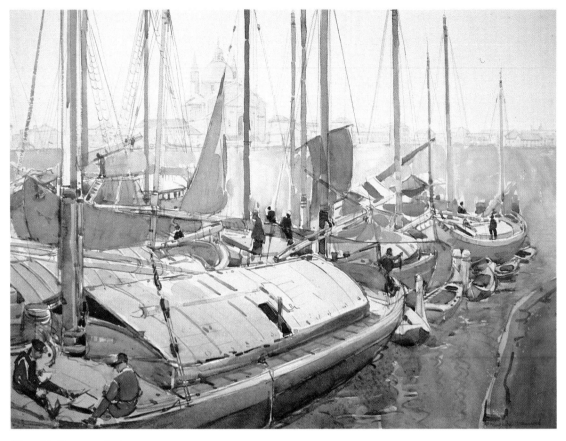

Plate 36. *Venetian Sailing Boats*. Water-colour. 46 x 61cm (18 x 24in). Private Collection.

cooler. He travelled by train with the artist, Job Nixon, and records in his diary that the scenery on the way was '. . . very striking – more striking as mountain scenery than anything I have seen'. On arrival at Cortina, Knighton Hammond immediately began some paintings of peaks in the Dolomites bathed in sunlight. The two artists spent many evenings together, generally over dinner, where art was the main topic of conversation. They exchanged views on each other's paintings and Nixon was full of praise for his companion's work, much to Knighton Hammond's delight. When painting open-air café scenes, each would pose for the other as a subject within the picture.

Churches with their campaniles were also of great interest to Knighton Hammond and featured in many of his works at this time. He travelled around the locality in search of subjects and painted prolifically. The air in Cortina obviously gave him a good appetite as his diary mentions nearly every day how much

he was enjoying his food! The artist returned to Venice in early September and attended the Accademia, where as well as using their etching press and other facilities, he also made studies of the sculpture. Whilst working in the Accademia, Knighton Hammond met the artist, Walter Tyndale and his wife, who were also working there. The three of them often went out together to eat in the evenings and to art galleries and churches during the day.

Tyndale illustrated a number of topographical books including *An Artist in the Riviera* (1916), *An Artist in Italy* (1923) and *The Dalmatian Coast* (1927). He became well known for his finely detailed water-colours of Egyptian temples, Tunisian streets, Italian townscapes and other topographical subjects. It was from Tyndale among others that Knighton Hammond gained much advice in planning his future painting trips. On 14 October, the artist was joined by his youngest daughter, Dorothy, whom he affectionately

Plate 37. *San Marco, Venice*. Water-colour. 46.5 x 62cm (18.25 x 24.5in). Reproduced by kind permission of Gordon Hodge Esq.

called 'Doll'. She immediately began working alongside her father with her sketchbook and would accompany him to social events with the Tyndales and others.

On 3 November, 1922, a dull, wet day, Knighton Hammond, with a keen eye for a good composition and a keen interest in his own welfare, positioned himself under some arches off St Mark's Square to paint a water-colour of the façade of the famous church. The picture *San Marco, Venice* (Plate 37) contrasts the full light on the buildings in the square with the shade under the arches. The hustle and bustle of the crowds reflected in the wet pavements gives energy and life to the scene. This water-colour marks a change in style, characterised by the bright dabs of colour so favoured by the Impressionist painters. The intense light and colour of Venice had clearly inspired this change in style.

A few days later the artist produced a series of water-colours of sails in this more impressionistic style. It is likely that *Drying the Sails, Venice* (Plate 38) was one of the four pictures he was working on during 5 November. This is a bright, colourful picture dominated by the boats and sails in the foreground and set against the more sombre architecture in the background. With bold, confident strokes the artist picks up the reflections of the colourful sails in the rippling water of the lagoon. His style was becoming much more fluid and ornate with a dazzling sense of colour. Many of the water-colours were parcelled up and sent back home to an art agent named Horner, who distributed them to various outlets throughout England. The artist retained a sufficient number of works for exhibitions he was planning to hold on the continent.

On 16 November, Knighton Hammond and his daughter set off on a trip to Tunisia. The journey involved brief stop-overs at Florence and Rome. In Rome, he visited St Peter's, the Forum, the Pantheon and Keats's house. A

stop in Naples allowed the artist to wander admiringly through the picturesque old streets. The boat from Italy docked briefly at Sicily before arriving at Tunis. Once there, the artist set out with his water-colours to find suitable subjects such as the mosques, gateways, arches and boats in the port. He then travelled on to Kairouan in search of new subjects.

With a significant portfolio of works completed, the artist and his daughter returned to Tunis and on 11 December they set sail for France. They arrived at Marseilles and went by train for San Remo. He was particularly impressed with Monte Carlo, Nice and Menton on the journey and made up his mind to return to them in the future to work. At San Remo, Knighton Hammond found a suitable house to rent and he and Dorothy were joined by his wife and Marjorie to inspect the property. Wyn, however, did not like the idea at all, preferring to live in England. Her stay was brief and their

relationship was becoming increasingly strained. She soon left with the girls to return to England and this departure appears to have marked the end of the marriage, although the artist would continue to visit his daughters when he was back in England.

The Greek Royal Family and their Circle of Friends

In San Remo, Knighton Hammond developed a temperature and was treated by Michael Foster, an English doctor who combined a summer practice in Harrogate with a winter one in San Remo. Dr Foster was impressed by the artist's work and offered him the use of his house to hold an exhibition. In the meantime, Knighton Hammond paid 6,000 lire rent on a house, Villa Bel Soggiorno, in San Remo. The rent covered the period up to the end of May 1923. Knighton Hammond set up his display of pictures and opened the exhibition at

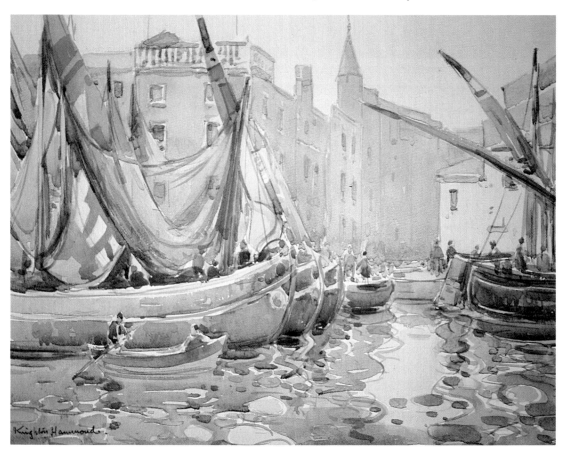

Plate 38. *Drying the Sails, Venice.* Water-colour. 28 x 36.5cm (11 x 14.5in). Author's Collection.

Fig. 28. Prince Nicholas of Greece.

Dr Foster's home. Early guests included Briga-
dier General Edmund Herbert (1866-1946) and
his wife from Moynes Court, Chepstow. The
large drawing-room of the house was, at times,
crowded. One couple, a tall, handsome man
and a striking-looking woman with a strange
head-dress spoke with the artist. The gentle-
man handed over his card as he asked to pur-
chase a water-colour of Venice which he had
been admiring. On the card was printed *'Prince
Nicolas de Grèce'* (Fig.28). 'Thus began one
of the most stimulating and exciting friend-
ships of my life' the artist later wrote describ-
ing this meeting.[1] The Prince's wife, HRH the
Grand Duchess Helen of Russia, Princess
Nicholas of Greece, to give her her full title,
was Russian by birth. The Royal couple had
three daughters: Princess Olga (later married
to Prince Paul of Serbia), Princess Elizabeth
(later Countess Toerring) and Princess Ma-
rina, who became the Duchess of Kent. Prince
Nicholas and his family were in exile from
their native Greece and at this time were living
in San Remo. After the exhibition, Prince
Nicholas would call regularly on Knighton
Hammond, generally accompanied by his eld-
est daughter, Princess Olga, and the three of
them would go off painting together. The artist
gave instruction in the art of water-colour paint-
ing to the Prince and his daughters. Prince
Nicholas, although not a great painter, was a
connoisseur of the arts and was able to give
Knighton Hammond constructive criticism
which the artist was happy to accept.

Prince Nicholas and his family later moved
along the Riviera to Monte Carlo. Knighton
Hammond visited him there on many occa-
sions and was introduced to many of the
Prince's friends. Captain and Mrs Harry
Beaumont became friendly with the artist fol-
lowing Prince Nicholas's introduction. Cap-
tain Beaumont was also a lover of art and was
a descendant of Sir George Howland Beaumont
(1753-1827), the connoisseur patron of art and
landscape painter whose collection of paint-
ings was left to the country on his death on
condition that a national gallery was insti-
tuted. The nucleus of the National Gallery was
subsequently formed by the purchase of thirty-
eight pictures from the Angerstein collection.
Captain Beaumont was so impressed with
Knighton Hammond's work that he immedi-
ately began to collect his water-colours.

From San Remo the artist moved briefly to
Florence where he held his first major
exhibition on the continent. The venue was the
Lyceum (Art College) where the exhibition
showing some fifty water-colours and thirty
etchings, opened on 5 June 1923. A
correspondent for a Florentine newspaper, a
Signor F. Paolieri, wrote an article which was
full of praise for the artist.

Mr Hammond is a prodigious water-
colour painter, direct, emotive, master of
the technique which responds wonderfully
to the feeling of the artist. . . . Seldom have
we seen such intensity of colour in this
medium. Mr Hammond prefers the
crowded sights of the streets, the markets,
the bridges, the squares of Florence and
reaches dynamic and extraordinary effects
with a great simplicity of lines.

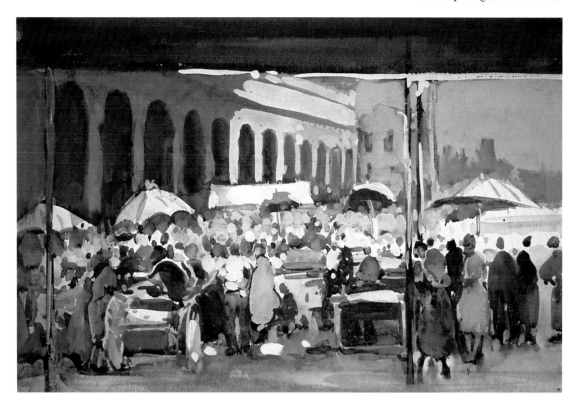

Plate 39. *Florentine Market, Early Morning.* Water-colour. 30.5 x 45cm (12 x 17.75in). Private Collection.

Florentine Market, Early Morning (Plate 39) may well have been painted at this time. The colourful activity of the busy market is conveyed in rich and vibrant colours, capturing the charm of the morning light most dextrously.

Whilst staying in Florence, Knighton Hammond accompanied Prince Nicholas on an excursion in an open-top car to San Gimignano. The roads were very dusty and both men were covered in dust on reaching their destination. The artist remembered the little Tuscan town with its cathedral and ancient walls as curiously interesting; for such a small town he was struck not only by the cathedral and ancient walls, but also by the number of towers and the rich variety of their colours, ranging from pale salmon pink to rich terracotta reds. The main reason for the visit was to see the Benozzo Gozzoli (1420-97) frescoes in the town hall and in the Church of Sant'Agostino, depicting scenes from the life of Saint Augustine. While Prince Nicholas took his time examining the frescoes, Knighton

Hammond got out his water-colours trying to catch some of the brilliant sunlight streaming on to the little palaces, houses and towers.

After this most enjoyable time spent in the company of Prince Nicholas and his family, Knighton Hammond returned temporarily to England, living with his family at 'Atelier', Station Road, Cheadle Hulme in Cheshire. The artist would occasionally take his children with him when visiting Manchester and Nottingham, although his relationship with his wife had by now become very distant.

Also during 1923, Knighton Hammond maintained his associations with America by sending six water-colours to a combined exhibition of the American Watercolor Society and the New York Watercolor Club. The artist remained in contact with Prince Nicholas of Greece, who was also in England at this time, and on learning of his daughter Olga's engagement to Prince Paul of Serbia, Knighton Hammond offered the Prince two water-colours as an engagement present for his daughter. Prince Nicholas, in a letter dated 7 September

1923, expressed his thanks for Knighton Hammond's gift: 'I am very touched by your kind attention in offering two of your lovely water-colours to my daughter, Olga on the occasion of her engagement; I am sure that she will appreciate your charming gift very highly as she is a great admirer of your work.' Prince Nicholas's letter was soon followed by one from Princess Olga, dated 11 September 1923, who was in Paris at this time. She wrote:

> Dear Mr Hammond,
>
> I was extremely touched and delighted with your two lovely water-colours, it was very kind of you to send them to me and I shall appreciate them all the more as I always admired your work so much! Please convey to your family my thanks for their kind wishes on my engagement. Thanking you again for your present, dear Mr Hammond, believe me,
>
> Yours sincerely,
>
> Olga

Towards the end of September Knighton Hammond returned to the continent, initially to Menton and San Remo before travelling on to Venice via Genoa. During this return visit to Venice the artist was working on an etching of the Bridge of Sighs when he was startled by a woman carrying an easel, paint box, stool and canvas, who asked to work alongside him. Deep in concentration on his subject, the sudden interruption caused Knighton Hammond to drop his etching needle into the canal. The woman apologised, introducing herself as 'Alice' (surname unknown). Somewhat annoyed, he replied that she could have his spot as he was now unable to complete his sketch without a needle. Perhaps it was her American accent, or his eye for an attractive woman which overcame Knighton Hammond's annoyance. Whatever the reason, the incident sparked off a friendship and the two artists spent some time painting and travelling together. In addition to painting alongside each other in Venice, they also went on a month's painting expedition down the coast to Chioggia. On returning to Venice, Alice had to leave for Monte Carlo to fulfil a painting commission. Knighton Hammond accompanied her as far

as San Remo, where he rented a studio flat. He visited Monte Carlo frequently to see Alice, and to paint. Soon after her work was completed, she returned to America to hold an exhibition in New York. Knighton Hammond stayed on in San Remo and the surrounding area for some time before making another trip to England, stopping off in Paris to work and attend life classes at one of the academies. A number of pencil drawings have survived from this period of study in Paris.

Back in England in February 1924, Knighton Hammond was commissioned by Lord FitzAlan[2] to undertake water-colours in and around Derwent Hall, Derbyshire. Lord FitzAlan appears to have been a frequent visitor to San Remo and was a friend of Captain Beaumont and Prince Nicholas of Greece. Knighton Hammond's initial introduction to Lord FitzAlan was probably on the Riviera where he had a house in Cannes. The week-long commission at Derwent Hall may have been to record the house and grounds before they were lost under a proposed reservoir. Seven pictures of varying sizes are noted in the artist's diary. Included among them is *Derwent Hall, Derbyshire* (Plate 40) which shows the main façade of this most impressive house. The artist combined the grandeur of the architecture with the elegance of the fine formal garden in traditional style to show the whole scene in contextual harmony with the rolling landscape beyond.

The artist returned to a familiar subject and made one of his frequent visits to Epsom in June 1924 where he produced water-colours and oils of the race meeting. It was at about this time that *Epsom Downs During Derby Week* (Plate 41) was painted. The picture was re-titled *The Morning After the Derby* when it was given to the Luxembourg Gallery, Paris, by Mrs Grace Ellison, a close friend of Prince Nicholas of Greece. Under its original title, the picture was featured in two books both published by *The Studio*. Adrian Bury's *Water-Colour Painting of To-day* comments: 'With hundreds of multi-coloured caravans and booths, racing tipsters, queer characters, horses, dogs, and children, it is a lively pageant of

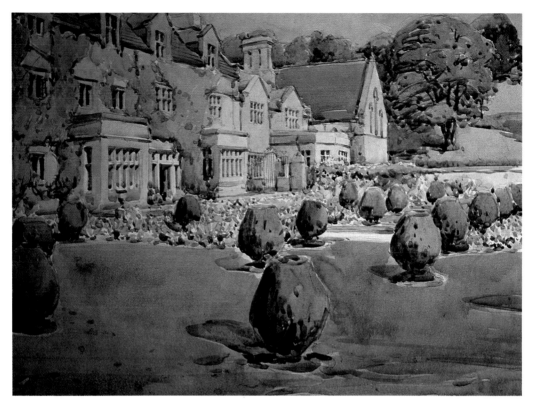

Plate 40. *Derwent Hall, Derbyshire.* Water-colour. 33.5 x 44.5cm (13.25 x 17.5in). Private Collection.

Plate 41. *The Morning After the Derby.* Water-colour. 45 x 61cm (17.75 x 24in). Reproduced by kind permission of the Musée National d'Art Moderne, Centre Georges Pompidou, Paris.
(Photo: Philippe Migeat)

Nature at her most boisterous. A.H. Knighton Hammond gives a glimpse of the scene before the great race.'[3] Percy V. Bradshaw, Director of The Press Art School Ltd, London, published *Water-Colour – A Truly English Art*. In it, he commented, 'Knighton Hammond is a water-colourist of astonishing versatility, and universal reputation'.[4] Writing in 1952, he records the picture as then being in the Musée de Jeu de Paume. (The water-colour is now in the Musée National d'Art Moderne, Centre Georges Pompidou, Paris – inventory no. JP 610 D). The variation in the titles and comments indicate that there is some confusion as to the exact day the picture portrays, *The Morning After the Derby* or according to Bury 'before the great race'.

Also in June, Knighton Hammond held a small exhibition of his work at the home of Baroness Knut Bonde (née Anstruther) in London. It is likely that Knighton Hammond also knew the Baroness from the social network of the Riviera. Prince Nicholas of Greece accompanied the artist to the viewing of the exhibition on 13 June 1924. The Prince also sent invitations to a number of his friends, including Lady Patricia Ramsay (daughter of the Duke of Connaught) who was an accomplished artist herself.

Prince Nicholas stayed at Browns Hotel in London and with Knighton Hammond lodging at 88 Oakley Street, Chelsea, the two saw a lot of each other and would visit the studios of other artist friends in Chelsea together.

The Beaux Art Gallery, London
During this period in London, Knighton Hammond made the necessary arrangements to hold a major exhibition of his water-colours of Venice and the Riviera at the Beaux Art Gallery in Bruton Street, London. The gallery was owned by Major Lessore and the artist arranged to hang his pictures a few days before the opening on 15 July 1924.

On 14 July, Prince Nicholas of Greece was lunching at Buckingham Palace and suggested to Queen Mary that she might like to see Knighton Hammond's exhibition of water-colours. The Queen insisted on going to the gallery that afternoon even though the exhibition was not officially open. The artist was at the gallery and, with the assistance of an artist friend, Rowley Smart, was busy hanging pictures. Rowley Smart's style was not unlike that of Knighton Hammond and *The Studio* described him as '. . . an artist of considerable individuality whose work is vigorous and expressive.'[5] Both men were in shirtsleeves when Her Majesty entered the premises where she was met by Major Lessore. He started to show the Queen around when the artist heard her voice say, 'But I don't want to see those. I came to see Knighton Hammond's water-colours'.[6] She was introduced to the artists and stayed for about half an hour, with Knighton Hammond and Rowley Smart holding up the pictures not already hung on the wall, for Her Majesty to view.

Prince Nicholas sent invitations to a number of his friends outlined in a letter to the artist dated 12 July, 'I spoke to several friends about it and sent cards to Mr Leverton Harris and Sir Joseph Duveen, the great art dealer, who both promised to come. I arranged with Sir Joseph to go to the Beaux Arts Gallery on Tuesday at 4 pm. . . .'

On the day of the private view, a large number of the Greek Royal Family came, including Prince and Princess Nicholas, the Prince's mother Queen Olga, Prince and Princess Andrew (parents of Prince Philip, The Duke of Edinburgh), and Princess Christina. Captain and Mrs Beaumont, who were staying in London, attended, as did the Duchess of Rutland and Knighton Hammond's architect friend, Sydney Foulkes, accompanied by his wife. Sir Joseph Duveen (1869-1939), later Lord Duveen of Millbank, duly attended and purchased three water-colours which he was reported as presenting to the Tate Gallery. The pictures were entitled: *Parliament Street from Trafalgar Square, Street in Old Town, San Remo* and *Boat in harbour at San Remo*. A newspaper reported under a heading of 'New English Artist', 'Sir Joseph Duveen was much impressed by these water-colours, and expressed the opinion to the press that "Mr Knighton Hammond was one of the finest

Plate 42. *Peter and Iris Benson.* Water-
colour. 62 x 46.5cm (24.5 x 18.25in).
Private Collection.

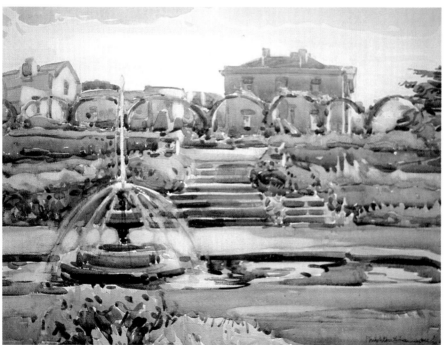

Plate 43. *White Lodge, Richmond.* Water-colour. 32.5 x 44cm (12.75 x 17.25in).
Reproduced by kind permission of Gordon Hodge Esq.

artists England had produced in recent years".'
Under a heading of 'Royal Patrons', the article
continued, 'Not many artists bask in Royal
smiles to the extent Mr Knighton Hammond
does. I referred yesterday to the Queen's visit
to the Beaux Arts Gallery while he was hanging
the pictures for his exhibition there.' Prince
Nicholas wrote to Knighton Hammond from
Sandringham in Norfolk, on 21 July, saying, 'I
am quite delighted with your great success;
remember that I always told you so. I saw Sir
Joseph yesterday who told me again how
pleased he was to have seen your pictures and
how highly he appreciated your talent.'

Knighton Hammond saw the notices in the
newspapers on 20 July, when he was visiting
the Benson family at their home Burpham
Court House, near Guildford, Surrey. He had
met Peter and Iris Benson (Plate 42) in San
Remo, and they were to meet many times in
the future, both in England and on the
Continent. This vibrant water-colour is one of
a number of pictures of the couple and was
probably painted in France. The particular
charm of this painting is the blend of subtle
detail with extravagant colour. Queen Mary
may have asked to see the three water-colours
purchased by Duveen again, since Knighton
Hammond certainly wrote to Duveen asking
to show them to her. In response to this letter,
Sir Joseph replied on 21 July, '. . . I note what
you say concerning showing the Queen the
drawings that I purchased before they go to the
Tate Gallery, and you certainly have my
permission to show them to Her Majesty. . .'

White Lodge, Richmond

Knighton Hammond met Prince Nicholas and
Prince Paul again towards the end of July and
was asked to visit them at White Lodge in
Richmond when he returned from a painting
expedition at Oxford. In the meantime,
however, Knighton Hammond sent Prince
Nicholas a water-colour of San Remo market
as a present. The Prince immediately wrote a
letter of thanks dated 8 August, saying,

I want to thank you first of all very,
very warmly for that delightful little water-
colour which you were so very kind to

send me; I appreciate your gift very much
and cannot tell you sufficiently how
touched I am by your kind thought. The
picture will be a charming reminder of San
Remo where I straight away became one of
the sincere admirers of your work. I believe
I foretold you then of a great success and I
am overjoyed to see, today, that you are
rapidly on the way to obtaining it. Needless
to say that I shall always follow your
progress with the keenest and friendliest
interest.

Knighton Hammond set off for Oxford
where he immediately began painting such
prominent landmarks as St Mary's Porch,
Magdalen Bridge. He stayed for about a week
before returning to London and to White Lodge
to paint for Prince Nicholas. Knighton
Hammond spent about four days from 26
August 1924 at the lodge during which time
Prince Nicholas was called away for the birth
of his grandson by his eldest daughter, Princess
Olga and her husband Prince Paul.

White Lodge (Plate 43) captures the fine
Palladian house, an occasional Royal residence
under Victoria, and its fine gardens in bold
colour wash. The straight classical lines of the
house stand out strongly against the richly
planted gardens. In full verdant foliage, the
trees and shrubs frame the house and lead the
eye inwards and up the steps to the portico in
the centre of the painting.

When Prince Nicholas returned to the lodge,
he found the artist had left his water-colours of
Oxford for him to view. His comments were
contained in a letter of 31 August 1924,

Yesterday I went to White Lodge where
I saw your water-colours of Oxford, some
of which I admired very much. I am sure
you do not mind my saying 'some' as you
know by now that I am pretty frank in my
judgement of pictures however incomp-
etent I may be in such matters. My very
humble opinion is that you have worked so
much in the south, that you are rather
inclined to see nature, wherever it is,
through the purest of contrasts of brilliant
light and shade; in England, I believe, this
is an exception and not the rule and the

character of English landscape is to be found more in shape than in colour. . . . I do not talk of your technique which I think is always wonderful (in spite of your tendency – as I have told you before – of becoming a little too free and slap-dash) but of your effects of light, which, in some cases are a little too 'southern', too Italian.

Knighton Hammond was always willing to listen to criticism from Prince Nicholas.

Return to the Continent

After further brief painting trips to Haddon Hall and again to Derwent Hall, Knighton Hammond travelled to Paris to discuss a possible exhibition. Prince Nicholas had approached M. Charpentier, of the Galerie Charpentier, 76 Faubourg Saint-Honoré, Paris, some time in May of that year. With Prince Nicholas's introduction and recommendation, M. Charpentier was extremely keen on Knighton Hammond holding an exhibition

there and all necessary arrangements were finalised. The agreement was extremely satisfactory to Knighton Hammond as M. Charpentier was to make no charge for the use of his magnificent premises and was to take only a small percentage on sold works.

From Paris, the artist set off for a painting expedition to Avignon. He stayed for about a week painting such subjects as the Pope's Palace, the Pope's Garden and St Benizet's Bridge. These pictures were to be exhibited at later exhibitions. From Avignon, Knighton Hammond returned briefly to San Remo. He may well have made a diversion en route to visit Dolceaqua in Italy. He painted a number of pictures of the town and *Dolceaqua, Italy* (Plate 44) is one of these water-colours. This picture focuses on the magnificent architecture of the area; with a blaze of Mediterranean light on whitewashed buildings, and the bright colourful figures in the foreground, the painting has great life and energy. This particular water-

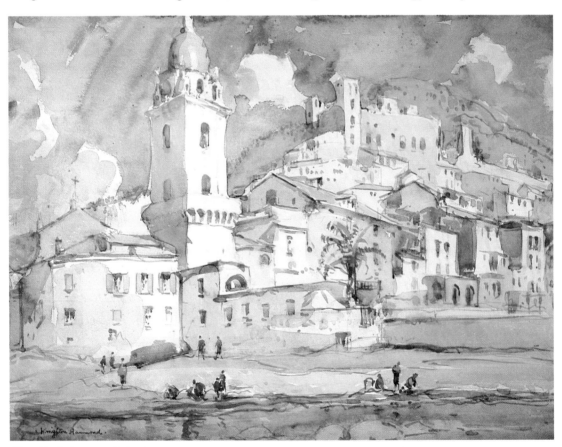

Plate 44. *Dolceaqua, Italy.* Water-colour. 48 x 62cm (19 x 24.5in). Private Collection.

colour was to remain with Knighton Hammond for many years and was exhibited at the Royal Institute of Painters in Water-colours some time after 1954. Other pictures from this region were exhibited on the Continent.

From San Remo the artist travelled to Florence, arriving there on 21 October 1924. He immediately set about painting water-colours of the magnificent sculpture in the Piazza della Signoria. Among the subjects he worked on in Florence were the copy of Michelangelo's *David*, Cellini's *Perseus*, the Loggia dei Lanzi and its sculpture and other fountains and buildings.

It was during this stay in Florence that Knighton Hammond undertook a commission for Prince Paul and Princess Olga. The couple had spent part of their honeymoon at the Villa Demidoff at Pratolino, near Florence, which was built by Francesco de Medici circa 1570. At this time the villa was owned by Princess Abamalik, daughter of Prince Demidoff and an aunt to Prince Paul. As a souvenir of their honeymoon the couple wanted a picture of the giant statue at Pratolino. The colossus was the mountain god Apennine, the bizarre commission of the Renaissance sculptor, Giambologna (1529-1608) for Francesco de Medici circa 1589. The dominant figure of the giant, standing approximately eleven metres high, appears to be carved from the living rock. However, only the lower part is in natural rock, and above is a construction of brick and stone covered with stucco and decorated with pieces of lava.

The Galerie Charpentier, Paris

Between the World Wars, the Galerie Charpentier had a reputation second to none. Many important exhibitions were held there during this time, including an exhibition of *A Hundred Years of French Life*[7] and also *A Hundred Drawings by Rodin*[8] which met with great success in the early 1930s.

Knighton Hammond arrived at the Galerie Charpentier on 30 October 1924 to hang the one hundred framed water-colours he had prepared for the exhibition. On the opening day, 3 November, Prince Nicholas attended

accompanied by his brother, Prince Andrew, who immediately purchased a large water-colour of San Remo harbour.

While Prince Nicholas was looking around the exhibition, a rich American lady named Mrs Corrie asked the Prince to advise her on which picture to buy as she wanted the best. He pointed out a picture of San Remo market-place which she immediately purchased. Next day the picture was delivered to the Prince's flat with a note from the lady saying she was pleased to be able to give him a present that he really liked. Prince Nicholas referred to the incident in a letter dated 28 January 1925. He told the artist, 'It made me feel very uncomfortable but at the same time I was delighted to possess it as it is one of your best.'

A Paris newspaper reviewed the exhibition saying,

Mr Knighton Hammond is showing some fine water-colour drawings of Oxford and London and of some Italian scenes at the Hotel Jean Charpentier. Painted in broad, vigorous style with spontaneous freedom of touch and admirable draughtsmanship, these clever works are being quickly snapped up by an appreciative public.

The Studio

The recognition Knighton Hammond was now receiving led to him being featured in an illustrated article in *The Studio*.[9] The correspondent, Jessica Walker Stephens,[10] wrote of him,

One had heard that the art of Mr Knighton Hammond had caused sensation in various brilliant circles. Being accorded the privilege of seeing it in mass – as it should be seen if the full effect is to be produced – one did not know at first whether he had performed any one duty, because sheer delighted excitement ousted all critical desires. Nothing more exhilarating could be imagined than these varied subjects, treated variously, and alike in only one thing – the elan of the handling and the sense of highly-tuned vivacity belonging to the spirit of the painter. That

the workmanship was almost uncannily clever one only remembered later. That which carried one away, that which accounts for the success of this Englishman and cosmopolitan artist, is a quite psychic faculty in the work which makes one supremely happy. The old marble of Italy was there, with all the soft glow which it possesses more frequently in nature than in pictures. Trees danced and figures moved: all things seemed alive. Now it is interesting to consider why and how all this excitement is produced, and whether there is any technical explanation for it. Mr Hammond works in a mercilessly difficult medium – pure, direct water-colour. Perhaps the greatest illumination of his secret is that which he himself gives. He works, he says, as a pianist must, in a certain highly-attuned and keyed condition. Only in this state can he do his best work.

Two pictures illustrated *The Studio* article: *The Old Town, San Remo* and *In the Luxembourg Gardens*. These were acknow-ledged as being in the possession of Lady Stratheden and The Dowager Countess of Poltimore, respectively.

Knighton Hammond wrote to Jessica Walker Stephens at her home to thank her for her kind remarks after the article was published and she replied with a letter dated 29 November 1924 saying, 'If the article was good the credit is yours – you inspired it. In writing, as in painting, some things set the fingers tingling and others have a deadening effect – I feel it most on the spine. . . . Finally – thank you indeed for the opportunity of writing about work which satisfies my soul, and which has, to me, that extraordinary quality which can't be defined, but which is art.'

A bust of Knighton Hammond by the sculptor Francis W. Doyle-Jones was featured in the following edition of *The Studio*, with the comment, 'The bust by Mr Doyle-Jones represents adequately a sculptor of well-trained capacity.'[11] *A Bust of A.H. Knighton Hammond* (Fig.29) is one of two busts almost identical apart from their finished colour. One was

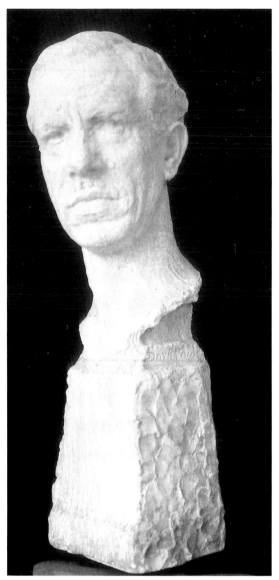

Fig. 29. *A Bust of A.H. Knighton Hammond*, Francis Doyle-Jones. Clay. 67cm (26.5in) high.
Private Collection.

exhibited by Doyle-Jones at the Royal Academy in 1926. He was an accomplished sculptor who exhibited at the Royal Academy regularly between 1905 and 1936. Indeed, he exhibited twenty-nine pieces in all; perhaps most notable was his model for a bronze bust of HRH The Prince of Wales in 1932.

Return to the Riviera
Early in January 1925, Knighton Hammond returned to San Remo via Menton. For the New Year the artist sent a parcel of water-

colours to Prince Nicholas of Greece for him and his family. Receipt of the package was acknowledged in a letter from Prince Nicholas dated 27 January 1925: 'Yesterday I received the parcel containing your charming gift with wishes for the New Year and we send you our warmest and sincerest thanks. The pictures are charming and remind us so pleasantly of San Remo, where we had the great pleasure of meeting you for the first time.' The pictures were divided amongst the family and their destinations were confirmed in a further letter dated 28 January: 'As Marina has left for Paris about a fortnight ago I think I shall send her the picture of the street of San Remo which is perfectly charming; I think you have seized the light most clearly and there is extraordinary life and movement in your figures. She will be delighted to have it and to decorate her small school-room.'

Knighton Hammond then returned to Menton where he found a gallery in which to hold a further exhibition. The premises, known as the Palais des Arts, 9 Avenue Félix Fauré, was owned by a M. Grenier. The artist immediately left a number of water-colours for sale and arranged to hold an exhibition at the gallery during March. Again, Prince Nicholas attended commenting in a letter dated 9 March 1925: 'I went one day to your exhibition with some friends who greatly admired your pictures. It was from the man at the shop that I heard the good news that two of your water-colours had been bought by the manager of the American gallery.'

During late March of 1925, Knighton Hammond returned to Tunis for a further painting expedition, staying approximately one month before moving back to Italy, arriving in Venice on 16 April. The artist was very busy putting together a sufficient quantity of water-colours for forthcoming exhibitions, in particular, at the Fine Art Society in London. It was for this exhibition that Knighton Hammond returned to London in May to make the final arrangements.

The Fine Art Society

The exhibition of sixty-one pictures, entitled *Water-colours of Sunny Lands: Italy, Tunisia and South of France* opened at The Fine Art Society on 9 June 1925. (See Appendix A for catalogue). The gallery was located at 148 New Bond Street in London. The exhibition catalogue contained an introduction by Jessica Walker Stephens in which she says, 'Mr Knighton Hammond possesses great craftsmanship – his mastery of the difficult medium of direct water-colour proves this. He has also used much intellect: but these things are subsidiary to the thrilling "something" which makes his work sought after, and worth seeking, by people all over the world. . .'

The exhibition was well reviewed in the press. *The Bazaar Exchange and Mart* of 20 June 1925 reported under the heading 'Notes on Art Topics':

. . . his water-colour work is certainly highly accomplished and will give pleasure to many. It has qualities of freshness and colour and vision, and the artist has the faculty, denied to some, of selecting subjects that look well not only as they appear in nature, but when separated from their surroundings and enclosed within the limits of a frame.

The *Birmingham Post* reported on 30 June 1925:

Mr Knighton Hammond's water-colours of "Sunny Lands," shown in the galleries of the Fine Art Society, have a convincing animation and directness of touch and beauty of fresh, luminous colour, but their particular charm comes from their sensitiveness of observation and their skilful transcription of nature's facts. His exhibition has a more than ordinary degree of authority.

A report from an unknown Australian source contained in the artist's scrap-book says: '. . . where Mr Hammond essays the force and brilliancy of direct sunlight, he gets it by the most simple means at his command, and in maintaining the balance of light and shadows and its relation to form he shows,

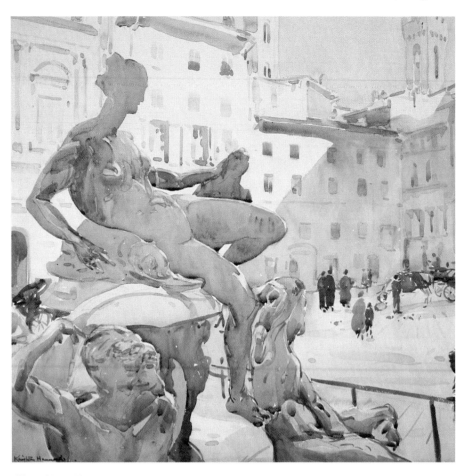

Plate 45. *A Florentine Fountain.* Water-colour. 44.5 x 48.5cm (18 x 19in). Reproduced by kind permission of the Victoria Art Gallery, Bath.

in addition to the skill of the technician, the sincere observation of the student.'

On the opening day of the exhibition, exhibit number six, *A Florentine Fountain* (Plate 45) was purchased by fellow artist, Helen Lavinia Cochrane. (The picture was eventually bequeathed to The Victoria Art Gallery, Bath, on the death of Mrs Cochrane). The water-colour features one of the marine goddesses on one of the corners of the Neptune Fountain by Bartolomeo Ammanati in the Piazza della Signoria in Florence. The busy piazza is bathed in strong sunlight, creating strong, contrasting shadows across the central feature of the fountain to dramatic effect. The painting style is meticulous and measured, yet the picture has a spontaneous and natural quality.

While Knighton Hammond was staying in London, his youngest daughter, Dorothy, came

to stay with him. They painted side by side around London, including Hyde Park and the bridges over the Thames. The artist's patron Lord FitzAlan, and Captain Charles Foxcroft MP made the necessary arrangements for him to paint in the Houses of Parliament. This work began on 29 July 1925 and he had tea there the following day with Captain Foxcroft, and dinner the day after. The artist painted in and around the Houses of Parliament on and off for about one month. *The Terrace, House of Commons* (Plate 46) was one of the pictures produced. The famous facade of this great building is emblazoned by the morning sunlight and as Westminster Bridge melts into the distant haze, the tiny figures grouped on the terrace have a chilling fragility against such awesome power and dignity.

During this stay in London, Knighton Hammond was joined by a young woman, Emmeline

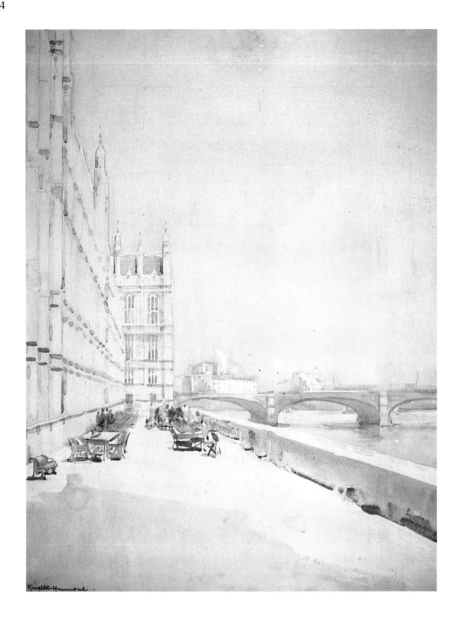

Plate 46. *The Terrace, House of Commons.* Water-colour. 59 x 43cm
(23.25 x 17.25in). Private Collection.

Mary Low, whom he had met earlier when she nursed him in a San Remo hospital after he had undergone a hernia operation in 1924. Emmeline was affectionately called May by Knighton Hammond and he introduced her to Prince Nicholas in London on 22 July 1925. The artist had plans to return to the Riviera but towards the end of July, he made a trip to Bristol, to the galleries of Messrs Frost and Reed at Clare Street to make arrangements for an exhibition to be held there that year.

Return to Menton
In late August 1925, the artist returned to the Riviera and at Menton he arranged further exhibitions at the Galerie Grenier. During October 1925, the Frost and Reed exhibition took place, showing twenty-four water-colours. An unidentified newspaper reported, 'at first sight some of his productions strike you as having an almost berserk savagery so aggressive are his methods of receiving and imparting impressions. And yet, when viewed

as pictures should be they are full of sweet charm.' The *Bristol Times & Mirror* reported on the 10 October, 'Mr A.H. Knighton Hammond . . . is a modernist who unites some of the best traditions of the past with an essentially individual outlook. He is wonderfully successful with colour effects, and paints water and skies in a way that brings some of Walter de la Mare's poems to mind, with their insight into beauty.'

At the January 1926 meeting of the American Watercolor Society, while he was in Menton, Knighton Hammond was elected an associate member. His election was probably the result of his work during 1920 for Herbert H. Dow and the recognition that it had attracted, together with his exhibits at the combined show of the New York Watercolor Club and the American Watercolor Society. He had been a member of the New York Watercolor Club from about 1924.

In Menton the artist produced a colourful composition, simply entitled *Menton* (Plate 47). A riot of pastel shades, this delightful painting illustrates Knighton Hammond's ability to adapt his style to reflect the distinctive climatic conditions of the Riviera; the intense Mediterranean light offering the artist the chance to experiment with a different colour range to the more sombre light of London.

Knighton Hammond's exhibition at the Galerie Grenier, in March and April 1926 received much acclaim. It was viewed by fellow artist Augustus John, who was reported in the *Menton & Monte Carlo News* on 6 March as commenting 'That man is the greatest English painter in water-colours of our time'. This was praise indeed from a fellow artist not renowned for praising the work of others. In this and other newspapers which reviewed the exhibition, John was referred to as a Royal Academician, although in fact he was only an associate at this time and did not become a full member until 1928. Nonetheless, John was an

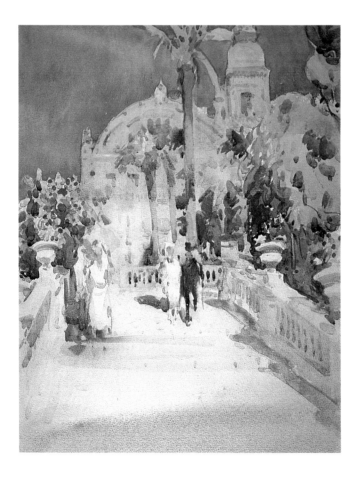

Plate 47. *Menton.* Water-colour.
42 x 31cm (17 x 12.25 in).
Private Collection.

artist with a formidable reputation by this time and his praise was greatly appreciated by Knighton Hammond.

Prince Nicholas of Greece had visited the exhibition and on receiving a copy of the newspaper article he replied to Knighton Hammond with a letter dated 18 March 1926,

I am also very pleased to read the news cutting which entirely expresses my personal appreciation of your work. I also know, by personal experience, that Augustus John is neither easy to please nor very obliging when criticising his brother-artists; his words, therefore, carry all the more weight. I am proud to be able to say that my judgement of your work has been a correct one from the first and that I did not need Augustus John's opinion to strengthen me in my conviction.

The Paris edition of the *New York Herald* reported, 'Extremely well executed are his studies of the old bridge at Sospel, the port at Menton and other Riviera sea and mountain scenes.' *Roman Bridge* (Plate 48) is a water-colour by the artist of Sospel. This picture captures the clarity of bright sunshine on the white buildings and snow-capped mountains with the Sospel bridge clearly detailed in the foreground. A similar study of the Sospel bridge was undertaken by Sir Frank Brangwyn and was illustrated by Adrian Bury in his book on water-colour painting.[12]

George Behrend and his Circle of Friends
Another visitor to this exhibition was fellow artist George Behrend (1868-1950). Knighton Hammond was in the gallery at the time of Behrend's visit and the two men struck up an immediate close friendship, which lasted until Behrend's death. Behrend, whose grandfather had set up a successful merchant shipping company in Liverpool, was a man of independent means. He was thus able to devote himself to painting and had become an accomplished water-colour painter and member of the Royal Society of British Artists. In a

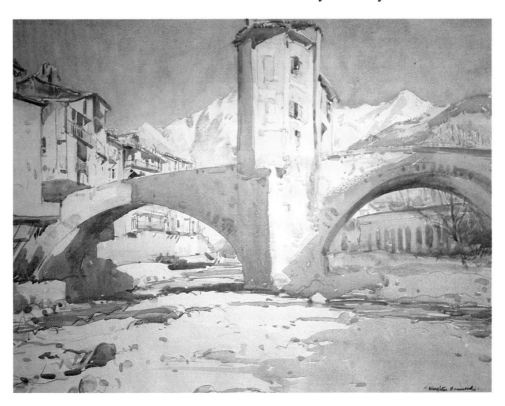

Plate 48. *Roman Bridge, Sospel.* Water-colour. 46 x 61cm (18 x 24in). Author's Collection.

letter dated 25 April 1948, he told Knighton Hammond, 'I have very pleasant memories of past years of painting from the time when I apprenticed myself (to learn the job) to A. W. Rich at Amersham, in 1912 [aged 44]. I paid him a sum down for 12 months and did a still life indoors daily, from October to April, except for a weekly day of rest, from 10 to 12 and finished the proceedings by walking down to the Crown for a gin and vermouth. . .' He lived with Mr and Mrs Rich at Amersham, and later at South Croydon and St Albans for about three years. Behrend's teacher, Arthur William Rich, was a disciple of Peter de Wint, and one can be sure that what knowledge Behrend gleaned from Rich was passed on to Knighton Hammond. In a letter dated 22 July 1944, he recalls days they spent at Menton, 'I used to have my rolls and coffee at 6.30, come round to you, usually, and we popped off for a morning's or day's painting, and very delectable it was, for never again shall I have the opportunity of painting in Mediterranean regions.' Behrend was also a very well-read man, and in his letters to Knighton Hammond he recommends Pepys and Boswell.

Knighton Hammond learnt from Behrend of his many painting trips with the leading artists of the day – Steer, Tonks, Brown, David Muirhead, etc and like Boswell, Behrend noted down their methods and techniques. These notes and letters were later extensively used by D. S. MacColl in his book on Philip Wilson Steer.[13] Behrend was happy to allow this as he considered MacColl the finest art critic of the day, and in a letter dated 19 January 1940, to Knighton Hammond, he wrote,

> I have always maintained, and still do, that no art critic has surpassed, and few have equalled, in interest, in explanation and value, that writing of MacColl, in the *Saturday Review* and elsewhere. In his book, *Confessions of a Keeper*, his trouncing and demolition of Roger Fry's theories about Cézanne is complete and final. . . . I do not forget that Steer and Tonks disliked showing their work to MacColl as he was so critical and Steer said to me 'MacColl is a man who thinks all pictures are bad, and some worse',

but I believe MacColl was just as critical (and also humble) about his own work. I remember saying to Tonks that MacColl's water-colours were good, fresh and direct. Tonks replied 'He drew straight lines well'.

Cap Martin

With a divorce from his first wife now absolute, Knighton Hammond's relationship with Emmeline Low flourished and the couple were married by the British Consul in Nice. They were delighted with the birth of a baby daughter, Mary Beatrix, and during the latter part of 1926, they bought a house and built a studio at Rue de l'Industrie, La Plage, Roquebrune, Cap Martin.

During the same year, Knighton Hammond returned to England for a further exhibition at the Beaux Arts Gallery in London and also to Paris for another exhibition at the Galerie Charpentier. At the time of the exhibition, a French magazine, *L'Illustration*, reproduced a full-page coloured illustration of a picture of San Remo by Knighton Hammond and also made reference to his show. It was also reviewed in the 6 November 1926 edition of the *Daily Mail* and under the heading 'Art Exhibitions Open in Paris' it was reported,

> A British artist, altogether worthy of his predecessors, Mr Knighton Hammond, has brought together at the Jean Charpentier salons . . . thirty-six water-colours that merit the placing of his name among the most brilliant specialists of the medium. Finely chosen landscapes have been absorbed by Knighton Hammond with a sensitive and intelligent eye. In Venice, which had been painted by thousands of other artists, he found means of transferring to paper motifs of an individual character. 'He did something new in Venice.' Isn't that the greatest compliment that can be paid to any artist?

Prince Nicholas of Greece again attended the exhibition and as he had not seen the artist on his visit he wrote to him on 23 December 1926 saying, 'I believe it was a very great success and personally I was delighted with many of your pictures, some of which seemed

to me to be conceived and carried out in a different way to your old style, but always with your surpassing and masterly technique.'

Although the artist was now settled on the Riviera, he still made frequent trips to England for exhibitions and to see his daughters by his previous marriage. On these trips, Knighton Hammond would paint places en route. *A French Fishing Port, Dieppe* (Plate 49), a lively water-colour full of people and activity, would have been painted whilst on such a trip, probably while waiting to cross the Channel. Inspired by the fine waterfront architecture of the ancient port, he captures the interest and excitement of the traveller's perspective. *A Street in Nevers* (Plate 50) would also have been painted whilst travelling to or from the south of France. This shows the dramatic contrasts created by the vivid sunlight which is characteristic of so many of the medieval towns of the Burgundy region. Ancient, mellow buildings on one side of the street are struck by a dazzling honey coloured light and cast deep shadows across the street, darkening and cooling the houses on the other side.

During the spring of 1927, Prince Nicholas of Greece, whilst staying with various friends in France, arranged for Knighton Hammond to paint in their gardens. Among those giving consent for the artist to visit were Lieutenant-Colonel Jacques Balsan, CMG and his wife Consuelo Vanderbilt Balsan (1877-1964), the former Ninth Duchess of Marlborough.[14] The Balsans' villa, 'Lou Sueil' was at Eze and had beautifully laid out gardens, much admired by Winston Churchill who used to visit the Balsans between the World Wars to paint in there.

Prince Nicholas also arranged for the artist to visit a Mrs Pulitzer and paint in her garden at the Chateau de la Garoupe, Antibes. Knighton Hammond was strongly advised to go to the garden as the Prince considered it to be one of the best on the Riviera.

During April 1927, the artist held an exhibition at the Galerie Lambert in Cannes. Prince Nicholas again attended with his friend Harry Beaumont. In a letter to Knighton Hammond dated 8 April 1927, he commented, 'I liked your pictures enormously and think that some of them are real masterpieces; I can't

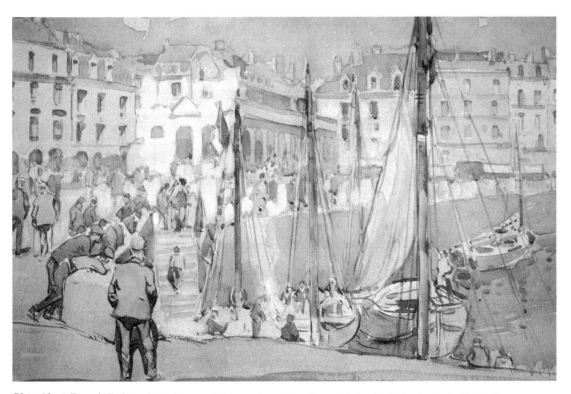

Plate 49. *A French Fishing Port, Dieppe.* Water-colour. 34 x 50cm (13.5 x 19.5in). Author's Collection.

Plate 50. *A Street in Nevers, France.*
Water-colour. 61 x 46cm (24 x 18 in).
Author's Collection.

remember the respective numbers, but I believe number two, where all the strong lights are left out in white is quite brilliant in its effect. My very best congratulations.'

Two of Knighton Hammond's water-colours, one entitled *Olives and Cypress Trees at Menton* were accepted by the Paris Salon of 1927 and were displayed in the Central Gallery. In the same year the artist also exhibited further afield. A water-colour, *Market Day, Dolo* was shown at the International Watercolor Exhibition at Chicago and the picture was featured by Adrian Bury in his book *Water-Colour Painting of To-day*[15] , acknowledged as being in the possession of the Art Institute of Chicago at that time (1936). In addition, thirty of his water-colours went to the Fine Art Society in Melbourne, Australia, for exhibition. Back in England, he exhibited for the first time at the New English Art Club with two

pictures being accepted.

In January 1928, Knighton Hammond spent a few days at Sospel, where the bridge was again the focus of his attention. Back in Menton, he spent some time with George Behrend. The following month, Knighton Hammond held a further exhibition at the Galerie Lambert in Cannes. On 23 February, Prince and Princess Nicholas attended the exhibition accompanied by Lady Waterlow.

In March 1928, Knighton Hammond was elected a Full Member of the American Watercolor Society. He was particularly delighted with this honour as he and Sir William Russell Flint were the only English members of this prestigious society.

On a return journey to England in May that year, Knighton Hammond called at the Paris Salon where he again had two water-colours accepted.

Style

It is clear that painting on the Continent brought about a considerable change in the artist's work. His water-colours show a much lighter, brighter and freer style. This may be due in part to the clear blue skies and bright sunshine of the Riviera, which pervade the paintings, but the change of style was clearly a development in the artist's technique. His study of light and atmosphere owe a great deal to the Impressionists' style of painting and his use of gouache gives an opacity to the brush-strokes which is much stronger than the translucence of his more traditional water-colours. He now records an 'impression' of his subject, creating an illusion of detail whilst maintaining the structure, form and perspective typical of his earlier architectural studies. On occasions, he records the effect of tone and colour upon the eye without any precise definition of contour or explanation of structure. His style implies a system of focusing on one area of interest and subordinating the rest by means of shadow, of vague contours and reduced contrasts of tone.

Knighton Hammond's work in this impressionistic style is viewed with a fresh eye, taking in the scene as a whole instead of the detail, much in the way we see and experience nature. Individual details may give little away on close scrutiny, but seen in the whole context of the painting, they reveal all the intensity of the experience of the scene. With that rare blend of precision and spontaneity the artist has learned to apply what at close quarters seem no more than individual daubs of paint, the colours carefully juxtaposed, which when viewed from a distance are transformed to reveal the whole and in the process produce an intensely personal and emotional response in the spectator, offering an experience of the senses as much as a record of a scene.

Knighton Hammond would always paint *en plein air* in the squares and streets of France and Italy, enjoying the interested gaze of the spectators he attracted. He recalled that all over Italy the poorest peasants had a great respect for the artist as the *maestro*. However, there were occasions when he found it difficult to concentrate with people watching him too closely and he recalled working in Monreale when a crowd gathered around him, fascinated by an artist painting in water-colour – an

Plate 51. *Conversation piece at Grasse.* Water-colour. 31.5 x 41.5cm (12.5 x 16.25in). Reproduced by kind permission of Rochdale Art Gallery.

uncommon medium. The crowd began to push and shove each other aside to watch him work. The situation was rapidly getting out of hand, as they jostled for position, when, fortunately, a passing religious procession defused the tension with the crowd falling to their knees in respect. The artist too removed his hat, struck by the passion of the people for their religion.

Conversation piece at Grasse (Plate 51) is a water-colour which exemplifies the fluid spontaneity which the artist had now achieved. This picture has such sensitivity and reality that we seem to be eaves-dropping on the conversation taking place between the two main figures in the scene. The water-colour was featured by Percy V. Bradshaw in his book *Water-Colour A Truly English Art* and he comments,

The Conversation Piece was drawn straight away with the brush, and completed

almost as a lightning sketch. . . . He does not normally limit himself to a definite range of colours. If he hasn't a light red handy, for instance, he will use a burnt sienna or a Venetian or Indian red. There is hardly time in such a sketch as the *Conversation Piece* to think of colour, their use being almost intuitive.[16]

Knighton Hammond painted extensively in water-colours during this time. However, he did occasionally return to his oil paints, *A Continental Street Market with Figures and Buildings* (Plate 52), was painted in this medium, probably around this time. Here again, his palette is considerably different from his earlier oils and shows the brighter, more vivacious colour, tone and style developed in his water-colours. This picture depicts sun-lit buildings with the colour and excitement of a busy market. The artist uses vigorous,

Plate 52. *A Continental Street Market with Figures and Buildings.* Oil on panel. 49.5 x 60cm (19.5 x 23.5in). Author's Collection.

Plate 53. *Morning Market, Dieppe.* Oil on canvas. 75 x 62cm (29.5 x 24.5in).
Private Collection.

flamboyant brush-work to shape the busy, colourful figures. The paint is applied in thick extravagant strokes with a confidence and liveliness more typical of water-colour. The same qualities appear in another oil painting, *Morning Market, Dieppe* (Plate 53). This composition centres on the solid forms of the buildings, with the play of light and colour on the architecture forming a backdrop to the market.

While the artist was in Provence in France he painted *A French Gypsy Encampment* (Plate 54), a water-colour where all the magic and excitement of the scene is captured with fluid, vibrant brush-strokes, again executed with confidence and vigour.

At the same time as this change of style, the artist's signature also changed. He initially signed *Arthur H. Hammond* with a flourishing hand on both water-colours (Plate 55a) and oils (Plate 55b). From about 1912, he introduced Knighton into his signature, which was signed in a similar manner (Plate 55c). From about 1923, he signed his water-colours 'Knighton Hammond' in either charcoal or pencil (Plate 55d), although he occasionally reverted to signing in water-colour; his etchings were signed in pencil in the margins in a similar

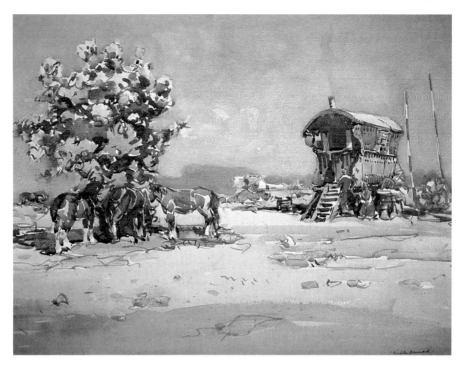

Plate 54. *A French Gypsy Encampment.* Water-colour. 48 x 63.5cm (19 x 25in). Reproduced by kind permission of Gordon Hodge Esq.

way. Although he painted predominantly in water-colours, for his oil paintings he used a different manner yet again, printing his name in capital letters (Plate 55e).

Exhibitions Overseas

In addition to his exhibitions in France, Knighton Hammond sent a further thirty water-colours to the Fine Art Society in Melbourne, Australia, for an exhibition held between 18 and 29 September 1928. His exhibition there

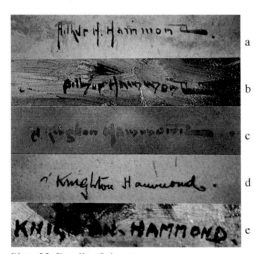

Plate 55. Details of signatures.

the previous year was so successful that it warranted a further show. The newspapers were very impressed with the exhibition reporting in an unidentified cutting from the artist's scrapbook:

Spontaneity of treatment is one of the great charms of true water-colour art, and in the works of Mr A.H. Knighton Hammond that form the present exhibition at the Fine Art Society's galleries this quality is an outstanding feature. To this directness of method there is added a strong feeling for atmospheric effect, and for refinement of colour. . . . He draws his subject well, and his choice of subject matter is directed by excellent taste. The colour schemes are often in delicate greys. Here and there a stronger note is struck, and the colour is bold and the brush is used as a definite instrument of draughtsmanship. Another article commented,

Very skilful in his handling, he is artist enough to make his technique secondary to his artistic thought, and thus we are charmed and dazzled afterward. Varied in subject matter, each mood is suggested

and assisted by variation in manner. So much is this the case that one could easily imagine this to be a joint exhibition. The color effect on the whole is cool rather than glowing, design is well considered, and the drawing is bold, direct and free.

The Museum of Fine Arts at Houston, Texas, held an exhibition entitled, *Water-colors of Venice and the Riviera* between 30 September and 31 October 1928. The 30 September edition of the *Houston Chronicle* reported enthusiastically on Knighton Hammond's work, which was on display.

During October 1928, Knighton Hammond exhibited at the Société Internationale des Acquarellistes, held at the Galeries Georges Petit, 6 Rue de Sèze, Paris. The six pictures he exhibited received good reviews in the 8 October edition of *The New York Herald*. Their reporter Georges Bal commented,

An English artist, Mr Knighton Hammond, has the six most interesting and luminous pieces. These include the view of the Escalier de la Fontaine at Grasse, in which a bright sun effect is rendered excellently. This artist's good technique is shown also in his pink roses in a glazed stoneware pot. In this the harmony of the tones is perfect.

On the strength of this exhibition and his reputation throughout France, Knighton Hammond was elected a member of the Société Internationale des Acquarellistes.

Portraiture

Back in England, the artist spent a few days in Arundel, Sussex before moving to his lodgings at 3A Warwick Avenue in London. Here, the artist began to undertake commissioned portraits. His most notable client was Lady Stratheden and Campbell[17] who had purchased his water-colours in the past (one of the water-colours in her possession was used to illustrate *The Studio* article of November 1924) and was a close friend of Baroness Bonde, another of Knighton Hammond's titled patrons. Lady Stratheden and Campbell attended her last sitting for her portrait on 18 August 1928. The next day she returned to the studio accompanied

by her husband to see the finished portrait. According to Knighton Hammond's diary, both were delighted with the result and the artist was paid a fee of two hundred guineas. Lady Stratheden wrote on 25 November 1928 from her home, 'Hartrigge' in Jedburgh, to say that the picture was now hung there and they were very pleased with it.

Prince Nicholas was interested in this new divergence, but sounded a cautious note in a letter dated 24 September 1928: 'I am indeed surprised to hear that you have taken up portrait painting (in oils) and would dearly like to see your work. Does it interest you just as much as your water-colour work? Anyhow I sincerely hope you will not give up one for the other.' Knighton Hammond's portraiture was not confined exclusively to oils. He carried out many portraits in water-colours, especially of his family. His wife was to pose for him on many occasions. During September 1928, the artist returned briefly to his home in Cap Martin, stopping en route to paint at Eu in Northern France. Here, he worked in one of his favourite locations, the market-place. These paintings were to be exhibited at later exhibitions.

Knighton Hammond returned to London and resumed his close relationship with his Royal patrons. On 8 December the ex-King and Queen of Greece visited his studio and were his guests for tea. Afterwards, the King and Prince Nicholas went with Knighton Hammond to the London Palladium in the evening to see a show.

Back to Cap Martin

In January 1929, the artist returned to his home in Cap Martin. Here, he met his friend George Behrend, who over a week or so, posed for a portrait. From their home the Knighton Hammond family travelled to Sospel before going on to Monte Calvario, Porto Maurizio, arriving on 15 March 1929. The family stayed at the home of the artist's architect friend, Edgar Wood.

Edgar Wood was born at Middleton, near Manchester, in 1860, the son of a well-to-do, middle-class family connected with the cotton trade. He qualified as an architect in 1885 and

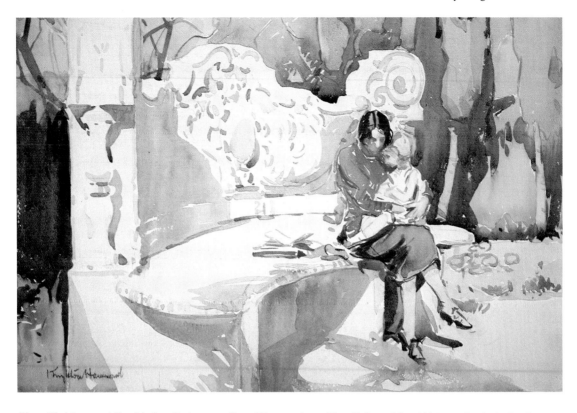

Plate 56. *Mary and Her Mother Sitting on a Seat.* Water-colour. 33 x 48.5cm (13 x 19in). Author's Collection.

set up his own practice soon afterwards. His speciality was working in the vernacular style of his home region, the Pennine foothills, in the best Arts and Crafts tradition. In 1922, he retired from his successful practice and moved to Italy to devote himself to art. His designs were frequently featured in *The Studio*. He remained a close friend of Knighton Hammond's until his death in 1935.

Knighton Hammond spent a great deal of time painting in and around Edgar Wood's garden and, in particular, he painted a large garden seat designed and made by the architect. *Mary and her Mother Sitting on a Seat* (Plate 56) was painted at this time. The picture shows the seat with Mrs Hammond and their young daughter, Mary, sitting on her lap. A strong command of the technique of drawing and a brilliant sense of colour make this picture most striking. The seat is indeed a fine piece of design and was to feature in a number of pictures which the artist painted during his stay which lasted until 3 April 1929.

The artist and his family then left Italy and travelled back to Cap Martin, calling at Grenier's en route to arrange to deliver further pictures. Knighton Hammond returned to his painting in and around the markets on the Riviera. *Continental Fruit Market* (Plate 57) is probably of one such market. Once again, he concentrates on the strong architectural background, using the tall Church tower as the dominant feature. The background is in pale pastel colours to contrast with the figures in the foreground going busily about their business in bright warm colours. Here, he blends his tints on wet paper to create a very fluid atmospheric effect. *A Riviera Coastal Town* (Plate 58) would appear to be of the same location, (possibly San Remo or Menton), but seen from another angle. This composition shows a particularly striking example of the effect of light and colour on the Riviera heightened by the strength of his drawing. The brush-work is rugged and sure, and has all the freedom unique to water-colour. *Continental Market Place* (Plate 59) is also full of the atmosphere of the region with a mountain

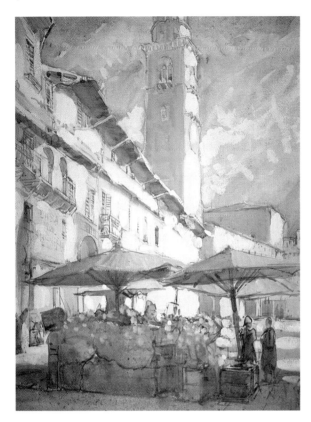

Plate 57. *Continental Fruit Market.*
Water-colour. 60 x 45cm
(23.5 x 17.75in). Author's Collection.

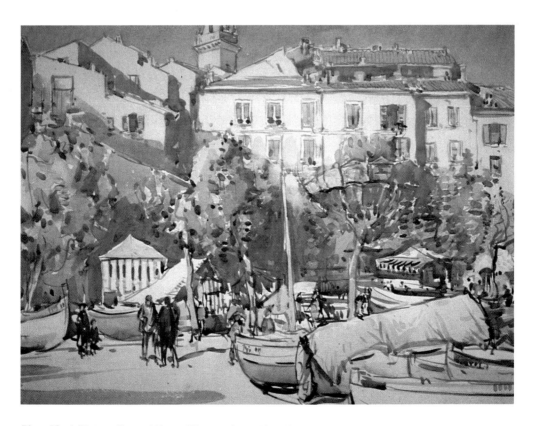

Plate 58. *A Riviera Coastal Town*. Water-colour. 49 x 63.5cm (19.25 x 25in). Private Collection.

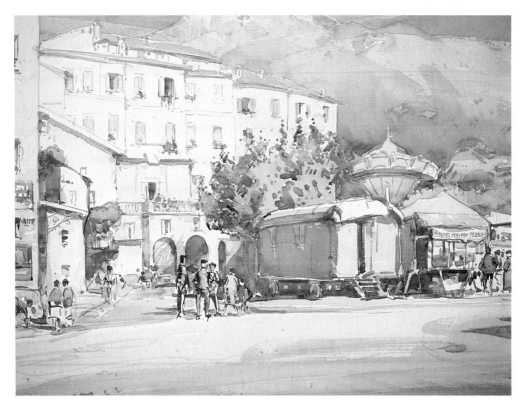

Plate 59. *Continental Market Place*. Water-colour. 47 x 64cm (18.5 x 25.25in). Private Collection.

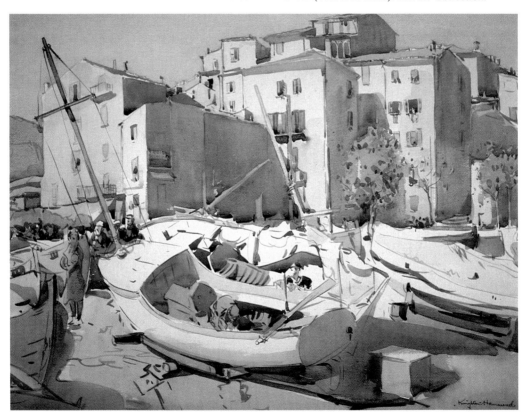

Plate 60. *Concarneau*. Water-colour. 49.5 x 63.5cm (19.5 x 25in). Private Collection.

Plate 61.
The Harbour at Concarneau.
Water-colour 49 x 45cm
(19.25 x 17.75in).
Private Collection.

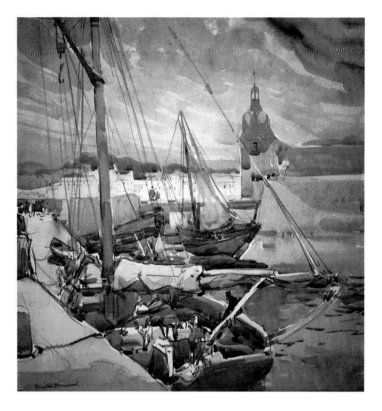

range, possibly the Alps, in the background. The wide, panoramic view, painted with vigour and freedom, conveys the splendour of the scene, with touches of human detail to give life and colour.

On the 15 April 1929, the artist made a further trip to Sospel where he stayed for a number of days. Again, the focus of attention was the famous bridge which he had painted on numerous occasions (see Plate 48). In May, Knighton Hammond held an exhibition of some twenty-eight pictures at the Galerie Bernheim, 83 Faubourg Saint-Honoré, Paris.

During June of 1929, the artist returned to England. He visited Sussex, painting at Arundel, Petworth and Chichester. This trip was, however, only short and the family returned to the Continent in mid-July. The destination this time was Concarneau in Brittany where, once again, the artist chose to paint in and around the harbour and markets. Concarneau was a haven for artists at that time and had been the haunt of the very influential Jules Bastien-Lepage during the development of painting *en plein air*. *Concarneau* (Plate 60) is particularly striking, perhaps due to the

rare absence of blue, characteristic of the less intense light of Northern France. The artist's sense of design is expressed to the full and the whole is drawn into harmony by the sensitive, fresh colours and tones. The same balance rules *The Harbour at Concarneau* (Plate 61), enhanced by the richness of light and colour. The artist also travelled along the coast to Douarnenez, where he etched a charming plate of his wife and small daughter overlooking the picturesque coastline (Fig.30). This gives us a more sentimental yet vibrant impression of this region of France. At Concarneau, Knighton Hammond met fellow artist, Terrick Williams, and a close friendship developed. At about this time, Knighton Hammond rediscovered his pastels and began to spend a great deal of time working in this medium.

In September 1929, the artist again successfully exhibited at the Galeries Georges Petit in Paris. While in Paris, Knighton Hammond also returned to his etching needle and plates to produce a series of etchings of the city. The Pont Neuf and Cathedral of Notre Dame were among his subjects.

The new decade of the 1930s saw the

Fig. 30. *Douarnenez*. Etching. 19 x 24cm (7.75 x 9.25in). Author's Collection.

Knighton Hammond family reconsidering life on the Continent. Mrs Hammond was keen to settle in England, so they put their house and studio up for sale. With the possibility of a move the artist continued to make the most of the immediate vicinity which was still of great interest, and frequently would go out in the early morning to paint markets, landscapes and harbour scenes. Frequent callers to the artist's studio were George Behrend and Baroness Bonde. Both had homes in the area and the latter had by now accumulated a collection of pictures by Knighton Hammond and took much interest in watching him at work. The Hammonds had a busy social life at this time. In his diary there are numerous entries describing their outings to gala evenings at the Casino, accompanied on occasion by May's mother, Mrs Low, who had joined them in Cap Martin for a holiday.

During February 1930, Knighton Hammond had to renew his passport. He calculated that on his old passport he had passed through customs no less than one hundred and twelve times. The majority of these trips were to the Continent.

In March 1930, the artist held another of his regular exhibitions at Grenier's in Menton. The gallery had a permanent selection of pictures by Knighton Hammond for sale which were supplemented by these exhibitions. Further exhibitions back in England were being planned at this time. This involved a return journey in late May, with the artist travelling alone on this occasion. He stayed in London and took the opportunity of arranging for his daughters, Marjorie and Dorothy, to visit him. Both the girls stayed with their father for a few days which he enjoyed immensely.

Studying the Great Masters
While in London, Knighton Hammond painted in and around the city, with Kensington Gardens, Marble Arch and Hyde Park being the principal subjects of his pictures. George Behrend had also returned to England and invited the artist to dine with him at the Arts Club, Dover Street, London. In his diary, Knighton Hammond recalls meeting fellow artists Philip Connard and William Lee-Hankey at the Arts Club. The artist's diaries for this period also show that he visited the British

Museum to study drawings by Claude Lorrain and Giambattista Tiepolo, and at various centres to study the drawings and water-colours of John Singer Sargent. He does not enlarge on this, but he must have thought that collectively these famous painters, whose lives spanned a period of some three hundred years, had something in common. Could it be that Consuelo Balsan had praised the Prince Altieri Claudes that were now hanging in the Vanderbilt Mansion in New York, or perhaps Captain Beaumont had praised the four Claudes that were part of his ancestor's bequest to the Nation, or had he heard that the cream of the Claude drawings were in the *Liber Veritatis* in the British Museum? The *Liber Veritatis* was 'a series of one hundred and ninety five drawings that Claude prepared in 1635 in which he copied faithfully year by year most of the compositions that he created, and in the majority of cases for whom or for which place they were destined'.[18] Boydell had published in 1777 a reproduction of the *Liber Veritatis* executed by Richard Earlom, a mezzotint engraver, in the style of the original drawings, and which for the most part were then in the possession of the Duke of Devonshire at Chatsworth but no doubt, Knighton Hammond had to see the originals which were now in the British Museum.

If the artist had read Bryan's *Dictionary of Painters and Engravers*, he would have seen that Claude Lorrain (or Claude Gellée to give him his correct name) was a man after his own heart who lived for painting. 'He sketched indefatigably in the open air from the earliest dawn to nightfall, so that he might be thoroughly imbued with the ever-changing aspects of nature under the varying conditions of light. Whether in the studio or in the short excursions he made into the surrounding country, his devotion to art never flagged'.[19] Knighton Hammond would be up at 5.30 am painting in the early morning light and would frequently work on to portray sunsets in the evening. He could produce in excess of six water-colours in a day, as his diary entries can verify. His devotion to art, like that of Claude Lorrain, never flagged.

George Behrend knew Claude's work and in a letter dated 6 February 1932 he mentions that he had been to see the Royal Academy Exhibition of French Art, 1200-1900, which ran from January to March 1932. He deals first with the oils and then remarks,

The drawings are very interesting, heaps of Claudes and Poussins, Watteau and Lancrets, etc. Fragonard drawings of parks, etc, – splendid, some reminding me of Steer – There is a large fat and stately volume in a glass case – Claude's *Liber Veritatis* – lent by the Duke of Devonshire, open at one page with a fine drawing. It probably contains 150 Claude's! Degas and his contemporaries' drawings come out well and Berthe Morisot – whether drawings, water-colours or oil, shines forth as one of the best.

So to Tiepolo, 'The last great Italian painter in the grand tradition'[20], more famous for his frescoes than oils. His contemporaries described him as *Veronese redivivus*,[21] and as Francis Watson, Director of the Wallace Collection and Surveyor of the Queen's Works of Art, says,

Both with the brush and with the pencil, Tiepolo was a supreme master of drawing. Not only did he produce innumerable studies for the figures in his great decorative compositions but he made hundreds of independent drawings for his own pleasure and for the pleasure of collectors. He used almost every medium – red chalk (generally for preparatory drawings for frescoes), black chalk (for portrait heads, of which he did great numbers) but above all pen and ink, often heightened with wash, a medium which he developed with consummate skill . . .'[22]

Knighton Hammond was in London when Christie's sold Sargent's studio contents at the end of July 1925 where seventy-five drawings fetched an average price of £65. His preliminary studies for his painting *Carnation, Lily, Lily, Rose* (The Tate Gallery, London) were probably the focus of Knighton Hammond's study. A. L. Baldry, in a series of articles for *The Studio* says of Sargent's drawings, 'In his drawings

everywhere they record nothing more than a momentary impression, there is invariably a clear intention helped out by every touch . . . Each one is in its own way perfectly complete, and finished as it need be.'[23] Martin Hardie likened Sargent's work to that of Constable, ' . . . as was the case with Constable, his water-colours seemed at times to his contemporaries too startling and forceful in their assertive satisfaction with life, almost brutal in their dominating strength. Strong, vital, burly – in art as in life – he preferred to face the harshness and glare, the midday glitter and contrasts, from which many painters shrink.'[24] The echoes in reviews of Knighton Hammond's work are obvious. Clearly, he was able to put this study of the work of three great masters to good use in the work he did in all mediums.

Along with studying the work of these artists, the main reason for this trip to London was the exhibition at the Beaux Arts Gallery at Bruton Place. This opened on 30 June 1930 and consisted of thirty-two pictures. The *Nottingham Guardian* reported on the exhibition in its 1 July edition,

Mr Knighton Hammond's methods are always original, whether one likes all his pictures or not, it is difficult to remain unimpressed by his bold and striking handling of what might have become, in other hands, commonplace sketches. . . . He seeks his subjects mainly in England, France and Italy, and specialises in water-colours. He knows the 'tricks of the trade' as regards water-colour painting, but he invests them with a fine sense of beauty, and uses his colours very courageously. Sometimes his vivid greens, reds and yellows – particularly his greens – are the making of a picture.

The *Birmingham Post* reviewed the exhibition in their 7 July 1930 edition commenting,

His paintings are delightfully fresh, free and sparkling, drawn with remarkable confidence and certainty, and marked by a liveliness of manner that is exceedingly well controlled, and his management of the water-colour medium is thoroughly

Plate 62. *Arundel Castle, 1930.* Water-colour. 34.5 x 49cm (13.5 x 19.25in). Author's Collection.

sound. He is certainly an artist with a rather rare balance of capacities.

It was probably during this stay in England that the artist painted *Arundel Castle, 1930* (Plate 62). This is a bold water-colour painted on a dull day, and indicates that he was able to adapt his palette to the subdued light and colour of England. Gone are the bright colours and light of the Riviera. In their place are the subtle, gentle hues of the English countryside.

Knighton Hammond returned to his family in early July. His wife and young daughter, Mary, known as Marie when in France, were waiting on the station at Menton. He at once settled down to producing many more water-colours and pastels of the area. Also further trips to Sospel were undertaken.

In 1930 the artist exhibited at the Royal Academy. He had not exhibited here since 1908 (as Arthur Hammond) and was pleased to have *The Plage at Dieppe* accepted. From his regular exhibition at Grenier's in March 1931, three water-colours and two etchings were selected by a representative of the Canadian government and sent to the National Art Exhibition in Canada. Also at this exhibition, the artist's friend Edgar Wood attended and purchased a number of pastels.

In April 1931 the artist asked a friend, a Mr Rushton, to take photographs of his house and the interior of his studio. Fig. 31 is one such photograph which gives an insight into his working environment. Some of his finished pictures can be seen hanging on the walls.

Some idea as to the artist's enthusiasm for his painting can be gained from a diary entry from 12 April 1931, 'Up at 4.45 am and painting on the Cap before 6.00 am. Do three water-colours,-two good ones. May and Marie come about 9.00 am. Home at 11.30 am for lunch.' Knighton Hammond preferred working in the early morning light and obviously painted at speed. He was also aware that not all his works were satisfactory and was not backward in saying so.

Fig. 31. Photograph. Interior of Studio, Cap Martin.

Towards the end of April 1931, the artist returned to England and arranged to show at an exhibition of the British Empire Society of Arts at the Grosvenor Hotel in London on 14 May. During June, the artist went to Epsom for the race meeting. This stay in England was brief and he soon returned to Cap Martin where he again had a further exhibition at Grenier's at Menton.

Knighton Hammond, happier in his second marriage, had become more of a family man and when returning to his family he would take great pleasure in buying presents for them. He undertook many large pastel portraits of his wife and daughter at this time. In *Mrs Hammond* (Plate 63), the soft muted use of pastel is very powerful. The strong but gentle modelling of the face and richness of colour and texture in the fabrics of the dress and cloak are built up with layers of graded pastels to create a striking portrait of charm and sensitivity. One is aware how much thought and technical knowledge have been brought to bear on this picture of his wife, and yet there is nothing laboured or heavy in the result. He has shown the essential strength and gentleness of the sitter, without sentimentality.

The Hammond family spent Christmas 1931 with Edgar Wood at Porto Maurizio. The two men spent a great deal of time together painting. It was a happy time for them all.

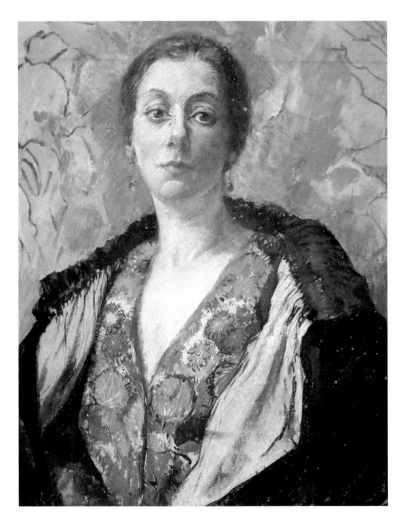

Plate 63. *Mrs Hammond.* Pastel. 59.5 x 46.5cm (23.5 x 18.25in). Reproduced by kind permission of Gordon Hodge Esq.

CHAPTER 5
ALTON AND DITCHLING
1932-1940

Studio in England

During 1932 the artist and his family began to spend more time back in England. As Mrs Hammond was expecting their second child, the couple decided to settle in Alton until the birth, so that the child would be born in England. To ensure that he had a base from which to work, Knighton Hammond rented a studio and cottage in Church Street, Alton, Hampshire, previously occupied by William Otway McCannell, Principal of Farnham Art School. In February 1932, he returned to the Riviera for another of his regular exhibitions at Grenier's, Menton. Among the pictures on exhibition was the oil portrait of George L. Behrend. A local unidentified newspaper report commented, 'Among the oil paintings . . . that of G. L. Behrend Esq. shows that the artist is quite au fait with the art of the portrait painter'. Behrend himself commented in a letter to the artist dated 6 February,

> Of course I have no objection to you exhibiting the portrait and if it should some way bring you a commission, so much the better. It is nearly 30 years since I went to a photographer's because I so dislike the look of my face (as a work of art) and I think your sketch was a very excellent effort.

Also during the same month, Knighton Hammond exhibited six water-colours at the Beaux Arts Gallery. This exhibition, entitled Exhibition of Water-Colours by Ten Leading Draughtsmen, included works by Sir William Russell Flint, Rex Whistler, Claude Muncaster, Sir David Young Cameron and other artists. To be placed in such eminent company was further recognition of Knighton Hammond's considerable talent as a draughtsman.

In the latter part of 1931, Knighton Hammond applied for membership of the Pastel Society. He was proposed by Alfred Lys Baldry, seconded by Terrick Williams and duly elected as a member. Early in 1932, Knighton Hammond exhibited for the first time at the Society. Among the five works he exhibited was a portrait of Iris Benson; the Benson family were known to the artist both from acquaintance on the Riviera and from Guildford.

In June 1932, Knighton Hammond was commissioned by Frances Stevenson,[1] secretary to the former Liberal Prime Minister, Earl Lloyd George of Dwyfor,[2] to paint a portrait of her ward, Jennifer. The commission was undertaken at *Bron-y-de*, Churt, Surrey, the home of the eminent statesman. Iris Benson had introduced Miss Stevenson to the artist and thus the commission resulted. The Hammond family lodged at nearby Stock Farm during the week-long commission. They were picked up each morning by Lloyd George's chauffeur and driven to *Bron-y-de*. Lloyd George was at home during the commission

Fig. 32. Photograph of the portrait of Jennifer.

go to Tilford Green armed with his pastel box to paint Cobbett's Oaks, as they were known locally. A picture of that title was exhibited later at his Alton studio.

The full-length portrait of Jennifer seated on a chair with a spray of flowers on her lap was executed in pastel, an increasingly popular medium for the artist. In addition to the main portrait, the artist carried out a number of smaller sketches also in pastel. Fig.32 is a copy of a photograph of the portrait from the artist's scrapbook.

On returning to Alton the artist busied himself painting local scenes, including the church and high street, and getting to know his neighbours. He became friendly with Mr and Mrs Curtis who were local dignitaries and near neighbours. The museum in the town is named after the Curtis family.

During the later part of 1932 the artist held an exhibition of his work at his studio in Church Street. His old friend, Viscountess FitzAlan of Windsor Park, opened the exhibition which was well attended. An unidentified local newspaper reviewed the show and reported, 'In opening the exhibition, the Viscountess FitzAlan said that it gave her very great pleasure to come from Windsor to do so. Mr Knighton Hammond was a very old friend of hers and came to stay with her in their old home, Derwent Hall, Derbyshire.' The report added,

There is no doubt that the pictures – and especially some of the local ones, particularly of the Alton streets – are very fine and cleverly painted. They are in the modern style, and a great deal of skill is displayed in the giving of the effects of sunlight and shade. They are works of a quite unusual and outstanding character, and obviously the work of a competent artist. . . . In his water-colours of local scenery, Mr Hammond shows the same prodigality of colour and technique as in his scenes of foreign lands and the same instinctive taste of the decoration.

The exhibition at Alton was followed by a show at Guildford in October 1932. The exhibition was arranged by the Guildford Art Society and was again opened by Viscountess

and took an active interest in the painting of the portrait. He would also entertain the artist's daughter, Mary, while Knighton Hammond was busy at a sitting with Jennifer. During the commission the artist and his family would often join Lloyd George for lunch or tea.

Knighton Hammond recalls in his diary that throughout the period at Churt, Lloyd George was always energetic, talkative and full of life. Lloyd George had a great admiration for, and would often talk about, William Cobbett (1762-1835) who was born and is buried at nearby Farnham, Surrey. Cobbett's *Rural Rides* make mention of Churt and the surrounding villages. Indeed, it was supposedly near Lloyd George's estate that Cobbett was given incorrect directions by his guide and lost his way.[3] The village of Tilford near Churt is also mentioned and, in particular, a mature oak tree on the Green which, as Cobbett recalls, was a mere sapling when he was a boy.[4] Between sittings, Knighton Hammond would

Plate 64. *May and Marie*
Oil on canvas. 100.5 x 77.5cm (39.5 x 29.5in). Private Collection.

FitzAlan. The pictures exhibited included local scenes as well as pictures from the Continent. The artist also visited the exhibition of the Royal Society of Portrait Painters in London in late October where he exhibited for the first time a painting entitled *The Black Cloak*. Unfortunately the sitter is not identified in the catalogue.

In January 1933 the artist exhibited six pictures at the Pastel Society, including the portrait of Jennifer. After reading *The Times* report which reviewed the exhibition, Miss Stevenson wrote a letter to the artist, dated 19 January 1933, 'I feel tremendously proud, and it is a feather in your cap, certainly. I am glad, as I have always liked the portrait and like it more the longer I have it. I expect you are very proud of it, too.' She went on to say, 'As for the comparison of Jennifer's picture with Duncan Grant's, it seems rather ridiculous to me. I do not see the slightest connection between the two styles, and I certainly did not like the pastels that I saw of his.' Duncan Grant had, in fact, studied at the Westminster School of Art shortly after Knighton Hammond in 1902, but later went on to study at the Slade.

The artist sent a copy of *The Times* report to Prince Nicholas of Greece who was quick to comment in a letter dated 31 January 1933,

It was very thoughtful of you enclosing in your letter that cutting from *The Times* concerning your show. The reference to your life-sized portrait in pastel as the most "successful thing" of the exhibition is very flattering; but the critic might have spared his readers the suggestion that you had been looking at – not to say inspired by – the work of Duncan Grant. It is humiliating for any artist to be told that his pictures have been inspired by another man's pictorial proceedings. But then we know that critics, as a rule, endeavour to impress their readers by the shrewdness of their observations which they fondly believe to be more accurate and deeper than anyone else! . . . On the whole the criticism of your picture is flattering chiefly owing to the last sentence – "the picture is very much alive".

Prince Nicholas went on to add, 'I would dearly love to see your portraits, and if they are as good as your landscapes in water-colour I am sure you will have a very great success.' The Duchess of Rutland also wrote to the artist on 23 January 1933, commenting on his exhibition,

I am glad you are succeeding with portraits. I expect it will be lucrative – Pastel can be very attractive – but don't look at or touch Duncan Grant – he is awful, awful, awful, don't you think? – This is fashion! but in Glasgow, I think it was, there was nothing sold in his exhibition. I believe those moderns are so incredibly awful, with their crude colours, no atmosphere, no distance and dark. . . .

During the month of January the artist painted a large oil painting of his wife and daughter called *May and Marie* (Plate 64) which portrayed them in their home with mother reading to the child. This is a particularly charming picture which captures a moment of domestic peace; his wife, by now heavily pregnant, is reading to her first-born child. The subtle use of tone and colour enhance the tranquil scene and are far removed from the bright and bustling markets Knighton Hammond painted on the Continent.

The Dow Family

During February, Mrs Hammond wrote a letter on her husband's behalf, to Herbert H. Dow, primarily to renew old acquaintances. A reply was received, dated 16 February, from Willard H. Dow, Herbert Dow's eldest son. He made references to the commission at the chemical plant, 'The pictures painted for us in 1920 still rank as the best portrayals of our plant. . . . I might add that reproductions of a number of his pictures have appeared in various chemical textbooks in this country as well as a number of the magazines.'

Knighton Hammond was confused and, indeed, concerned that Mr Dow Senior had not replied himself. He followed up his wife's letter with one of his own to Willard Dow. The reply, dated 17 March explained, '. . . I was under the impression that you were aware of the fact that my father died in October 1930, after a prolonged illness. Upon the death of

father, I was elected to his position in the organisation and have been endeavouring ever since to keep our plant running more or less according to the standards established by him.' Knighton Hammond was saddened by the news. He had great respect for Herbert Dow and had thoroughly enjoyed the friendship which had developed during 1920.

The letter went on to give brief news of the remainder of the Dow family and friends,

You might be interested to know that my brother, Alden, who was quite a youngster when you were here, has since graduated from Columbia University in architecture. He is quite the artistic member of the family and is very much enthused over his work. We all think he does very well. His principal hobby seems to be in the design of small homes and residences. He was the designer of our new Country Club, which is considered one of the best in the State and has since designed other buildings that are receiving considerable attention. . . .

Knighton Hammond would have been pleased with Alden Dow's success in architecture. The two had spent some time together on the estate during the artist's commission in America.

Addition to the Family and Tragic Loss
On 28 February 1933, Mrs Hammond gave birth to a boy. Unfortunately, it was not an easy birth and the health of mother and son gave cause for concern. Knighton Hammond made a frantic dash to London to the Royal Institute of Painters in Water-Colours to leave two pictures for exhibition, both of which were accepted for the 124th Exhibition. His first exhibition with the Royal Institute of Painters in Water-Colours was not the joyous occasion it might have been, as his wife's condition was not improving. He decided to make a last trip back to Cap Martin to sell his house and studio as he badly needed the money. The property had been on the market for some time. Knighton Hammond left with Mary on 24 March, and arrived in Menton on the 26th. He hurriedly packed and arranged for a show at Grenier's to

be organised on his behalf. Friends at Cap Martin all helped him and the necessary arrangements for the sale of the property at a reduced price were put in hand. In quick succession a letter and telegram were received from the doctor in Alton saying that May's condition was worse and advising him to return as soon as possible.

Mrs Hammond was visited by Iris Benson. The artist's wife was aware she was dying and made a plea to Iris Benson to look after her family after her death. An agreement was made between the two friends, which would have done much to console May.

Knighton Hammond and his daughter arrived home on 1 April to the news that his wife was dying. Further examinations were made by other doctors but the same conclusion was reached. Arthur sat at May's bedside, day and night, until she quietly passed away on 5 April 1933. His diary entry read, 'I'm terribly desolate and heart broken'. The artist began writing letters to family and friends, and messages of sympathy were received. Within a short space of time reporters called at the house to cover Knighton Hammond's sad news. The *Evening Standard* reported, under the heading of 'Artist's Dash to Dying Wife',

Mrs Emmeline Mary Hammond, wife of Mr Knighton Hammond, the portrait and landscape painter, died at Alton to-day, at her husband's studio in Church Street. Five weeks ago she gave birth to a son. Mr Hammond rushed back from France on Saturday when his wife's condition became serious. Mrs Hammond was aged 35 and the daughter of Mrs Low, of Hove, and the late Mr John Low, of Dulwich, S.E.

The *Daily Telegraph, Morning Post* and *The Sunday Times* all published Mrs Hammond's obituary.

After the service on 8 April at St Lawrence Church, Alton, the artist scattered his wife's ashes under a flowering magnolia tree in the grounds of Woking crematorium. Many local dignitaries, family and friends attended. Knighton Hammond, his daughter and baby son stayed a few nights with Mr and Mrs

Curtis and visited friends over the following days. The artist received many messages of sympathy, including a letter dated 10 April from Viscountess FitzAlan saying, 'It is with sincere sympathy that I write you these few lines to tell you how shocked Lord FitzAlan and I were to hear such sad news, and how much we think of you in your sorrow . . .'

Exhibitions at Home

On 24 April 1933, the artist called at the Royal Academy for varnishing day. There he met his friends, Herbert Davis Richter, Terrick Williams, Doyle-Jones, and others. A further trip to the Royal Academy was made on 28 April for private-view day. The artist exhibited one picture entitled *The Resting Place*. The *Hampshire Herald* of 29 April reported, 'Knighton Hammond, the artist, who resides in Alton, is exhibiting a painting of Alton Churchyard at the Royal Academy Exhibition.

He has entitled it "A Resting Place," and has done it from the angle of Amery-hill.'

On 3 May, Knighton Hammond and his daughter Mary travelled to Mapledurham (near Reading) to stay with Lynette Mitchell, Iris Benson's elder sister. On arrival the artist immediately walked around the village looking for potential subjects for pictures. The next day he was out at the picturesque mill with his oil paints and canvas. *Mapledurham Mill* (Plate 65) was one of the results. Here the paint is applied in a thick impasto manner, the dabs of paint creating a dappled light effect giving luminosity to the picture. He also worked on a water-colour of the village street with children playing and the church in the background. *Mapledurham* (Plate 66) captures the colours of the English countryside in a vibrant manner, yet the tone remains controlled. He does not stray into the colours, and tone, of the Continent. The water-colour has a deceptive

Plate 65. *Mapledurham Mill*. Oil on canvas. 44.5 x 61cm (18 x 25in). Private Collection.

Plate 66. *Mapledurham.* Water-colour. 48 x 61cm (18.75 x 24in). Author's Collection.

simplicity. Great care is evident in the accuracy of the perspective of the buildings and garden walls and the foliage of the trees, showing the variety of species to good effect. The children playing in the road are drawn with a spontaneity and fluidity suggestive of movement.

On his return home on 19 May, the artist received a letter saying that the picture which he had exhibited at the Royal Academy was to go to the Brighton Art Gallery for exhibition. Also, a letter from Baroness Bonde, sent from the Riviera, informed him that she had taken charge of packing the remainder of his belongings in Cap Martin and would have some of them shipped back to England. The letter, dated 21 May 1933, went on to say, 'I hope you and Marie will come to Fife as soon as your show is over. Angelica looks forward with delight to your lessons and I am sure we can have happy days out of doors on the links and sands.' The letter was signed 'Grizel Bonde'.

The exhibition to which the Baroness referred was held at the gallery of J. Leger & Son, 13 Old Bond Street, London, between 24 May and 17 June 1933. Thirty-eight works were exhibited in oil, water-colour and pastel. The exhibition was reviewed by *The Times* on 30 May 1933 reporting,

Space, light, and movement are the chief preoccupations in the recent paintings in water-colour and pastel . . . the results are most pleasing when colour, as such, is kept subordinate to these aims. This is not to say that Mr Hammond is not a good colourist, but only that he uses colour most happily when he can exploit its decorative possibilities without reference to the larger conditions of landscape.

Knighton Hammond received a visit on 26 May 1933 from Reginald Blackmore, who informed him that he had been elected a member of the Royal Society of Painters in Water-Colours at a meeting the previous evening, an honour which was particularly satisfying for the artist as recognition of his skill in this medium.

Early in June, Knighton Hammond went to London to visit his old friend Rowley Smart

Plate 67. *Kilconquhar '33.* Water-colour.
37 x 27cm (14.5 x 10.5in). Private Collection.

who was ill. He also met Baroness Bonde at
his show at Leger's Gallery and made
arrangements to visit her at her home in
Kilconquhar, Fife.

Scotland

With the exhibition at Leger's coming to a
close, the artist and his daughter left for
Scotland on 17 June on the Scots Express.
They were met at Edinburgh and driven to
Charleton, Kilconquhar, the home of
Baroness Bonde. After dinner the Baroness
showed Knighton Hammond over the
impressive house and grounds. Next morning
the artist set to work with his pastels painting
a picture of the interior of the salon and also
worked in the garden. The following day, 20
June, he began a water-colour of a statue in
the garden. This was a copy of the Bacchus
by Jacopo Sansovino (1486-1570).[5] The
picture, entitled *Kilconquhar '33* (Plate 67)
is a fine study of the sculpture silhouetted
against the blue sky. The study is reminiscent
of John Singer Sargent's *Cellini's 'Perseus'*[6]
which is in the National Gallery of Art,
Washington, DC.

The Lloyd George Portrait

As a result of the success of the portrait of
Jennifer, Knighton Hammond received a
communication from Earl Lloyd George of
Dwyfor regarding the painting of a portrait.
The artist arrived at *Bron-y-de* on 8 September
1933 and began making the necessary
preparations of setting up his easel and pastel
box. A seat was strategically placed to ensure
the light from the window was correct and to
the artist's satisfaction. The sitting started at
9.30, after breakfast. When Lloyd George sat
down the artist was pleased with the effect of
light and shadow on his hair and the side of his
face. Knighton Hammond started sketching
out as quickly as possible in charcoal a life-
size, half-length, three-quarter profile portrait.
After about fifteen minutes, Lloyd George
apologised and said that he had not arrived
home until late the previous night and needed
to sleep. He went in to the adjoining library to
have a 'snooze' on the settle while the artist
continued working on the portrait. Knighton
Hammond did all he could to the painting and
then made sketches of a number of the views
from the garden. At tea, Lloyd George promised
a good sitting the following day.

During the hour-long sitting the next day,
again starting at 9.30 am, Lloyd George told
the artist about a previous sitting for a portrait
carried out by Sir William Orpen in 1927. The
sitter had asked Orpen if he considered
Augustus John to be a very great artist. Orpen's
reply was that he considered John to be the
greatest draughtsman since Leonardo da Vinci.
Orpen's portrait of Lloyd George was in oil on
canvas, showing the statesman at his desk. It is
a fine picture displaying Orpen's wonderful
skill as one of the leading portrait painters of
his time and is now in the National Portrait
Gallery, London.

Knighton Hammond arrived at *Bron-y-de*
the next day, Sunday, at 9.30 am, as arranged.
However the sitter was not in the best of moods
and refused to pose again. He had told the
artist previously that he disliked posing for
portraits. Knighton Hammond spent the
remainder of the day in the garden sketching. He
was still there in the evening when heath fires

broke out on the estate. As Lloyd George directed troops from the nearby Bordon Camp and local helpers battling to get the fires under control, the artist had his sketchbook in hand and produced three pastels capturing the drama of the scene.

Knighton Hammond returned home to Alton and continued work on the portrait and other scenes of Churt. On 13 September, reporters arrived at the studio to put together a report on the commission. Many newspapers carried similar stories. The 23 September 1933 edition of the *Nottingham Journal and Express* commented,

> It is a very spirited pastel and prior to going to its permanent home it will be exhibited at the Pastel Society's next exhibition. . . . Mr Lloyd George is a great admirer of Mr Knighton Hammond's works, and possesses several examples. He readily gave permission to the artist to paint several large pastels of the house and grounds at Churt. It is understood a number of these will also be exhibited in London together with the portrait.

With the finishing touches now completed on the pastel portrait, the artist carried out a copy in oils. The finished portrait *The Right Hon. D. Lloyd George, OM, MP* (Plate 68) caught the sitter with a very pleasant and alert expression showing his abundance of silky white hair and hearty complexion. The portrait remains in the Lloyd George family today along with other pictures by Knighton Hammond collected by the former Prime Minister.

Prince Nicholas of Greece in a letter to the artist dated 1 October 1933 commented,

> I read the cutting you sent me with the greatest interest and offer you my sincere congratulations for your success . . . What an experience you must have had doing that man's portrait and watching his disportment during the fires! . . . I am terribly grieved to hear of your heavy loss and offer you my sincerest condolences, I am so sorry I did not know this before in order to express all my sympathy. It is a consolation for you to have the children and I earnestly wish they will be a great comfort to you in your lonely life.

Plate 68. *The Right Hon. D. Lloyd George, OM, MP.* Pastel. 73 x 61cm (28.75 x 24in). Private Collection.

Towards a New Family

On 23 September 1933, Knighton Hammond travelled to Greenwich and stayed at the Ship Hotel, where he ensured that he had a room with a balcony overlooking the River Thames. The artist was immediately busy with his pastels and produced a number of pictures, generally entitled *The Thames at Greenwich*, which he was to exhibit over a period of years. One of these pictures was later featured in a half-page coloured illustration in an article on the Pastel Society in *The Studio*, May 1947.[7] This picture shows the busy river scene, full of colour and movement. Davis Richter wrote the article and he clearly considered the picture of significant importance to be included.

Knighton Hammond's relationship with Mrs Iris Benson (née Mitchell) flourished, possibly as a result of the plea Emmeline Hammond made on her death bed. They had met a number of times while the artist was working at Churt and had known each other since 1924. Iris had a daughter, Ann, but her husband, Peter, had died in 1929. During the First World War, Iris had been a Voluntary Aid Nurse. She was well travelled, and had spent time in Spain and South Africa as well as on the Riviera. After much correspondence and much consideration, Knighton Hammond proposed to Iris and was eventually accepted. As his first wife was still alive and bearing the name of Hammond, it was decided that 'Knighton' would be introduced as part of the family surname by deed poll. Prior to the wedding the artist stayed in London at 108 Oakley Street. On 15 November 1933 the couple were married and left for a holiday on the Riviera. They arrived at Menton on 17 November and stayed at the artist's house in Cap Martin where they spent most of the time packing his remaining possessions. This was to be Knighton-Hammond's last trip abroad.

On arrival back in England on 9 December, the artist looked for a studio in London, settling for one at 1 Scarsdale Villas. He also made trips to the Royal Institute of Painters in Water-Colours and the Pastel Society to discuss future exhibitions. Prince Nicholas of Greece wrote to Knighton-Hammond on 11 December 1933

saying, 'I had no idea you had married again and I hasten – although rather late – to offer you sincerest congratulations. I think you were quite wise in taking the step for an artist needs a companion to look after him, and do those things which he is incapable of doing himself.'

A good insight into the artist's character can be drawn from the comments made by his friend George Behrend in a letter dated 26 October 1933, 'Please accept my congratulations on your engagement: amongst your many qualities are reasonableness and even temper, which are qualities making for happiness and contentment, and I have no doubt that your betrothed has qualities equal to yours.'

Ditchling

Prior to their marriage, Knighton-Hammond and Iris had given considerable thought to where they should live. Dymocks Manor, adjacent to the post office in Ditchling, Sussex was purchased. They made several trips to their new home during mid-December, soon after returning from the Continent. Some alterations were required and the couple organised a builder to carry out the work. Ditchling was at that time a haven for artists such as Sir Frank Short, Sir Frank Brangwyn, Louis Ginnett, Eric Gill, Philip Hagreen, Charles Knight, the calligraphist Edward Johnston, and others.

Back in London, the artist was invited at this time to join the Arts Club, Dover Street, by Peter A. Hay and A. D. McCormick. He also took his Lloyd George portrait and others to the Pastel Society's 1934 exhibition which was to be held at the Royal Institute gallery in Piccadilly. Exhibited along with the portrait of Lloyd George was one of Ann, Iris's daughter, and four landscapes.

The Knighton-Hammonds moved into Dymocks Manor on 26 January 1934. Arrangements were made for Ann and Mary to go to school at Burgess Hill. Arthur went to work in his new studio, but kept the other at Scarsdale Villas as it was useful to have a London studio for his patrons. The artist exhibited five pictures at the Royal Institute of Painters in Water-Colours in their spring

exhibitions in 1934. He also sent a number of water-colours to exhibitions in the north of England at Dudley Art Gallery and Museum, and at the Atkinson Art Gallery, Southport, where he had exhibited the picture *Menton Harbour* the previous year.

At the annual exhibition of the work of Ditchling Artists which was held between June and August 1934 at the Hove Museum and Art Gallery, Knighton-Hammond exhibited four pictures, mostly landscapes. Also during June the artist sent three pictures, *Winter Sunlight*, *Epsom Downs* and *In Provence* to Canada via an art agent either for exhibition or for a client.

The artist took to working in and around the village of Ditchling, which provided many varied subjects. Anne of Cleves' House made a very interesting subject, the building having been greatly altered over many years. Knighton-Hammond produced a water-colour (Plate 69) in pale pastel colours and light tones, and by

way of a contrast, he also etched a plate of the house (Fig. 33) but did not reverse the picture thus giving a mirror image. The etching relies for its effect on the unusual depth of the 'bite', the thickness of ink which this produced strengthening the impact of the image. This technique avoids the danger of over-working the plate and thus detracting from the overall quality.

In January 1935, the artist exhibited as usual, six pictures at the Pastel Society. In February, Knighton-Hammond was elected on to the Council and also the Hanging Committee of the Royal Institute of Painters in Water-Colours. At a committee meeting, he met Samuel John Lamorna Birch and they exchanged views on painting and discussed the work of the Newlyn School. Knighton-Hammond found their *plein air* method and their depiction of humble ways of life very interesting as he had drawn his inspiration from similar themes whilst on the Continent. Had he not gone to

Plate 69. *Anne of Cleves' House, Ditchling.* Water-colour. 51 x 63.5cm (20 x 25in). Reproduced by kind permission of Gordon Hodge Esq.

Fig. 33. *Anne of Cleves' House, Ditchling.* Etching. 15 x 20cm (6 x 8in). Author's Collection.

live in France and Italy, he might well have considered moving to Newlyn as he would have found sympathy with the way of life.

In March, Knighton-Hammond met with the other committee members to select and hang works for the annual exhibition of the Royal Institute of Painters in Water-Colours. He exhibited five of his own water-colours at the exhibition, one of which, *Building the Rick*, was illustrated in the exhibition catalogue. Also during the spring of 1935, Knighton-Hammond exhibited again at the Atkinson Art Gallery in Southport at their Fiftieth Golden Jubilee Exhibition of Modern Art. Later in the year, he exhibited for the first time in Scotland. The Royal Glasgow Institute of the Fine Arts showed his water-colour *Epsom Downs during Derby Week*. This was the first of many pictures to be exhibited in Scotland over the forthcoming years.

On 19 March 1935 the artist attended the Royal Institute banquet in celebration of the one hundred and twenty-sixth exhibition. He dined in the company of its president, Terrick Williams, and vice-president, Martin Hardie. Also present among the guests and members were the honorary treasurer, Frederick Beaumont, the secretary, Reginald Blackmore, Sir John Lavery, Sir Herbert Hughes-Stanton, Harold Knight and Norman Wilkinson. Knighton-Hammond had always enjoyed the company of other artists and revelled in gatherings such as this.

Holiday in the West Country

Although Knighton-Hammond had learnt to drive in America, he had never been comfortable at the wheel of a car and, as Iris enjoyed driving, he gave up and became a contented passenger. The artist bought a caravan for painting expeditions, which proved most useful and actually featured in a number of his paintings, particularly of Epsom during Derby week.

On 10 May 1935, Knighton-Hammond and

Iris set off in their car, towing the caravan, to combine a holiday in the west country with attendance at the wedding of Iris's nephew. Their route from Ditchling took them through Petersfield, Winchester, Salisbury, Shaftesbury and to Sherborne in Dorset, where they stayed the night in the caravan. The following day, after having breakfast at the Digby Arms Hotel, Sherborne, they got ready for the wedding. The reception was held at Cheriton Manor, near Wincanton, Somerset, where Knighton-Hammond met other members of the Mitchell family, Iris's relatives.

The couple spent a few days in the locality travelling to Cerne Abbas, Dorchester and Abbotsbury, before going to Wayford Manor, near Crewkerne, Somerset, which belonged to a distant relative of Iris. The artist was so impressed that he was to return, some years later, to paint the house. Returning to Sherborne to look over the abbey and castle, the weather was so bad that the artist was unable to paint, so the couple set off to the west, passing through Chard, Honiton, Exeter and on to Okehampton in Devon. By 16 May they had reached Polperro, where the artist immediately got out his paints, in spite of the poor weather. Their travels around Cornwall took them to

Mousehole. There they had tea at the Old Coast Guard's Hotel, where Knighton-Hammond immediately recognised water-colours and oil paintings by his friend Lamorna Birch hanging on the walls. They later travelled to Lamorna to visit him and his wife who showed Knighton-Hammond around the haunts of the artists of the Newlyn School, including Newlyn Harbour.

Whilst at St Ives, the artist heard on the radio the news that T. E. Lawrence had been killed in a motor cycle accident. Throughout his life, Knighton-Hammond studied famous men and Colonel Lawrence was among them. Thomas Edward Lawrence (1880-1935) had an outstanding military career, and, like many who took a great interest in Lawrence's life, the artist was deeply saddened by the news of his death and resolved to pay his respects.

Further trips to Polperro were made to work on more water-colours of this picturesque fishing village before setting off for home. The Knighton-Hammonds stopped off on Dartmoor where Arthur produced the water-colour of *The Clapper Bridge, Postbridge* (Plate 70). This water-colour relies on the contrasts between the strong blues and deep russet browns of the landscape. Further stops were

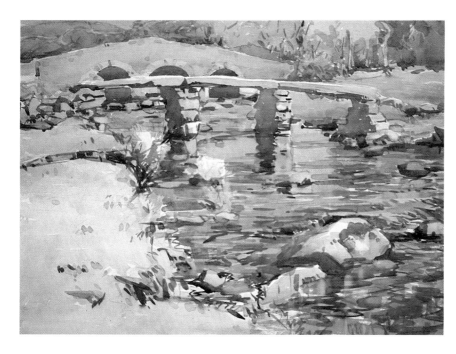

Plate 70. *The Clapper Bridge, Postbridge, Dartmoor.* Water-colour. 49.5 x 62cm (19.5 x 24.5in). Reproduced by kind permission of Gordon Hodge Esq.

Plate 71. *North End Farm, Ditchling.* Water-colour. 48 x 61.5cm (19 x 24.5in). Author's Collection.

made en route at Exeter, to visit the cathedral, and at Lyme Regis where the couple stayed overnight in the comfort of a hotel. On 22 May the continuation of the journey took them back through Dorchester and, at nearby Moreton, Knighton-Hammond visited the grave of T. E. Lawrence, who had been buried the day before. He recalled that only a simple wooden cross and a bunch of lilac marked the resting place.

Back at Ditchling the artist resumed his work in and around the village. He painted a water-colour of *North End Farm, Ditchling* (Plate 71), which shows the farm bathed in sunlight, although the colours here are the softer pastel shades of blue and ochre, highlighted with a single bright splash of red to give depth by drawing the eye to the centre.

Knighton-Hammond's marriage to Iris relieved his financial burden as she had private means and was able to provide a comfortable house and appropriate staff. Miss Dinah White (later Mrs Dinah Wright) was appointed to

look after the children after the family had been in Ditchling about a year. She very soon became known as 'Di' to everyone and over the years became a very dear friend to all members of the family. Initially, her main duties were to look after the artist's son, John, who was mentally handicapped as a result of complications at his birth.

Before the war, Dinah would accompany the family on their holidays. Knighton-Hammond and Iris would sleep in the caravan and Dinah would stay with the children in nearby accommodation. The caravan was used a great deal by the artist and his wife, especially during the summer when they would travel all over the country.

On one of his frequent trips to London, the artist stopped off to paint *Ye Olde Punch Bowle, Esher* (Plate 72). This water-colour has all the vigour and brightness of colour of his Continental pictures.

A portrait entitled *Miss Ann Benson* (his

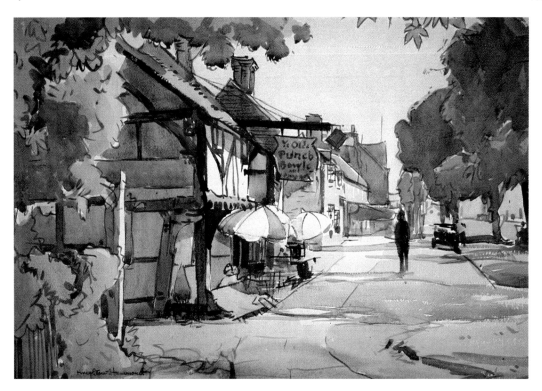

Plate 72. *Ye Olde Punch Bowle, Esher*. Water-colour. 33.5 x 48cm (13.25 x 19in). Private Collection.

Fig. 34. *Mrs Knighton-Hammond and Mrs Wright Playing Cards*. Etching. 20 x 25cm (8 x 9.75in).
Private Collection.

Fig. 35. *The Arts Club, Dover Street*. Etching. 17.5 x 25.5cm (7 x 10in). Author's Collection.

step-daughter) was exhibited at the Royal Society of Portrait Painters in 1935. Again, his family were favourite subjects for the artist. Portraiture was now becoming a major part of his output. *Mrs Knighton-Hammond and Mrs Wright Playing Cards* (Fig.34) is an etching from this period, showing the two women engrossed in their game.

The Arts Club, Dover Street

Knighton-Hammond enjoyed his membership of the Arts Club. He would go there for lunch or dinner whenever he was in London. The artist produced two etching plates of the interior of the club, depicting the artists relaxing in comfortable chairs or sitting at tables, deep in discussion. Knighton-Hammond experienced obvious difficulty in defining the detail in the dark interior of the club. This resulted in perhaps a slight over-working of the plate (Fig.35). However, the draughtsmanship is to his usual high standard. Among the artists in the picture are Herbert Davis Richter, and John

Sanderson Sanderson-Wells. The etching was produced, probably in the studio, from a number of red chalk (sanguine) drawings which the artist would have done at the club.

Towards the end of 1935 the Knighton-Hammond family returned for two weeks to Mapledurham, which resulted in a number of paintings of the village. In December, Knighton-Hammond had an invitation to exhibit a water-colour, *A Hampshire Church in Early Morning*, at Rochdale Art Gallery. The picture had previously been at the Atkinson Art Gallery, Southport, some months earlier, but had not sold.

The annual round of exhibitions in 1936 started as always at the Pastel Society. Knighton-Hammond sent a mixture of Continental and English scenes, and a portrait of his young son, John. Also at this time, *A Hampshire Church in Early Morning* had found its way from Rochdale to an exhibition at the Corporation Art Gallery, Bury, Lancashire.

Sir Frank Brangwyn

On 2 February 1936, Knighton-Hammond was introduced to Sir Frank Brangwyn, RA. The first meeting at Ditchling was brief but the two artists arranged to meet the following Sunday evening at Brangwyn's house, The Jointure. There was an immediate rapport between these two artists whose careers had crossed once before during the First World War. They spent the evening in deep conversation and a close friendship developed between them.

Brangwyn had travelled extensively on commission in Europe, the Near East, and South Africa. During these travels, he was able to indulge his glorious sense of colour, and the scenes he saw he was able to store in his memory and draw on them again throughout his lifetime. A sketching journey to Spain with Arthur Melville, produced a further explosion of colour in Brangwyn's work and a new maturity of his style. Melville's influence on Brangwyn was perhaps best summed up by Martin Hardie,

Melville's outstanding personality and brilliant technical powers have exercised a profound influence upon other water-colour painters. . . one contact with him was dramatic, almost volcanic, in its results. In 1892, Frank Brangwyn made a tour through Spain in the company of Melville, twelve years older than himself. Hitherto Brangwyn had painted grey, low-toned, sea-pictures such as *The Burial at Sea* in the Glasgow Gallery. He came back to paint *The Buccaneers*, first of a series where glowing brilliance of colour is used as a pattern of separate notes and masses. The mosaic of blots of rich colour, the deliberate decorative planning, which we find in Melville's water-colours, became on a large scale an integral part of Brangwyn's work in oil.[8]

Bright colour and bold technique were typical of the revolutionary artists of the time, and to these elements Brangwyn added grandeur of scale.

For thirty years of his life Brangwyn was principally occupied with the execution of large murals, the activity in which he particularly

Fig. 36. *A River Procession to Westminster in 1453: City and State Barges (After Sir Frank Brangwyn)* Pencil. 18.5 x 19cm (7.25 x 7.5in). Author's Collection.

Fig. 37. *The Blacksmith from a sketch for a panel by F. Brangwyn.* Pen and ink. 13 x 18cm (5.25 x 7in). Author's Collection.

excelled and for which he became best known. The earliest and latest of his surviving murals are in the Skinners' Hall, London (1902 and 1937). Knighton-Hammond undoubtedly saw these murals or studies for them since he produced a drawing of them, *A River Procession to Westminster in 1453: City and State Barges* (Fig.36). The drawing was inscribed *From a reproduction of a decorative painting by F. Brangwyn in the Hall of the Skinners' Company.* The range of colour of Brangwyn's original is suggested by detailed hatching in pencil.

An illustrated article by A. S. Covey in *The Studio* in May 1905 deals exclusively with Brangwyn's contribution to the biennial International Exhibition in Venice. The article comments, 'In casting his eye over the British horizon, Professor Fradeletto found in Frank Brangwyn the most conspicuous figure in English decorative art, and he has wisely chosen this artist as designer and decorator of the rooms of the British groups.'[9]

Among the panels at the exhibition was *The Blacksmiths.* A lifelong characteristic of Brangwyn's work, due no doubt to natural

sympathy as a result of his own upbringing, was his preoccupation with the working classes and their labours. *The Studio* article goes on to say, 'The group of the smiths is perhaps the finest of the four panels. Here the scheme of lighting is reversed, and the two foreground figures stand out in the warm, golden light from the forge, while the two on the opposite side of the anvil sink into a greyish-blue shadow. . .'[10] Knighton-Hammond also made a drawing of this panel (Fig. 37), retaining the strong chiaroscuro effect of the original.

The Studio comments further 'The pleasure he has given us is far greater. He has filled the room with a vibration of colour, harmonies, as the skilled musician at the organ floods the room with harmonious volumes of sound . . .'[11] His work was so well received that he was awarded a gold medal by the Exhibition Committee.

In 1924 a large exhibition of Brangwyn's work was opened by the Prime Minister, Ramsay MacDonald. The rejection of his British Empire panels, commissioned in 1925 by Lord Iveagh (1847-1927) as a war memorial for the House of Lords and the culmination of his mural work, on the grounds of unsuitability

for the building was a wounding disappointment. G.S. Sandilands, in an article for *The Studio* commented, 'The incomplete scheme was judged by a body known as The Fine Arts Commission. The commission consists of some half a dozen men, not one of whom is a painter. They considered the panels and decided that they were not suitable. Largely as a result of the Commission's report the House of Lords declined the work. . . .'[12] The lack of qualification of those judging merely added to Brangwyn's disappointment. However, the panels eventually found an honourable place in Swansea where the new Guildhall was specially adapted to accommodate them.

Brangwyn was knighted in 1941 and in 1952 the Royal Academy paid him the unprecedented honour of a retrospective exhibition within his own lifetime. He was an active member of the Royal Society of British Artists and many other academies and art societies at home and abroad. Brangwyn enjoyed international fame and was long considered to be the outstanding British artist of his day. He received many honours from abroad,[13] including a commission for a self-portrait for the Uffizi Gallery.

Knighton-Hammond and Brangwyn spent a great deal of time together. Both artists had travelled widely, adopted an individual style and were very highly thought of by their fellow artists. Furthermore, both men had very similar views on modern art: Knighton-Hammond, in an unpublished article on water-colour painting, commented, 'I am assuming that these new fashions in art, Cubism, Vorticism and above all Surrealism are all passed by, by the reader, perhaps with a slight shrug of the shoulders.' Brangwyn comments,

Abstract painting? But there isn't such a thing. Abstract art, heh! There isn't such a thing, is there? There can't be such a thing! A man paints a face as if it had been

Fig. 38. *The Hanging Committee of the ROI.* Etching. 20 x 25.5cm (8 x 10in). Author's Collection.

run over by a steam roller, lop-sided, with the eye on top of the head and the ear under the chin. It isn't abstract, but concrete, and remains a damned bad job of a face.[14]

Working at Ditchling

In the spring of 1936, Knighton-Hammond sent five pictures to the Royal Institute of Painters in Water-Colours exhibition. These again depicted a variety of subjects with *Windsor Castle* and *Le Marché* being illustrated in the exhibition catalogue. Prior to an exhibition, the Selection Committee would meet to discuss their duties. Knighton-Hammond etched a plate of one such meeting, *The Hanging Committee of the ROI* (Fig.38), which portrays the members sitting around a table in the galleries. The committee appear to have completed their task as they are relaxing over tea with the pictures hanging proudly on the walls around them.

Knighton-Hammond also sent two pictures to the Atkinson Art Gallery, Southport, for their annual exhibition. The Royal Institute, where he was by now a very active member, held their first summer exhibition in 1936, and the artist sent just one picture on this occasion.

During 1936, Knighton-Hammond became steward of the Artists' General Benevolent Institution. This involved collecting donations, which Knighton-Hammond took seriously. His stewardship took up a great deal of his time and with the help of his wife, he managed to contact a great many fellow artists, patrons, galleries and commercial organisations. Knighton-Hammond also placed a letter seeking financial assistance for the AGBI in *The Times* and the *Daily Telegraph*. His year as steward was a success and in addition to a letter of thanks from Martin Hardie, Honorary Secretary, there was a dinner held in London where he was also thanked for his considerable efforts.

Knighton-Hammond's work was also featured that year in an illustrated article on 6 June 1936 in *Country Life* under heading '*Modern Sporting Art*'. *Epsom Downs* was given a half-page feature in which it was commented that Knighton-Hammond's paintings 'show a quality of technique more familiar in landscape than sporting art, and make pleasing designs out of the litter and jubilation of the Downs.'

The Royal Mint

In Ditchling, Knighton-Hammond was introduced to Edward Johnston, who was by now an internationally renowned calligraphist. The skill of Johnston's hand was of great interest to Knighton-Hammond and through their respective arts they became close friends. In Ditchling, there was great camaraderie between the artists, who were most interested in each other's work, and in art in general. Indeed, a number of them felt sufficiently strongly when Edward Johnston's design for the new King Edward VIII coins was rejected that they wrote a letter to the editor of *The Times* giving their views on the successful designs for the coins and stamps. They disliked the designs and felt that it was an artistic opportunity wasted. The letter was published on the 8 October 1936 and commented, 'when it comes to designing something that shall represent our well-loved King and our country's own artistic taste . . . a little thing of beauty could be used that would give delight to the eye and help to educate our people and our children'. The letter continued, 'We hope that when the new coinage is designed, or when a new issue of the postage stamp is contemplated, these things will be given out for competition throughout the British Empire, and when the result comes in a few knowledgeable men be asked to adjudicate.' The names of Charles Knight, Frank Short, Frank Brangwyn, Louis Ginnett, and A.H. Knighton-Hammond appear at the end of the letter, but the chief author was Knighton-Hammond.

He received a number of letters in support of their views, including one from Sir Edwin Lutyens, who wrote on 9 October 1936 saying, 'I read your letter in yesterday's *Times* with interest. The stamp question came up before the Royal Fine Arts Council last week, a body of which I happen to be a member. We saw a lot of stamps in all the varying colours and sizes. . . . We made criticisms with which I am sure you would have agreed.'

Plate 73. *The Ditchling Postman*
Oil on canvas. 76 x 62cm
(30 x 24.5in). Author's Collection.

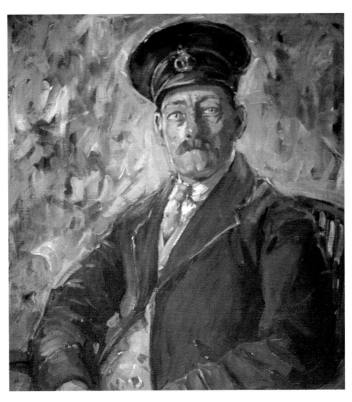

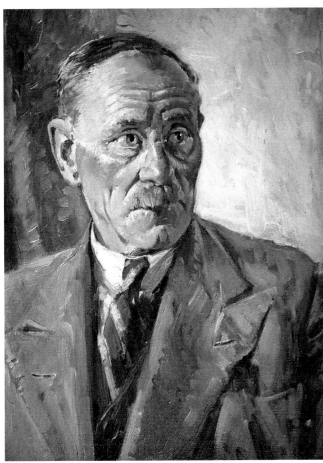

Plate 74. *Portrait of a Man*
Oil on canvas. 50.5 x 35cm (20 x 14in).
Author's Collection.

The letter in *The Times* was also read by Sir Robert Johnson, Deputy Master and Controller of the Royal Mint in London. He wrote to Brangwyn informing him that the new King Edward coinage was in preparation and inviting the artists to the Mint so that he could demonstrate some of the difficulties involved in such a task. The invitation was duly accepted but on the date arranged, 5 November 1936, Brangwyn was not well, so Knighton-Hammond and Louis Ginnett were welcomed at the Mint by their host. They were shown the many designs for coins, including that of Edward Johnston, and it was explained, in confidence, the reasons why it was not chosen, although it was considered by many, including Sir Robert Johnson, to be the best.

Character Portraiture at Ditchling

Knighton-Hammond's interest in portraiture grew while he was at Ditchling. In particular, he studied the old characters of the village, many of whom he was to paint. During 1937, he was deeply involved with oil studies and Ditchling provided many suitable subjects. Indeed, Sir Frank Brangwyn also recognised this,

> There are hundreds of good subjects to paint . . . the trouble is people don't use their eyes . . . don't look around them or use their imagination. Damn it, if I wanted to take a stroll down the village this very moment, I bet you I could bring back a string of old stagers who'd make a good study to paint. [15]

The most striking things about these character studies are that they are both creatively and keenly observed. The richness of colour and the boldness of design is comparable with the work of John Singer Sargent and Augustus John.

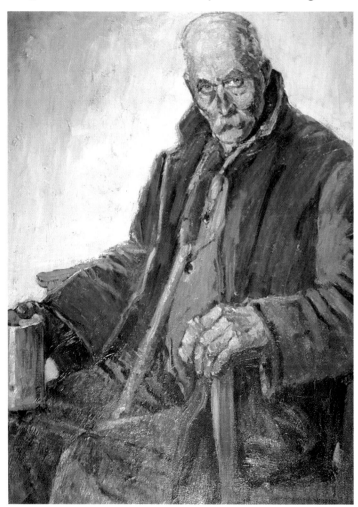

Plate 75. *Reeves, the tramp, with a broken finger*
Oil on canvas. 101.5 x 76cm (40 x 30in). Reproduced by kind permission of Gordon Hodge Esq.

Many of the characters were well known to the artist. The Ditchling postman, Joseph Faulkner, was a well-known local personality and lived in the post office next door to Dymocks Manor. Plate 73 is one of at least two known portraits of him, one of which was exhibited at the Exhibition of Ditchling Artists and Craftsmen, entitled: *Joe, the Village Postman.* The 11 October 1937 edition of the *Sussex Daily News* reported, 'Joe, the Ditchling postman, his bag over his shoulder and a packet of letters in his hand, occupies pride of place in the annual exhibition. . . . His portrait, an oil painting . . . has caught Joe to the life, and one would not be a bit surprised if at any minute it said "No, nothing for you to-day, miss".' The portrait was exhibited a year later at the Royal Society of Portrait Painters. Joseph Faulkner lived at Neville Cottages, Beacon Road, Ditchling, and he served in the 1914-18 war, after which he joined the Post Office. *The Ditchling Postman* (Plate 73) was clearly not the portrait exhibited at the above show, but is a remarkable character study. Like the majority of his portraits, Knighton-Hammmond pays particular attention to the sitter's face to try to convey some of the character and complexity of the individual. *Portrait of a Man* (Plate 74) exemplifies this point: Knighton-Hammond has focused deliberately on the sitter's gaze, giving an acute intensity to the portrait. The sitter for this portrait was a professional model and would have been painted some years earlier at the artist's London studio.

In the construction of his faces, Knighton-Hammond uses the most surprising colours. Picking out the lowlights in shades of blue and then with light touches of primary colours, he takes advantages of the effect of optical mixing where the colours come together in the viewer's eye.

These techniques are brought together in

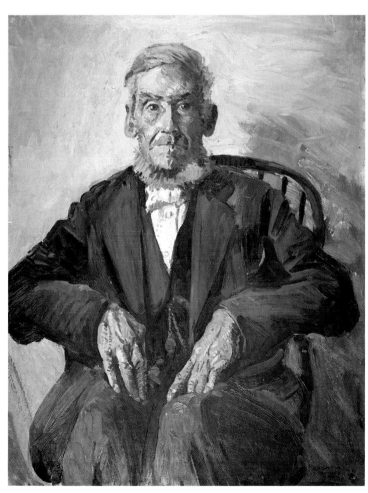

Plate 76. *An Old Man of Sussex*
Oil on panel. 91.5 x 71cm
(36 x 28in). Reproduced by kind
permission of Gordon Hodge Esq.

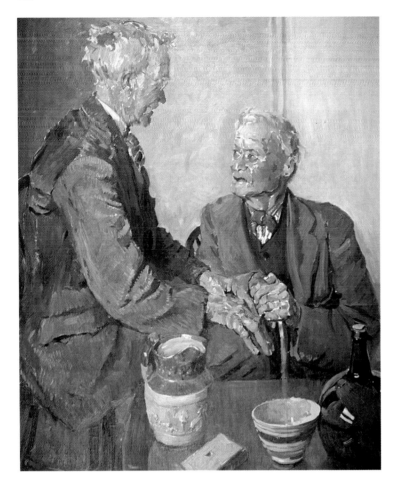

Plate 77. *The Cronies.*
Oil on canvas. 125 x 101cm
(49.5 x 39.75in).
Private Collection

Reeves, the tramp, with a broken finger (Plate 75) and *An Old Man of Sussex* (Plate 76), which was the first of his character portraits to be exhibited at the Royal Society of Portrait Painters in 1934. In these pictures, the paint has been applied liberally, yet the brushwork is crisp and decisive.

A similar combination style is evident in *The Cronies* (Plate 77). In the modelling of the heads, each brushstroke economically articulates contour and defines form. *The Cronies* was painted during 1937 while the artist was staying at a cottage at Blewbury, Berkshire, near the home of his friend, Herbert Davis Richter. The old characters featured in the picture are a farm labourer and the village carpenter, shown deep in conversation. Knighton-Hammond also etched a plate of this picture, *The Cronies* (Fig. 39), which skilfully picks out the central flavour of the composition.

Knighton-Hammond's two close friends in Ditchling, Brangwyn and Johnston, both sat for him. The artist produced a half-length drawing of Brangwyn in red chalk from which he also etched a plate. Both the drawing and an artist's proof of the etching are in the National Portrait Gallery, London. The preparatory study (Fig.40) of Brangwyn has a delightful spontaneity and freshness and it is not unusual for these qualities in a preparatory drawing to be lost when transferred to the etching plate where the linework has to be more controlled. Knighton-Hammond manages to maintain the spontaneity in his etching (Fig.41) working up the detail in the plate with great skill.

Edward Johnston (Plate 78) is a portrait in oils on canvas, showing the sitter at his desk. He looks very thoughtful as he gazes beyond the open book on the desk. The artist has caught this pensive expression admirably and at the same time has focused on the sitter's hands clasped before him, the tools for which he was world famous. The painting was exhibited at the Royal Society of Portrait

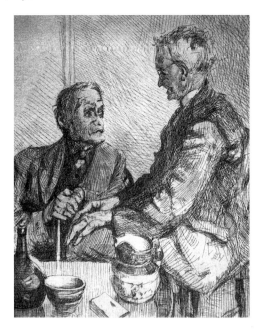

Fig. 39. *The Cronies.* Etching. 19 x 15cm (7.5 x 6in). Author's Collection.

Fig. 40. *Sir Frank Brangwyn.* Sanguine. 28 x 22.5cm (11 x 8.75in). By courtesy of the National Portrait Gallery, London.

Fig. 41. *Sir Frank Brangwyn.* Etching. 20 x 25cm (7.75 x 10in). Reproduced by kind permission of Gordon Hodge Esq.

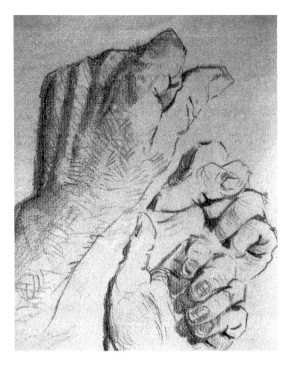

Fig. 42. *A Study of Hands*
Red Chalk. 28 x 21cm (11 x 8.25in). Author's
Collection.

Painters, and is now in the National Portrait
Gallery, London.

Each of these portraits has its own unique
power. Each new sitter inspired Knighton
Hammond with fresh interest enabling him to
explore the character of the sitter through the
chosen medium. *A Study of Hands* (Fig. 42)
was drawn around this time and has the same
interest in the individual, combined with
sensitive handling of the medium.

These character studies were not confined
to men. Knighton-Hammond had painted
Gypsy Lee in oils, by the side of her caravan
on Ditchling Beacon, during 1935. Some idea
of the speed at which the artist worked is given
by the fact that this picture, measuring 63.5 x
76 cm (25 x 30 ins) was completed in two hours.

Major Exhibitions
At the beginning of 1937, Knighton-
Hammond's pictures at the Pastel Society
included portraits of Miss Ann Benson, his
step-daughter, and Miss L.R. Mitchell, his
wife's sister from Mapledurham. He also
included a selection of river and coastal scenes.

Plate 78. *Edward Johnston.* Oil on canvas. 71 x 91.5cm (28 x 36in). By courtesy of the
National Portrait Gallery, London.

Knighton-Hammond appeared to enjoy painting pastels for exhibition at the Pastel Society, so much so that he continued to exhibit there, on and off, for many years. At the Royal Institute of Painters in Water-colours spring exhibition, five pictures were selected, one of which, *Threshing*, was illustrated in the exhibition catalogue. He also exhibited at the summer exhibition, and also at Northampton Art Gallery where six water-colours were shown.

With the success of his portraits in oils, Knighton-Hammond exhibited for the first time at the Royal Institute of Oil Painters in 1937. His exhibit, *The Sunday Joint*, featured an errand boy carrying a joint of meat in a basket. This picture is a clear example of his talent in portraiture in oils and it was hung in a prominent position on the line. The painting was offered for sale at £105, which was a higher price than previous exhibits. As a result of his outstanding work in oils, Knighton-Hammond was elected a member of the Royal Institute of Oil Painters, much to his delight.

In September 1937 the artist was pleased to be asked to exhibit at his birthplace, Arnold, Nottingham. The Bonington Memorial Exhibition was held at Arnold Public Library, and eleven works were sent, including *An Old Sussex Gentleman*, (probably *An Old Man of Sussex* Plate 76). The *Evening News* reviewed the exhibition and in the 24 September edition reported,

In the past, this exhibition to commemorate this famous painter's [Bonington's] association with Arnold, relied on some of his works for the greater part of its interest. This year interest will be concentrated on living artists. Chief among these is Arnold-born A.H. Knighton-Hammond, who lives by the Sussex Downs. He is an eminent painter who is represented by a pastel, two oils, and some splendid fresh water-colours. A pastel of a hunting scene, done in 1900, shows how he has progressed in the last 30 years.

A water-colour was dispatched by the artist to the Exhibition of Contemporary British Painting, which was held in 1937 at the National Gallery of Canada.

During 1938, Knighton-Hammond pursued his usual round of exhibitions, which included a show at the Brighton Public Art Galleries for Members of the Brighton Arts Club. At the Royal Institute, his five works included a

Plate 79. *Epsom Downs on Derby Day.* Oil on panel. 48 x 59cm (19 x 23.25in). Private Collection.

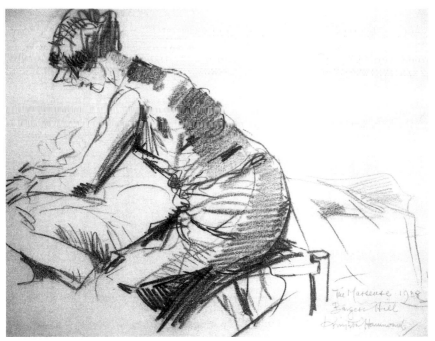

Fig. 43. *The Masseuse,
1938, Burgess Hill*
Charcoal. 27 x 35.5cm
(10.5 x 14ln).
Author's Collection.

portrait of *Master Julian Benson*, a young relative of his wife. *Stokesay Castle* and *Brighton Beach* were illustrated in the exhibition catalogue.

At the Royal Academy, he exhibited two pictures, *A Sussex Farmer* and *The Village Horse Show*. The *Sussex Farmer*, which was hung on the line, showed Mr Holman, a farmer from Ditchling, who supplied the Knighton-Hammond family with milk and eggs. This was a large character study with the farmer dressed in his best apparel. The painting was featured in a photograph in the 28 March 1938 edition of *The Daily Telegraph and Morning Post* with the caption, 'Oil paintings, early arrivals among those to be submitted for the Royal Academy Summer Exhibition, being unloaded at Burlington House.' The photograph showed the portrait being unloaded from a van by Bourlets.

The picture of *The Village Postman* was exhibited at the Royal Society of Portrait Painters. His enthusiasm for portraits was such that three of the four paintings exhibited at the ROI (Royal Institute of Oil Painters) were character studies, including *The Cronies* (Plate 77), which was offered for sale at £400 – a considerable sum of money at that time.

In the annual exhibition of Ditchling Artists

and Craftsmen, Knighton-Hammond exhibited *At Ditchling Horse Show* and *Portrait of Mr Holman*, which had previously been exhibited as *A Sussex Farmer* at the Royal Academy. This had been the first of his character studies to go on exhibition. The exhibition was a meeting place for local artists to get together and view each others' work. His friend, Louis Ginnett, was chairman of the Society, and Charles Knight was a member of the committee.

Epsom Downs on Derby Day (Plate 79) was one of a number of oils painted in the studio during 1938. The picture would have been produced from water-colours and sketches made previously. Knighton-Hammond includes himself and his wife in the composition.

Knighton-Hammond, whilst at Burgess Hill during 1938, did a bold charcoal drawing called *The Masseuse* (Fig. 43). Here, the 'masseuse' (physiotherapist) is seen at work and Knighton-Hammond uses strong, bold linework to characterise the effort of his subject. The year ended with five water-colours being exhibited at the Corporation Art Gallery, Bury.

In 1939, among the works exhibited at the Pastel Society were six portraits, four of which were studies of tramps. Knighton-Hammond found these old stagers, who travelled through

Ditchling, fascinating. He would invite them into his studio to sit for him where, no doubt, they were recompensed with food and drink. In this way the artist continued to develop his portrait skills in pastel.

The water-colours exhibited at the Royal Institute were of a variety of British landscapes and conversation pieces, such as *The Village Horse Show*. This picture was later taken to an exhibition at Bradford Art Gallery, and put on show along with *A Sussex Farmer* which had been exhibited elsewhere before and now carried a price of £300.

At the Royal Academy, Knighton-Hammond exhibited a water-colour which was hung on the line. *The Times* commented, '. . . Arthur Knighton-Hammond has a strong, swift sketch of *The Day of the Oaks*, Epsom, 1938'. At the Royal Institute of Oil Painters, the artist exhibited four oils, including *Evacuees in the Garden*, showing evacuees from London arriving in Ditchling at the beginning of the Second World War. The garden is probably that at Dymocks Manor, and Knighton-Hammond found the war brought a whole new subject to Knighton-Hammond's doorstep.

In the latter part of 1939, Knighton-Hammond exhibited two paintings, a self-portrait and *Old Age Pensioners* at the Royal Society of Portrait Painters.

On New Year's day, 1940, Knighton-Hammond was at the Royal Academy for varnishing day for the exhibition of the United Society of Artists. From the Academy, he went to the Arts Club in Dover Street where he met Alfred Munnings and many other artists. In the evening, Knighton-Hammond went out to post some letters, in the blackout. He recalled he had great difficulty finding his way back to the club in the dark and decided not to go to London again during the blackout. The next day the artist attended a committee meeting at the Pastel Society before returning home to Ditchling.

At the exhibition of the United Society of Artists, the critic and painter, D.S. MacColl, commented in 26 January 1940 edition of the *Spectator*, '. . . Next in the order of my finds was another unknown, Mr Knighton-Hammond, whose *Sussex Byre* (134) is a water-colour rare in its free, full brushing on an unobtrusively secure foundation of form.' Knighton-Hammond would, no doubt, have been very pleased with a favourable review from such an eminent critic as MacColl. He may have been less pleased at being referred to as an 'unknown' but this was perhaps the price he paid for spending so much of his time on the Continent during, arguably, the most significant period of his career.

As the war progressed, the Knighton-Hammond family became increasingly concerned with the fact that they could be in the flight path of German bombers aiming for London. They decided, therefore to look for a safer place to live. Iris knew the West Country and had relations in the Somerset area, including an aunt, Mrs Mitchell, at Seaborough Court near Crewkerne. It was eventually decided that they would move and they bought Old Court in Misterton near Crewkerne.

A local man, Mr Nathaniel Brayne (1881-1965), had been working in the garden at Dymocks Manor for some time and when the decision was made to move he was offered a job with them as gardener/handyman in Somerset. His wife, Ellen (1877-1950), was also offered a job as cook/housekeeper. The Braynes were to feature in a number of pictures from this time onwards. They posed for *The Card Players*, an oil painting which was later exhibited at the Royal Academy. As the title suggests, Mr and Mrs Brayne are shown engrossed in a game of cards sitting at the card table with their son, Harold, looking on.

CHAPTER 6
SOMERSET AND DORSET
1940-1970

The Artist Magazine

Knighton-Hammond's reputation as a pastelist had developed during the 1930s. He had exhibited regularly at the Pastel Society since becoming a member in 1932 and received very favourable notices. As a result of this a letter arrived on 27 January 1940, just before the family moved to Somerset, from the editor of *The Artist* magazine asking Knighton-Hammond to write a series of articles on pastel painting and offering the sum of 30 guineas in payment. This offer was accepted and the artist immediately set about writing the articles and working on some pastels for illustration.

The Artist magazine was a monthly publication in which the majority of the articles were written by working artists. The magazine was edited by Harold Sawkins and had a wide circulation in Great Britain and in America. Knighton-Hammond wrote five articles under the main heading of 'Creating Telling Pictures with Pastels'.

In the first article, the editor's preamble introduced the artist as one who 'proves how fallacious is the view that pastel is a medium of secondary importance and stresses its value in picture making'. Knighton-Hammond then explained how he was reintroduced to the art of pastel painting whilst staying with Edgar Wood at Monte Calvario. He recalls his friend allowing him full use of his pastel box and

paper and illustrates the article with two coloured reproductions, one of Edgar Wood's house entitled *Piazza on Mount Calvario* and another entitled, *Garden Seat on Mount Calvario* (Plate 80) which may be compared with *Mary and her Mother Sitting on a Seat* (Plate 56). The artist also makes reference to watching Terrick Williams doing outdoor studies in pastels at Concarneau in 1929. Knighton-Hammond reveals that from these pastel sketches, Williams produced his large exhibition pictures back in the studio. A black and white illustration of Knighton-Hammond's, *Portrait of Lloyd George* (Plate 68), was also included. The article cites Rosalba Carriera, Jean-Baptiste Chardin, Maurice Quentin de La Tour and Edgar Degas as the major popularisers of the use of pastel, showing the great tradition behind the use of the medium and its place alongside other mediums. With regard to drawing, Knighton-Hammond goes on to say that in his view, the great majority of contemporary oil paintings were badly drawn and composed, and the vast numbers of weak and sloppy water-colours would be greatly improved if students spent more of their time in drawing with chalks.

In the second article, the artist dicusses the materials used in pastel painting. He gives an account of the types of pastel available and the papers used with the medium and includes an

Plate 80. *Garden Seat on Mount Calvario.* Pastel. 30.5 x 32.5cm (12 x 12.75in). Private Collection.

illustration of the ideal pastel box. The article was also illustrated with a coloured reproduction of one of Knighton-Hammond's own works in pastel *A Breton Pardon*. This shows a religious ceremony at a village near Concarneau in Brittany, and was painted in 1929. An unidentified magazine article later commented on this picture, 'Knighton-Hammond works, it seems clear, with rapidity and at a white heat of enthusiasm, achieving dramatic effects by driving home the pastels with short jabs or long sweep or a punch that might come from the shoulder: but in this art of suggestion every blow tells.'

The third article concentrates on portraiture. Taking *Portrait of Mr Nathaniel Brayne* (Plate 82) as an illustrative example, the artist takes the reader, step-by-step, through the process of creating a portrait, from the initial charcoal drawing (Fig. 44), to the finished study. Knighton-Hammond stresses the importance of the initial drawing, and how the artist needs to be completely satisfied with it before proceeding. In the charcoal drawing (Fig.44), the areas of light and shade are indicated. From this drawing the pastel is applied giving colour and texture. The finished work shows

Fig. 44. Photograph of study drawing of Mr Brayne.

the full depth and character which this soft and delicate medium can bring to portraiture.

Article number four looks in detail at his work on a half-length pastel portrait *Sinden the Chemist at Ditchling* (Plate 81) in which he engaged a photographer to give greater coverage to the progress of the work. The article is illustrated with five photographs, of the four progressive stage drawings and the finished picture in which the subject, Mr Sinden, father of the actor, Donald Sinden, is captured with the characteristic sympathy and sensitivity which Knighton-Hammond gave to all his subjects.

In the introduction to the fifth article the editor comments, '. . . so as to give readers some useful tips he [Knighton-Hammond] goes on to describe in detail the various methods he adopted to obtain the effects required, when painting landscape study in pastel'. A coloured reproduction entitled *The Village,* was used to illustrate this final article.

The series of articles in *The Artist* ran consecutively, with the first appearing in the September 1940 edition (Volume 20, Number 3), and during the preparation of the

Plate 81. *Sinden the Chemist at Ditchling*
Present whereabouts unknown.

articles, the artist was in the process of moving to Somerset. With all the upheaval of a move of both house and studio, one might have

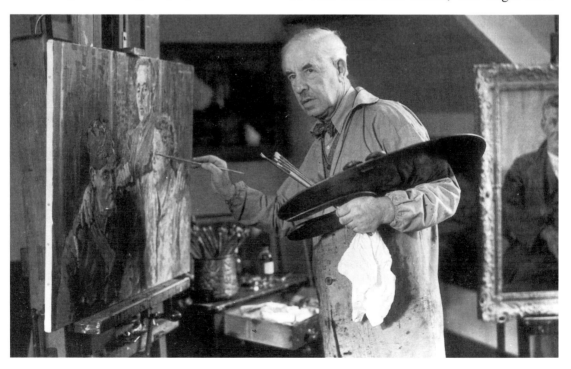

Fig. 45. Photograph of the artist in his studio at Old Court

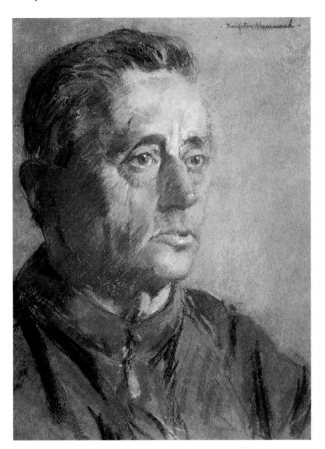

Plate 82. *Portrait of Mr Nathaniel Brayne.*
Pastel. 44.5 x 32cm (17.5 x 12.5in).
Author's Collection.

expected that the artist, now in his sixty-fifth year, and with a very full life already behind him, would consider sitting back and relaxing. However, it seems from the response to his articles that nothing was further from his mind.

After receiving an advance copy of *The Artist*, Herbert Davis Richter wrote to Knighton-Hammond on 23 August 1940 saying, 'I'm very glad you are doing some articles on pastel. I saw the first and thought it should give a lift up to the medium. The print of Lloyd George reproduced well. . . .'

Accompanying the second article in the October 1940 edition of *The Artist*, the editor, Harold Sawkins writes,

A. H. Knighton-Hammond writes me that he has now settled down in his house in Somerset, and has just bought a couple of Pedigee Jersey cows "so," he states, "we are getting plenty of milk and cream." His next move is to buy a couple of pigs and feed them on skimmed milk. Who said artists are not practical people?

After Knighton-Hammond had settled in his new home and studio, Harold Sawkins asked him to provide a photograph of himself at work for publication in the 'Round the Artists' Studios' feature of the magazine. A photograph was duly provided (Fig. 45) and appeared in the March 1941 edition (Volume 21, Number 1). It shows the artist in his studio standing at his easel, on which stands an oil painting of the Brayne family. This picture is of *Young Brayne joining the army, his mother and father* and would have been painted earlier at Ditchling.

Members of the Brayne family were frequently the subjects of paintings. Their son, Harold, had joined the Seventieth Sussex Searchlight Regiment of the Royal Artillery as a gunner, and Knighton-Hammond was keen to paint him in uniform so whenever Harold was home on leave from his base in Hove, Sussex, he would be asked to pose. *A Private of a Searchlight Unit* was one of the resultant pictures. When the young soldier was away on

duty, Mr and Mrs Brayne sat for the artist.

In May 1940, Knighton-Hammond exhibited two water colours in an open exhibition at the Royal Water Colour Society. When he visited the gallery on private-view day, he was pleased to find that his pictures had been hung in the centre of the walls on the line. During this stay in London the artist left one of his oil portraits of Harold Brayne, entitled *Watcher of the Skies*, at the Arts Club, Dover Street, for collection by Bourlets for distribution to exhibitions. *A Private of a Searchlight Unit* was also exhibited, with a portrait composition, at the Royal Society of Portrait Painters in 1941.

In June, Knighton-Hammond sent two water-colours to the Royal Glasgow Institute of the Fine Arts for exhibition and a number of pictures were distributed by Bourlets for exhibition at Ipswich Art Club and at Brighton Art Gallery. At the latter exhibition, in addition to two water-colours, he exhibited the *Card Players* which had been shown at the Royal Academy earlier in the year.

Old Court

Knighton-Hammond enjoyed Somerset. His new home consisted of a number of buildings of varying periods built in the local vernacular style, and was flanked by St Leonard's Church to the south and the stable block with the studio over to the north. The authoress Helen Mathers, who wrote the Victorian classic *Coming Through the Rye*, was born at Old Court.[1]

The structure of Old Court was, in the main, built of stone under a clay-tiled roof. The Ham stone mullion windows, with a label moulding over and arch-headed door surrounds, dated from the early seventeenth century, and gave great character to this impressive house. The front elevation, facing a court yard and surrounded on three sides by the church and stables, is made up of flanking walls and one gable end wall. With such a rich variety of features for the artist to exploit, the house soon became the subject for a water-colour. *Old Court* (Plate 83) enhances all the architectural details, including the remains of a first-floor fourteenth-century tracery window above the entrance door to the right, adjacent to the stable/ studio block which came from the old church. A mature tree stands graciously in the foreground between the house and the church. The full range of Knighton-Hammond's experience is brought to bear in this painting which combines his early skills of draughtsmanship with his maturing creative eye for landscape, all masterfully executed with a clarity and vigour afforded by the fluidity of water-colour.

In addition to the house and gardens Knighton-Hammond had acquired a

Plate 83. *Old Court Misterton.* Water-colour. 54.5 x 77cm (21.5 x 30.25in). Private Collection.

smallholding, which according to the information gathered for the Ministry of Agriculture, Foods and Fisheries, consisted of: two cows and a calf, two pigs, fifteen fowls, seven acres of rough grazing land and three acres used for hay. Local people were employed to tend the animals, land and garden. Mr Brayne, in addition to his duties as a handyman and occasional butler, also had to find time to pose for the artist. The members of the household staff were featured in a painting, *Cook, Butler, Gardener and Others*, which was exhibited at the Royal Society of Portrait Painters in 1941.

Local writer, Mrs Monica Hutchings, in her book *Inside Somerset* commented,

> The rambling old house was for long the home of artist Knighton-Hammond who, having spent a lifetime painting in France and Italy as well as being one of the leading water-colourists of this country, turned his attention to the Somerset-Dorset scene and its interesting characters and inhabitants.[2]

Difficulties of War
Meanwhile, the war was taking its toll on London. The Arts Club, formed in 1863, which had moved to Lord Stanley of Alderley's house in Dover Street at the end of the previous century, was a casualty. The artist received a letter dated 29 September 1940, from G. W. Stainer, the Secretary of the Arts Club, Dover Street, informing him, 'I regret to say that the Club and its contents are almost entirely destroyed. The building received a direct hit from a H. E. bomb which appears to have penetrated through the library and coffee room exploded in the basement and brought down that entire side of the building. . .' Knighton-Hammond had spent a great deal of time in the Club's cultured environment with fellow artists and its destruction was to mark the end of his long link with the London artistic scene.

For artists, 1941 was a difficult year. Many of the London galleries had also been damaged by bombing. The various art societies and institutes had to share undamaged galleries with each other. This, together with an unwilling-ness to go to London, made exhibiting difficult. Knighton-Hammond again chose to exhibit in Scotland, this time at the Royal Scottish Society of Painters in Water-Colours. His past achievements and reputation combined with the impact of the three fine water-colours he exhibited, were such that he received a letter dated 6 January 1941 saying, 'I have pleasure in advising you that at the Annual General Assembly of Members you were unanimously elected a Member of the Royal Scottish Society of Painters in Water-Colours.' This was an achievement which gave the artist great pleasure as it brought him further recognition in his favourite medium.

During 1941, soldiers were billeted at Misterton and Knighton-Hammond recalled in his diary that the family had numerous soldiers at the house. The diary shows that a Brigadier General slept at least one night in the spare bedroom and thirty-four other soldiers slept elsewhere in Old Court.

Water-colour Painting
Around this time, Knighton-Hammond wrote an article on the art of water-colour, which was never published, but may have been originally intended for *The Artist* magazine, in a similar manner to his article on pastel painting. He began by saying, 'People think that water-colour painting is one of the easiest forms of expression but really it is one of the most difficult. . . .' He then goes on to give an account of how critical artists are of their own work,

> One summer afternoon several years ago I was wandering round Chelsea with a friend [Prince Nicholas of Greece], calling at one or two studios and, amongst them, we went to the studio of Jacomb-Hood in Tite Street. Sargent, whose house was opposite to Jacomb-Hood, had died a short time before [15 April 1925] and his water-colours then had just been sold at Christie's [24 & 27 July 1925] and the prices that they reached created quite a sensation, Jacomb-Hood told us that a few months before Sargent died, he had told him that, that day, he had destroyed more than two hundred of his own water-colours. I mention this to show how

critical a master like Sargent was of his own water-colour work.

With regard to how easy it is to over-work a water-colour, Knighton-Hammond cites an illustrated article on water-colour in *The Artist* magazine by Claude Muncaster. The colour reproduction of an unfinished work was, according to Knighton-Hammond as good a water-colour as had ever been produced in a periodical. He recalls that it was extremely well drawn in a spirited and crisp manner; full of light, colour, air, and altogether a real pleasure to look at. The following month there was another reproduction of the same picture which was now finished. However, Knighton-Hammond considered the finished picture to be utterly spoiled by the extra work to the 'unfinished' illustration. The extra work which brought the picture to a finished state was to please the public and not the artist, according to Knighton-Hammond. He clearly believed, as can be seen in his own pictures, that impressionistic work shows the artist's initial

inspiration and has a fluid spontaneity which is often lost in highly finished work. This theory was further reinforced by A. W. Rich in his book *Water Colour Painting*. In the commentary on an illustration of a water-colour by Peter de Wint, Rich observes, 'His sense of colour was more brilliant, his choice of subject more apt, and his judgement as to the exact time when a picture should be left, better than that of any of his contemporaries . . .'[3]

Commenting on giving instruction in water-colour painting, Knighton-Hammond considered that, 'To produce a really good water-colour one wants the passion of Van Gogh together with the brush drawing of Rembrandt and with all the knowledge of colour, light and air that the impressionists have taught us.' The care Knighton-Hammond took in his own efforts to emulate these great masters accounted in large measure for his growing success.

With regard to his own style and technique,

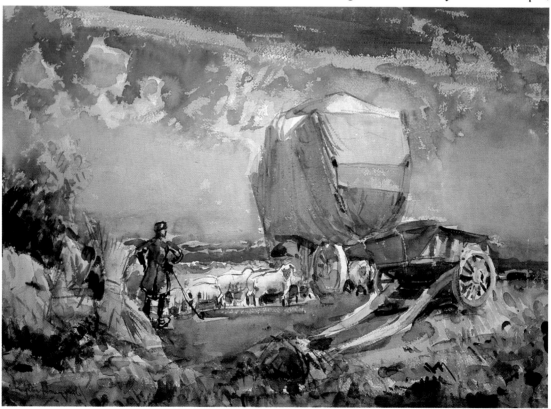

Plate 84. *Misterton, Somerset with covered wagon and sheep.*
Water-colour. 54.5 x 77cm (21.5 x 30.25in). Author's Collection.

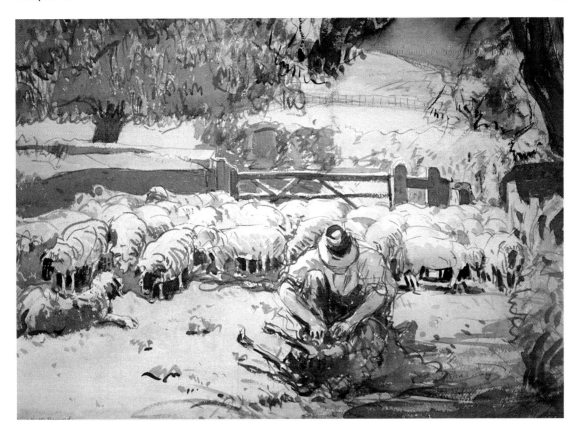

Plate 85. *Mr Jeffrey attending his Sheep.* Water-colour. 53 x 75cm (20.75 x 29.5in). Private Collection.

Knighton-Hammond gives an account of a typical day's work. He describes the day he attended a village horse show, probably in Ditchling, complete with parked farm wagons, carthorses, hacks, hunters, thoroughbreds and children, ostlers, men and women who would have attended such a show. He started with a sheet of imperial size paper on which was sketched in charcoal the permanent features such as trees. Next, in water-colour, he sketched in the figures, at lightning speed, before they moved away; followed by the horses, motor cars and other features that affect colour, form, light and shade. Splashes of colour were added as near to the shape of the shadows as possible; then the tents in the middle distance were drawn, followed by the distant fields and hedges behind them, the shapes of the branches, masses of leaves and so on to the sky. As the splashes of colour forming the shadows dried, the colour of the light green grass was added, and the whole was left after something like an hour's work.

Knighton-Hammond carried out four similar water-colours during the day. Working at speed in a changing environment was essential and the artist was well equipped to do so. His technique, as described above, can be seen in many of his water-colours. Indeed, this account gives an intriguing insight into the artist's work and the way he built up one of his pictures.

In Somerset, Knighton-Hammond worked in and around the local fields which were where he painted *Misterton, Somerset with covered wagon and sheep* (Plate 84). Here, he uses considerably more brush-work than is usual for him, yet each stroke of the brush, which seems to attack the paper so casually is in fact carefully and masterfully executed. The artist's sure hand and eye enables him to indicate form, light and colour, which breathe life on to the paper.

Similarly, in two of his other local studies, *Mr Jeffrey attending his Sheep* (Plate 85) and *The Bent Tree* (Plate 86), Knighton-Hammond uses this free and sketchy technique with bold assuredness.

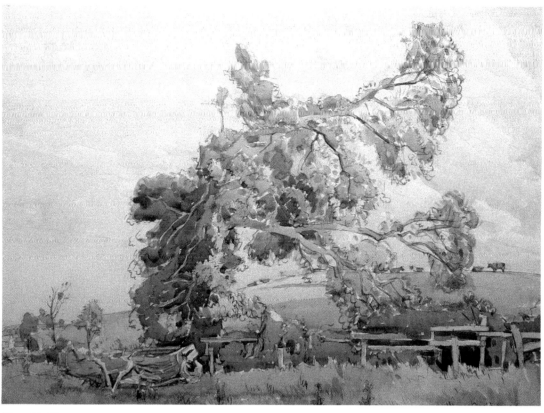

Plate 86. *The Bent Tree*. Water-colour. 54.5 x 76cm (21.5 x 30in). Private Collection.

Cloud Studies

When discussing cloud studies one immediately thinks of John Constable, who, throughout his life, made a great many studies of the subject. Knighton-Hammond would have seen these works on trips to the galleries in London, in particular on his visits to the Victoria and Albert Museum.

Although Knighton-Hammond had carried out many cloud studies in the past, he gave greater time to the subject when he was settled in Somerset. His friend, George Behrend, encouraged him in this, recounting to him in their correspondence his memories of the many occasions when he had accompanied Philip Wilson Steer on painting expeditions to estuaries where cloud studies had dominated the composition. Steer would choose a precise time and location to show the sky reflected in the water and mud at low tide to best advantage. In a letter to Knighton-Hammond dated 29 July 1941, Behrend said, '. . . I never tire of watching the atmospheric changes, sky effects, cloud shadows and

reflections in this vast landscape, and in my latter years it is effect and not fact which gives me pleasure, and is what Steer always went for and was so successful in capturing.' Steer's talent in cloud studies in water-colour is well known and documented. Pictures such as *Stormy Sky, near Stroud,*[4] *Bridgnorth*[5] and *Misty morning on the Severn,*[6] are typical.

A. W. Rich, who had given instruction to Behrend, said of cloud studies, '. . . nothing in nature has afforded me greater pleasure than contemplating the sky and its ever-changing moods. I have felt ever since I started painting from nature that here was much that would last me for my lifetime.'[7] His feelings were obviously shared by his pupil, who in turn passed them on to Knighton-Hammond.

Clouds of Wessex (Plate 87) and *Stormy Dawn over Druid's Hill* (Plate 88) are examples of the artist's cloud studies in water-colours. These pictures were later exhibited at the RI in 1965 and at the 'Britain in Water-Colours' show; the latter picture under the title of *Stormy Sunrise*. He could

Plate 87. *Clouds of Wessex*. Water-colour. 37.5 x 56cm (14.75 x 22in). Private Collection.

Plate 88. *Stormy Dawn over Druid's Hill*. Water-colour. 28 x 38cm (11 x 15in). Private Collection.

Plate 89. *Wayford Manor*. Water-colour. 58.5 x 76cm (23 x 30in).
Reproduced by kind permission of Gordon Hodge Esq.

not have painted these studies without the combined skills of keen observation and rapid notation. At the point where the land meets the sky, Knighton-Hammond brings drama and mystery. He shows no distinction, blending the paint from one to the other in a continuous tone, blurring the edges and filling the void. Druid's Hill featured in many of his landscapes and was the name given to a hill in Bale's field, near Old Court, reputed to have been where druids held their mysterious ceremonies.

Wayford Manor

Many of Iris' relatives lived in the area with connections to the three main local manor houses. Iris would often visit a distant relative, Mrs Helen Baker, at Wayford Manor near Misterton. On one of these occasions, Knighton-Hammond went to the house and painted a water-colour, *Wayford Manor*

(Plate 89), which featured the south elevation and loggia from the terraced garden.

Building work on this house started in about 1602 and it was originally designed by Giles Daubeney to a conventional 'E'-shaped plan. The work, however, was not finished until many years later. The house and land were purchased in 1899 by Lawrence Ingham Baker, Helen Baker's husband, who employed his architect brother-in-law, Harold Ainsworth Peto, to design the three-arched loggia for the east end in about 1905 and also to lay out the gardens.

Helen Baker's other brother, Sir Henry Peto (1840-1938), lived at nearby Chedington Court (Harold Peto was Sir Henry's younger brother), while a further member of the Peto family, Ellen, was married to William Roland Mitchell and lived at nearby Seaborough Court. William and Ellen Mitchell were Iris's aunt and uncle.

When Lawrence Baker died, his son Humphrey inherited the property and continued

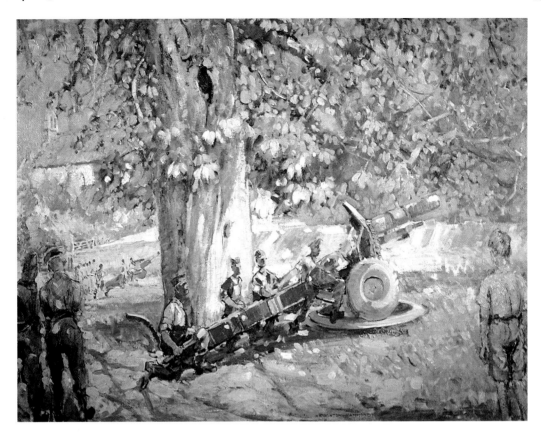

Plate 90. *25 Pounders under a Chestnut Tree.* Oil on panel. 70 x 91.5cm (27.5 x 36in).
Reproduced by kind permission of Gordon Hodge Esq.

to care for the garden. He was living at Wayford at the time of Knighton-Hammond's visit. This attractive manor house was built in a vernacular style with the window surrounds, arches, label mouldings and coping stones constructed of dressed Ham stone, and the remainder of the structure built of random rubble.

In *Wayford Manor* (Plate 89), Knighton-Hammond dramatically captures all of the elegant charm of the house set in its graceful gardens. He uses the whiteness of the paper, untouched by paint, to pick out the highlights, and these white areas are in brilliant contrast to the explosion of surrounding colour from the blaze of blossom and foliage in front of the manor, and the vivid blue sky, framing and deepening the honey coloured tones of the manor.

Painting in Somerset

The artist had a number of local haunts in addition to Bale's field. A favourite was Manor Farm which was immediately to the south of Old Court and was farmed by the Jeffrey family.

Knighton-Hammond was frequently out in Jeffrey's fields where he painted countless pictures of a wide variety of subjects including farmyard scenes, landscapes, farmers at work, horses working and at play, cattle and sheep.

Back at Old Court the soldiers returned in August 1942 and gave the artist an opportunity to record their stay. He painted a number of water-colours and oils such as *25 Pounders under a Chestnut Tree* (Plate 90). This oil painting portrays the artillery attending their guns with the artist's son, John, looking on. St Leonard's Church is visible in the background. Two pictures recording the army in Misterton were exhibited at the United Society of Artists Exhibition held at the Royal Academy in 1942. Herbert Davis Richter was on the hanging committee and wrote to Knighton-Hammond on 21 December saying, 'Your oil has an excellent place on the line opposite the entrance to what is generally the Architectural Room, now turned into the "Gem" Room. The water-colour also has a place on the line centre right

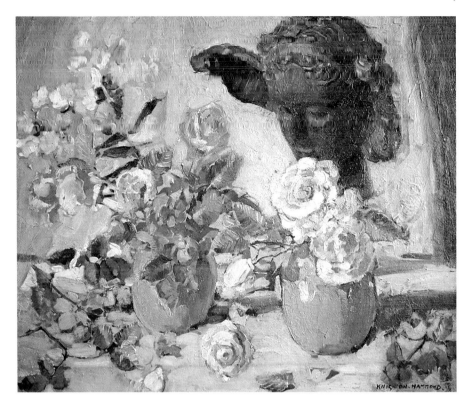

Plate 91. *Roses and Clematis in Blue Vases.* Oil on panel. 49 x 59.5cm (19.25 x 23.5in). Author's Collection.

hand side of doorway in No.1 Gallery.'

As part of the war effort, during 1942, Knighton-Hammond donated a picture to Mrs Churchill's 'Aid to Russia' exhibition held at the Wallace Gallery. Also, an oil painting, *Derby Day on Epsom Downs,* and a water-colour, *The Good Earth,* were donated to the Royal Air Force Benevolent Fund exhibition, held at the Central Institute of Art at the National Gallery, London.

The artist continued to exhibit in England and Scotland at the usual societies and institutes on an annual basis. At the Royal Academy during 1943, Knighton-Hammond exhibited *The Muck Cart.* This was a striking oil painting which he painted at Manor Farm. The picture was purchased by a Mrs C. T. Roberts of Deddington Manor, Oxford.

During bad weather, Knighton-Hammond would select flowers from the garden and arrange them within a still-life composition for painting in his studio. He appeared to have had no particular preference as to the medium for this subject. Indeed, he produced many examples in oils, water-colours and pastel. *Roses and Clematis in Blue Vases* (Plate 91) is

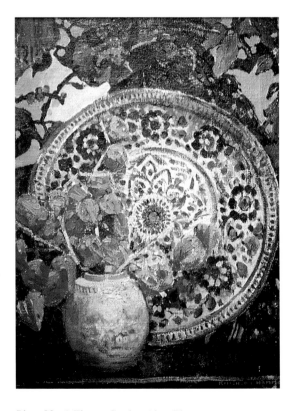

Plate 92. *A Flower Study with a Plate.* Oil on canvas. 60 x 44.5cm (23.75 x 17.5in). Author's Collection.

Plate 93. *A Flower Study.*
Oil on canvas.
89.5 x 69cm (35.25 x 27.25in)
Private Collection.

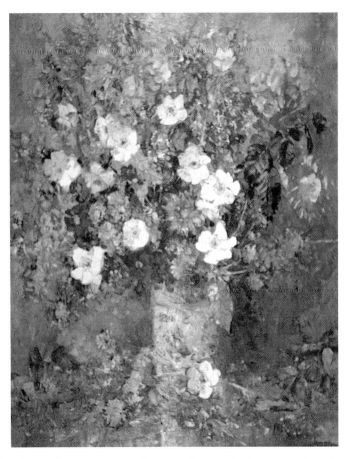

an example in oils in which he added a piece of sculpture to the composition. In this picture, as with many of his oil studies, he uses the paint in an impasto manner, thick in texture and rich in colour. More subdued in colour is *A Flower Study with a Plate* (Plate 92) which shows a vase filled with bright orange Chinese lanterns and a plate which he probably brought back with him from Tunisia in 1922 and which remains in the Knighton-Hammond family to this day. A more detailed and intricate composition is produced in *A Flower Study* (Plate 93). This large oil painting is a glorious flower study and ranks alongside works of the great flower painters of the era such as his friend, Herbert Davis Richter.

Iris would assist her husband with his still-life compositions by making flower arrangements for him to paint. Indeed, she was quite accomplished in this art having taken a course in flower arranging with Constance Spry in London. Her skills were also put to good use making wedding bouquets to order and

arranging flowers for local churches. As Iris was also a keen gardener, the flowers were always well tended and freshly picked. Often, after the flowers had been skilfully arranged for him, the artist would remove the odd blossom and place it on the table next to the vase, much to his wife's annoyance!

Roses (Plate 94) was produced with a sparing use of pastels and was exhibited at the Pastel Society in 1949. *Full Summer* (Plate 95) is an example of a flower study in water-colour. This picture is one of a series he carried out of the four seasons. Each of the pictures had very little paintwork to the background, relying on the colour and texture of the paper and the strength of colour to the flowers. This picture was later exhibited at the RI. He went on to paint a similar series of flower paintings relating to the months of the year. *September* and *October* are examples which were exhibited at various exhibitions. They clearly indicate that the artist had developed a style of decorative flower painting in all mediums, and

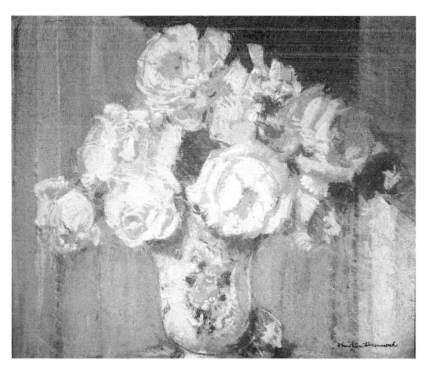

Plate 94. *Roses*.
Pastel. 31 x 38cm
(12.25 x 15in).
Private Collection.

are well composed, strong in colour and vigorously painted.

In his studio, Knighton-Hammond would paint subjects from the Riviera. These would have been worked up from his sketchbooks or copied from pictures still in his possession. Whilst in his younger days he would always have painted *en plein air,* he was now at a stage in his life where he did not want to travel long distances. However, such was his love of the blue skies and busy market-places of the Continent that he was able to relive his past and enjoy copying his earlier work.

During June 1944, the artist painted a picture of *Horseshoe bend on the Severn.* This was probably a studio picture and may well have been inspired by Philip Wilson Steer who painted a number of pictures of this subject dating from around 1909.[8] The picture was later (1946) exhibited at the Royal Scottish Society of Painters in Water-Colours (RSW). He had a copy of Robin Ironside's book on Wilson Steer, which he loaned to his friend George Behrend, who was with Steer when he painted a number of the pictures illustrated. In a letter dated 11 March 1945, Behrend wrote, 'I had a deal of pleasure from the Steer and shall return it by registered post very shortly,

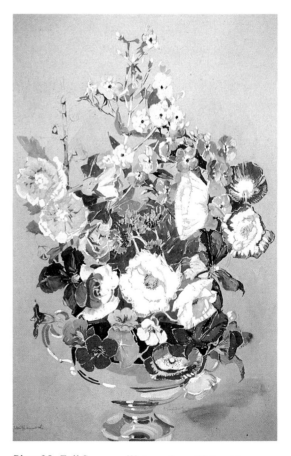

Plate 95. *Full Summer*. Water-colour. 68.5 x 44cm
(27 x 17.25in). Private Collection.

and with grateful thanks for your loan of it. . . Its illustrations reminded me of many names mentioned and of places stopped.'

In August 1944, the Knighton-Hammond family hosted a garden fête at Old Court. About two hundred people attended and the artist immediately busied himself with sketchbook and paints. He produced a number of water-colours, one of which was later (1951) exhibited at the RSW and purchased by Dundee Art Galleries and Museums for their permanent collection. As Old Court was immediately adjacent to St Leonard's Church, the family were to host the annual church garden fête on many occasions, a task which they appear to have enjoyed.

Throughout his life, the artist had exhibited regularly in the north of England, at Bradford City Art Gallery, Sunderland Art Gallery and, in early 1945, at the Manchester Academy of Fine Arts exhibition. This exhibition, at which he was to exhibit annually for many years, was held at Manchester City Art Gallery. Also during 1945, he exhibited at the Royal Society of British Artists and the New English Art Club, which may have been some compensation for not being selected for the Royal Academy earlier in the year. Knighton-Hammond was bitterly disappointed by this rejection and had hoped that frequent exhibiting there would eventually lead to his election to membership. Herbert Davis Richter wrote to the artist on 8 May 1945 saying, 'Sorry you did not have luck with the RA. It's always impossible to size up or estimate the fortune of this show. . . .' Also a letter from Sir Frank Brangwyn, dated 29 September 1945 may have put this disappointment in perspective, 'Have you sent to the RA? It seems to me that all that made the RA great has gone, now it is a cheap sort of an affair. Why they do not elect men like yourself is a mystery beyond my understanding. I wish I could have a talk with you, or see my dear friend John.'

With regard to the artist's son, John, as he began to grow up, it was obvious that his mental ability was not developing as it should. This was such a disappointment to Knighton-Hammond that he would not face up to it for a long time. However, in due course, a place was found for John in a suitable residential home in Surrey. Knighton-Hammond was heartbroken when he realised his son would never develop normally. Mrs Wright, who had been charged with John's care, left to work in London in the middle of the war. After the war, she went abroad to join her husband. However, when she returned to England on leave she and her husband would often stay at Old Court.

During times of illness the artist was attended by Dr Lawrence Wear of Crewkerne. A close friendship developed, and Dr Wear would often visit him at his studio and watch him at work with great interest and admiration. Dr and Mrs Wear dined with the Knighton-Hammonds on special occasions, and they also acquired several pictures.

Arnold Library

In 1946 Knighton-Hammond donated a collection of oil paintings and water-colours to Arnold Urban District Council. It was primarily intended as a memorial to his parents who were both born in the town. In addition to the pictures was a scroll, the work of the artist's daughter, Dorothy, giving the names of Knighton-Hammond's mother and father with a photograph of both of them.

The artist was invited by Arnold Urban District Council to formally present the pictures but he was unwell so his sister, Harriet, and his cousin, Sam Hammond, represented him. Fig. 46 is a photograph of the presentation showing a number of the pictures hanging on the wall of Arnold Public Library. Harriet is second from the left, proudly viewing her younger brother's paintings.

Knighton-Hammond's connections with Nottingham were further reinforced in 1953 with the publication of Henry Hall's book, *Artists and Sculptors of Nottingham and Nottinghamshire*. The artist was featured in the book with a very complimentary account of his life.[9]

At the Manchester Academy of Fine Arts exhibition in 1946, *Brighton Beach* was purchased by Maxwell Reekie, an art agent acting on behalf of the National Gallery of

Fig. 46. The Presentation at Arnold Public Library.

South Africa, for their permanent collection. In addition to the usual exhibitions in the north of England and Scotland during 1946, the artist also exhibited at the Bath Society of Artists at the Victoria Art Gallery. Four pictures were exhibited and later in the year a pastel, *The Thames at Greenwich*, was also sent when the Pastel Society held an exhibition at Greenwich.

After the war, Knighton-Hammond did not venture far from home, except in October 1946, when Iris drove him to London. They stayed at Bailey's Hotel, Gloucester Road. The next day they drove to the Royal Earlsworth Hospital near Redhill, Surrey and collected John, who was now a permanent resident. They had lunch at the Downs Hotel, Hassocks, and went on to visit Brangwyn at Ditchling before returning to London. The next day they were joined by Knighton-Hammond's daughter Mary, and they all visited the National Gallery, the Wallace Collection and to see the work of Constable at the Victoria and Albert Museum. The following day was equally busy and the couple returned home by early evening from what was to be the artist's last visit to London.

Self–Portraits

Early in 1947, Knighton-Hammond painted a self-portrait in oils for an 'Exhibition of Self-Portraits by Living Artists' at the Russell-Cotes Art Gallery, Bournemouth, Dorset. The exhibition was well represented and the artist was in the eminent company of artists such as Augustus John and Wilfred G. de Glehn. Ninety of the one hundred and forty one self-portraits were illustrated in the exhibition catalogue, including that of Knighton-Hammond. He started a further self-portrait soon after (Frontispiece), also in oils.

While he busied himself painting local landscapes and manor houses, he also found time for portraiture. Many local people had their portraits painted by Knighton-Hammond and models would come to his studio for him to paint from life.

Life in Somerset

During April 1947, Knighton-Hammond sat at the end of the avenue of lime and plane trees leading to the rear entrance of Old Court and painted a number of water-colours, including

Plate 96. *The Avenue of Trees, Old Court, Misterton.* Water-colour. 56 x 77cm (22 x 30.25in). Author's Collection.

The Avenue of Trees, Old Court, Misterton (Plate 96). The trees and grass are bathed in bright sunlight and are painted in soft, light tones. The artist's son is walking through the avenue of trees towards the house. This simple scene has a peaceful and comforting tranquillity.

On 26 April 1947, the artist, his wife and daughter Mary travelled to the city of Bath, to visit the Victoria Art Gallery where the Bath Society of Artists held their annual exhibitions. The family also had tea in the Assembly Rooms after a trip round the Roman Baths. This was a pleasant return visit to the city for Knighton-Hammond who had been there to paint in the early 1920s when he produced the *Abbey Church Yard and Pump Room, Bath* (Plate 35).

The artist received his regular copy of *The Studio* on 29 April 1947, and was pleased to see that his pastel of *Morning on the Thames at Greenwich* had been reproduced in colour in an article on the Pastel Society by Herbert Davis Richter.[10] The picture had been painted many years earlier, possibly in 1933 while

Knighton-Hammond was staying at The Ship Hotel, overlooking the Thames.

In rural Somerset, the artist was still keen to tour the district seeking out new subjects to paint. Iris would drive him to his chosen location. In late May 1947, Ham Hill was the destination, when he painted a number of water-colours of the landscape, quarry and stone-cutting works.

On a further trip to Bath in June, Knighton-Hammond stopped off on his way to paint a water-colour of the thirteenth century George Inn at Norton St Philip. This was also a convenient place for refreshment and the heavily carved interior of the building was of historical interest to the artist. Whilst in Bath the artist called on Charles Davis Richter, brother of his friend, Herbert. Charles was also a painter and was involved with the Bath Society of Artists.

The latter part of 1947 was spent painting in the studio. Knighton-Hammond would often take pictures from his studio collection and

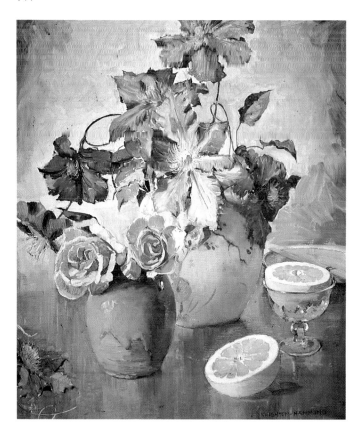

Plate 97 *The Climbing Clematis*
Oil on panel. 59 x 50cm
(23.25 x 19.75in) Private Collection

work on improving them. These were generally pictures from the 1920s and 30s. He would also paint copies of those he particularly liked, generally for his own amusement and not necessarily for exhibition.

In addition to the many and regular exhibitions in 1948 in London, the north of England and Scotland, he exhibited an oil painting, *Derby Day*, at the Royal Cambrian Academy. He also exhibited two works at the Royal Scottish Academy: *Derby Day* and *Oxford* (from Sir Montagu Pollock's Garden, 1937). The latter is a view from Headington Hill and the visit to paint this view would have been arranged by George Behrend, who was a close friend of Pollock.[11]

The following year was equally filled with exhibitions and the artist exhibited for the first time at Aldridge's Gallery in Worthing, Sussex. During 1949, Knighton-Hammond worked on a number of still-life paintings which included his own bust by Doyle Jones (Fig.29). He had two of these busts in his possession and they are still in the family to this day. Among the still-life paintings was *The Climbing Clematis* (Plate 97)

which was exhibited at the ROI in 1949.

On 13 July 1950, the artist received a letter from Rochdale Art Gallery saying that they had bought *Conversation Piece at Grasse* (Plate 52) from the RI exhibition for their permanent collection. This picture was proving popular as Percy V. Bradshaw of the Press Art School Limited, London, approached Knighton-Hammond for permission to illustrate it in a book he was compiling for *The Studio*.[12] A letter from Bradshaw dated 18 May 1951 read, 'Your work at the RI has already shown me that you have an astonishing variety of styles at your command, but a few notes about this particular type of work, its size, colours used, etc, would be greatly appreciated, and you may be sure that I will get *The Studio* to use this.'

In addition to the regular exhibitions during 1951, Knighton-Hammond sent works to the Russell-Cotes Art Gallery and Museum, Bournemouth. The exhibition was entitled, 'Art Inspired by Music' and the artist sent six pictures, each with a commentary about the piece of music which inspired the picture. Also,

Plate 98. *Portrait of Mrs Wright*
Oil on panel. 75 x 62cm
(29.5 x 24.5in). Private Collection.

the artist was pleased to exhibit again at Nottingham Castle Art Gallery during 1951.

Di Wright and her husband returned home from the Far East to settle in Dorset in 1951. Knighton-Hammond had painted a *Portrait of Mrs Wright* (Plate 98) for Christmas 1939. However, on her return he had the oil painting returned to his studio to bring it more up to date. The artist inscribed on the rear of the panel 'To Dinah X-mas 1939. Finished February/March 1951'.

Sydney Colwyn Foulkes continued to visit Knighton-Hammond and purchase his pictures, some for himself and some for re-sale. In a letter dated 20 March 1952, he comments, 'I am very proud of *Threshing*, it gives me great joy. Even prouder am I of the Dolwyddelen one with Ralph and I in the foreground. I have this hanging in my office and nothing else.'

During 1952, Knighton-Hammond arranged through Bourlets for pictures to be sent to the regular exhibitions. He also exhibited at the 'Britain in Water-Colours' show at the Royal Water-Colour Society in London, where he chose to exhibit the typically English scenes of *The Garden Party* and *Heifers and a Byre*.

Herbert Davis Richter was on the hanging committee of the ROI and he wrote a letter to Knighton-Hammond regarding the 1952 exhibition saying, '*The Farm Labourer* has a centre line position in the large gallery on the left hand wall passing in to the West Gallery – excellent.'

Gradually, from around the mid-1950s, Knighton-Hammond worked less and less. He still went to his studio regularly but was not turning out as much work as he had in the past. He had accumulated a large quantity of pictures over a great many years, which were stored there. It was from this store that he continued to exhibit on a regular basis.

The lack of new work may have been the reason for Knighton-Hammond's decision to resign from the Pastel Society. The letter of resignation received a reply from his friend Herbert Davis Richter after it had been placed

before the committee. Dated 20 November 1952, it read,

> I have delayed writing you about your resignation of membership of the Pastel Society until after our meeting last night. The members were extremely sorry. . . . We were anxious however to pay honour to so distinguished a pastelist and unanimously elected you an honorary member, a position you will share with Brangwyn and Sanderson-Wells. We hope you will be able to contribute a work from time to time.

At an exhibition of 'English Water-colours and Drawings' at the National Museum of Belgrade, Yugoslavia, staged from July 1953 to January 1954, a water-colour by Knighton-Hammond was displayed. *Trafalgar Square* (Fig. 47) was from the museum's permanent collection and had been acquired some time before. This dates from the 1920s or '30s and may have found its way to the collection from Prince Paul of Serbia, who was the son-in-law of Prince Nicholas of Greece.

In June 1954, Knighton-Hammond resigned from the Royal Scottish Society of Painters in Water-Colours. This was probably again a result of his declining output. After all, he was by now, seventy-eight years old.

Seaborough

In 1955 the Knighton-Hammond family decided to move. Old Court was too large for their needs and they decided to buy a seventeenth-century farmhouse, Higher Farm, four miles away in the neighbouring village of Seaborough over the county line in Dorset. The house was a typical Dorset stone farmhouse and at the end of the garden there was a large barn which was immediately converted into a studio. Knighton-Hammond frequently said it was the best studio he had ever had.

During 1955, now settled in his new studio, Knighton-Hammond placed in *The Studio* magazine a number of advertisements offering lessons in 'Oil-painting, Water-colour, Pastel and Drawing, Figure, Landscape and Flowers from Nature.' Giving lessons seemed to suit him better as he gradually withdrew from public life. In a letter dated 26 April 1955, in reply to the artist's resignation from the Royal Institute of Oil Painters, the secretary, Reginald

Fig. 47. *Trafalgar Square* Water-colour. 46 x 49cm (18 x 19.25in). National Gallery of Belgrade.

Blackmore, said to Knighton-Hammond 'I personally fully appreciate your wish not to be further bothered with the framing and dispatching of work for the exhibitions, and it must certainly be gratifying to you again to commence teaching which will keep your great interest in painting alive . . .' Knighton-Hammond, however, continued to exhibit on occasion at the ROI.

On 28 April 1955, the artist received a letter from the President of the American Watercolor Society informing him he had been made a life member. Knighton-Hammond had always considered his membership of this prestigious society to be very special, and to have it crowned with life membership gave him great personal satisfaction.

Local people continued to be collectors of Knighton-Hammond's work. Sir Edward du Cann, former MP for Taunton, and John Peyton, MP for Yeovil, now Baron Peyton, both visited the artist and bought pictures direct from his studio.

'Captured on Canvas'

In an extensive article entitled 'Captured on Canvas' for the 1 July 1955 edition of a local newspaper, the *Western Gazette*, writer Monica Hutchings recalls in considerable detail a visit she made to Knighton-Hammond's studio. Her initial reaction when confronted by 'great canvases of Italy and France hung side by side with studies of English farm-workers or the more homely scenes of Epsom Downs. . .' was one of sheer frustration at not being able to paint! She then raised the question of what makes an artist great,

This spark of genius lifts the true artist above those who "sketch for a hobby," or (like myself) have to recourse to a camera to express themselves in visual art. Mr Knighton-Hammond . . . is modern and "uncluttered" in his approach to art, and yet has all the traditions of the great masters behind him, without which, I think, the present is always hollow and empty. Beauty is everywhere for him, whether in some colourful Continental scene where he travelled and studied widely or in the sunlight

falling on some Dorset farmyard. And his busy brushes interpret with equal felicity the features of some well-known member of society or the unsophisticated lineaments of a village child. He requires only that they shall have character and be paintable!

In Dorset, Knighton-Hammond had plenty of characters to paint. One of his many portraits of local girls, entitled *Brenda as Joan of Arc*, had been hung on the line at the 1954 exhibition of the Royal Institute of Oil Painters. Many local people, including the sitter and her family, travelled to London to view the painting at the gallery.

Mrs Hutchings also provided the artist with subject to paint. She appears to have been instrumental in bringing along her dance group to a garden party at the artist's home. He immediately began to paint them as they danced to the music. The article records Mrs Hutchings' observations,

Soon I was to find two dreams coming true at one and the same time. First of all to see these delightful young friends of mine captured on canvas in all their joy of living and moving, and secondly to see a proper artist "at work." I was amazed at the swift deftness, the firm building up under our eyes of a picture true to life, yet always something more – an impression, an interpretation. It was an inspiration to watch both the growing likeness and the enjoyment somehow shared between artist and sitter.

Mrs Hutchings even sat herself for Knighton-Hammond and received one of the two portraits he painted. She was also given a portrait of her husband as a surprise gift and commented in an article, '. . . there he is, captured on canvas, an extraordinary likeness, my only complaint being that the face possessed more authority than I thought it had. Is that how he looks to other people?'

On 12 June 1956, the artist was sad to hear the news on the wireless that his old friend Sir Frank Brangwyn had died the previous day. The two artists had kept in touch for over 20 years and Knighton-Hammond must have reflected back to the days they spent in Ditchling discussing painting and telling each

other stories of their past. Much correspondence had passed between them and Drungwyn's letters to Knighton-Hammond are now in the British Museum.

At the beginning of 1957, the artist held an exhibition of more than thirty pictures at Yeovil Museum. He was a frequent visitor to Yeovil Library borrowing books on art and artists. He still had a great interest in his subject and the librarian, Mr E. A. Batty, who was also curator of the museum, would get him the books he required. Mr Batty and his assistant Mr C. G. Clarke helped hang the exhibition, which was much appreciated by the local community.

Memoirs

In 1958, Knighton-Hammond began writing his memoirs. It is regrettable that he did not begin this task earlier because by the time he made a start his memory was failing and consequently the contents suffered. He had made numerous previous attempts at recording the early period of his life up to about the First World War and had kept notes on this period from which to work, but he appears not to have referred to his diaries for dates and events which may explain why his memoirs are not in chronological order and he also frequently repeats himself.

His memoirs start with one of his earliest recollections when, aged about six years, he accompanied his mother on a trip to London to visit his older brother who had recently married. They were met at King's Cross station by his new sister-in-law and the three of them travelled by bus to his brother's house in Wimbledon. He recalled the view of the Thames and its shipping as they passed over London Bridge, and St Paul's Cathedral dominating the surrounding area. He found the whole experience fascinating.

The text was typed for him and he made many corrections to the first draft. Knighton-Hammond was never fully satisfied with it and this may have been the reason why he never finished it or had it published – though the unpublished memoirs have been of great assistance to the author in compiling this book.

One-Man Exhibition

With a vast accumulation of work in his studio, the artist decided to hold a one-man show in London. The Royal Water-Colour Society's galleries in Conduit Street were selected and all necessary arrangements were put in hand. Stiles and Sons, agents for the RWS were employed to do the framing and hanging. One hundred and seventy-five pictures were to be exhibited under the title 'Exhibition of Water-Colours, Oil Paintings, Etchings, Pastels and Drawings in Sanguine'. The exhibition was held in June 1959.

Knighton-Hammond did not attend the exhibition himself because, by now, he was beginning to feel his age of eighty-three, and was unwell. Much of the organisation for the exhibition was done from his bed with his wife's assistance. With such a quantity of pictures in a variety of mediums, the exhibition was well received.

During 1959, with renewed enthusiasm, Knighton-Hammond rejoined the Royal Scottish Society of Painters in Water-Colours and the Manchester Academy of the Fine Arts.

In 1961, he exhibited for the last time at the Royal Academy. *Grand Canal with the Church of the Madonna della Salute, Venice* was selected from his studio collection and accepted by the Academy. It remained a great disappointment to him not to have been elected to membership of the RA. His other achievements however, were significant compensation.

Portrait of a Nurse

During the latter part of 1962, Knighton-Hammond was sent by Dr Wear to Bridgwater Hospital in Somerset for an operation. Throughout his six-week stay he was attended by a number of nurses including Staff Nurse Margaret Thomas. A good insight into the artist's generous character was that immediately on his discharge from hospital, as an expression of his gratitude, he arranged to paint the portrait of the Staff Nurse. The painter's promise was reported in a *Daily Sketch* item 'When I get out I would like to paint your portrait'.

Staff Nurse Thomas attended four sittings

Plate 99. *A ministering angel thou.*
Oil on canvas. 73.5 x 59.5cm
(29 x 23.5in). Private Collection.

at the artist's studio. The resultant picture was exhibited at the ROI under the title *A ministering angel thou* (Plate 99), and received a great deal of attention. The *Express* reported, 'One of Britain's eldest artists has painted the portrait of a nursing sister who looked after him in hospital . . . Mr Knighton-Hammond said last night: "She was very charming and I was particularly struck by her pleasant face and scrupulously neat appearance".' The article went on to say that the artist gave each of the six nurses who attended him one of his water-colours.

The painting shows that even at the age of eighty-seven years, Knighton-Hammond had not lost any of his skills in the art of portraiture. In a sympathetic study, he has captured the nurse with an expression of caring dedication.

A reproduction of the picture was featured in the *Shell B.P. News*, the company's monthly magazine, possibly as a tribute to Margaret's father, Mr I. J. Thomas, who had just retired from Shell after thirty years' service. The *Nursing Mirror* of 2 November 1962, also used the portrait in an article about the nurse.

Another portrait painted around this time, *Carter* (Plate 100) is also an affectionate study of a local farmworker, Frank Hole, who worked on West Swillets Farm, Scarborough, for Mr and Mrs Creed. The artist would, no doubt, have enjoyed painting this portrait which would have reminded him of his days in Ditchling and the many characters he painted while he was there.

The Greek Royal Family
In this less active period of his life, Knighton-Hammond remained in contact with members of Prince Nicholas of Greece's family. In a letter from Kensington Palace dated 4 January 1958, in reply to a letter from Mrs Knighton-Hammond, Princess Alexandra wrote,

The two lovely pictures of Mr Knighton-Hammond's, which you sent me, are so enchanting and I shall always treasure them. I would like him to know how very touched I was by his kind thought, and send him all my warmest wishes for the New Year. I look forward to hanging the paintings in my sitting room, they look so peaceful and warm, that

they will be a pleasure to gaze at.

His main contact was with Princess Olga. In a letter dated 27 August 1963 sent from Pratolino, Florence, she said,

> Only yesterday, after another delay of two months, that I at last received the parcel containing your water-colour, forwarded from Turin where it got stuck at the customs since last November!! The picture has luckily not suffered any ill effects and I am truly enchanted to have it, as it is full of happy memories of that summer in 1924, just before my eldest son, Alexander was born. . . . The painting is enchanting, so full of colour and movement, and I am most grateful to you for letting me have it and cannot thank you enough for such a kind thought.

Further contact was maintained through the exchange of Christmas cards and messages with other members of the Greek Royal Family including Princess Marina, The Duchess of Kent. Her Royal Highness would normally send a card of a family group portrait. From this, Knighton-Hammond was able to observe the children's progress as they grew up.

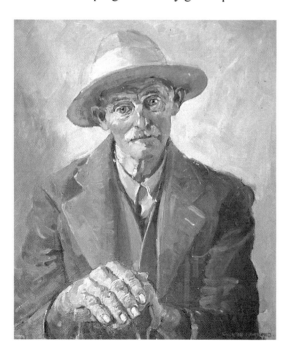

Plate 100. *Carter (Mr Frank Hole).*
Oil on panel. 59 x 49.5cm (23.25 x 19.5in). Private Collection.

TV Feature

During this latter part of the 1960s, Knighton-Hammond was featured on a regional tea-time television news programme. Filming took place in the studio at Higher Farm with some of the family looking on. His step-daughter, Ann, recalls how uncomfortable Knighton-Hammond was under the bright television lights and that it took a great deal of persuasion to get him to have make-up put on his face for the camera. After the necessity for it was explained, he relented but only reluctantly allowed the minimum of make-up to be applied. Knighton-Hammond was interviewed on camera about his life and work. The studio, which was full of his pictures, was a feast of colour and interesting objects for the viewer.

A photograph (Fig. 48) taken at around this time, shows the artist sitting in his studio surrounded by his work. Fig. 49 shows him in his home pouring himself a glass of sherry, a rare indulgence.

The Final Years

In these latter years of his life, Knighton-Hammond became much less active. He would always have his breakfast in bed and rise quite late. After lunch, he would return to bed for a siesta, a habit he probably acquired on the Continent. He would retire to bed at about 8.30 in the evening. Many local people remember with much affection that Knighton, as many of them knew and still refer to him, did not lose his Nottinghamshire accent throughout his long life, even though he left his native county in 1900.

The artist had always enjoyed his birthday parties and his ninetieth was a very significant milestone to which many friends were invited. The cake, made by his step-daughter, Ann, had nine candles, one for every decade. Dr and Mrs Wear recall how pleased the artist was with the occasion.

During his ninety-first year, Knighton-Hammond painted his last portrait which was of his long-time friend, Sydney Colwyn Foulkes. The portrait (Fig. 50 – reproduced from a photograph) shows that Knighton-Hammond still possessed his great skill in oil

Fig. 48 Knighton-
Hammond in his
studio at Higher Farm,
Seaborough.

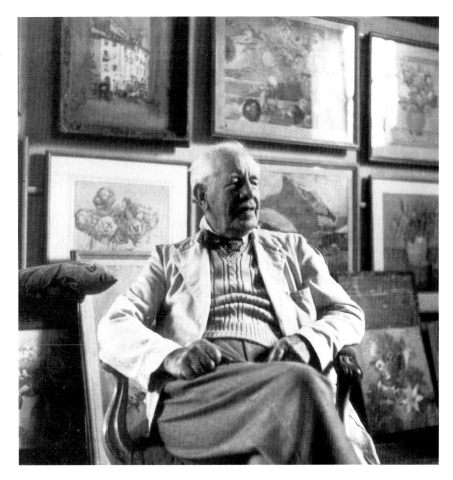

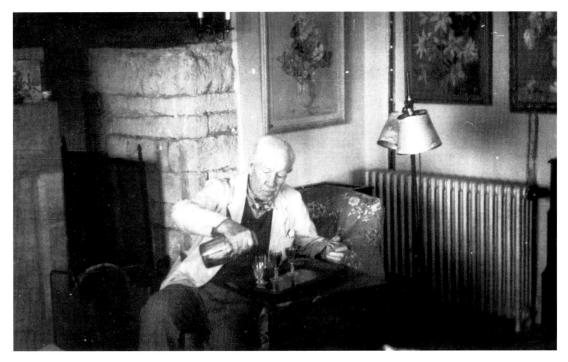

Fig. 49 Knighton-Hamond at home at Higher Farm, Seaborough.

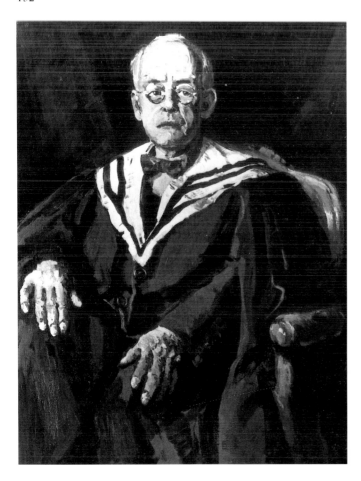

Fig. 50. Portrait of
Sydney Colwyn
Foulkes.

portraiture. Very few further works were carried out by the artist.

Knighton-Hammond died peacefully in his sleep on 28 February 1970 at his home aged ninety-four. His death was widely reported in both local and national newspapers. The *Daily Telegraph* and *The Times* both reported his death in their obituary columns. The latter also carried a separate account of his life and great achievements.

The local *Western Gazette* in its 6 March edition ran a long article and also invited Monica Hutchings to pay tribute to the artist. Under the sub-heading of 'Tribute by Authoress' she recalled, 'We first met when Knighton, as he preferred to be called, was living at Old Court, Misterton, a fitting setting for a remarkable and prolific artist. His great studio was like an Aladdin's cave of colour and art treasures and a sitting with him was an event to remember.' Mrs Hutchings, who had become a friend of the family, further

recalled, 'At his 92nd birthday party he "raffled" three of his paintings to his guests and I was fortunate enough to draw a number out of his hat and chose a scene of shipping off the coast of Brittany.' Her closing words read, 'He was a kind man, particularly to the young, a staunch friend and a very great artist, his circle of friends in the area was wide and he will be missed by many who, like us, account it an honour to have known him.' Knighton-Hammond was cremated at Weymouth on 6 March and his ashes were scattered on the rose garden at the crematorium.

Retrospective Exhibitions

Soon after Knighton-Hammond's death, a pastel portrait *Emmeline Mary*, of his second wife, was exhibited at the Pastel Society. This was followed by a number of other major retrospective exhibitions. The Upper Grosvenor Galleries, London, held one in March 1971. The preface to the catalogue was written by Adrian

Hill, PROI, RBA, who comments,

> Knighton-Hammond was very much the professional artist, who distinguished himself in all three mediums of oil, water-colour and pastel, in which he displayed equal technical "know how". A true and lovable romantic, he was a universal artist travelling widely, and wherever he chose to visit and live he brilliantly recorded the climate and the ways and life of the people. He was just as happy in painting flowers as he was in depicting the features of the flower seller, as searching in his regard for the character of buildings as in discovering the personalities of his sitters who lived within them. . .

An exhibition at Tonbridge, Kent, in May and June 1972 was opened by Sir Edward du Cann. The preface for the catalogue was compiled by Rowland Hilder, PRI, who wrote,

> As a raw and newly elected member of the Royal Institute of Painters in Water-Colours in the mid Thirties, I can well remember the impact that Knighton-Hammond water-colours made on us at the time as they hung in the spacious Piccadilly Galleries. These pictures expressed a sense of vitality that made it easy to appreciate why Augustus John said of him "This is the greatest English painter of water-colour of our time".

Review of a Long Life

From a humble background and little formal education, Knighton-Hammond, through hard work and his gift for painting, rose to significant heights. His determination is undoubted when one recalls his attendance at evening classes after having done a full day's work and with a four-mile walk home at 10.00 at night, and how he struggled to make a living when he made the big step of moving to London. During the First World War, his talent for drawing was recognised and put to good use by the British Government and British Dyestuffs Corporation Limited. His flare for illustrating industry in art was then given full encouragement by Herbert H. Dow. As time went by, his work evolved from that of a traditional landscape painter to an industrial illustrator, and perhaps most significantly of all, to an accomplished water-colourist. On the Continent he flirted with impressionism. He did not share the preoccupation of the French Impressionists with the effects of light on canvas, yet a lightening of his palette and the use of pastel colours owed much to the French artist Adolphe Valette. His pictures during this period were a those of a 'connoisseur's artist', appealing greatly to the connoisseurs of the day such as Prince Nicholas of Greece, Sir Joseph Duveen and, indeed, Queen Mary. His world did not appear to have received the recognition from the English public that one might have expected, given the acclaim he received on the Continent.

During the 1930s, his painting in oils developed as did his reputation as a portrait painter. He had the honour of being commissioned to paint the portrait of Earl Lloyd George of Dwyfor.

The latter decades of his life saw him exhibiting frequently, from his collection stored in his studio and newly painted pictures.

Knighton-Hammond's working life spanned in excess of seventy-five years. This, coupled with the fact that he worked at great speed, resulted in a prolific output of work. By his own admission not all of it was great but much of it was significant.

What changes he must have experienced in his ninety-four years! He was born before the invention of the internal combustion engine and lived to see man walking on the moon. Many of man's great achievements took place during his lifetime.

Knighton-Hammond's work has now been re-evaluated. Like many artists, shortly after his death the prices of his pictures fell. Now, more than twenty years on, there is a renewed appreciation of his work which is long overdue. It is to be hoped that this will continue, and that he will take his rightful place in modern British art history.

NOTES

Notes to Chapter 1

1. Knighton-Hammond, A.H., Unpublished Memoirs; p. 251.
2. Ibid; p. 252.
3. Lord John James Robert Manners, Seventh Duke of Rutland. Born Belvoir Castle 13 December 1818. Entered Parliament as MP for Newark, 1841. Died 4 August 1906.
4. Knighton-Hammond, A.H., Unpublished Memoirs; p. 253.
5. Dorothy was the wife of Sir John Manners (d. 4 June 1611), who acquired the Haddon Hall estate by this marriage (they are said to have eloped). Dorothy Vernon (d.1584) was the daughter of Sir George Vernon. Manners was called the 'King of the Peak'.
6. Henry John Brinsley Manners, Eighth Duke of Rutland. Born London 1852. Son of 7th Duke of Rutland. MP for Leicestershire 1888-95. Died 8 May 1925.
7. Colonel The Hon. Charles Hugh Lindsay CB. Third son of 7th Earl of Balcarres and 24th Earl of Crawford.
8. *Art Journal*, Volume XII, 1873; p. 349.
9. *The Studio*, Volume CXXX, Number 629, August 1945; pp. 40-1.
10. *Royal Academy Pictures, 1902*; Illustrating the Hundred and Thirty-Fourth Exhibition of the Royal Academy; Cassell & Company Limited, 1902; p. 3. (Catalogue No. 1638).
11. Ibid; p 177. (Catalogue No. 202)
12. Charles Alfred Cripps, First Baron Parmoor. Born 3 October 1852. Third son of Henry William Cripps. Appointed KCVO in 1908. In 1914 he was raised to the peerage, on Asquith's recommendation, as Baron Parmoor, of Frieth in the county of Buckinghamshire, and a member of the Privy Council. Died at Parmoor, Henley-on-Thames, 30 June 1941.
13. Sir (Richard) Stafford Cripps. Born 24 April 1889, fourth son of Sir Alfred Cripps. In 1930 became Solicitor-General and was knighted. In January 1931 he was elected Labour member for East Bristol. In 1942 Churchill made him leader of the House of Commons as well as giving him a seat in the War Cabinet as Lord Privy Seal. In 1947 he was made Chancellor of the Exchequer. Died on 21 April 1952.
14. Sir Charles Seely, 1st Bart. Born 11 August 1833. Only son of Charles Seely MP. Died 16 April 1915.

Notes to Chapter 2

1. *The Studio*, Volume LXXXVI, Number 368, November 1923; p. 287.
2. John Fletcher Moulton (1844-1921), educated Kingswood School, Bath, London and Cambridge Universities. A mathematician, eminent patents lawyer and scientist, his research into the nature of positive and negative electricity led him to be elected FRS, the first practising barrister to be so elected. In 1906 became a Lord Justice of Appeal, and in 1912 entered the House of Lords as a Lord of Appeal in Ordinary. Career in politics sitting intermittently as a Liberal MP for twenty years. As Director General of the Explosives Supply Department, was able to economise by inventing a new compound explosive to supersede TNT, known as amatol, and undertook the manufacture of poison gas when retaliatory action was decided upon. Awarded the KCB and GBE for his war-time services.
3. Joseph Pennell (1858-1926) Student at Philadelphia Academy of Fine Art, follower of Whistler after meeting him in England in 1884. Produced many etchings, lithographs, drawings and water-colours, illustrating a number of books and exhibiting at the Fine Art Society, London. Became a member of the Royal Society of Painter-Etchers and Engravers.

4. Pennell, Joseph, *Joseph Pennell's Pictures of War Work in England*; William Heinemann, 1917.

5. Levinstein Limited, *Four Years Work*; Levinstein Limited.

Notes to Chapter 3

1. Midland Art Council, News Release; H.C. Stephens, January 1983.

2. Ibid.

3. Matthews, Dr J. Merritt, 'Art and the Dyestuff Factory', *Color Trade Journal*; New York, c1921; p. 37.

4. Ibid.

Notes to Chapter 4

1. Knighton-Hammond, A.H., Unpublished Memoirs; p. 144.

2. Fitz Alan of Derwent, 1st Viscount c1921 of Derwent: Edmund Bernard FitzAlan-Howard, KG 1925; PC 1918; GCVO c1919; MVO 1902; DSO 1900. Born 1 June 1855. Died 18 May 1947.

3. Bury, Adrian, *Water-Colour Painting of To-day*; The Studio Ltd, 1936; Fig. 239.

4. Bradshaw, Percy V., *Water-Colour - A Truly English Art*; The Studio Ltd, 1952; p. 63.

5. *The Studio*, Volume XCV, Number 418, Jan-July 1928; p. 192.

6. Knighton-Hammond, A.H., Unpublished Memoirs; p. 168.

7. *The Studio*, Volume 99, Number 443, February 1930; p. 138.

8. Ibid, Volume 102, Number 460, July 1931; p. 68.

9. Ibid, Volume 88, Number 380, November 15, 1924; pp. 268-9.

10. Stephens, Jessica Walker (née Walker). Born: Arizona, USA. Painter, critic and writer. Studied at Liverpool School of Art (travelling scholarship to Italy), Paris and Florence. Exhibited 1904-32. Correspondent for *The Studio*.

11. *The Studio*, Volume 88, Number 381, December 1924; pp. 335-6.

12. Bury, Adrian, *Water-colour Painting of To-day*; The Studio Ltd, 1936; Fig. 99.

13. MacColl, D.S., *Life Work and Setting of Philip Wilson Steer*; Faber and Faber Limited, 1945.

14. Vanderbilt Balsan, Consuelo. Daughter of William Kissam Vanderbilt (USA). She married Charles Richard John Spencer-Churchill, Ninth Duke of Marlborough (1871-1934) on 6 November 1895 at St Thomas's, Fifth Avenue, New York City. The marriage proved unhappy, and they lived apart after January 1907. They divorced in 1921 and she married Lieut. Col. Jacques Balsan on 4 July 1921. Mother to the Tenth Duke of Marlborough and Lord Ivor Charles Spencer-Churchill.

15. Bury, Adrian, *Water-Colour Painting of To-day*; The Studio Ltd, 1936; Fig. 197.

16. Bradshaw, Percy V., *Water-Colour - A Truly English Art*; The Studio, 1952; p. 89.

17. Stratheden and Campbell, Lady (Jean Helen), CBE 1954; Daughter of Colonel William Anstruther-Gray, Kilmany, Fife; She married in 1923, 4th Baron Stratheden and Campbell; They had three daughters. She died on 9 August 1956.

18. Waddingham, Malcombe R., *Claude Lorrain - The Master Series*; Purnell and Sons Ltd, 1966; p. 2.

19. Bryan, Michael, *Dictionary of Painters and Engravers*; George Bell and Co., 1902; pp. 552-5.

20. Watson, Francis, *Tiepolo - The Master Series*; Purnell and Sons Ltd, 1966; p. 2.

21. Ibid; p. 4.

22. Ibid; p. 6.

23. *The Studio*, Volume XIX, Number 84, March 1900; pp. 107-19.

24. Hardie, Martin, *Water-colour Painting in Britain, Volume III - The Victorian Period*; B.T. Batsford Ltd, 1971; p. 168.

Notes to Chapter 5

1. Frances Louise Stevenson was formerly secretary to Lloyd George. When his first wife died, Miss Stevenson became the 2nd countess of Dwyfor, when they were married in 1943.

2. Lloyd George, of Dwyfor, 1st Earl, c1945; David Lloyd George. Born Manchester, 17 January 1863. Distinguished political career - Chancellor of the Exchequer, 1908-15; Minister of Munitions, 1915-16; Secretary of State for War, 1916; Prime Minister and First Lord of the Treasury, 1916-22. Died 26 March 1945.

3. Cobbett, William, *Rural Rides*; Penguin Books, 1987; p. 88.

4. Ibid; pp. 39-40.

5. Pope-Hennessy, Sir John, *Italian High Renaissance and Baroque Sculpture*; Phaidon Press Limited, 1985; Plate 50.

6. Ratcliff, Carter, *John Singer Sargent*; Abbeville Press, 1982; Plate 330, p. 219.

7. *The Studio*, Volume CXXXIII, Number 650, May 1947; p. 133.

8. Hardie, Martin, *Water-colour Painting in Britain, Volume III, The Victorian Period*; B.T. Batsford Ltd, 1971; p. 202.

9. *The Studio*, Volume XXXIV, Number 146, May 1905; p. 286.

10. Ibid; p. 292.

11. Ibid; p. 292.

12. Ibid, Volume CI, Number 458, May 1931; p. 312.

13. *Who Was Who, 1951-1960* - LLD Univ. of Wales; Officer and Cross of Legion of Honour, France; Commander and Cross of the Order of St Maurice and St Lazarus, Italy; member of the Institut de France; member of the Reale Accademia di S. Luca, Rome; Hon. Citizen of City of Bruges; Grand Officer of

Leopold II; Vice-Pres. Poetry Society, and many
others.

14. Belleroche, William de, *Brangwyn Talks*; Chapman
 and Hall Ltd, 1946; p. 160.
15. Ibid; p. 18.

Notes to Chapter 6

1. Hutchings, Monica, *Inside Somerset*; The Abbey
 Press, 1963; p. 146.
2. Ibid; p. 147.
3. Rich, Alfred W., *Water Colour Painting*; The New
 Art Library; Seeley, Service & Co. Ltd, 1927; p. 196.
4. Ironside, Robin, *Wilson Steer*; Phaidon Press, 1943;
 Plate 71.
5. Ibid; Plate 73.
6. Ibid; Plate 74
7. Rich, Alfred W., *Water Colour Painting*; The New
 Art Library, Seeley, Service & Co. Ltd, 1927; p. 75.
8. Ironside, Robin, *Wilson Steer*; Phaidon Press, 1943;
 Plates 51 and 53.
9. Hall, Henry C., *Artists and Sculptors of Nottingham
 and Nottinghamshire*; Herbert Jones and Son Ltd,
 1953; pp.79-80.
10. *The Studio*, Volume CXXXIII, Number 650, May
 1947; p. 133.
11. Pollock, Sir Montagu Frederick Montagu - Born in
 Nice 31 January 1864. Lived at Headington Hill,
 Oxford. Died 14 August 1938.
12. Bradshaw, Percy V., *Water-Colour - A Truly English
 Art*; The Studio Ltd, 1952; p. 63.

BIBLIOGRAPHY

Anscombe, Isabelle and Gere, Charlotte, *Arts and Crafts in Britain and America*; Academy Editions, London, 1978.

Art Journal; Vol. XII, 1873.

Artist, The; Vol. 20, No. 1 (Sept. 1940), 2 (Oct. 1940), 3 (Nov. 1940), 4 (Dec. 1940) and 5 (Jan. 1941); Vol. 21, No. 1 (Mar. 1941).

Belleroche, William de, *Brangwyn Talks*; Chapman and Hall Ltd, London, 1946.

Bradshaw, Percy V., *Water-Colour - A Truly English Art*; The Studio Ltd, London, 1952.

Bury, Adrian, *Water-colour Painting of To-day*; The Studio Ltd, London, 1936.

Burke's Peerage; Burke's Peerage Ltd, London.

Campbell, Murray and Hatton, Harrison, *Herbert H. Dow - Pioneer in Creative Chemistry*; Appleton-Century-Crofts, Inc., New York, 1951.

Cobbett, William, *Rural Rides*; Penguin Classics, 1987.

Dolman, Bernard, *A Dictionary of Contemporary British Artists, 1929*; Antique Collectors' Club, Woodbridge, 1981 (Reprint).

Fox, M. R., *Dye-Makers of Great Britain 1856-1976*; Imperial Chemical Industries plc, 1987.

Gilbert, Martin, *Winston S. Churchill*; Volume IV, 1916-1922; Heinemann, London, 1975.

Gilbert, Martin, *Winston S. Churchill*; Volume V, 1922-1939; Heinemann, London, 1976.

Hardie, Martin, *Water-colour Painting in Britain, Volume III - The Victorian Period*; B.T. Batsford Ltd, 1971.

Hubbard, Hesketh, *A Hundred Years of British Painting 1851-1951*; Longmans, Green and Co., London, 1951.

Johnson, Charles, *English Painting*; G. Bell & Sons Ltd, London, 1932.

Johnson, J. and Greutzner, A., *The Dictionary of British Artists 1880-1940*; Antique Collectors' Club, Woodbridge, 1976.

Knighton-Hammond, A.H., Unpublished Memoirs.

MacColl, D.S., *Life Work and Setting of Philip Wilson Steer*; Faber and Faber Ltd, London, 1945.

Pennell, Joseph, *Joseph Pennell's Pictures of the Panama Canal*; William Heinemann, London, 1912.

Pennell, Joseph, *Joseph Pennell's Pictures of War Work in England*; William Heinemann, London, 1917.

Pope-Hennessy, Sir John, *Italian High Renaissance and Baroque Sculpture*; Phaidon Press Ltd, London, 1985.

Ratcliff, Carter, *John Singer Sargent*; Abbeville Press, New York, 1982.

Reader, W.J., *Imperial Chemical Industries - A History*, Volume I The Forerunners 1870-1926; Oxford University Press, London, 1970.

Royal Academy Exhibitors 1905-1970; Vol. III.

Royal Academy Exhibitors 1905-1970; Vol. IV.

Royal Academy Pictures 1902 Illustrating the Hundred and Thirty-Fourth Exhibition of the Royal Academy; Cassell & Company Ltd, London, 1902.

Rutherston, Albert, *Contemporary British Artists: Sir Charles Holmes*; Ernest Benn Ltd, London, 1924.

Rutter, Frank, *Modern Master-Pieces*; Geo. Newnes Ltd, London. No date.

The Studio; Vol. XIX, No. 84 (Mar. 1900). Vol. XXXIV, No. 146 (May 1905). Vol. LVII, No. 236 (Nov. 1912). Vol. LXXIII, No. 299 (Feb. 1918). Vol. LXXXVI, No. 368 (Nov. 1923). Vol. LXXXVIII, No. 380 (Nov.1924). Vol.LXXXVIII, No. 381 (Dec. 1924). Vol. XCV, No. 418 (Jan. 1928). Vol. IC, No.443 (Feb. 1930). Vol. CI, No. 458 (May 1931). Vol. CII, No. 460 (July 1931). Vol. CII, No. 461 (Aug. 1931). Vol. CXXX, No.

629 (Aug. 1945).

Vanderbilt Balsan, Consuelo, *The Glitter and the Gold*; George Mann, Maidstone, 1973 (Originally published 1935).

von der Hoven, Baroness Helena, *Intimate Life Story of H.R.H. The Duchess of Kent*; Cassell and Company Ltd, London, 1937.

Waddingham, Malcombe R., *Claude Lorrain - The Master Series*; Purnell and Sons Ltd, Paulton, 1966.

Waters, Grant M., *Dictionary of British Artists Working 1900-1950*; Eastbourne Fine Arts, Eastbourne, 1975.

Watson, Francis, *Tiepolo - The Master Series*; Purnell and Sons Ltd, Paulton, 1966.

Whitehead, Don, *The Dow Story*; McGraw-Hill, New York, 1968.

Who Was Who; Vols I-VII; Adam & Charles Black, London, 1920-1981.

Wood, Christopher, *The Dictionary of Victorian Painters*; Antique Collectors' Club, Woodbridge, 1978.

APPENDIX A
LIST OF EXHIBITIONS AND WORKS EXHIBITED
BY A.H. KNIGHTON-HAMMOND

(The exhibition details listed here are as comprehensive as possible: titles are as catalogued, although pictures exhibited in France are given their English titles, and reference is given where pictures are illustrated in the exhibition catalogue).

1895
Nottingham Castle Museum
64. *A Winter's Morning* (w/c)		8 gns

1896
Nottingham Castle Museum
37. *A Spring Morning* (w/c)		2 gns
48. *A Passing Storm* (w/c)		£2.5.0.
49. *Evening Shadows - Haddon Hall* (w/c)		2 gns
52. *The Churchyard Path - Haddon Hall*		4 gns
71. *A Quiet Homestead*		£2.5.0.

1897
Nottingham Castle Museum
54. *Birth place of Richard Parkes Bonington* (w/c)		£5.0.0.
107. *Sunday Morning* (oil)		£5.0.0.
187. *Gedling Church, Notts* (oil)		£1.10.0

1898
Nottingham Castle Museum
90. *A Summer Morning* (w/c)		6 gns

1899
Nottingham Castle Museum
277. *A Summer's Afternoon, a hundred year's ago* (oil)		3 gns

1905
Bakewell Town Hall

1906
Bakewell Town Hall
Tankerville House, Hardwick Street, Spring Gardens, Buxton
Joint Exhibition with H. Caffieri RI (72 works)
Works include -
Views of Derbyshire dales and moors
Bradford Dale
Youlgreave, Alport
Buxton (2 no. water-colours)
Rouen (sketches)
Incomplete list

1907
Royal Academy
363. *Golden Autumn, Derbyshire*
Manchester City Art Gallery Exhibition
An April Afternoon, Alport (24 x 20ins) (oil)		£18.18.0.

Manchester City Art Gallery
42. *A Warm March Day*		£12.12.0.

Bakewell Town Hall
Oils and Water-Colours
15 works sold

1908
Royal Academy
506. *An Autumn Afternoon, Lathkil Dale, Derbyshire*
Manchester City Art Gallery
26th Autumn Exhibition
116b. *An Autumn Afternoon, Lathkil Dale, Derbyshire*		£31.10.0

Mr Carruther's Gallery
3 Bull's Head Yard, Market Place, Manchester
'One-man show'

50 works (mostly landscapes) - oils and water-colours
> *Alport Mill* (oils)
> *Youlgreave - main street*
> *Lathkil Dale*

Incomplete list

Bakewell Town Hall

(60 or 70 works)

Horner Gallery, Watson's Walk, Sheffield

21 oil paintings

40 water-colours

pen and ink sketches

pencil drawings

1909

Studio, 4 St Peter's Square, Stockport

36 works exhibited

> 1. *Golden Autumn* (RA Exhibit of 1907)
> 6. *The old love and the new*
> 7. *View of the Terrace, Haddon Hall*
> 8. *View in Rouen* (w/c)
> 27. *The Stream below The Mill*
> 32. *Derbyshire homestead*

Incomplete list

Corporation Art Gallery, Manchester

> 11. *The Clouds that gather round*
> *the setting Sun* £25
> 13. *Morning Brights* £10.10.0.
> 224. *The Terrace* £14

Studio, Grosvenor Chambers, Deansgate, Manchester

54 paintings (oils and water-colours)

1910

Manchester City Art Gallery

> *Manchester* £9.19.6.

Deansgate, Manchester

5 water-colours

> *Youlgreave Church* (upright)
> *Fields near Youlgreave*
> *Bradford*
> *Haddon Hall*
> *Eau de Robec, Rouen* £15.0.0.

Messrs Fowler, Son and Chapman, High Street, Evesham

> *Summer Evening, Cropthorne*
> *Post Office, Chariton*
> *Spring on the Avon, near Fladbury*
> *Avon near Fladbury*
> *Summer Morning, Avon near Cropthorne*
> *Fladbury Mill*

Incomplete list

Studio, Grosvenor Chambers, Deansgate, Manchester

(40 to 50 works)

1912

Exhibition of landscapes in oil and water-colour
3 Bull's Head Yard, Market Place, Manchester

Landscapes of Derbyshire, Worcestershire and North Wales
Exhibition - Grosvenor Chambers, 16 Deansgate, Manchester

> *Manchester's River*
> *Youlgreave village street*
> *Kings Street* (2 drawings)
> *Woodford, Cheshire*
> *Brecon*
> *Colwyn Bay*
> *May landscape*

Incomplete list

1920

Community Center, Midland, Michigan, USA

1922

Exhibition at the home of Dr Michael Foster at San Remo

1923

Florence - Lyceum (Art College)

50 water-colours

30 etchings

American Water-Color Society
New York Water-Color Club

(combined exhibition)

6 water-colours exhibited

1924

Beaux Arts Gallery

'Venice and the Riviera'

> *The Loggia dei Lanzi*
> *The Uffizi Gallery*
> *The View from the Colleoni Statue, Venice*
> *Raglan Castle*
> *Near Ponte Vecchio, Florence*
> *Parliament Street from Trafalgar Square*
> *Street in Old Town, San Remo*
> *Boat in harbour at San Remo*

Incomplete list

Hotel Jean Charpentier
76 Faubourg Saint-Honoré, Paris

> 1. *Before the Church at San Remo*
> 2. *San Vidal from the Accademia, Venice*
> 3. *Olive trees, San Remo*
> 4. *Abingdon on Thames*
> 5. *The Market, San Remo*
> 6. *Lavender, Badelucca*
> 7. *Christ Church College, Oxford*
> 8. *High Street, Oxford*
> 9. *Ponte Rialto, Venice*
> 10. *Casino at Monte-Carlo*
> 11. *Dusk, San Remo*
> 12. *Saint-Gervais, Paris*
> 13. *Monte-Carlo*
> 14. *The Green Boat, San Remo*
> 15. *Porto Maurizio, Italian Riviera*
> 16. *Abingdon*

17. *Evening at Monte-Carlo*
18. *Gypsies on Hampstead Heath, London*
19. *A Venetian Palace*
20. *Monaco, from Ventimiglia*
21. *Hostelry at Abingdon*
22. *San Remo*
23. *Christ Church College, Oxford*
24. *Waterloo Place, London*
25. *At the Henley Regatta*
26. *Gypsies*
27. *Battersea Bridge (Dawn)*
28. *Oxford*
29. *St Paul's, by Westminster bridge (misty morning)*
30. *Meadow, near Magdalen College, Oxford*
31. *Christ Church College, Oxford*
32. *Boats at Chioggia*
33. *Notre-Dame*
34. *Entrance court, Musée du Luxembourg*
35. *Olive trees above San Remo*
36. *Fishing Boat, Venice*
37. *Trees, Chioggia*
38. *Leicester Sq., London*
39. *Hampstead Heath*
40. *Fishing Boat, Chioggia*
41. *Riviera Carnations*
42. *Hereford Bridge*
43. *Riviera Roses*
44. *The Rialto Market, Venice*
45. *Raglan Castle*
46. *Mosque, Tunis*
47. *On the Italian Riviera*
48. *The Port at San Remo*
49. *The Cathedral, San Remo*
50. *Doorway, Tunis*
51. *Bridge of Sighs, Venice*
52. *Flower Market, San Remo*
53. *Fruit stall, Venice*
54. *Near the church, San Remo*
55. *Riviera Flowers*
56. *Market, San Remo*
57. *Dolceaqua, Italian Riviera*
58. *Kairouan, Tunisia*
59. *Venice*
60. *San Marco, Venice*
61. *Venetian interior*
62. *Church Door, Saint-Mary the Virgin, Oxford*
63. *In the park, San Remo*
64. *Santa Madonna della Salute, Venice*
65. *Houses, Chioggia*
66. *Gypsies at Epsom during Derby week*
67. *Courtyard at Kairouan, Tunisia*
68. *View near Chepstow*
69. *The Riviera* (sketch)
70. *Evening, San Remo*
71. *Doorway, San Remo*
72. *Market-Place, Florence*
73. *On the Ponte Vecchio, Florence*
74. *Italian Peasants*

75. *The Maritime Alps*
76. *The rest*
77. *The Dolomites seen from Cortina*
78. *In the Val d'Aosta*
79. *By the Ponte Vecchio*
80. *The old town, San Remo*
81. *In the Dolomites*
82. *Chioggia*
83. *Carpet seller, Tunis*
84. *Market-Place, Florence*
85. *Making Mattresses, San Remo*
86. *Browning's Palace, Venice*
87. *Santa Madonna della Salute, from the Grand Canal*
88. *Tunis*
89. *Kairouan*
90. *The Regatta, Henley*
91. *Raglan*
92. *Courtyard, Kairouan*
93. *San Barnaba, Venice*
94. *In the Luxemburg Gardens*
95. *Venetian Canal*
96. *Sunny Morning in the Luxemburg Gardens*
97. *Canal, Chioggia*
98. *Henley Bridge during Regatta week*
99. *The Boar Market, Florence*
100. *The Maritime Alps*

1925

The Fine Art Society Ltd
148 New Bond Street, London, W1
Exhibition of Water-colours of Sunny Lands
Italy, Tunisia and South of France

1. *Mother-o'-Pearl - Early Morning on the Lagoon*
2. *Florence from San Miniato*
3. *Afternoon - San Remo*
4. *The Maritime Alps*
5. *The Piazza - Venice*
6. *A Florentine Fountain*
7. *Olive Trees - Liguria*
8. *On the Ponte Vecchio, Florence*
9. *A Tunisian Mosque*
10. *Morning - near Carthage*
11. *Morning - Venice*
12. *A Wet Day - San Marco, Venice*
13. *Morning Market - San Remo*
14. *In Provence*
15. *The Gulf of Tunis*
16. *"Perseus" and "David", Florence*
17. *Bazaars at Tunis*
18. *Near Carthage*
19. *Sunshine and Mist - The Harbour, Marseilles*
20. *In the Dolomites*
21. *The Piazzetta - Venice*
22. *A Church door - San Remo*
23. *San Giorgio - Early Evening*
24. *Early Evening in the Loggia dei Lanzi, Florence*
25. *In a Riviera Garden*

26. *Outside the Souks - Tunis*
27. *Evening - San Remo*
28. *A Mendicant*
29. *Olive Trees - San Remo*
30. *A Grey Morning - Venice*
31. *The Morning Market*
32. *Early Morning - Venice*
33. *Rialto, Venice*
34. *In the Pope's Garden, Avignon*
35. *Late afternoon after a Stormy Day - Venice*
36. *Autumn - San Remo*
37. *Venetian Boats*
38. *Late Afternoon - The Gulf of Tunis*
39. *A Jolly Beggar*
40. *The Market - San Remo*
41. *Maritime Alps from Ventimiglia*
42. *Under the Bridge of Sighs*
43. *On the Guidecca*
44. *The Jesuati - Venice*
45. *Old San Remo*
46. *A Window in Venice*
47. *Boats on the Guidecca*
48. *In the Arab Quarter - Tunis*
49. *The Piazzetta - Early Evening*
50. *St Benizet's Bridge, Avignon*
51. *The Italian Model*
52. *A Street in Tunis*
53. *The Blue Lagoon*
54. *Ducal Palace - Early Evening*
55. *Magdalen Bridge, Oxford*
56. *The Riva - Early Morning*
57. *Venetian Fishing Boats*
58. *Autumn Sunshine - Liguria*
59. *San Giorgio - Early Morning*
60. *The Salute - Early Morning*
61. *Riviera Carnations*

1925
Frost & Reed's Galleries, Clare Street, Bristol
24 water-colours exhibited
 Porch at St Mary, Oxford
 Italian Washerwomen at San Remo
 San Remo Market
 Grand Canal, Venice
 Italian Dolomites from Cortina
 Riviera Carnations
 Rialto Bridge
 The Salute, Venice, in Early Morning
 Hyde Park Corner
 Nelson's Column
 View near Chepstow
 Tom Tower, Christchurch, Oxford
Incomplete list

1926
Salle Grenier
Palais des Arts, 9 Avenue, Félix Faure, Menton
 Near Venice

Italian Washerwomen
Sospel (The Old Bridge, Sospel)
Loggia dei Lanzi
Port at Menton
The Church at Santa Margherita
The Old Town at San Remo
The Ponte Vecchio, Florence
Church among the Olive Trees
Menton Flower Market
Incomplete list
Hotel Jean Charpentier, 76 Faubourg Saint-Honoré, Paris
36 water-colours

1927
Exhibition at Gallery Lambert, Cannes, France. The New English Art Club
102. *Olive Wood: Cap Martin*
110. *An Italian Fishing Port*
Jubilee Exhibition
23. *Venice*
26. *San Remo*
39. *Chipping Campden*
Salon des Artistes Français. (Paris Salon)
Central Gallery
Nos. 743 and 744
International Water Color Exhibition, Chicago, USA.
List of Paintings sent to Australia for Exhibition
1. *Boats on Lagoon Venice showing Doge's Palace* 20 gns
2. *Bougainvillaea* 18 gns
3. *Menton Harbour* 20 gns
4. *Show on the Maritime Alps* 15 gns
5. *The Church at Amberley, Sussex, England* 15 gns
6. *The Perseus and the David, Florence* 15 gns
7. *Bathers* 30 gns
8. *Nude study in wood* 30 gns
9. *Roses in Sunlight* 15 gns
10. *Anemones* 25 gns
11. *Arundel Castle* 12 gns
12. *Carnations* 25 gns
13. *Magdalen Bridge, Oxford, early morning* 20 gns
14. *The Crypt, House of Commons. Scene of Guy Fawkes plot* 20 gns
15. *Richmond Bridge* 20 gns
16. *Interior Westminster Hall* 25 gns
17. *Big Ben, House of Commons* 25 gns
18. *The Wine Boat, Menton Harbour* 25 gns
19. *Gypsy Caravans, Epsom Downs, Derby Week* 15 gns
20. *Statue, Riviera Garden* 15 gns
21. *In a Mediterranean Harbour, Menton* 15 gns
22. *Bank Holiday, Hampstead Heath* 8 gns
23. *On Ascot Race Course* 6 gns
24. *In the Pope's Garden, Avignon* 15 gns
25. *Abingdon on Thames* 15 gns

26. *San Giorgio, early morning* 20 gns
27. *Church doorway, San Remo* 20 gns
28. *Harbour, San Remo* 25 gns
29. *Fishing Boats, Venice* 25 gns
30. *Mosque at Tunis* 30 gns

1928

Exhibition at Gallery Lambert, Cannes.
 Salon des Artistes Français (Paris Salon)
2 works exhibited
Exhibition of Water-Colours by Knighton-
Hammond
Fine Art Society's Gallery
 100 Exhibition Street, Melbourne
1. *The Mosque at Tunis* 40 gns
2. *The Interior of Westminster Hall* 35 gns
3. *Anemones* 28 gns
4. *Fishing Boats, Venice* 28 gns
5. *Carnations* 35 gns
6. *The Yard of the House of Commons*
 showing Big Ben 30 gns
7. *The Crypt of the House of Commons* 22 gns
8. *Bougainvillaea* 23 gns
9. *Magdalen Bridge, Oxford, early morning* 25 gns
10. *Richmond Bridge, Surrey* 25 gns
11. *Windsor Castle from the Meadows*
 by the Thames 23 gns
12. *The Grand Canal, Venice* 22 gns
13. *Bridge, Houses, and Castle at Arundel,*
 Sussex 25 gns
14. *Menton Harbour* 25 gns
15. *Boats on the Guidecca Canal, Showing the*
 Dogana, Venice 25 gns
16. *Fittleworth Bridge, Sussex* 25 gns
17. *A Church Doorway, San Remo* 26 gns
18. *Corner of the Cloisters, Eton College* 22 gns
19. *San Giorgio, Venice, Early Morning* 22 gns
20. *Sunshine and Mist, Marseilles Harbour* 25 gns
21. *Windsor Castle from the Thames* 20 gns
22. *In the Pope's Garden, Avignon* 20 gns
23. *Abingdon on Thames* 17 gns
24. *Old Houses and Castle, Arundel* 17 gns
25. *Corner of the Racecourse, Ascot* 17 gns
26. *Bowl of Anemones* 11 gns
27. *On Ascot Racecourse* 9 gns
28. *A Sussex Village* 9 gns
29. *The Bathers* 40 gns
30. *After the Bathe* 40 gns
The Museum of Fine Arts, Houston, USA
Exhibitions of water-colours of Venice and the
Riviera
1. *Wine Boat Misty Evening Menton*
2. *House of Lords*
3. *Green Boat Harbour, San Remo, Italy*
4. *Fittleworth Bridge, Sussex, England*
5. *Gypsy Caravans, Epsom Downs After the Races*
6. *Richmond Bridge*
7. *Market San Remo*

8. *Les Immortelles*
9. *Roses*
10. *In a Riviera Garden*
11. *Rye Harbour, Sussex*
12. *In a Mediterranean Harbour*
13. *Village in Provence*
14. *Gypsy Caravans, Epsom Downs*
15. *Mountains in Provence*
16. *Bowl of Anemones*
17. *Anemones*
18. *The Maritime Alps*
19. *In Provence*
20. *Old Town Menton*
21. *Bank Holiday, Hampstead Heath*
22. *Windsor Castle*
23. *On the Ponte Vecchio, Florence*
24. *Roses in Sunlight*
25. *Corner of Cattle Market, Le Puy*
26. *Mending the nets*
27. *Blue and Gold Menton Harbour Boat*
28. *In the Cevennes*
The Société Internationale des Acquarellistes,
 Galeries Georges Petit, 6 Rue de Sèze, Paris
6 Works exhibited
Goupil Gallery, 5 Regent Street, Waterloo Place,
 London
1. *Cypress and Olive, Menton*
2. *Boats at Venice (Dogana)*
3. *Provençal Fountain*
4. *Trafalgar Square*
5. *Martigues*
6. *An Italian Aqueduct*
7. *Harbour at Menton*
8. *Archway at Orange*
9. *Perseus and David, Florence*
10. *Ascot*
11. *Village Street, Le Puy*
Fine Art Society
1. *Promenade du Midi*
2. *Harbour Menton*
3. *Pope's Palace, Avignon*
4. *The Terrace, Grasse*
5. *The Italian Coast, Early Morning*
6. *A Fruit Stall, Venice*
7. *Eze from Gardens, Corniche*
8. *Menton Harbour*

1929

Galeries Georges Petit, 6 Rue de Sèze, Paris
 Italian village
 Cathedral, Eu
 Plage, Dieppe
 Le Post, Concarneau
 Venice
Incomplete list
Bernheim Jeuve, 83 Faubourg Saint-Honoré, Paris
1. *Italian Coast from Menton*
2. *The Terrace Steps*

3. *An Italian Church*
4. *Venetian fishing boats*
5. *Olive trees*
6. *Flower Market, Menton*
7. *Near Sospel*
8. *Albenga, Italy*
9. *Cortina*
10. *Promenade du Midi, Menton*
11. *The Garden Seat* (pastel)
12. *Peach Blossom*
13. *The Italian Coast*
14. *Menton*
15. *The Market, San Remo*
16. *Bread Stall, Kairouan*
17. *Florence*
18. *Cypress and Olive Trees*
19. *Menton Flower Market (No.2)*
20. *Wallflowers*
21. *Dolceaqua*
22. *Figures talking, Grasse*
23. *Nomades de Provence*
24. *Fishermen, Menton*
25. *Chioggia*
26. *Man and Goat*
27. *San Giorgio, Venice*
28. *Anemones*

1930

Beaux Arts Gallery, Bruton Place, Bruton Street, Bond Street, London

1. *Concarneau*
2. *Cypress and Olive Trees*
3. *Plum Blossom*
4. *Bathing Beach at Dieppe*
5. *Promenade, Menton*
6. *Morning after the Derby*
7. *Fishing Boats, Concarneau*
8. *Boats at Menton*
9. *Almond and Peach Blossom*
10. *Fishing Boats, Menton*
11. *The Red Mat - Boats at Menton*
12. *Maritime Alps from Ventimiglia*
13. *Martigues*
14. *The Church, Mortola*
15. *Sospel Bridge*
16. *The Port, Camogli*
17. *St Benezet's Bridge, Avignon*
18. *Dieppe*
19. *Venetian Boats*
20. *Trafalgar Square*
21. *Magdalen Tower, Oxford*
22. *The High, Oxford*

Etchings
23. *Sardine Boats - Concarneau*
24. *The Port, Concarneau*
25. *The Jetty, Concarneau*
26. *Olive Trees, San Remo*
27. *The Grand Canal*

28. *The Traghetto*
29. *Rag Pickers - Pont Neuf*
30. *Browning's Palace - Venice*
31. *Tewkesbury*
32. *Winter Sunshine*

Exhibition at Grenier's, Menton
 The Royal Academy
713. *The Plage at Dieppe*
Walker Art Gallery, Liverpool
569. *Dieppe* £21.0.0
571. *Promenade, Menton* £31.10.0

1931

National Art Exhibition, Canada
5 works exhibited

1932

The Pastel Society
33rd Exhibition
190. *Maritime Alps* £10.10.0
191. *Mountains* £6.6.0
192. *Olive Frances Benson*
194. *On the Beach* £6.6.0
195. *In Italy* £6.6.0
Grenier's, Menton
 Portrait of George L. Behrend (oil)
20. *Menton from Cap Martin* (oil)
Incomplete list
Beaux Arts Gallery, Bruton Place, Bond Street, London
Exhibition of Choice Water-colours by Ten Leading Draughtsman.
25. *Promenade, Menton* 28 gns
26. *Dieppe* 17 gns
27. *Fishing Boats* 13 gns
28. *Boats at Menton* 11 gns
29. *Menton Harbour* 10 gns
30. *Mending Nets* 10 gns
Alton, Hampshire
 Normandy Street, Alton
 High Street, Alton
 Interior of St Lawrence Church, Alton
 Exterior of St Lawrence Church, Alton
 Froyle (village)
 Jane Austen's Cottage, Chawton
 Farnham
 Cobbett's Oak, Tilford
 Churt - Landscape
 W.H. Curtis - portrait
 Self-portrait
 May - portrait
 Mary - portrait
 Interior of a chemical works in USA
Guildhall Art Society
 Borough Council Offices
Incomplete List
 Portrait (pastel)
 The Market Place (w/c) 12 gns

Rag Pickers	2 ½ gns
Pont Neuf	2 gns
Ludlow	3 gns
Browing's Palace (etching)	2 gns
Blacksmiths Shop (etching)	3 gns
Durham Cathedral	4 gns
Venice (etching)	2 gns

Royal Society of Portrait Painters
126. *The Black Cloak*

1933

The Pastel Society
34th Exhibition

112. *Winter Sunshine*	£21.0.0
113. *Portrait*	
114. *Stony Jumps*	£21.0.0
115. *Miss Mary Bolton*	
119. *Portrait*	
353. *Jennifer*	

Royal Institute of Painters in Water-Colours
124th Exhibition

25. *An Autumn Bunch*	£15.15.0
169. *In Italy*	£21.0.0

Recent Paintings by Knighton-Hammond
 J. Leger & Son, 13 Old Bond Street, London, W1

1. *High Street, Guildford* (w/c)
2. *Rain Clouds - Newlands Corner* (w/c)
3. *A Surrey Sky* (w/c)
4. *Ploughing* (w/c)
5. *Alton - Hampshire* (w/c)
6. *A Winter Morning* (w/c)
7. *Kentish Upland* (w/c)
8. *Cloudy Day* (w/c)
9. *Almond Blossom* (w/c)
10. *An April Day* (w/c)
11. *Epsom Downs (1)* (w/c)
12. *Near Selborne* (w/c)
13. *An Autumn Bunch* (oil)
14. *Evening Light* (w/c)
15. *Epsom Downs (2)* (w/c)
16. *In Italy* (w/c)
17. *October* (w/c)
18. *Dawn on the Mediterranean* (w/c)
19. *Mary in Wonderland* (oil)
20. *A Hampshire Village* (w/c)
21. *Brighton Beach - No. 1* (pastel)
22. *"Energy"* (pastel)
23. *Trees and Clouds* (pastel)
24. *Kensington Gardens* (pastel)
25. *Richmond Village* (pastel)
26. *Brighton Beach - No. 2* (pastel)
27. *The Churchyard* (pastel)
28. *Winter Sunlight* (pastel)
29. *Brighton Beach - No. 3* (pastel)
30. *Nursemaids - Kensington Gardens* (pastel)
31. *Richmond* (pastel)
32. *Early Morning* (pastel)
33. *Richmond Bridge* (pastel)
34. *Spring* (pastel)
35. *Dogana - Venice* (w/c)
36. *Surrey Common* (w/c)
37. *Concarneau* (w/c)
38. *Mapledurham Mill* (oil)

Atkinson Art Gallery, Southport
48th Exhibition of Modern Art
198. *Menton Harbour* (w/c)

The Royal Academy
215. *The resting place*

1934

The Pastel Society
35th Exhibition

312. *Amongst the Pines and Heather -*	
Mr Lloyd George's House at Churt	£31.10.0
313. *The Busy River*	£7.7.0
314. *Ann*	
315. *The River at Greenwich*	£7.7.0
354. *The Right Hon. D. Lloyd George, OM, MP*	
355. *Mother of Pearl*	£21.0.0

Royal Institute of Painters in Water-Colours
125th Exhibition

175. *Mending the Nets*	£12.12.0
332. *Springtime*	£16.16.0
409. *The Morning Market* (illustrated p. 72)	£21.0.0
437. *The Quayside*	£12.12.0
481. *Tower Bridge*	£8.8.0

County Borough of Dudley Art Gallery and
 Museum
Exhibition of Water-Colours by Living British
Artists

62. *Storm on the Heath*	£26.5.0

Atkinson Art Gallery, Southport
49th Spring Exhibition of Modern Art

67. *Epsom Downs* (w/c)	£21.0.0
125. *Sospel* (w/c)	£12.0.0

An Exhibition of Work of Ditchling Artists
 Hove Museum and Art Gallery
12. *Olive Trees, San Remo*
25. *A Hampshire farmyard*
28. *Blue and gold*
65. *A Fifeshire Village* (pastel)

Walker Art Gallery, Liverpool

474. *Mending the Nets*	£12.12.0
478. *The Quayside*	£12.12.0
671. *The Morning Market*	NFS

Royal Society of Portrait Painters
91. *An Old Man of Sussex*

1935

The Pastel Society
36th Annual Exhibition

258. *A Young Navvy*	
259. *Surrey*	£15.15.0
260. *Pamela*	
261. *Green and Gold*	
262. *A Village Woman*	

263. *Where France and Italy meet* £21.0.0
Royal Institute of Painters in Water-Colours
126th Exhibition
 82. *Gypsy Encampment* £15.15.0
358. *Building the Rick* (illustrated p.82) £21.0.0
364. *Epsom Downs during Derby Week* £21.0.0
440. *Morning in Surrey* £15.15.0
507. *Menton Harbour* £21.0.0
Atkinson Art Gallery, Southport
50th Golden Jubilee Exhibition of
Modern Art
 66. *A Hampshire Church -*
 Early Morning (w/c) £10.10.0
131. *The Harbour at Menton* (w/c) £12.12.0
Walker Art Gallery, Liverpool
739. *Near the South Downs* £7.7.0
744. *The Fifeshire Coast* £12.12.0
Rochdale Art Gallery
 A Hampshire Church - Early Morning
The Royal Glasgow Institute of the Fine Arts
692. *Epsom Downs during Derby Week* (w/c) £21
Royal Society of Portrait Painters
 61. *Miss Ann Benson*

1936

The Pastel Society
27th Annual Exhibition
324. *A Surrey Common* £10.10.0
325. *Battersea Reach* £10.10.0
326. *Early Evening, Greenwich* £8.8.0
327. *John*
328. *Riviera Roses* £10.10.0
329. *A Church in Liguria* £10.0.0
Corporation Art Gallery, Bury
Loan Exhibition of Oil Paintings and Water-Colour
Drawings
 44. *A Hampshire Church -*
 Early Morning (w/c) £12.12.0
Royal Institute of Painters in Water-Colours
127th Exhibition
280. *Windsor Castle* (illustrated) £10.10.0
382. *Le Marché* (illustrated) £21.00.0
394. *After the last race, Derby Day,*
 Epsom Downs £21.00.0
513. *Roses* £10.10.0
518. *The Flower Market* £10.10.0
Atkinson Art Gallery, Southport
51st Exhibition of Modern Art
 27. *The Mirror* (oil) £31.10.0
140. *Epsom Downs during Derby Week* (w/c) £20.0.0
Royal Institute of Painters in
 Water-Colours
First Summer Exhibition
137. *A Bunch from Sussex Fields* £31.10.0
Walker Art Gallery, Liverpool
538. *Epsom Downs During Derby Week* £21.0.0
548. *The Grey Mare* £8.8.0
556. *The Sussex Weald* £10.10.0

1937

The Pastel Society
38th Annual Exhibition
195. *Miss Ann Benson*
196. *The Thames at Battersea* £8.8.0
197. *The Mistral* £12.12.0
198. *The Vale of Rest* £21.0.0
199. *Miss L.R. Mitchell*
200. *Boats at Concarneau* £8.8.0
The Royal Institute of Painters in Water-Colours
128th Exhibition
 56. *Threshing* (illustrated) £15.15.0
 82. *The Market Place, Menton* £15.15.0
167. *The Thames near Mapledurham* £21.00.0
351. *The Wine Boat, Evening,*
 Menton Harbour £21.00.0
357. *The Harbour* £21.00.0
Northampton Art Gallery, Guildhall Road
Exhibition of Water-Colour Drawings by Twenty
Modern Artists
 12. *Afternoon light* £12.12.0
 13. *Sussex Weald* £10.10.0
 14. *Epsom Downs on the Derby Morning* £21.0.0
 15. *Monte Carlo from Cap Martin* £12.12.0
 16. *Venice* £18.18.0
 17. *Menton from Cap Martin* £15.15.0
Royal Institute of Painters in Water-Colours
Exhibition of Sketches and Drawings by Members
326. *Our Village* £21.0.0
327. *An Old Town, South of France* £21.0.0
328. *Notre Dame de Paris* £21.0.0
329. *Auxerre* £25.0.0
330. *Noon* £12.12.0
331. *In the Garden* £21.0.0
332. *Mapledurham* £21.0.0
Royal Institute of Oil Painters
54th Annual Exhibition
165. *The Sunday Joint* £105.0.0
Bonington Memorial Exhibition
Arnold Public Library, Arnold, Nottingham
eleven works exhibited
(including *An Old Sussex Gentleman* in oils)
Exhibition of Ditchling Artists and Craftsmen
 Ditchling
 'Joe' the Village Postman (oil)
 The Promenade, Menton (w/c)
 Afternoon light (w/c)
Incomplete list
National Gallery of Canada
Exhibition of Contemporary British Painting 1937
 15. *The Flower Market* (w/c) £10.10.0
Royal Society of Portrait Painters
143. *Edward Johnson Esq*
Walker Art Gallery, Liverpool
201. *An Ancient Farm* £31.10.0
428. *Sussex Farm Carts* £10.10.0
800. *Early Morning, Chambery* £18.18.0

1938

The Pastel Society
39th Annual Exhibition

134.	Early Evening, Provence	£15.15.0
135.	Patience	£31.10.0
136.	In the Infirmary	£21.0.0
137.	The Dining Room	£31.10.0
138.	Clouds and Distance	£21.0.0
139.	The Christmas Party	£31.10.0

Brighton Public Art Galleries, Church Street
Exhibition of Works by Members of the Brighton Arts Club

51.	A Sussex farmer	
95.	The gypsy	
160.	At the horse show	£31.10.0
230.	Flowers	£12.12.0
254.	On the Downs near Lewes	£31.00.0

Royal Institute of Painters in Water-Colours
129th Exhibition

153.	Master Julian Benson	
168.	Sunshine in the South of France	£26.5.0
198.	Stokesay Castle (illustrated p.56)	£31.10.0
208.	A Day of Sirocco in Venice	£21.0.0
364.	Brighton Beach (illustrated p.68)	£31.10.0

The Royal Glasgow Institute of the Fine Arts

672.	The Village Horse Show (w/c)	£53
692.	Brighton Beach (w/c)	£42
751.	Stokesay Castle (w/c)	£42

Royal Society of Portrait Painters
144. The Village Postman

The Royal Academy
342. A Sussex Farmer
804. The Village Horse Show

Royal Institute of Oil Painters
55th Annual Exhibition

29.	A Village Carpenter and His Mate	£75.0.0
148.	The Young Dairyman	£150.0.0
219.	The Cronies	£400.0.0
274.	From Sussex Woods	£40.0.0

Ditchling Artists and Craftsmen
Village Hall, Ditchling
12. At Ditchling Horse Show
22. Portrait of Mr Holman

Corporation Art Gallery, Bury
Modern British Water-Colours

56.	Monte Carlo from Cap Martin	£12.12.0
57.	Afternoon Light	£12.12.0
58.	Venice	£18.18.0
59.	Sussex Weald	£10.10.0
60.	Menton from Cap Martin	£15.15.0

1939

The Pastel Society
40th Annual Exhibition
337. A Tramp (No 3)
338. A Tramp (No 2)
339. John
340. Father Christmas
341. A Tramp (No 1)
342. A Tramp (No 4)

Royal Institute of Painters in Water-Colours
130th Exhibition

240.	The Conway Valley	£52.10.0
279.	The Village Horse Show	£52.10.0
285.	Chepstow Castle	£52.10.0
428.	North Wales	£52.10.0
434.	"Three to one, bar one, two to one on the Field"	£52.10.0

City of Bradford Corporation Art Gallery
Forty-Sixth Spring Exhibition

27.	A Sussex Farmer (oil)	£300.0.0
186.	The Village Horse Show	£52.10.0

The Royal Academy
781. The Day of the 'Oaks' Epsom 1938

Royal Institute of Oil Painters
56th Annual Exhibition

50.	Evacuees in the Gardens	£25.0.0
63.	Herring Drifters near Yarmouth	£25.0.0
223.	Autumn, near Chepstow	£100.0.0
355.	Still Life	£100.0.0

The Royal Glasgow Institute of the Fine Arts

269.	Chepstow Castle (w/c)	£42

Royal Society of Portrait Painters 1939
89. Self-Portrait
120. Old Age Pensioners

1940

The Pastel Society
41st Annual Exhibition

368.	Purple Iris	£10.10.0
369.	Where the French-Italian Frontier meets the Sea	£7.7.0
370.	Winter Sunlight	£12.12.0
371.	Miss Walder	
372.	An Evacuee	£26.5.0
373.	A Breton Pardon	£8.8.0

United Society of Artists
(At the Royal Academy)
134. A Sussex Byre

Royal Institute of Painters in Water-Colours
131st Exhibition

90.	Summer on the Cote d'Azur	£10.10.0
188.	Old England	£31.10.0
199.	Epsom Downs	£26.5.0
443.	A Berkshire Barn	£42.0.0
455.	Chepstow Castle	£31.10.0

Royal Water-Colour Society Open Exhibition
2 water-colours exhibited.

The Royal Academy
176. The Card-Players

Glasgow Institute of the Fine Arts
Old England (w/c)
Epsom Downs (w/c)

Ipswich Art Club
two water-colours

Brighton Art Gallery
A Berkshire Barn (w/c)
Chepstow Castle (w/c)
Card Players (oil)
The Royal Glasgow Institute of the Fine Arts
270. *Old England* (w/c) £25
282. *Epsom Downs* (w/c) £20

1941

Royal Scottish Society of Painters in Water-Colours
Sixty-First Annual Exhibition
103. *Brighton Beach* £31.10.0
177. *April in Somerset* £26.5.0
252. *The Morning of the Derby, Epsom* £26.5.0
Royal Society of Portrait Painters
49th Annual Exhibition
193. *A Private of a Searchlight unit*
245. *Cook, Butler, Gardener and Others*

1942

Towner Art Gallery, Eastbourne Exhibition
164 Pictures selected from the 'Royal Academy
United' Exhibition 1942.
26. *Lunch-time* £42.0.0
The Royal Glasgow Institute of the Fine Arts
232. *Fishing Boat, Menton Harbour* (w/c) £10
234. *Monte Carlo and the Tête de Chien
from Cap Martin* (w/c) £8
297. *Early Morning - Sunlight* (w/c) £25
302. *An April Morning* (w/c) £30
**The Royal Scottish Society of Painters in
Water-Colours**
112. *The Storm Cloud*
120. *The Good Earth*
135. *An Old Farm Labourer - The Man with a Scythe*
212. *My Neighbour's Cattle*
Bournemouth Art Gallery
four water-colours exhibited.
United Society of Artists
Exhibition at the Royal Academy
25 pounders under Chestnut tree (oil)
Cleaning 25 pounders in Parson's Stable Yard
(w/c)

1943

Sunderland Art Gallery
Pictures from the Royal Academy United Artists
Exhibition 1942
40. *Lunch Time*
The Royal Academy
507. *The Muck Cart*
**The Royal Scottish Society of Painters in
Water-Colours**
38. *Early Morning*
144. *The Wireless Unit*
254. *The Wind on the Heath*
297. *View 3 miles outside Tunis, looking Westward*

The Royal Glasgow Institute of the Fine Arts
72. *'For Ever Will He Love and She Be Fair'* £60
144. *The Rain Cloud* (w/c) £11
175. *Early Spring* (w/c) £11
722. *Bottles and Jars* £100
Bradford City Art Gallery
Fiftieth Spring Exhibition 1943
110. *An April Morning* (w/c) £21.0.0
196. *Early Morning* (w/c) £21.0.0
278. *Monte Carlo from Cap Martin* £8.8.0
The New English Art Club
173. *The Old Story* (oil)

1944

**The Royal Scottish Society of Painters in
Water-Colours**
29. *Guildford High Street*
100. *Early Morning - Chancery*
250. *Avignon*
299. *In an Italian Village*
Bournemouth Art Gallery
1. *Brighton Beach*
2. *The Flower Market*
3. *'An Autumn Bunch'*
4. *View near Guildford Surrey*
United Society of Artists
8. *Ditchling Horse Show*
Royal Institute of Painters in Water-Colours
125. *The Sky across the Fields* £25.0.0
130. *The Avenue in Spring* £25.0.0
183. *A Sussex Farmyard* £18.18.0
338. *September* £6.6.0
410. *Brighton Beach, 1939* £18.18.0
The Royal Glasgow Institute of the Fine Arts
518. *Souvenir du Louvre* £30
590. *Epsom Downs on Derby Day* £80
631. *Storm over Chepstow Castle* £50
714. *Early Morning* £35
Royal Society of Portrait Painters
195. *A Yeoman of the Guard*

1945

**Manchester Academy of Fine Arts 86th Spring
Exhibition, City of Manchester Art Gallery**
93. *Michaelmas Daisies and Roses* (oil) £50.00.0
101. *Before the Race, Derby Day,
Epsom Downs, 1939* (oil) £100
164. *A Yeoman of the Guard* (oil)
168. *Roses and Blue Vases* (oil) £25.00.0
Sunderland Public Art Gallery
Exhibition of painting by the United Society of Artists (1944)
31. *Ditchling Horse Show* 48 gns
**The Royal Scottish Society of Painters in
Water-Colours**
40. *Brighton Beach 1939*
93. *The Sky Across the Fields*
105. *The Avenue in Spring*
123. *A Sussex Farmyard*

Bradford City Art Gallery
Fifty-Second Spring Exhibition 1945
60. *On Epsom Downs during 'Derby' Week* £80.0.0
372. *Flowers from an Old Garden* £20.0.0
Royal Society of British Artists Summer Exhibition
303. *The Avenue in Spring* (w/c) £30.00.0
529. *High Summer* (oil) £120.00.0
Ridley Art Club 56th Exhibition RI Galleries
112. *The Man with a Scythe* £35.00.0
135. *The Ending of the Day* £35.00.0
136. *Aetatis Florentis Initium* £26.5.0
The Royal Glasgow Institute of the Fine Arts
395. *Brighton Beach* (w/c) £25
463. *An Autumn Morning* (w/c) £30
687. *Grand Canal, Venice* £120
The New English Art Club
264. *Derby Day, Epsom Downs, before the War* (w/c)

1946

Manchester Academy of Fine Arts
64. *Brighton Beach* (w/c) £21.00.0
103. *The English Farm* (oil) £100.0.0
114. *The Old Story* (oil) £25.00.0
267. *Guildford High Street* £8.8.0
276. *The Ash Grove* £20.0.0
**The Royal Scottish Society of Painters in
 Water-Colours**
7. *The Herring Fleet going out from Yarmouth*
73. *The Horseshoe Bend of The Severn*
85. *Building the Rick*
124. *Bathing Huts at Brighton*
301. *The Grey Mare*
305. *Sunrise*
Bradford City Art Gallery
Fifty-Third Spring Exhibition 1946
124. *The Rain Cloud* (w/c) £10.0.0
164. *An Autumn Afternoon: Somerset* (w/c) £20.0.0
Bath Society of Artists
41st Exhibition, Victoria Art Gallery, Bath
119. *Memories of the Louvre, Paris* (oil) £20.00.0
116. *Autumn Morning* (w/c) £21.00.0
117. *Ash Grove* (w/c) £21.00.0
150. *Brighton Beach* (w/c) £18.18.0
Atkinson Art Gallery, Southport
55th Spring Exhibition of Modern Art
40. *The Herring Fleet Going Out
 From Yarmouth* (w/c) £8.8.0
287. *The Horseshoe Bend of the Severn* (oil) £21.0.0
288. *Chepstow Castle* £35.0.0
The Royal Glasgow Institute of the Fine Arts
198. *A Summer Shower on the Quay, Dieppe* £11
505. *A Peasant's Vintage - Provence* £25
581. *The Old Story* £40
Victoria Art Gallery, Bath
Pastel Drawings
An Exhibition by Members of the Pastel Society from
the Art Exhibitions Bureau
16. *The Thames at Greenwich* 20 gns

County Borough of Bolton Art Gallery
Exhibition of Contemporary British Art
(selected from works submitted for the 1946
Royal Academy Summer Exhibition)
113. *Epsom Downs during 'Derby Week'* 84 gns

1947

Manchester Academy of Arts
31. *The Valley Farm* (w/c) £8.18.6
103. *The Votive Offering* (oil) £52.10.0
287. *November Rain* £21.00.0
**The Royal Scottish Society of Painters in
 Water-Colours**
36. *Clearing after Rain*
45. *Rain Clouds*
91. *The Valley Farm*
235. *Venice: The Ducal Palace*
269. *The Morning Sky*
**Russell-Cotes Art Gallery and Museum,
 Bournemouth**
Exhibition of Self Portraits by Living Artists
852. *Arthur H. Knighton-Hammond RI, ROI, RSW
 Date of Work 1947* £25
Bradford City Art Gallery
Forty-Fourth Spring Exhibition 1947
162. *Autumn on the French Riviera* (w/c) £8.18.6
236. *A Summer Symphony* (w/c) £25.0.0
Borough of Accrington, Haworth Art Gallery
Pastel Society Exhibition
16. *The Thames at Greenwich* 20 gns
Atkinson Art Gallery, Southport
56th Spring Exhibition of Modern Art
57. *The Rialto, Venice* (w/c) £9.9.0
118. *Manchester Royal Exchange, from the
 Market Place, Twenty-Five Years Ago* £12.12.0
**Russell-Cotes Art Gallery and Museum,
 Bournemouth**
136th Exhibition of the Royal Institute of Painters
in Water-Colours
917. *Autumn on the Riviera* 9 gns
935. *The Avenue in Spring* 10 gns
938. *Venice* 10 gns
The Royal Glasgow Institute of the Fine Arts
193. *Autumn Morning* £40
287. *Market Place, San Remo* (w/c) £14
498. *Early Morning - Kensington* £25
Royal Institute of Oil Painters
60th Annual Exhibition
73. *June Roses*
117. *Gypsies on the South Downs*
175. *The Gardener's Wife*
197. *The Mediterranean*

1948

Manchester Academy of Fine Arts
Spring Exhibition
115. *Hilary* (oil) £15.15.0
149. *The Muck Cart* (oil) £60.00.0

189. *Storm at Polperro* (oil) £30.00.0
229. *A Harbour near Genoa* £30.00.0
276. *The Ash Tree's Shade* £30.00.0

The Royal Scottish Society of Painters in
 Water-Colours
19. *The Storm*
41. *A Showery Day*
72. *Early Spring*

Royal Cambrian Academy
3. *Derby Day* (oil) £52.10.0
Exhibited in the Victoria Room

Atkinson Art Gallery, Southport
57th Spring Exhibition of Modern Art
7. *Storm at Polperro* (oil) £30.0.0
266. *The Muck Cart* (oil) £60.0.0

The Royal Glasgow Institute of the Fine Arts
255. *Camogi, near Genoa* (w/c) £20
393. *The Muck Cart* £60
476. *Labourers* £40

Royal Institute of Painters in
 Water-Colours
24. *An April Sky*
62. *From the South Downs*
94. *The Busy Threshing Machine*
125. *Anemones*

Royal Scottish Academy
208. *Derby Day* (oil) £100

Royal Institute of Oil Painters
61st Annual Exhibition
226. *Chepstow Castle* £40.0.0
268. *Polperro* £30.0.0
270. *Clematis and Roses* £30.0.0
293. *Epsom Downs on Derby Day, 1939* £80.0.0

1949

The Pastel Society
43rd Annual Exhibition
286. *Roses No. 3* £10.10.0
287. *Roses No. 1* £15.15.0
288. *Brighton Beach* £15.15.0
289. *Morning Light* £20.0.0
290. *Italian Village* £15.15.0
291. *Roses No. 2* £12.12.0

Royal Institute of Painters in Water-Colours
129. *Building the Rick* £40.0.0
147. *Kensington Gardens* £15.15.0
290. *Hampshire* £15.15.0
292. *April* £12.12.0
312. *Evening Sky* £12.12.0

Manchester Academy of Fine Arts
9. *The Mediterranean Shore* (w/c) £12.12.0
91. *A Harbour in Brittany* (oil) £35.00.0
125. *Chepstow Castle* (oil) £30.0.0
275. *My Own, My Native Land* £15.15.0

The Royal Scottish Society of Painters in
 Water-Colours
14. *Early Morning on the Thames at Greenwich*
22. *A Garden in the Wild*

33. *Alton - Hampshire*
36. *The Summer Air*

Bradford City Art Gallery
Fifty-Sixth Spring Exhibition 1949
253. *The Muck Cart* (30 x 25) (oil) £50.0.0
563. *Camogli, Italy* (w/c) £25.0.0

Atkinson Art Gallery, Southport
58th Spring Exhibition of Modern Art
279. *Sedgemoor* (w/c) £15.0.0
293. *Chepstow Castle* (oil) £35.0.0
314. *There's a Wind on the Heath,*
 Brother (oil) £60.0.0

Royal Cambrian Academy
14. *A Harbour in Brittany* (oil) £35
Exhibited in the Victoria Room

Aldridge's 38th Annual Exhibition of Water-Colour
 Drawings,
The Little Gallery, 35 Warwick Street, Worthing
3. *Sweet Peas* £25.00.0
17. *Dorset Landscape* £18.18.0
31. *Marshwood Vale near Lyme Regis* £12.12.0

The Royal Glasgow Institute of the
Fine Arts
84. *Despair* £100
579. *Now Comes Still Evening On* (w/c) £13
646. *The Village Horse Show* (w/c) £50

Royal Scottish Academy
131. *Morning in Brittany* (oil) £30

Royal Institute of Oil Painters
62nd Annual Exhibition
241. *A Summer's Day* £31.10.0
269. *The English Scene* £35.0.0
276. *The Climbing Clematis* £31.10.0
371. *Gypsy Encampment* £31.10.0

1950

Manchester Academy of Fine Arts
78. *The Thames at Greenwich* (w/c) £20
121. *The English Scene* (oil) £30
133. *The Thames at Greenwich* (pastel) £25
140. *Summer Morning, Venice* (oil) £30
145. *Morning at Breton Port* (oil) £30

Corporation Art Gallery, Rochdale
Exhibition of Works by Members of The Pastel
Society
37. *The Dorset Coast* 12 gns

Royal Institute of Painters in Water-Colours
149. *Santa Maria Della Salute and*
 the Grand Canal £31.0.0
206. *"Conversation Piece" at Grasse* £15.15.0
269. *Early Morning on the Cote D'Azur* £21.0.0
333. *Italian Washerwoman* £25.0.0
385. *Summer in Southern France* £12.12.0

Atkinson Art Gallery, Southport
59th Spring Exhibition of Modern Art
75. *The English Scene* (oil) £25.0.0
81. *Morning, The Thames at Greenwich* (oil) £20.0.0
188. *I Stood in Venice* (oil) £25.0.0

The Royal Scottish Society of Painters in
 Water-Colours
 8. *Now Came Still Evening on Twilight Grey*
 52. *The Sky Across the Fields*
150. *Picnic on the Dorset Coast*
162. *The Clouds that Gather Round the Setting Sun*
210. *An Autumn Afternoon*

Ferens Art Gallery, City of Kingston-
 Upon-Hull
Pastel Society
 37. *The Dorset Coast* 12 gns

The Royal Glasgow Institute of the Fine Arts
583. *Windsor Castle* (w/c) £35
668. *Full Summer* (w/c) £13
743. *Early Evening* (w/c) £13

Royal Institute of Oil Painters
63rd Annual Exhibition
170. *The English Gypsy* £200.00.0
267. *The Slanting Sunlight of the Dawn* £150.00.0
277. *The Bridge of Sighs, a Palace and*
 a Prison on each hand £42.00.0
280. *Early Morning Market, Eu* £150.00.0

1951

Manchester Academy of Fine Arts
83. *The Garden Party* (w/c) £8.8.0
201. *Cathedral and Morning Market, Eu* (oil)
 £50.00.0

Royal Institute of Painters in Water Colours
147. *Wessex* £12.12.0
182. *Building the Rick* £8.8.0
192. *The Garden Party* £10.10.0
291. *Moonrise on the Mediterranean*
 at Menton £15.0.0
394. *The Beach at Lyme Regis* £25.0.0

The Royal Scottish Society of Painters in
 Water-Colours
 80. *Conservation Piece*
 92. *The Garden Party*
179. *Early Morning - Porto Maurizio, Italy*
198. *Derby Day - Epsom Downs*
264. *Conversation at Grasse*

The Royal Glasgow Institute of the Fine Arts
544. *August* (w/c) £30
608. *A Mixed Bunch* (w/c) £30

Royal Institute of Oil Painters
64th Annual Exhibition
271. *Busy Morning* £40.0.0
323. *Chepstow* £35.0.0
325. *Tunis* £42.0.0
409. *Epsom Downs during Derby Week* £105.0.0

Russell-Cotes Art Gallery and Museum,
 Bournemouth
Exhibition of Art inspired by Music
857. *June Roses* 40 gns
939. *Carmen* 40 gns
957. *'The lily petal grows and buds the rose'* 40 gns

992. *A Venetian Window* 40 gns
1006. *Clematis* 20 gns
1023. *Love's Dream* 15 gns

Britain in Water-Colours Exhibition
Nottingham Castle Art Gallery
127. *The Church Fete*
202. *Epsom Downs*

1952

The Pastel Society
439. *Maritime Alps from near Monte Carlo* £8.8.0
440. *Blue Mediterranean* £12.12.0
441. *Monte Calvario* £14.14.0
442. *Alresford* £5.5.0
443. *Evening Glow* £7.7.0
444. *Solitude* £6.6.0

Manchester Academy of Fine Art
123. *Mosque at Tunis* (oil) £20.00.0
125. *Epsom Downs During Derby Week* (oil) £50.00.0
244. *June Poppies* £15.15.0
251. *Standing Nude* £7.7.0

The Royal Scottish Society of Painters in
 Water-Colours
 13. *The Church Fete*
165. *On Epsom Downs during 'Derby' Week*
180. *Building the Rick*
224. *The Source*
234. *October*

Ridley Art Club
(RI Galleries, London)
 August 25 gns
 The Church Fete £15
 Dorset from Beaminster - 'Hardy' Country 12 gns
 Sunday Morning - Guildford High Street 25 gns

Britain in Water-Colours Exhibition
The Royal Water-Colour Society Galleries,
London
 The Garden Fete 20 gns
 Heifers and a Byre 15 gns

The Royal Glasgow Institute of the Fine Arts
284. *A Bunch of Roses Painted in Italy* (w/c) £37
613. *Dawn on Mont Blanc - from Near*
 Val D'Aosta (w/c) £21

Corporation Art Gallery, Bury Manchester
 Academy of Fine Arts
Exhibition of Pictures
 39. *The Muck Cart* (oil) £105.0.0
 72. *Sunday morning Guildford High Street*
 (22 x 23 ins) (oil) £26.5.0
 77. *August* (w/c) £26.5.0
 81. *Dorset from near Beaminster* (w/c) £12.12.0

Royal Institute of Oil Painters
65th Annual Exhibition
 94. *Piazza San Marco, Venice* £25.0.0
208. *Early Morn* £125.0.0
317. *Aetatis Florentis Initium* £52.10.0
437. *A Farm Labourer* £250.0.0

1953

Manchester Academy of Fine Art

29. *An Autumn Morning* (w/c)	£10.10.0
184. *Aetatis Florentis Initium* (oil)	£42.00.0
222. *In Conway Valley* (w/c)	£35.00.0
230. *Raglan Castle* (w/c)	£35.00.0

Royal Institute of Painters in Water-Colours

4. *The Blue Vase*	£21.0.0
179. *Taggia*	£26.5.0
197. *Roses*	£31.10.0
376. *The Rainbow*	£36.15.0
483. *Venice*	£26.5.0

Atkinson Art Gallery, Southport

Diamond Jubilee Spring Exhibition

7. *Aetatis Florentis Initium* (oil)	£52.10.0
62. *Raglan Castle* (w/c)	£35.0.0
201. *Piazza, San Marco, Venice* (oil)	£25.0.0

The Royal Scottish Society of Painters in Water-Colours

49. *Autumn Evening*
99. *A Man with a Scythe*
122. *Autumn Afternoon*
125. *Autumn Morning*
154. *A Wessex Hamlet*

The Royal Glasgow Institute of the Fine Arts

223. *The Man with a Scythe* (w/c)	£37
231. *The Ending of the Day* (w/c)	£37
594. *Aetatis Florentis Initium* (w/c)	£26

Royal Institute of Oil Painters

66th Annual Exhibition

65. *A Port in Brittany*	£42.0.0
311. *A Farm Labourer*	£200.0.0
359. *A Market in France*	£100.0.0
371. *The Muck Cart*	£75.0.0

1954

Royal Institute of Painters in Water-Colours

171. *Glennis*	£26.5.0
323. *Tea in the Garden*	£12.12.0
335. *The Church Fete*	£21.0.0
368. *A Somerset Farmstead*	£40.0.0
374. *Egdon Heath*	£40.0.0

Russell-Cotes Art Gallery and Museum, Bournemouth

Exhibition of Oil Paintings by Present Day Artists

821. *A Wessex Farm Labourer*	£200

Atkinson Art Gallery, Southport

61st Spring Exhibition

241. *An Italian Village - Taggia*	£20.0.0
258. *Venice*	£20.0.0
265. *The Man with a Scythe*	£40.0.0

Exhibition of English Water-Colours and Drawings, National Museum, Belgrade, Yugoslavia

12. *Trafalgar Square* (460 x 490 mm) (w/c)

Royal Institute of Oil Painters

67th Annual Exhibition

322. *Janet*	60 gns
410. *English Soldier - Painted immediately on his arrival in England from Dunkirk June 1940*	100 gns
430. *Brenda - as Joan of Arc*	60 gns

1957

Yeovil Museum

30 plus works exhibited

Church Fete, Misterton (w/c)
The Ox Stall (w/c)
Wind-Whistle Hill (w/c)
Making the Rick (oil)
Jeffrey's Muck Cart (oil)
Carnations (oil)
A Dancing Girl (oil)
The Laughing Girl (oil)

two etchings

Incomplete list

Royal Institute of Oil Painters

70th Annual Exhibition

123. *Charmian*

1958

The Pastel Society (RI Galleries)

377. *Menton from Cap Martin*	20 gns
378. *Monte Carlo*	15 gns
379. *Winter Sunlight*	25 gns
380. *Toska*	30 gns
381. *The Women's Ward*	25 gns
382. *June*	15 gns

Royal Institute of Painters in Water-Colours

146th Exhibition

310. *Aix-En-Provence*	30 gns
320. *The Robe*	30 gns
333. *The Bloom*	30 gns
444. *Flower Piece*	30 gns
450. *The Ordered Tumult of the Sky*	20 gns

Royal Institute of Oil Painters

71st Annual Exhibition

301. *Flower Group*	30 gns
364. *A Wessex Farm Labourer*	30 gns
396. *Hilary*	60 gns
464. *The Student*	30 gns

1959

Royal Institute of Painters in Water-Colours

147th Exhibition

5. *Beside the River's Flow, Joigny, 1926*	30 gns
262. *Flowers in Bright Profusion Dancing*	40 gns
350. *Gusty Skies Upon the Hill*	20 gns
385. *The Sky Across the Fields*	20 gns
401. *The Dawn Wind's song, a Somerset Sunrise*	50 gns

**Exhibition of Water-Colours, Oil Paintings,
Etchings, Pastels and Drawings in Sanguine**
At the Galleries of the Royal Water-Colour Society
26 Conduit Street, London, W1

1. The Muck Cart	30 gns
2. The Morning of the Derby	30 gns
3. Building the Rick	30 gns
4. Autumn Flowers and Fruit	30 gns
5. October Flowers in the Grecian Urn	35 gns
6. English Flowers in the Grecian Urn	35 gns
7. September Flowers in Silver Bowl	35 gns
8. July Flowers in Chinese Bowl	35 gns
9. September Flowers in Chinese Bowl	35 gns
10. August Flowers in Grecian Urn	35 gns
11. Autumn Leaves in a Greek Bowl	35 gns
12. Flowers in Silver Bowl	35 gns
13. A Dorset Beauty	20 gns
14. Anne of Cleves House, Ditchling, Sussex	30 gns
15. Druid's Hill, Misterton, Somerset	30 gns
16. Autumn Leaves and Berries	35 gns
17. Study in Sanguine for 50 x 40 mm oil	20 gns
18. The Blue Girl	20 gns
19. Autumn Afternoon, Tintern Abbey	30 gns
20. Autumn Evening, Windsor Castle	35 gns
21. Sunshine on Brighton Beach - c.1938	35 gns
22. Gypsy Encampment - Early Morning	30 gns
23. The Wine Boat, Menton Harbour	30 gns
24. Flowers in Chinese Vase	25 gns
25. Cupid, Roses and Grecian Urn	30 gns
26. Preparing for War. 1941 in the Manor House Yard, Misterton, Somerset	40 gns
27. 'The Beauty of Red Roses, Soft as Silk'	25 gns
28. Brighton Beach	30 gns
29. The Doorway of a Brothel, France	30 gns
30. Durham Cathedral, An Oxford Don and Others	40 gns
31. Tom Tits, The Landgirl and Another	30 gns
32. 'Twelve Drawings Done Fifty-Five Years Ago'	50 gns
33. Various Drawings in Sanguine	25 gns
34. An Autumn Morning on Druid's Hill	30 gns
35. Epsom Downs During Derby Week	35 gns
36. Man Sitting by the Wayside on a Cold Day. 'Blow! Blow! Thou Winter Wind'	40 gns
37. Autumn Ploughing, 1945	30 gns
38. Sunny Morning on Druid's Hill	30 gns
39. The Man with a Scythe	35 gns
40. The Beach at Lyme Regis	30 gns
41. The Cobb, Lyme Regis	30 gns
42. Rainbow on Epsom Downs	30 gns
43. Sky Over Druid's Hill	30 gns
44. The Bridge at Ludlow	30 gns
45. 1942 In an English Village	40 gns
46. An Autumn Dawn	30 gns
47. Farmyard with Anne of Cleves House, Ditchling, Sussex	30 gns
48. Chepstow Castle	30 gns
49. The Butterfly's Joy	35 gns

50. Ditchling Horse Show, 1937	35 gns
51. Early Morning	10 gns
52. The Tumult of the Sky	20 gns
53. Ranelagh, c.1929	7 gns
54. View from Ponte De Cristo, Venice	8 gns
55. Park Lane, Prior to demolition	10 gns
56. Margaret	8 gns
57. September Morning	10 gns
58. Druid's Hill	8 gns
59. Rain clouds	10 gns
60. Moonrise at Moynes Court, near Chepstow	10 gns
61. Boats at Concarneau	15 gns
62. Pastel on Etching of a Venetian Palace	10 gns
63. The Sunset Sky	12 gns
64. Fall and Expulsion from Paradise from a Fresco by Michael Angelo	18 gns
65. Dolwyddelan Castle, N. Wales	12 gns
66. Christies, 1939	20 gns
67. The Italian Model	12 gns
68. Late Afternoon Sunlight, Wells Cathedral	30 gns
69. Storm in the Conway Valley	35 gns
70. Darby and Joan	60 gns
71. Morning Market, Santa Margharita, Genoa	30 gns
72. Guildford High Street	30 gns
73. Drying Fishing Nets. Monastery near Portofino	30 gns
74. Circus at Martigues	30 gns
75. Early Morning, Old Town, Menton	30 gns
76. Moustiere Ste Marie, Provence	35 gns
77. A Spring Morning	30 gns
78. Windsor Castle	30 gns
79. Flower Group	30 gns
80. Sunshine at Epsom During Derby Week	30 gns
81. Rainstorm	15 gns
82. Evening Glow. Boats at Chioggia on the Lagoon outside Venice	20 gns
83. Cromford Court, Looking across Corporation Street to Bull's Head Yard, Manchester, 1922	30 gns
84. The Harbour Polperro	30 gns
85. Group of Roses, Painted at Monte Calvario, Italy	30 gns
86. An Autumn Afternoon, Beaminster, Dorset	18 gns
87. Rainstorm	15 gns
88. A Dish of Tea	35 gns
89. The Laughing Irishman	40 gns
90. A Flower Group	30 gns
91. An Old-Age Pensioner	30 gns
92. A Tramp, 1935	25 gns
93. Studies of a Boy's Head	30 gns
94. The 'Oaks' Day at Epsom	35 gns
95. The Man with a Scythe	35 gns
96. Ditchling Horse Show, c.1937	35 gns
97. Ascot, c.1938	30 gns
98. An English Model	25 gns

99. *A Maid of Portofino* — 30 gns
100. *Rain Clouds, Dorset* — 18 gns
101. *The Rialto, Venice* — 25 gns
102. *The Edge of a Mandarin's Robe and Anemones* — 30 gns
103. *Clematis, Roses and Blue Vases* — 30 gns
104. *Misty Morning, Menton* — 12 gns
105. *Dieppe* — 100 gns
106. *Stormy Dawn on Druid's Hill* — 18 gns
107. *Autumn Flowers* — 30 gns
108. *A Chinese Bowlful* — 30 gns
109. *Souvenir Du Louvre* — 45 gns
110. *An English Farmer* — 650 gns
111. *Cronies* — 950 gns
112. *Old Friends* — 950 gns
113. *Building the Rick* — 650 gns
114. *Bronze Statue in the Piazza Signoria, Florence* — 30 gns
115. *A Study in Pink* — 30 gns
116. *Wind on the Heath* — 30 gns
117. *Cellini's Bronze and Michael Angelo's David in the Piazza Signoria, Florence* — 30 gns
118. *The Italian Coast from Cap Martin, Early Morning* — 18 gns
119. *Breezy Early Morning - Autumn* — 18 gns
120. *Early Morning Shower* — 15 gns
121. *September Morning on Druid's Hill* — 12 gns
122. *An English Sky* — 20 gns
123. *An Old Farm Labourer, 1935* — 650 gns
124. *Venetian Canal* — 6 gns
125. *Storm over Kimmeridge Bay, Dorset* — 6 gns
126. *Preparing for the Fishing, Concarneau, Brittany* — 7 gns
127. *The Arts Club, Dover Street, W1* — 7 gns
128. *Clee Hills, Shropshire* — 7 gns
129. *Old Paris - 1913* — 8 gns
130. *Hyde Park Corner, c.1925* — 7 gns
131. *Rag Pickers under the Pont Neuf, Paris, 1922* — 8 gns
132. *Venice, 1922* — 7 gns
133. *Canal, in Manchester* — 10 gns
134. *Browning Palace, Venice* — 7 gns
135. *Durham Castle - Sunset* — 8 gns
136. *Haddon Hall and the Pack-Horse Bridge, Pre-Reformation* — 8 gns
137. *Olive Gatherers, Italy* — 10 gns
138. *Moreton Old Hall* — 10 gns
139. *The Butler Cross, Ludlow* — 10 gns
140. *Building a Factory, Huddersfield, 1919* — 10 gns
141. *The Potato Gatherer, Cheshire* — 8 gns
142. *A Gargoyle on Notre Dame, Paris* — 7 gns
143. *The Smithy, Woodford, Cheshire, 1913* — 8 gns
144. *Winter Woodland, Sussex* — 8 gns
145. *Early Morning, Concarneau, Brittany* — 7 gns
146. *A Tragheto, Venice* — 6 gns
147. *Arts Club, Dover Street, W1 1938* — 6 gns
148. *A Pyramid of Roses* (oil) — 18 gns
149. *Mr Reeves, A Super Tramp, 1935* — 8 gns

150. *Paris, 1928* — 8 gns
151. *Our Cottage at Kimmeridge, Dorset, 1938* — 7 gns
152. *The Dow Chemical Works, Michigan, USA, 1920* — 7 gns
153. *Christies, 1939* — 7 gns
154. *Dining Hall, Chetham's Hospital, Manchester, 1914* — 7 gns
155. *The ROI Selection Committee, 1936* — 7 gns
156. *Durham Cathedral* — 10 gns
157. *Sir Frank Brangwyn* (Sanguine drawings) — 20 gns
158. *Knutsford* — 10 gns
159. *The Pre-War Parlour Maid* — 30 gns
160. *The Gas Producer Plant* — 12 gns
161. *The Thames at Greenwich from the Balcony of the Old Ship Hotel* — 25 gns
162. *Porto Maurizio from Monte Calvario, Liguria* — 25 gns
163. *The Daily Help's Daughter* — 30 gns
164. *The Church and Monastery, Monte Calvario, Liguria* — 30 gns
165. *A Gypsy at Kimmeridge Bay* — 8 gns
166. *Evening Light - After a Wet Day - Wells Cathedral* — 10 gns
167. *Demolition of The Royal Exchange, Manchester, 1915* — 12 gns
168. *Sir Frank Brangwyn* — 8 gns
169. *On the Zattere, Church of San Miniato, Venice* — 8 gns
170. *Old Shambles, The Market Place and Royal Exchange, Manchester, 1914* — 12 gns
171. *The Works* — 8 gns
172. *Dalton Works, Huddersfield* — 10 gns
173. *The Salute, Venice* — 6 gns
174. *A Provençal Gypsy and her Family* — 350 gns
175. *A Provençal Gypsy* — 200 gns

1960

Manchester Academy of Fine Arts

1. *Old Man on a Cold Day* (w/c) — 60 gns
74. *The Man with a Scythe* (w/c) — 60 gns
217. *An English Farmer* (oil) — 500 gns
236. *Cromford Court, Manchester* (oil) — 28 gns

The Pastel Society

29. *Old Women's Ward, Alton, Workhouse 1933* — 25 gns

Royal Institute of Oil Painters

107. *The Auburn Haired Model* — 200 gns
108. *The Gypsy's Daughter* — 100 gns
140. *Portrait of Janet* — 60 gns
177. *The Muck Cart* — 60 gns

1961

Royal Institute of Painters in Water-Colours
149th Exhibition
124. *Autumn Ploughing* — 60 gns
231. *Dorset Uplands* — 12 gns
261. *The Model* — 12 gns

313. *Autumn Flowers* 60 gns
441. *Chepstow Castle* 60 gns
The Royal Academy
867. *Grand Canal with the Church of the*
 Madonna della Salute, Venice
Manchester Academy of Fine Arts Exhibition
37. *Sunshine at Epsom during Derby Week* (w/c)
 NFS
148. *The Muck Cart* (oil?) £70

1962

Royal Institute of Oil Painters
75th Annual Exhibition
235. *A Yeoman of the Guard* 500 gns
273. *Australian soldiers in England*
 Tasting the Soup 300 gns
283. *"A ministering angel thou"* 300 gns
296. *Mary* 150 gns

1963

Royal Institute of Painters in
 Water-Colours
151st Exhibition
32. *A Wessex Sky* 12 gns
196. *The Model* 20 gns
267. *Roses* 35 gns
328. *'Despair', Gypsies in Provence* 75 gns
480. *Full Summer* 40 gns
The Royal Glasgow Institute of the Fine Arts
262. *A Wessex Farmer* £210
447. *A Corner of the Village Horse Show* £35
Royal Institute of Oil Painters
76th Annual Exhibition
280. *A Wessex Farm Labourer* 150 gns
288. *Ludlow* 200 gns
301. *Basket of Roses* 30 gns
321. *A Mixed Bunch* 60 gns

1964

Royal Institute of Painters in
 Water-Colours
152nd Exhibition
234. *Alton Church, Hants* 60 gns
325. *The Muck Cart* 30 gns
497. *Piazza Signoria Florence* 25 gns
502. *The Man with a Scythe* 60 gns
508. *Evening Light on West Front, Wells*
 Cathedral 30 gns
The Royal Glasgow Institute of the Fine Arts
255. *A British Farmer* £315
431. *The Man with a Scythe* (w/c) £60
Royal Institute of Oil Painters
123. *The Handsome Gypsy* 75 gns
188. *Peonies* 50 gns

1965

Royal Institute of Painters in Water-Colours
153rd Annual Exhibition

170. *An Autumn Afternoon, Dorset* 15 gns
171. *Early Morning, Somerset* 15 gns
172. *A Morning Sky* 30 gns
174. *Skyscape* 30 gns
175. *A Stormy Day, Wales* 10 gns
293. *Cellini's Statue and Piazza Signoria,*
 Florence 30 gns
339. *The Hilltop* 40 gns

1966

Royal Institute of Painters in Water-Colours
154th Annual Exhibition
381. *A Nude Girl* 30 gns
383. *The Hilltop* 30 gns
384. *Sunrise in the Conway Valley* 30 gns
387. *Autumn in Wales* 30 gns
388. *Morning in Italy* 35 gns
The Pastel Society
60th Annual Exhibition
61. *A Breton Pardon* 15 gns
62. *Old Town, Menton* 20 gns
63. *Porto Maurizio, Liguiria, Italy* 30 gns
64. *Roses* 20 gns
65. *Winter Sunset* 15 gns
66. *On the Italian Riviera* 20 gns

1967

Royal Institute of Painters in
 Water-Colours
155th Exhibition
21. *Derby Week on Epsom Downs* 30 gns
45. *Wine Boats, Menton* 25 gns
46. *Ludlow* 30 gns
47. *Houses on the Hill* 30 gns
48. *Kensington Gardens* 15 gns
82. *Bridge of Sighs, Venice* 25 gns
341. *August* 30 gns

1968

Royal Institute of Painters in
 Water-Colours
80. *The Midday Rest* 40 gns
81. *The Ploughing Team* 40 gns
85. *An English Sky* 40 gns
86. *Man with a Scythe* 40 gns
87. *Chepstow Castle* 40 gns
91. *The Muck Cart* 40 gns
92. *The Storm* 50 gns

1969

The Pastel Society
63rd Annual Exhibition
350. *Roses* 20 gns
351. *Menton Bay* 15 gns
352. *View of Porto Maurizio* 20 gns
353. *Battersea Power Station* 25 gns
354. *Moonrise* 20 gns
355. *Liguria* 15 gns

RETROSPECTIVE EXHIBITIONS

1970

The Pastel Society
 (Federation of British Artists)
64th Exhibition
The Late Mr A.H. Knighton-Hammond
142. *Emmeline Mary* 400 gns

1971

Upper Grosvenor Galleries
 19 Upper Grosvenor Street, London, W1
Water-Colours

1. *Misterton Landscape, Dorset*	£45
2. *The Church at Eu, Normandy, Early Morning*	£45
3. *The Fountain, Castellane*	£40
4. *Mercato, Venice*	£40
5. *Evening Light, Auxerre*	£45
6. *Saigueglia Church*	£55
7. *The Bathing Jetty, Near Dieppe*	£60
8. *San Fruituosa, Near Portofino*	£60
9. *Kimmeridge Bay, Dorset*	£90
10. *A Landscape in Somerset*	£45
11. *The Bathing Beach, Dieppe*	£50
12. *Chrysanthemums*	£75
13. *Mediterranean Landscape*	£50
14. *Storm Over Misterton*	£40
15. *Cattle on Druid's Hill*	£60
16. *A Day in November*	£65
17. *Menton Bay*	£60
18. *Entering the Harbour, Dieppe*	£80
19. *In the Harbour, Dieppe*	£75
20. *On the Beach*	£55
21. *Sunday Morning*	£50
22. *Early Morning, Druid's Hill*	£65
23. *Near Cap Martin*	£45
24. *Concarneau*	£60
25. *Moustiere Ste Marie, Provence*	£75
26. *Pont D'Avignon*	£70
27. *Caravan Holiday*	£100
28. *After the Races, Epsom Downs*	£85
29. *Ploughing*	£90
30. *A Somerset Pastureland*	£90
31. *Italian Fishing Boats*	£85
32. *Boats, Venice*	£70
33. *Flower Study*	£45
34. *Stokesay Castle*	£85
35. *Basket of Roses*	£75
36. *Gypsy with Black Eye, Provence*	£75
37. *A Country Lane*	£45
38. *Wine Boats, Menton*	£80

Pastels

39. *Ventimiglia*	£40
40. *Monte Calvario, Italy*	£40
41. *Menton*	£30
42. *Seashore*	£30
43. *Alpes Courmeyeur*	£30
44. *Dolomites*	£25
45. *Snow Mountains*	£35
46. *Hunting Scene*	£30
47. *Somerset*	£30
48. *Roses*	£40
49. *Italian Fishing Boats*	£30
50. *South of France*	£30
51. *Sunset, Menton*	£30

Coloured Etchings

52. *Fishermen, Kimmeridge*	£20
53. *Kimmeridge Bay*	£20
54. *Fishing Boats, South of France*	£18
55. *Fishing Port*	£18

Water-Colours in Portfolio

56. *Marguerites*	£35
57. *Vase of Flowers*	£25
58. *Roses in Blue Vase*	£30
59. *Roses in Green Vase*	£40

1972

Gallery 27, 27 Shipbourne Road,
 Tonbridge, Kent
Water-Colours

1. *Italian Picnic*	£30
2. *Menton Bay*	£25
3. *Afternoon Tea*	£36
4. *Flower Market*	£30
5. *Sunshine at Epsom*	£50
6. *Picnic in the Cornfield*	£25
7. *Auxerre*	£30
8. *Bedtime*	£10
9. *Polperro*	£45
10. *Port Napoleon*	£30
11. *London Bridge*	£45
12. *Models Relaxing*	£35
13. *Bathing from the Rocks*	£28
14. *Old Houses - Menton*	£35
15. *Bridge of Sighs*	£35

Etchings

16. *Hyde Park Corner*	£8
17. *Kimmeridge Bay*	£9
18. *Rag Pickers*	£8
19. *Christies*	£10
20. *The Smaller Arts Club*	£8
21. *The ROI Selection Committee*	£10
22. *Concarneau*	£10

Chalk

23. *Little Girl*	£15

Pastels

24. *St Pauls*	£30
25. *Tower Bridge*	£30

Oil Paintings

26. *Cape Gooseberries*	£40
27. *The Gardener's Wife*	£40
28. *Self Portrait*	NFS
29. *Apple Blossom*	£80
30. *Misty Morning, Thames*	£30

31. *Windy Day*	£35
32. *Cronies*	£150
33. *Chelsea Pensioner*	£100
34. *Sunflowers*	£75
35. *Mediterranean Harbour*	£60
36. *Study in Blue*	£75
37. *Menton Bay*	£50
38. *Daisies*	£60
39. *Lunchtime Drinks*	£25

Water-Colours

40. *Menton Quayside*	£45
41. *Italian Villa*	£20
42. *Cornfield in Hampshire*	£35
43. *Stonemason's Yard*	£20
44. *Blue Horses*	£50
45. *Fishing*	£22
46. *Ploughed Field*	£15
47. *Moynes Court*	£18
48. *Cap Martin*	£25
49. *Ducks* (autographed)	£25
50. *Paddling*	£12
51. *Red Dress*	£40
52. *Horses at Polperro*	£42
53. *Stonemason's Yard*	£20
54. *The Beach*	£25
55. *Breakfast in the Garden*	£45
56. *John*	£20
57. *Mary* (Red Chalk)	£20
58. *Picnic Supper*	£25
59. *Emmeline*	£18
60. *Milking Time*	£18
61. *Mother and Child*	£20

Oil Painting

| 62. *Harbour* | £20 |

1973

Stockport Art Gallery

Oils

1. *The Old Tramp*	£500
2. *Late Summer Flowers*	£250
3. *Study in Blue*	£100
4. *Light through study window*	£100
5. *Roses*	£50
6. *Windy day*	£50
7. *Self Portrait*	NFS
8. *Worcestershire scene*	NFS
9. *Untitled*	NFS
10. *The Crook of Lune*	NFS

Water-Colours

11. *Old Houses, Menton*	£50
12. *Early Morning, Nevers*	£50
13. *France, 1925*	£20
14. *Fishing*	£35
15. *Ploughed Field*	£20
16. *Italian Picnic*	£40
17. *The Italian Coastline*	£40
18. *Flower Market*	£45

19. *Bathing from the Rocks*	£35
20. *The Beach*	£35
21. *Milking Time*	£30
22. *Italian Villa*	£45
23. *Chubby Baby*	£30
24. *Cap Martin*	£40
25. *The Last Rose of Summer*	£65
26. *Stormy Horses*	£70
27. *English Bay*	£65
28. *Sussex 1928* (autographed)	£35
29. *Dorset View*	£35
30. *Cleobury Mortimer*	NFS
31. *Woodford*	NFS
32. *Langdale Pikes and Langdale Beck*	NFS
33. *Haddon Hall*	NFS
34. *Prestbury*	NFS
35. *Styal*	NFS
36. *Venice*	NFS
37. *Old Cottage*	NFS
38. *Main Street, Cleobury Mortimer*	NFS
39. *Country Scene*	NFS
40. *Landscape (the Dolomites)*	NFS
41. *Landscape with Trees*	NFS
42. *Pont Dwgan Mill*	NFS

Red Chalk

| 43. *Mary* | £30 |

Pastels

44. *John*	£80
45. *The Maritime Alps*	£25
46. *Sailing Boats*	£20
47. *In the Ring*	£35
48. *Cloudy Sky*	£25
49. *Fishing Boats*	£40
50. *Nursemaids in Hyde Park*	NFS

Etchings

51. *The Smaller Arts Club*	£10
52. *The Bath Tub at Kimmeridge, 1938*	£12
53. *A Notre Dame Gargoyle, 1922*	£20
54. *Olive Gatherers*	£10
55. *Clee Hills, Shropshire*	£15
56. *Manchester Canal*	£50
57. *Venice*	NFS
58. *Venice*	NFS
59. *Country Scene with Horse and Cart*	NFS
60. *Interior*	NFS
61. *Country Scene*	NFS
62. *Royal Exchange, Manchester*	NFS
63. *Untitled*	NFS
64. *Untitled*	NFS
65. *Country Scene*	NFS
66. *Country Scene*	NFS
67. *Rochdale Canal, Manchester*	NFS
68. *Great Camberton, Worcs.*	NFS
69. *Kimmeridge Bay*	NFS

Pencil Drawings

| 70. *Bramhall 1918 and others* | £55 |
| 71. *Haddon Hall and others* | £65 |

1974

The Gallery, Brookside, Sandhurst,
 Camberley, Surrey

Oils

1.	*Late Summer Flowers*	£360
2.	*Study in Blue*	£125
3.	*Windy Day*	£60
4.	*Flowers in a Green Vase*	£300

Water-Colours

5.	*Chubby Baby*	£44
6.	*Above Cap Martin*	£57
7.	*Flower Market*	£57
8.	*Building the Rick*	£44
9.	*Italian Coastline*	£51
10.	*Sussex 1928* (autographed)	£36
11.	*Rialto, Venice*	£78
12.	*Bathing from the Rocks*	£49
13.	*The Beach*	£48
14.	*Old Houses, Menton*	£60
15.	*Figures on the Beach*	£42
16.	*Olive Gatherers*	£36
17.	*French Girl at Cap Martin*	£55
18.	*Picnic Supper*	£60
19.	*Egdon Heath*	£54
20.	*Butter Market, Concarneau*	£48
21.	*Dieppe*	£12
22.	*Sunflowers*	£48
23.	*By the Church Doorway San Remo*	£30
24.	*Emmeline*	£42
25.	*Dieppe Beach*	£54
26.	*Mary and Sunshade*	£55
27.	*Cap Martin*	£50
28.	*Mary, Mummy and Teddy*	£55
29.	*Mid-day*	£55
30.	*The Fisherman's Wife, Cap Martin*	£55
31.	*Early Evening, Bay of Menton*	£48
32.	*San Giorgio, Venice*	£48
33.	*Anemones*	£42
34.	*Poppies*	£48
35.	*Arbutus*	£46
36.	*Flowers at Concarneau*	£48
37.	*By the Sea*	£18
38.	*Figures at Porto Fino*	£48
39.	*Mary at Monte Calvario*	£36
40.	*Menton Bay with Tree*	£48
41.	*Garden Seat*	£30
42.	*Menton*	£42
43.	*Boats*	£36
44.	*Menton Bay*	£42
45.	*Blue Mountains*	£48
46.	*Bathers at Cap Martin*	£36
47.	*French Model*	£72
48.	*Hymn to Pan*	£80

1976

Chichester House Gallery,
Ditchling, West Sussex

APPENDIX B
LIST OF PAINTINGS BY A.H. KNIGHTON-HAMMOND IN PUBLIC GALLERIES

GREAT BRITAIN

DUNDEE ART GALLERIES & MUSEUMS
The Garden Party water-colour

MANCHESTER CITY ART GALLERY
Manchester Royal Exchange 1920 pencil drawing
Manchester Royal Exchange 1920 pencil drawing
Hobson Square 1923 pencil drawing

NATIONAL PORTRAIT GALLERY, LONDON
Edward Johnston oil on canvas
Sir Frank Brangwyn pencil drawing
Sir Frank Brangwyn etching

NEWPORT MUSEUM & ART GALLERY
Chepstow Castle water-colour

ROCHDALE ART GALLERY
Conversation Piece at Grasse water-colour

STOCKPORT ART GALLERY
The Crook of Lune oil on canvas
Pont Dwgan Mill water-colour
Landscape with Trees water-colour
Landscape (The Dolomites) water-colour
Italian Picnic water-colour
Ploughed Field water-colour
Stormy Horses water-colour

VICTORIA ART GALLERY, BATH
The Fountain, Florence water-colour

OVERSEAS

NATIONAL GALLERY OF SOUTH AFRICA
Brighton Beach water-colour

NATIONAL MUSEUM OF BELGRADE
Trafalgar Square, London water-colour

CENTRE GEORGES POMPIDOU, PARIS
Derby Week at Epsom water-colour

BRIEF BIOGRAPHY OF ARTISTS
MENTIONED IN TEXT

BALDRY, Alfred Lys (1858-1939) Landscape painter and art critic (*Birmingham Daily Post* and the *Globe*). Born at Torquay, Devon. Studied at the Royal College of Art and under Albert Moore. PS.

BASTIEN-LEPAGE, Jules (1848-84) Born in Damvillers in north-eastern France, worked there for most of his career. Studied under Cabanel at Ecole des Beaux-Arts, Paris, from 1867. Visited London annually 1870-82 and travelled to Venice, 1881, to Concarneau, Brittany, 1883, and to Algiers, spring 1884, shortly before his death.

BEER, John (See p.8, 9-10, 11, 12)

BEHREND, George Lionel (1868-1950) (See p.79-80ff)

BIRCH, Samuel John "Lamorna" (1869-1955) Landscape painter. Born at Egremont, Cheshire. Worked in the mills in Manchester and Lancaster and painted in his spare time. Self-taught in art but spent a year in Paris at the Atelier Colarossi 1895-96. Worked with Stanhope Forbes at Newlyn from 1889. RWS 1914, ARA 1926, RA 1934.

BONINGTON, Richard Parkes (1801-28) Painter in oil and water-colours. Born Arnold, Nottinghamshire, on 25 October 1801. Emigrated with his parents to Calais in 1817 where he studied under the water-colourist, François Louis Thomas Francia (1772-1839). Studied in Paris at the Louvre where he met Eugène Delacroix and a friendship grew. In 1820 entered the *atelier* of Baron Gros and also studied at the Ecole des Beaux Arts. Exhibited at the Paris Salon for the first time in 1822. Died in London on 23 September 1928 after a brief but extremely productive career.

BOWMAN, John (Jack) Landscape painter. Exhibited 1892-1915. NSA 1908.

BRANGWYN, Sir Frank (1867-1956) Born at Bruges in Belgium 13 May 1867 of Welsh extraction. Son of William Curtis Brangwyn, a church architect. Moved to London in 1875. Taken up by Arthur Heygate Mackmurdo and Harold Stewart Rathbone, who set him to draw as a student in the Victoria and Albert Museum. With their influence he was able to get a position with William Morris from 1882-84, where he was employed in enlarging the designs for tapestries, embroideries and wall-papers. First exhibited at the Royal Academy in 1885. Married Lucy Ray in 1898 and elected ARA in 1904 and RA in 1919. Moved to Ditchling in 1924 where he died 11 June 1956.

BROWN, Professor Frederick (1851-1941) Landscape, genre and portrait painter. Born in Chelmsford. Studied at the Royal College of Art 1868-77 and in Paris under Bouguereau and Tony Fleury 1883. Taught at Westminster School of Art 1877-92. Professor at the Slade School 1892-1918. Founder member of NEA 1886.

CAFFIERI, Hector (1847-1932) Landscape painter and water-colourist. Born in Cheltenham. Studied in Paris under Bonnat and J.Lefebvre. RBA 1876, RI 1885, ROI 1894.

CAMERON, Sir David Young (1865-1945) Painter, etcher and illustrator. Born in Glasgow. Studied in Glasgow and Edinburgh. Official artist for World War I for Canadian Government. ARA 1916, RA 1920, ARE 1889, RE 1895, ROI 1902, ARSA 1904, RSA 1918, RSW 1906, HRSW 1934, ARWS 1904,

RWS 1915. Knighted 1924.

COCHRANE, Helen Lavinia (1868-1946) née Shaw. Water-colour landscape and figure painter. Born in Bath. Studied at Liverpool School of Art, Munich and Westminster. Director of military hospitals in France and Italy 1915-18. RI 1932, SWA.

CONNARD, Philip (1875-1958) Painter and designer. Studied at South Kensington and under Constant and Laurens in Paris. Art Master at Lambeth School of Art. NEA 1909, ARA 1918, RA 1925, RI 1927, ARWS 1933, RWS 1934.

DE GLEHN, Wilfred Gabriel (1870-1951) Formerly Von Glehn. Landscape, portrait and marine painter Studied at South Kensington and Ecole des Beaux Arts, Paris. NEA 1900, RP 1904, ARA 1923, RA 1932

DE WINT, Peter (1784-1849) Landscape painter and water-colourist. Born at Stone in Staffordshire. Studied with William Hilton under John Raphael Smith, a mezzotint engraver. Came under the influence of Varley who gave him instruction. Developed into one of the great masters of the art of pure water-colour. Died in London on 30 January 1849. AOWS 1810, OWS 1811.

DRESSLER, Conrad (1856-1940) Sculptor of portrait and figure subjects, potter. Studied at Royal College of Art under Lanteri and in France. Set up pottery in Birkenhead with Harold Rathbone 1893-95.

EARLOM, Richard (1743-1822) Mezzotint engraver. Born in London in 1743. Pupil of Cipriani, and first artist who made use of the point in mezzotint work. First engraved for Boydell, who in 1777 brought out *Liber Veritatis* consisting of two hundred plates, executed by Earlom in the style of the original drawings by Claude Lorrain. Especially known for his groups of flowers after Van Huysum and Van Os. Executed some etchings as well as some plates in chalk style.

FLINT, Sir William Russell (1880-1969) Painter, illustrator, medical illustrator and lithographer. Studied at Edinburgh School of Art and Heatherleys, London. On the staff of *London Illustrated News* 1904-8. ARA 1924, RA 1933, ARE 1931, RE 1933, ROI 1912, RSW 1913, ARWS 1914, RWS 1917, PRWS 1936, Member of the American Water Color Society.

FLORENCE, Mary Sargent (1857-1954) née Sargent. Decorative mural painter and fresco artist. Studied at the Slade School and Colarossi's, Paris. NEA 1911.

FOSTER, Herbert Wilson Figure painter. Exhibited 1881-1917. Taught at Nottingham School of Art.

FOULKES, Sydney Colwyn (d. 1971) Architect, civic and landscape designer. Studied architecture at Liverpool University before becoming an Associate of the RIBA in 1916 and a Fellow in 1939. Worked on many projects, including large-scale educational and industrial buildings, private residences, council housing estates and civil engineering projects. Took his middle name from his home town of Colwyn Bay, where he died in April 1971.

FRAMPTON, Sir George James (1860-1928) Sculptor. Studied at Lambeth School of Art, the Royal Academy Schools (gold medal and travelling studentship) and Paris. ARA 1894, RA 1902, HRBA 1907, HRI 1926. Knighted 1908. Died 21 May 1928.

GARDNER, Sydney V. Landscape and flower painter. NSA 1908.

GILL, Eric (1882-1940) Sculptor, wood engraver and draughtsman. Born in Brighton. Apprenticed to an architect 1899-1903. ARA 1937.

GINNETT, Louis (1875-1946) Portrait and interior painter and decorative artist. ROI 1908. Lived at Chichester House, Ditchling.

GRANT, Dr Duncan James Corrowr (1885-1978) Painter. Born at Rothiemurchus, Inverness. Studied at Westminster School of Art, the Slade School, in Italy and in Paris under Jacques Emile Blanche. Original Member of the London Artists' Association, Member of Camden Town Group and of the London Group. Doctor of the University of Arts, 1921.

HAGREEN, Philip (1890-1988) Painter and wood engraver. Studied painting under Norman Garstin in Cornwall and at New Cross, London. Moved to Ditchling in 1922 to work with Eric Gill. Moved to Wales and France. Returned to Ditchling in 1932.

HARDIE, Martin (1875-1952) Painter and etcher. Studied under Sir Frank Short. Keeper of the Departments of Painting and Engraving, Illustration and Design at the Victoria and Albert Museum. Author of *Water-colour Painting in Britain* (Three Volumes). ARE 1907, RE 1920, RI 1924, VPRI 1934, RSW 1934. CBE.

HARRISON, Joseph Landscape painter. Exhibited 1881. Headmaster of Nottingham School of Art. NSA 1881.

HAY, Peter Alexander (1866-1952) Landscape, portrait, figure and still life painter. Born in Edinburgh. Studied at the Royal Scottish Academy, Academie Julian, Paris, and Antwerp. RI 1917, RSW 1891.

HOLMES, Sir Charles John (1868-1936) Landscape painter, etcher and writer. Born at Preston. Editor of the *Burlington Magazine* 1903-9. Slade Professor of Fine Art, Oxford 1904-10. Director of the National Portrait Gallery 1909-16, Director of the National Gallery 1916-28. NEA 1905, ARWS 1924, RWS 1929. Knighted 1921, KCVO 1928.

HUGHES-STANTON, Sir Herbert (1870-1937) Landscape painter. Studied under his father William. ARA 1913, RA 1920, HRMS 1925, ROI 1901, HROI 1922, RSW 1922, ARWS 1909, RWS 1915, PRWS 1920. Member of the Society of 25 Artists. Knighted 1923.

JOHN, Augustus Edwin (1878-1961) Portrait and decorative painter and etcher. Born at Tenby, Wales. Studied at the Slade School 1894-98. Travelled widely on the continent. Professor of painting at Liverpool University. Trustee of the Tate Gallery. NEA 1903, ARA 1928, RA 1928 (resigned 1938 and re-elected 1940), RP 1926, Hon. Member of the London Group 1940. OM.

JOHNSTON, Edward; Born in Uruguay 11 February 1872, second son of Capt. Fowell Buxton Johnston and Alice Douglas. Moved to England at a young age. Studied medicine at Edinburgh (1896-7), but health broke down. On advice of W.R. Lethaby studied manuscripts at British Museum. Encouraged by Sir Sydney Cockerell in learning to master calligraphy. From 1899-1912 taught writing and lettering at London County Council Central School of Arts and Crafts of which Lethaby was principal. From 1901 onwards also taught at Royal College of Art. Wrote *Writing and Illuminating, and Lettering* (1906) and *Manuscript and Inscription Letters* (1909). Appointed CBE in 1939. Died at Ditchling 26 November 1944.

JONES, Francis W. Doyle (d.1938) Sculptor. Exhibited 1903-36.

KNIGHT, Charles (1901-1990) Landscape and figure painter and etcher. Born at Hove, Sussex. Studied at Brighton School of Art and the Royal Academy Schools (Landseer scholarship and Turner Gold Medal for landscape). ROI 1933, ARWS 1933, RWS 1935. Lived at Chettles, 34 Beacon Road, Ditchling.

KNIGHT, Harold (1874-1961) Landscape, portrait, flower and figure painter. Son of William Knight (architect). Studied at Nottingham School of Art and l'Ecole des Beaux Arts, Paris. NSA 1908, PNSA 1937, ARA 1928, RA 1937, ROI 1906, RP 1925.

KNIGHT, Dame Laura (1877-1970) née Johnson. Landscape, figure, portrait painter and etcher. Born at Long Eaton, Derbyshire. Studied at Nottingham School of Art. Married Harold Knight. NSA 1908, ARA 1927, RA 1936, ARE 1924, RE 1932, ARWS 1909, RWS 1928, SWA 1933, DBE 1929.

LAVERY, Sir John (1856-1941) Portrait and landscape painter. Born in Belfast, March 1856. Studied at Glasgow, London and Julian, Paris. NEA 1887, ARA 1911, RA 1921, ARHA 1906, RHA 1907, HROI 1910, RP 1893, ARSA 1893, RSA 1896. Knighted 1918.

LEE-HANKEY, William (1869-1952) Portrait and landscape painter and colour engraver. Studied at Chester School of Art, Royal College of Art and in Paris. Served with the Artists Rifles 1915-19. RBA 1896, ARE 1909, RE 1911, RI 1896 (resigned 1906, re-elected 1918, resigned 1924), RMS 1896, ROI 1901 (Hon. Ret. 1940), ARWS 1925, RWS 1936, Member of the Society of 25 Artists.

LORRAIN, Claude (1600-82) (see p.92, 93)

LOWRY, Laurence Stephen (1887-1976) Born in Manchester. Studied art at Manchester School of Art between 1905 and 1915 and also at Salford School of Art. Painted the bleak northern industrial landscapes in a "naïve" style. RBA 1935.

MacCOLL, Dugald Sutherland (1859-1949) Water-colour painter and critic. Born in Glasgow. Studied at Westminster School of Art. NEA 1896, RSW 1938.

McCANNELL, William Otway (1883-1969) Figure and landscape painter. Born at Wallasey. Changed his name from Cannell to MacCannell c1919. Studied at Bournemouth Art School, Royal College of Art, France and Italy. Life instructor and lecturer of Art for the London County Council. Principal of Farnham Art School. ARBA 1919, RBA 1921, ARMS 1916, RMS 1917.

McCORMICK, Arthur David (1860-1943) Landscape and figure painter. Born at Colgraine, Ireland. Studied at the Royal College of Art. RBA 1897, RI 1906, ROI 1906.

MELVILLE, Arthur (1854-1904) Water-colour genre and figure painter. Studied in Paris and at the Royal

Scottish Academy Schools. RP 1891, ARSA 1886, ARWS 1888, RWS 1899.

MOORE, Claude Thomas Stanfield (1853-1901) Marine painter. NSA 1881.

MOORE, Thomas Cooper (1827-1901) Painter. Nottingham.

MORRIS, William (1834-1896) Painter, stained glass, tapestry and wall-paper designer and poet. Born in Walthamstow.

MUIRHEAD, David (1867-1930) Landscape painter. Born in Edinburgh. Studied at the Royal Scottish Academy Schools and the Westminster School of Art. NEA 1900, ARA 1928, ARWS 1924, Member of the Society of 25 Artists.

MUNCASTER, Claude (1903-74) Marine and landscape painter, etcher, illustrator, lecturer and writer. ROI 1932, ARWS 1931, RWS 1936. Exhibited 1923-39.

MUNNINGS, Sir Alfred, P.R.A. (1875-1959) Sporting painter. Born 8 October 1878 at Mendham, Suffolk. Studied at Norwich School of Art and Paris. ARA 1919, RA 1925, PRA 1944-49, RI 1905 (resigned 1911), RP 1925, ARWS 1921, RWS 1929. Knighted 1944.

NIXON, Job (1891-1938) Painter and etcher. Born at Stoke on Trent. Studied at the Royal College of Art and the Slade School (Studentship in engraving at the British School in Rome in 1923). Assistant teacher of etching at South Kensington. NEA 1936, ARE 1923, ARWS 1928, RWS 1934.

ORPEN, Sir William (1878-1931) Portrait painter. Born at Stillorgan, Co. Dublin. Studied at the Metropolitan School of Art, Dublin and at the Slade School 1897-99. Official artist for World War I. NEA 1900, ARA 1910, RA 1919, ARHA 1904, RHA 1907, HRHA 1930, RI 1919, HROI 1929, RP 1905. Knighted 1918.

PENNELL, Joseph (1860-1926) (see p.27-28, 58)

PETO, Harold Ainsworth (1854-1933) Architect and designer. Fifth son of Sir Samuel Morton Peto, Bart, MP, the railway contractor and builder. Articled to Lowestoft architect, J. Clements, in 1871, joined the practice of Sir Ernest George as a partner in 1876. Poor health led to move to Italy, where he concentrated on garden design. On return to England continued to design gardens, including his own at Iford Manor, Bradford-on-Avon. Designed some interiors for the Cunard liner *Mauretania* in 1912.

REDGATE, Arthur W. (1860-1906) Landscape and figure painter. Exhibited 1880-1906. NSA 1884.

RICH, Alfred William (1856-1921) Water-colour landscape painter. Studied at the Slade School 1890-96. and at Westminster. Wrote *Water Colour Painting*, Seeley, Service & Co. Ltd. London; 1923.

RICHTER, Charles Augustus (b.1867) Painter, interior decorator and furniture designer. Born at Ovingdean. Studied at Bath School of Art, London School of Art and Heatherleys.

RICHTER, Herbert Davis (1874-1955) Flower painter, decorative artist, furnishings designer and lecturer. Born at Brighton. Studied under J.M.Swan and Frank Brangwyn. RBA 1910, RI 1920, ROI 1917, RSW 1937.

ROWE, Ernest Arthur (1863-1922) Landscape and garden painter.

RUSKIN, John (1819-1900) Writer, critic and artist. Studied under Copley Fielding and J.D.Harding. Rede lecturer at Cambridge 1867, Slade Professor at Oxford 1869-84. HRWS 1873.

SANDERSON-WELLS, John Sanderson (1872-1955) Portrait and sporting painter. Studied at the Slade School and Julian, Paris. RBA 1896, RI 1903.

SARGENT, John Singer (1856-1925) Painter and water-colourist. Born in Florence. Son of a Philadelphia doctor. Studied in Rome, Florence and with Carolus Duran in Paris 1874. Travelled often in Europe, North Africa, the Middle East and America. NEA 1886, ARA 1894, RA 1897, HROI 1898, RP 1903, HRSA 1906, RSW 1917, ARWS 1904, RWS 1908.

SHANNON, Sir James Jebusa (1862-1923) Figure and portrait painter. Born at Auburn, New York, U.S.A. of Irish parents. Moved to London 1878. Studied at the Royal College of Art 1879-91. Founder member of NEA 1886, ARA 1897, RA 1909, RBA 1888, ARHA 1907, HRMS, ROI 1889, RP 1891, PRP 1910-23. Knighted 1922.

SHORT, Sir Frank (Francis Job) (1857-1945) Painter, etcher and engraver. Born at Worcester. Studied at South Kensington and Westminster. Teacher of engraving at the Royal College of Art. Lived at Jointure Cottage, Ditchling. NEA 1888, ARA 1906, RA 1911, RE 1885, PRE 1910, RI 1917, HRMS 1912. Knighted c1911.

SMART, Rowley (1887-1934) Water-colour landscape painter. Studied art at Manchester School of Art (1901-3), in Liverpool (1903-6) and later in Paris at the Ecole des Beaux Arts.

STEER, Philip Wilson (1860-1942) Landscape, coastal, portrait and genre painter. Born at Birkenhead. Studied at Gloucester School of Art 1878-81, at Julian under Bouguereau 1882-3, and at the Ecole des Beaux Arts 1883-4. Teacher of painting at the Slade School from 1895. NEA 1886.

TEMPLE, Robert Scott Landscape painter. Exhibited 1880-1905.

THESIGER, Ernest (1879-1961) Painter and actor. Studied at the Slade School. Exhibited 1909-38.

TIEPOLO, Giambattista (1696-1770) (see p.92,93)

TONKS, Professor Henry (1862-1937) Landscape and figure painter. Born at Solihull, Warwickshire. Studied at Westminster School of Art. Assistant to Fred Brown at the Slade School 1893. Official artist for World War I. Professor at the Slade School 1918-30. NEA 1895.

TURNER, Joseph Mallord William (1775-1851) Born in London, Turner was admitted to the Royal Academy Schools in 1789 and first exhibited at the RA in 1791. Turner became an ARA in 1799, RA in 1802, Professor of Perspective in 1807 and Deputy President in 1845. In 1792 made the first of many sketching tours. Worked exclusively in water-colour until c.1796 when exhibited his first oil painting at the RA. In 1819 made first of four trips to Italy. Work was much acclaimed by Ruskin and is considered one of Britain's greatest painters.

TYNDALE, Walter (1855-1943) Landscape, architectural, portrait and genre painter. Born at Bruges. Studied at the Bruges Academie and later at the Antwerp Academie before travelling to Paris to study under Bonnat and the Belgian artist Jan Van Beers. On returning to England worked in oil painting portraits and genre. Later took up painting in water-colours and was much influenced by Claude Hayes (1852-1922) and Helen Allingham (1848-1926). RI 1911.

VALETTE, Pierre Adolphe (1876-1942) Born 13 October 1876 at St Etienne near Lyon, France. Trained at the Ecole Regionale des Arts Industriels, St Etienne, and Lyon around 1892. Worked as a commercial painter and engraver. Studied at the Ecole des Arts Decoratifs at Bordeaux (1900-03) and travelled widely, living for some time in Paris. Scholarship to Birkbeck Institute, London (1904). Moved shortly after to Manchester where worked as a commercial artist and continued studies at the Municipal School of Art. Within two years had joined the staff as life class teacher and later appointed Principal Art Master. During period in Manchester (1906-28) co-founded the Society of Modern Artists and participated in their exhibitions from 1912-28. In 1928, after working as Master of Drawing at Victoria University, retired and returned to France to parents' cottage in Blace where continued to paint until his death in 1942.

WATTS, George Frederic (1817-1904) Historical and portrait painter. Born in London. Studied at the Royal Academy Schools from 1835. OM, ARA 1867, RA 1867, HRCA.

WHISTLER, James Abbott McNeill (1834-1903) Painter, etcher and lithographer. Born at Lowell, Mass., USA. Studied in Paris 1851. Moved to London 1859. Visited Venice 1879-80. Settled in Paris 1892 and ran his own Art School, the Academie Carmen 1898-1901. RBA 1884, PRBA 1886-88, RP 1892, HRSA 1902, RSW 1894.

WHISTLER, Rex John (1905-1944) Painter and illustrator and mural painter. Studied at the Slade School and Rome.

WILKINSON, Norman (1878-1971) Marine painter, etcher and poster artist. Born in Cambridge. RBA 1902, RI 1906, PRI 1937, ROI 1908.

WILLIAMS, Terrick (1860-1936) Marine and landscape painter. Born in Liverpool. Studied in Antwerp under Verlat, and Paris. PNSA 1930, ARA 1924, RA 1933, RBA 1894, RI 1904, PRI 1934, ROI 1903, VPROI 1933, Member of the Society of 25 Artists. Exhibited from 1883.

WOOD, Edgar (1860-1935) (see p.87-8, 95, 96, 126)

ABBREVIATIONS

IS	International Society of Sculptors, Painters and Engravers
H . . .	Honary member of . . .
NEA	New English Art Club
NPS	National Portrait Society
NSA	Nottingham Society of Artists
OWS	Old Water Colour Society
P	Royal Society of Portrait Painters
PS	Pastel Society
RA	Royal Academy
RBA	Royal Society of British Artists
RBS	Royal Society of British Sculptors
RCA	Royal Cambrian Academy
RE	Royal Society of Painter-Etchers and Engravers
RHA	Royal Hibernian Academy
RI	Royal Institute of Painters in Water-Colours
RMS	Royal Miniature Society
ROI	Royal Institute of Oil Painters
RP	Royal Society of Portrait Painters
RSA	Royal Scottish Academy
RSW	Royal Scottish Society of Painters in Water-Colours
RWA	Royal West of England Academy
RWS	Royal Society of Painters in Water-Colours
SWA	Society of Women Artists

INDEX